Designmuseen der Welt
Design Museums of the World

IMPRESSUM

Designmuseen der Welt
Design Museums of the World

im Neuen Museum
Staatliches Museum für Kunst und Design in Nürnberg
at Neues Museum
State Museum for Art and Design in Nürnberg

eingeladen durch
Die Neue Sammlung
Staatliches Museum für angewandte Kunst, München
invited by
Die Neue Sammlung
State Museum of Applied Arts and Design, Munich

Ausstellung / Exhibition

Idee / Idea:	Dr. Florian Hufnagl
Konzeption / Concept:	Dr. Petra Hölscher / Dr. Florian Hufnagl
Organisation:	Dr. Petra Hölscher
Restauratorische Betreuung / Restorational support:	Tim Bechthold, Dipl. Rest. Univ.
Ausstellungsarchitektur / Exhibition architecture:	bangert projects, Schopfheim
Bauten / Installations:	Jürgen Jehnich, Metall- und Messebau, Weil am Rhein
Presse / Press:	Rita Werneyer M.A., Neues Museum in Nürnberg / at Nuremberg
	Dr. Corinna Rösner, Die Neue Sammlung, München / Munich
Internet:	Konzept / Concept, Design,technische Umsetzung / technical execution:
	Cockatoo Press, München / Munich , www.die-neue-sammlung.de
Web-Adressen / Web adresses:	www.nmn.de ; www.die-neue-sammlung.de

Publikation / Publication

Herausgeber / Chief editor:	Dr. Florian Hufnagl
Redaktion / Editors:	Dr. Petra Hölscher, Dr. Corinna Rösner, Dr. Jeremy Gaines (eng.)
Übersetzung / Translations:	Dr. Jeremy Gaines (eng. / fr.), John Arnold (fin.)
	Wolfgang Himmelberg (nl.), Anita Hopf (jap.)
	Silke Matinniemi (fin.), H.-P. Schwenk-Köhn (fr.)
	Caroline Sternberg (czech.)
Gestaltung / Design:	bangert grafik, Schopfheim
Produktion / Production:	Corinna Haneke
Verlag / Publishers:	Birkhäuser – Verlag für Architektur
	Birkhäuser – Publishers for Architecture
	Basel_Berlin_Boston

A CIP catalogue record for this book is available from the Library of Congress, Washington D.C., USA.
Bibliographic information published by Die Deutsche Bibliothek
Die Deutsche Bibliothek lists this publication in the Deutsche Nationalbibliografie;
detailed bibliographic data is available in the internet at www.dnb.ddb.de

ISBN 3-7643-6741-5

Designmuseen der Welt
Design Museums of the World

neuesmuseum

Staatliches Museum für Kunst und Design in Nürnberg

Birkhäuser – Verlag für Architektur
Birkhäuser – Publishers for Architecture
Basel_Boston_Berlin

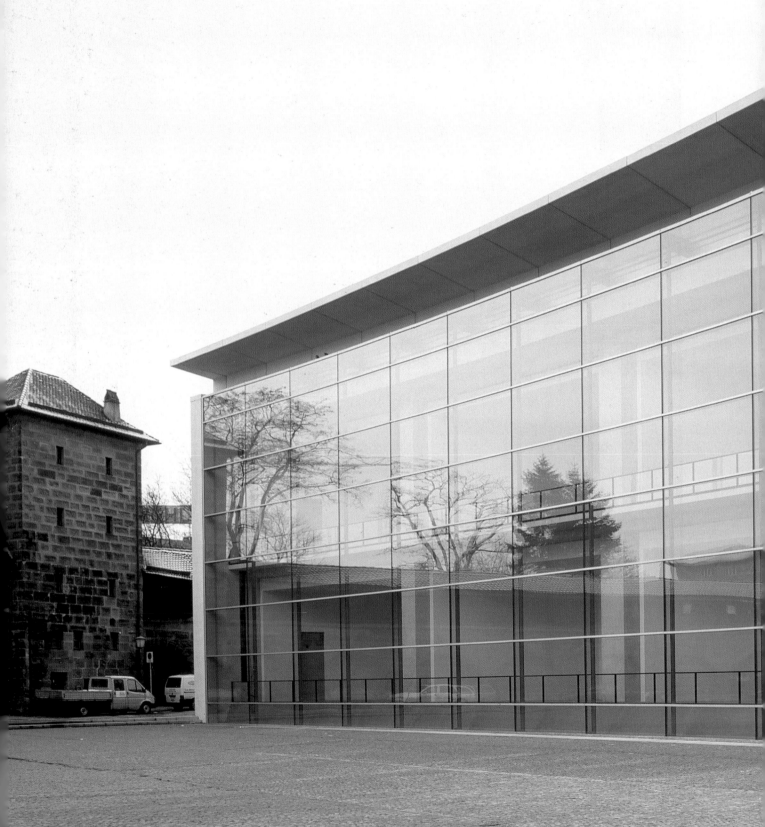

Neues Museum in Nuremberg. Outside view along the glass facade with the city walls in the background.
Neues Museum in Nürnberg. Außenansicht entlang der Glasfassade mit Blick auf die Stadtmauer.

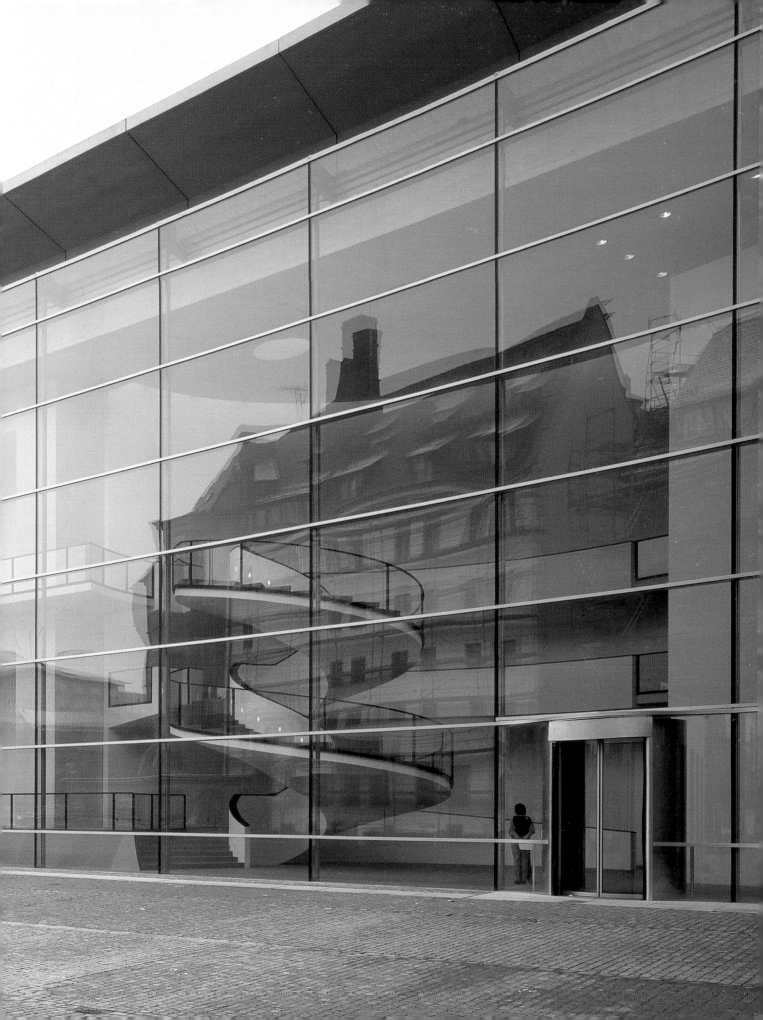

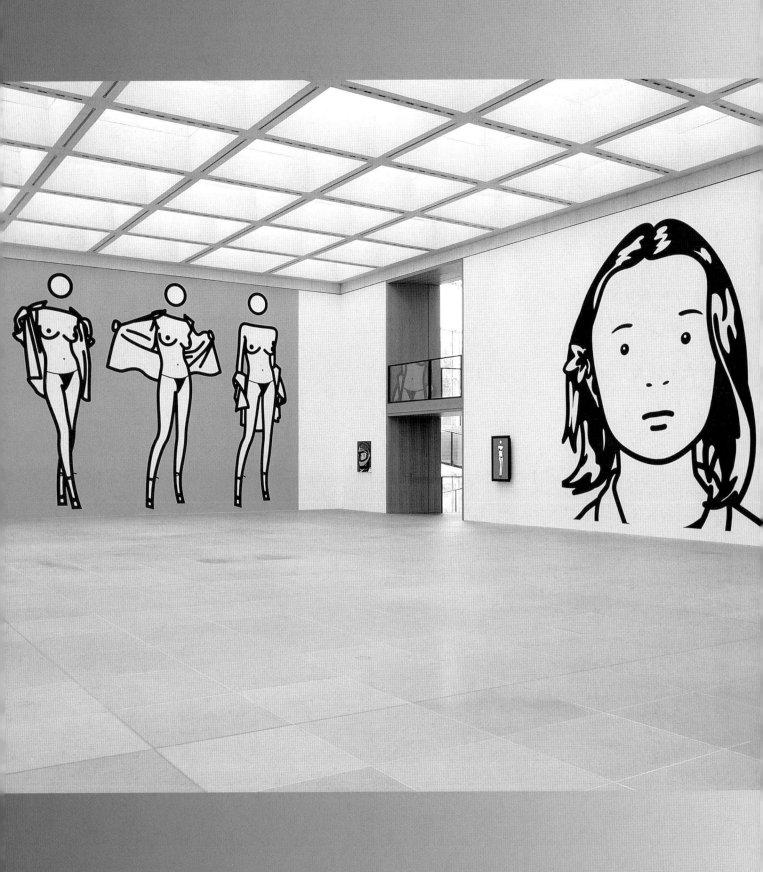

Neues Museum in Nuremberg. View of the exhibition "Julian Opie" 2003.
Neues Museum in Nürnberg. Blick in die Ausstellung „Julian Opie" 2003.

KUNST UND DESIGN UNTER EINEM DACH

Unter dieser Devise tritt das vom Freistaat Bayern in einem wunderschönen Hause neu gegründete Neue Museum in Nürnberg, das sich in seinem Untertitel als Staatliches Museum für Kunst und Design ausweist, seit seiner Eröffnung im Jahre 2000 an. Die Trennung von freier und angewandter Kunst aufzuheben und durch ein fruchtbares Miteinander zu ersetzen, das ist in den letzten Jahren in vielen Kunstmuseen gefordert und erprobt worden. Man hat inzwischen an den verschiedensten Stellen mit den unterschiedlichsten Verbindungen und Mischungen erste Erfahrungen gesammelt. Ein gleichgewichtiges Nebeneinander, wie es das Neue Museum in Nürnberg mit seinen Sammlungen von Kunst und Design praktiziert, ist so etwas wie eine Weltneuheit, die nunmehr im vierten Jahre zu erleben ist und sich auf Auseinandersetzung und Kritik freut.

Es wurden aber in diesem Museum nicht nur zwei Sammlungen unter einem Dach zusammengeführt, sondern zwei sehr unterschiedliche Sammeltraditionen: diejenige des modernen Kunstmuseums, das dazu neigt, die Werke der Künstler in seinen White Cubes trotz aller historischen Argumentation in die Zeitlosigkeit zu erheben, und diejenige des Designmuseums, das seine Objekte sowohl als Vorbilder mit ewigem Wert wie als Zeugnisse bestimmter Epochen präsentiert. Schließlich wurde mit diesem Nebeneinander die Möglichkeit eröffnet, sich auch mit den Wechselwirkungen, den gegenseitigen Anregungen, Interpretationen und Kommentierungen von Kunst und Design auseinander zu setzen.

Praktiziert wird unser Miteinander von Kunst und Design unter einem Dach in einer Verschränkung zweier Institutionen, die als solche wohl ohne Beispiel ist. Innerhalb der Institution des Neuen Museums in Nürnberg hat Die Neue Sammlung, das Staatliche Museum für angewandte Kunst in München, den Auftrag, eigenverantwortlich und zugleich integriert in das Gesamtprogramm eine Sammlung des internationalen Design seit den 50er Jahren des zwanzigsten Jahrhunderts – ausgewählt aus der reichen Fülle ihrer Bestände – zu präsentieren und in regelmäßiger Folge Ausstellungen zu diesem Thema zu veranstalten.

Diese Ausstellung, bei der Designmuseen der Welt mit Hauptwerken der Designgeschichte unsere Gäste sind, ist eine Premiere auf diesem Wege, und wir wissen, dass nicht nur wir selbst, sondern auch die Öffentlichkeit, das internationale und das regionale Publikum des Neuen Museums, große Erwartungen in diese Beiträge zum Ausstellungsprogramm unseres Museums setzt.

Dank gilt meinem Kollegen Florian Hufnagl, der als Direktor der Neuen Sammlung die Verantwortung für diesen Bereich im Neuen Museum in Nürnberg trägt, seinen Mitarbeiterinnen und Mitarbeitern, die von München aus zum Gelingen dieses ersten gemeinsamen Ausstellungsprojektes in Nürnberg beigetragen haben, sowie allen denjenigen im eigenen Hause, die dabei mithelfen konnten.

Lucius Grisebach
Direktor des Neuen Museums in Nürnberg

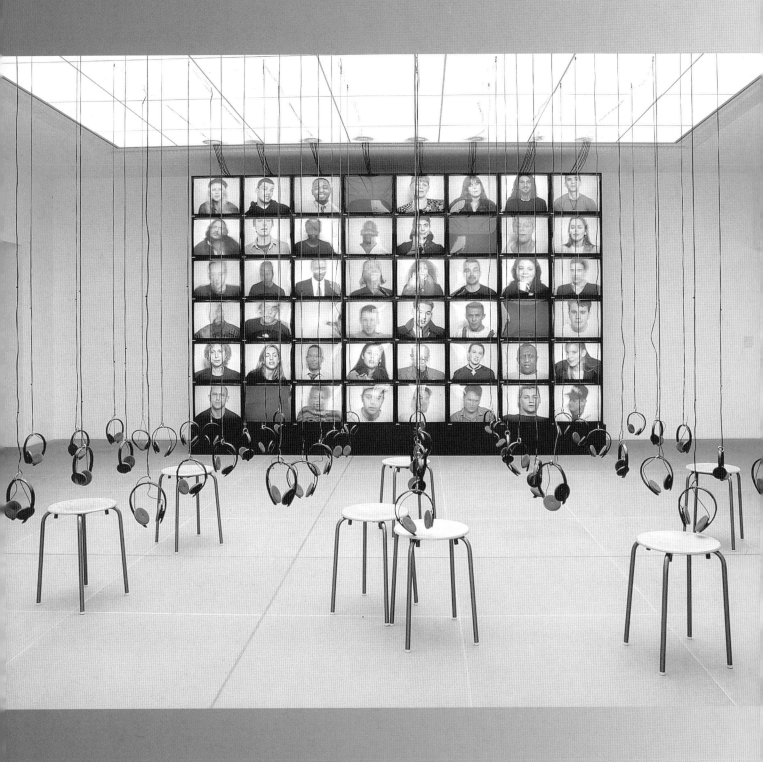

Neues Museum in Nuremberg. Art Collection. York der Knöfel "Thoughts".
Neues Museum in Nürnberg. Sammlung Kunst. York der Knöfel „Thoughts".

ART AND DESIGN UNDER A SINGLE ROOF

This has been the motto taken by Neues Museum in Nuremberg – whose sub-title declares it to be the State Museum for Art and Design – ever since it was founded in a marvelous new building by the Free State of Bavaria in 2000. In recent years, many museums have endeavored to overcome the division between free and applied art and instead ensure their fruitful coexistence. Initial experiences have been gained in all sorts of places on the widest range of different combinations and admixtures. Yet treating them as equals, as does Neues Museum in Nuremberg with its Art and Design collections, is a world novelty – now in its fourth year and eager to hear praise or criticism.

Yet, in this museum not only have two collections been brought together under a single roof; so, too, have two very different collecting traditions: that of a modern art museum that tends to accord works of artists an elevated timeless status in its white cubes above and beyond all the historical arguments offered; and that of the design museum, which presents its objects both as models that have an eternal value and as witnesses to specific epochs. Essentially, this coexistence is an opportunity: to focus on the interaction, the mutual stimulation, interpretation and commentaries of art and design.

At Neues Museum in Nuremberg this coexistence of art and design is being pursued by dovetailing the two institutions under a single roof – a quite unprecedented approach. Within the institution of Neues Museum in Nuremberg "Die Neue Sammlung", the State Museum of Applied Arts and Design in Munich has the task of presenting a collection of international design since the 1950s – chosen from the wealth of its holdings. The latter Museum alone is responsible for how it structures its exhibitions and yet also has the task of integrating these projects into the overall Neues Museum program. Likewise, its role is to organize exhibitions at regular intervals. The current exhibition, in which design museums from all over the world guest in Nuremberg with key examples from the history of design, is a true premiere – and we are well aware that not only we, but also the general international and regional public who come to Neues Museums have great expectations as regards these items in the Museum's exhibition program.

My thanks go to my colleague Florian Hufnagl, who in his capacity as Director of Die Neue Sammlung is responsible for this section at Neues Museum in Nuremberg, to his staff who from their Munich base have contributed to the success of this first joint exhibition venture in Nuremberg, and to all those in the museum in Nuremberg who have helped along the way.

Lucius Grisebach
Director of Neues Museum in Nuremberg

Neues Museum in Nuremberg, Design Collection, the 1980s.
Neues Museum in Nürnberg, Sammlung Design, 80er Jahre.

„INTERNATIONAL, CERTAINLY!"

Mit diesem apodiktischen Postulat stellte einst Prinz Albert von Sachsen-Coburg, Gemahl der Königin Viktoria von England, die Weichen zur ersten Weltausstellung in London 1851.[1] Die finanziellen Gewinne der überaus erfolgreichen Veranstaltung flossen in Sammlungen angewandter Kunst, die zur Entstehung des Victoria & Albert Museums in South Kensington führten – als Vorbild vieler weiterer Museen für Kunstgewerbe oder Gewerbekunst, Kunstindustrie, Kunsthandwerk oder Gestaltung, Dekorative Kunst oder Angewandte Kunst, für die Nützlichen Künste oder – Design... eine Kettenreaktion von historischer Bedeutung.[2]

Damals in London ging es um den „friedlichen Wettstreit der Nationen". Es folgten Weltausstellungen der Superlative, Biennalen, Triennalen, Messen unterschiedlichster Couleurs, repräsentative Produktschauen – stets unter dem Vorzeichen des internationalen Anspruchs. Auch wenn ihr Konzept heute durch komplexe globale Kommunikationssysteme ersetzt und zunehmend obsolet scheint, so ist der Traum solcher Begegnungen doch lebendig geblieben.

150 Jahre nach Gründung des ersten Museums dieser Art sind 29 Designmuseen von internationalem Rang der Einladung der Neuen Sammlung gefolgt, sich mit jeweils einem signifikanten Objekt ihres Landes im Neuen Museum in Nürnberg – als dem jüngsten Mitglied dieser „Familie" – vorzustellen. Die Gesamtheit der Leihgaben, die wie Stellvertreter der einzelnen Häuser entsandt wurden, bildet ein funkelndes Mosaik zur Designgeschichte des 20. Jahrhunderts – und dies gleichsam als signifikantes Zeichen zu Beginn des Ausstellungsreigens aus dem Bereich Design in den kommenden Jahren.

„Museen aller Orte haben gewisse Dinge miteinander gemeinsam"[3] – das liegt in der Natur der Sache und könnte bedeuten, man fände überall das Gleiche vor. Jede Sammlung spiegelt aber auch ihre ganz spezifische Entwicklung und zugleich Aspekte ihres jeweiligen kulturellen Zusammenhangs. Wir haben daher die Gäste gebeten, möglichst in Beschränkung auf ein aussagestarkes Objekt sowohl diese Charakteristik und nationale Besonderheit als auch die globale Vernetzung zu berücksichtigen und aus ihrer Sicht zu illustrieren. In hoch verdichteter Weise und genauer Abstimmung mit den Wissenschaftlern der eingeladenen Häuser entsteht so nicht nur eine äußerst konzentrierte Geschichte der Gestaltung, sondern auch das Portrait einer Institution.

Die Gästeliste liest sich fast wie ein „Who's Who" der prominentesten Einrichtungen zur Bewahrung, Vermittlung und Dokumentation von Design – einschließlich jener Kunstgewerbemuseen, die sich erst nach und nach für das Thema geöffnet haben. Es ist im übrigen auch das erste Mal, dass sich Designmuseen der Welt an einem Ort zusammenfinden und doch fehlen leider einige Partner wie etwa – besonders schmerzlich – das Museum of Modern Art New York, das während seiner Auslagerung in Queens wegen Umbau keinen Leihverkehr leisten kann. Dafür aber zeigen das Metropolitan Museum of Art und das National Design Museum in New York, bekannter als Cooper Hewitt Museum, das Wolfsonian in Miami und das Musée des Beaux Arts in Montréal herausragende Stücke aus ihrem Besitz. Museen aus Israel, Australien, Neuseeland und Japan bereichern mit ihren Leihgaben die Ausstellung ebenso wie die Häuser aus ganz Europa.

Modifikationen innerhalb der Konzeption ergaben sich durch den sehr unterschiedlichen Charakter der Häuser. Die Niederlande und Italien etwa verfügen bis heute nicht über ein explizit dem Design gewidmetes Museum. Eine verwandte Funktion erfüllt in Italien jedoch die Triennale in Mailand, die schon seit den zwanziger Jahren eine zentrale Rolle für die internationale Promotion von Design spielt und daher in der Ausstellung vertreten sein muss. Ein ähnliches „Must" – obgleich kein Museum im traditionellen Sinne – verkörpert das Vitra Design Museum. So verrät der Querschnitt der Gäste auch einiges über die Akzeptanz und Integration von Design in unserem Bewußtsein.

Museen, die sich mit Design beschäftigen, richten ihr Augenmerk zwangsläufig sehr stark auf Gegenwart und Zukunft. Freilich geraten sie zugleich auch zu einem „Ort der Erinnerung"[4]. Die Ausstellung schlägt daher nicht nur Brücken zwischen Kontinenten und Epochen, gewährt Vor- und Rückschau und verspannt stilistische Tendenzen und Strömungen, sondern demonstriert auf anschauliche Weise, dass die Avantgarden des 20. und 21. Jahrhunderts letztlich keine Grenzen kannten und kennen. In exemplarischen Werken wird von entscheidenden Innovationen und Visionen der Formgebung erzählt. Künstler wie Henry van de Velde, Gerrit Rietveld, Walter Gropius, Joe Colombo, Frank O. Gehry gehören ebenso dazu wie Entwerfer der jüngeren Generationen, etwa Marc Newson, Karim Rashid oder Stephen Richards. Viele der Objekte wurden längst zu Klassikern der Moderne gekürt oder gelten bereits als Ikonen zeitgenössischer Gestaltungsideen – und sie demonstrieren eindrucksvoll, dass gutes Design ästhetische und ideelle Beständigkeit beinhaltet. Dies gilt für eine Stehleuchte aus dem Paris der 20er Jahre ebenso wie für einen englischen Sportwagen zu Beginn der 60er Jahre oder ein zeitgenössisches Schmuckstück aus Neuseeland.

Mit der Gründung des Neuen Museums, Staatliches Museum für Kunst und Design in Nürnberg, hat der Freistaat Bayern ein Zeichen gesetzt: der erste Museumsbau in Deutschland mit ausdrücklich interdisziplinärem Auftrag, der gezielt und programmatisch freie Kunst und Design zusammenführt. Die permanente Sammlung Design konzentriert sich hier zeitlich – in Reaktion auf die Exponate der Sammlung Kunst – auf das Industrieprodukt seit 1945. Die nun erste Sonderausstellung der Neuen Sammlung ist als ein weiterer Akzent gedacht, Design an diesem Hause in einen fruchtbaren internationalen Dialog zu bringen. Die begeisterten Zusagen unserer Kollegen aus aller Welt sind als Referenz an das Konzept des Neuen Museums in Nürnberg zu werten, und die Ausstellung selbst quasi als Hommage an das unermüdliche Engagement all der eingeladenen Häuser, die Gestaltung von Gebrauchsgegenständen als ästhetische Disziplin im Kontext der Kunstgeschichte und ihrer musealen Institutionen zu etablieren. Eben darin liegt auch eine wesentliche Chance: aus der Vereinzelung herauszutreten zugunsten von Austausch und Kooperation.

Es ist zu hoffen, dass der zündende Funke überspringt und den Namen des Neuen Museums in den Kreis der anderen Protagonisten auf dieser Weltbühne hineinträgt. Und mehr: dass damit das Thema Design innerhalb der internationalen Museumslandschaft verdientermaßen eine deutlichere Positionierung und schärferes Profil gewinnt. Damit könnte die Ausstellung – analog zur innovativen Idee, ein Museum für Kunst und Design zu errichten –, programmatischen Charakter für die Zukunft gewinnen.

Florian Hufnagl

13

1 Kretschmer, Winfried: Geschichte der Weltausstellungen, Frankfurt am Main / New York 1999, S. 23
2 Vgl. ebd., S. 55 / 56 und Mundt, Barbara: Die deutschen Kunstgewerbemuseen im 19. Jahrhundert, Passau 1974, S. 35ff.
3 Sheehan, James J.: Geschichte der deutschen Kunstmuseen. Von der fürstlichen Kunstkammer zur modernen Sammlung, München 2002, S. 11
4 Groys, Boris: Logik der Sammlung. Am Ende des musealen Zeitalters, Wien / München 1997, S. 8

Neues Museum in Nuremberg. Design Collection. German Design of the 1950s and 1960s.
Neues Museum in Nürnberg. Sammlung Design. Deutsches Design 50er / 60er Jahre.

"INTERNATIONAL, CERTAINLY!"

With this programmatic claim Prince Albert of Saxony-Coburg, husband of Queen Victoria of England, set the tone for the first World Exposition in London in 18511. The profits from the highly successful event were channeled into collections of applied art, which led to the founding of the Victoria & Albert Museum in South Kensington – a model for many additional museums for arts and crafts and commercial art, the art industry, crafts, the decorative arts and applied arts, for the useful arts or – design ... a chain reaction of historical importance.[2]

In the London of the time attention focused on the "peaceful competition between nations". There followed superlative World Expositions, biennials, triennials, the most varied of trade fairs, illustrious product exhibitions – always under the portent of claiming to be international. Even if today their concept has been replaced by complex global communication systems and appears to be increasingly obsolete, the dreams that such encounters produced are just as much alive.

150 years after the first museum of this kind was founded, 29 design museums of international standing took up Die Neue Sammlung's invitation to present their collections in the form of one outstanding object from their country at Neues Museum in Nuremberg – the most recent addition to the "family". Taken as a whole, the loans, which function as representative emissaries of the individual institutions, form a glittering mosaic of 20th-century design history – and this is a significant symbol, as it were, marking the beginning of a round of design exhibitions scheduled for the coming years.

"Museums all over have certain things in common"[3] – that is in the nature of things and could mean that we come across the same things wherever we go. However, each collection reflects its own quite specific history as well as aspects of its specific cultural context. For this reason we asked our guests to take into account this salient feature and national quality as well as global networking and illustrate it from their own particular angle by focusing their choice on just one especially significant and telling object. What emerges is not just an extremely condensed history of design, produced in a highly concentrated form and in close cooperation with the scholars from the institutions that were invited, but also the portrait of an institution.

The guest list reads almost like a "Who's Who" of the best-known establishments engaged in the preservation, dissemination and documentation of design – including those arts and crafts museums which only gradually came to concern themselves with the subject. It is also the very first time that design museums from all over the world have congregated in one place, and yet there are still some missing: for example, and this is particularly painful, the Museum of Modern Art in New York. Due to conversion work, it is temporarily located in Queens and is unable to engage in any loan activities. However, the Metropolitan Museum of

Art and the National Design Museum in New York, better known as the Cooper-Hewitt Museum, the Wolfsonian in Miami and the Musée des Beaux Arts in Montréal are all showcasing outstanding exhibits from their collections. Museums from Australia, Israel, Japan and New Zealand have enriched the exhibition with their loans, as have institutions from throughout Europe.

The highly disparate character of the various institutions resulted invariably in modifications to the overall concept. Even today, for example, neither the Netherlands nor Italy has a museum devoted specifically to design. Yet in the latter country, the Triennial in Milan fulfills a similar function: since the 1920s it has played a pivotal role in the international promotion of design and as such must be represented in the exhibition. Although not a museum in the traditional sense, the Vitra Design Museum was a similar "must". As such the cross-section of our guest institutions goes a long way to giving us an insight into the acceptance and integration of design in our general outlook on life.

Museums involved with design must of necessity focus firmly on the present and the future. That said, they are likewise a "place for memories"[4]. Thus the exhibition does not just build bridges between continents and epochs, look back to the past as well as forward to the future, and embrace stylistic trends and currents. It also illustrates visually, that at the end of the day the avant-gardes of the 20th and 21st century did not, and indeed today still do not recognize any boundaries. The works on display relate decisive innovations and visions of design. Artists such as Henry van de Velde, Gerrit Rietveld, Walter Gropius, Joe Colombo, Frank O. Gehry are just as much included as are younger generation designers such as Marc Newson, Karim Rashid and Stephen Richards. Many of the exhibits have long become Modernist classics and are considered icons of contemporary design – and they demonstrate very impressively that the aesthetics and ideas behind good design are lasting. This applies just as much to a 1920s Parisian standing lamp as to a 1960s English sports car or a piece of contemporary New Zealand jewelry.

With the founding of Neues Museum, State Museum for Art and Design in Nuremberg, the Free State of Bavaria has made a mark: it is the first museum in Germany to be built expressly with inter-disciplinary projects in mind, a policy that focuses programmatically on uniting free art and design. As a response to the exhibits contained in the art collection, time wise the permanent design exhibition concentrates on industrial products since 1945. Die Neue Sammlung's first special exhibition in Neues Museum is thought of as further emphasis on integrating design within this institution in a fruitful international dialogue. The fact that so many colleagues from all over the world accepted our invitation with such enthusiasm can be considered as confirmation of the concept devised at Neues Museum in Nuremberg, and the exhibition itself as a form of homage to the tireless commitment of all those institutions invited in establishing the design of everyday objects as an aesthetic discipline in the context of the history of art and its institutions. And this creates another highly important opportunity: to swap isolation for exchange and cooperation.

We can only hope that the spark catches, and that the other protagonists on the international stage become aware of Neues Museum. Indeed, we can also justifiably hope that in this way on the international museum scene the subject of design will rightfully achieve a more a sharper positioning and a clearer profile. As such the exhibition, – parallel to the innovative idea of establishing a museum for art and design – could set the stage for the programs of the future.

Florian Hufnagl

1 Kretschmer, Winfried: Geschichte der Weltausstellungen, (The History of World Exhibitons) Frankfurt / Main, New York 1999, p. 23.
2 cf. ibid., pp. 55-56 and Mundt, Barbara: Die deutschen Kunstgewerbemuseen im 19. Jahrhundert, Passau 1974, pp. 35ff.
3 Sheehan, James J.: Geschichte der deutschen Kunstmuseen. Von der fürstlichen Kunstkammer zur modernen Sammlung, Munich 2002, p. 11.
4 Groys, Boris: Logik der Sammlung. Am Ende des musealen Zeitalters, Vienna, Munich 1997, p. 8.

DANK / MY THANKS

Mein Dank gilt meinem Kollegen Lucius Grisebach, dem Direktor des Neuen Museums in Nürnberg, und seinen Mitarbeitern für ihre Unterstützung, den Mitarbeitern im eigenen Hause für ihr ungewöhnliches Engagement bei diffizilen Sachverhalten, den Kolleginnen und Kollegen der eingeladenen Museen für ihr spontanes Interesse gegenüber unserer Ausstellungsidee, ihr in aller Intensität und mit hohem Enthusiasmus im Dialog geführtes Ringen um die Auswahl der Stücke und für ihr großzügiges unbürokratisches Entgegenkommen bei den Leihgesuchen, das das erste weltweite Treffen der Designmuseen in Nürnberg ermöglichte, sowie Freunden und Mitstreitern für die freundschaftlich intensiven und immer fruchtbringenden Diskussionen und Gespräche, und sodann den vielen guten und hilfreichen Geistern im Hintergrund, die hier unbenannt bleiben wollen.

My thanks go to my colleague Lucius Grisebach, Director of Neues Museum in Nuremberg, and his staff for their unwavering support, my staff in Munich for their extraordinary dedication to a very complex enterprise, to my colleagues in the museums invited to participate for their spontaneous interest in our exhibition concept, for the zest and enthusiasm in the intense discussions that led to the selection of the exhibits, and for their generous and unbureaucratic handling of our requests for loans – the loans that enabled this, the very first international assembly of design museums in Nuremberg to take place, to my friends and companions along the way, for the intensive and fruitful debates and conversations, and then to all the very many kind and helpful spirits who have worked behind the wings and wish to remain unnamed.

– Amsterdam, Stedelijk Museum, W.S. van Heusden, Ingeborg de Roode
– Barcelona, Museu de les Arts Decoratives, Teresa Bastardes i Mestre, Silvia Ventosa
– Barcelona, Tresserra Collection, Jaime Tresserra, Susan Zühr
– Berlin, Bauhaus-Archiv / Museum für Gestaltung, Peter Hahn, Annemarie Jaeggi,
 Christan Wolsdorff, Monika Tritschler
– Berlin, Staatliche Museen zu Berlin, Preußischer Kulturbesitz, Kunstgewerbemuseum,
 Angela Schönberger, Susanne Netzer
– Copenhagen, Det Danske Kunstindustrimuseet, Bodil Busk Laursen,
 Jorgen Schou Christensen, Christian Holmsted Olesen
– Ghent, Design museum, Lieven Daenens, Bernadette de Loose
– Göteborg, Röhsska Museet, Elsebeth Welander-Berggren, Jan Norrman
– Göteborg, Rolf Walter
– Helsinki, Designmuseo, Marianne Aav, Jukka Savolainen
– Kyoto, The National Museum of Modern Art, Takeo Uchiyama, Yuko Ikeda
– Leipzig, Museum für Kunsthandwerk / Grassimuseum, Eva-Maria Hoyer,
 Olaf Thormann, Uta Camphausen
– London, Victoria & Albert Museum, Christopher Wilk, Rebecca Milner, Lara Raymond,
 Anne Steinberg, Helen Whitcombe

19

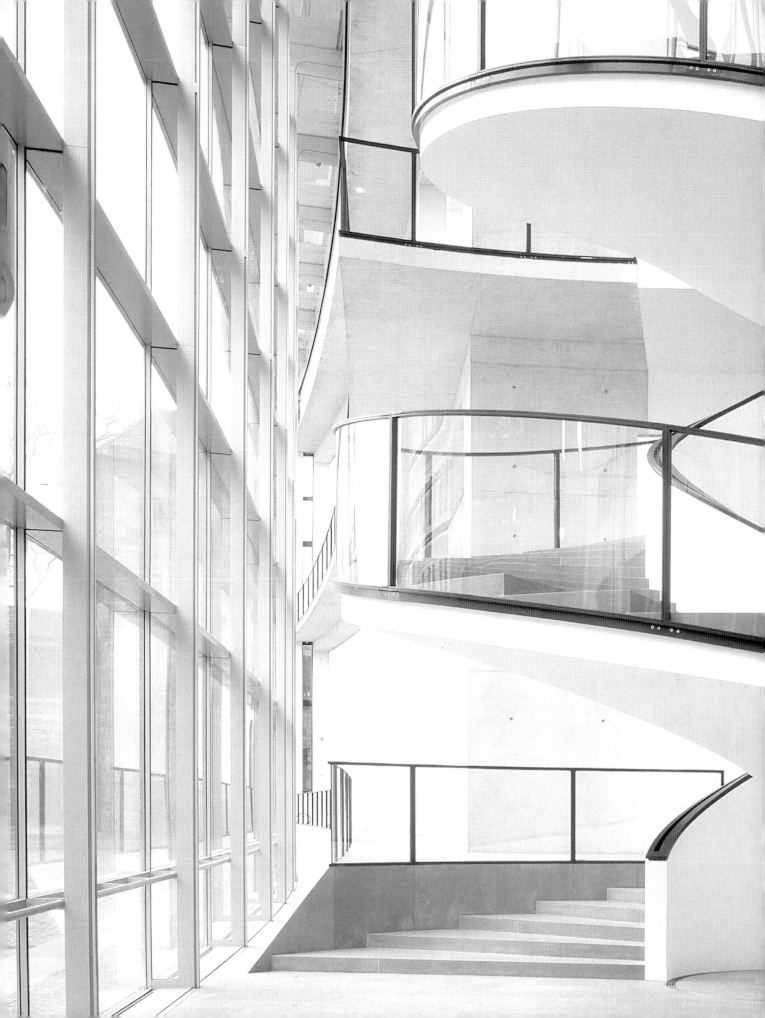

Amsterdam

Stedelijk Museum
www.stedelijk.nl

COLLECTION

Stedelijk Museum

DESIGNER / ARCHITECT

Gerrit Thomas Rietveld

OBJECT

Aluminium chair / Aluminiumsessel

DATE

1942

MANUFACTURER

unknown / unbekannt

Stedelijk Museum Amsterdam

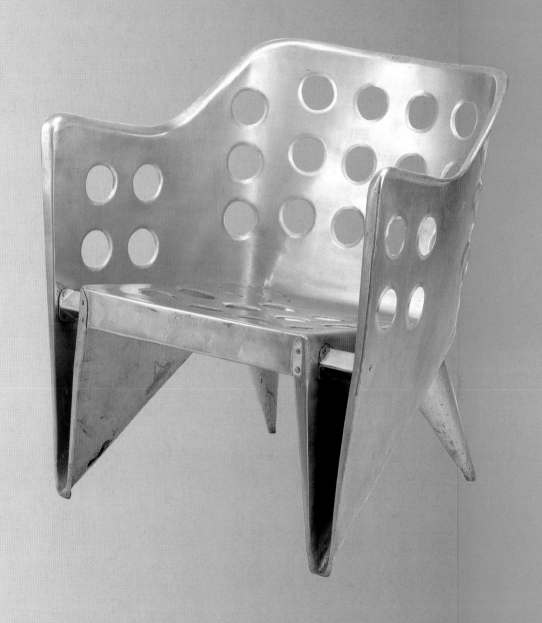

GESCHICHTE DES MUSEUMS

Amsterdam **Stedelijk Museum**

1900–1934 – Ausstellungen, aber noch keine Sammlung

Schon seit mehr als einem Jahrhundert werden im Stedelijk Museum Amsterdam Ausstellungen organisiert, in denen moderne angewandte Kunst oder modernes Design zu sehen ist.[1] Das Museum wurde 1895 eröffnet, und fünf Jahre später wurde zum ersten Mal eine solche Ausstellung gezeigt. St. Lucas, die wichtigste der Künstlervereinigungen, die in der Anfangszeit Arbeiten ihrer Mitglieder in Verkaufsausstellungen vorstellte, zeigte 1900, in ihrer ersten Präsentation, Möbel des Entwerfers H. W. Mol, der später in Vergessenheit geriet.

In den ersten Jahrzehnten gaben Initiativen dieser Art, die von außen an das Museum herangetragen wurden, den Ton an. Neben Verkaufsausstellungen wurden auch mehrere Präsentationen organisiert, die „erzieherisch" auf den Geschmack des Publikums einwirken sollten. Das bezeichnendste Beispiel war die gleichnamige Ausstellung der Vereinigung „Kunst aan het Volk" (Kunst für das Volk) von 1905: an der Seite einer musterhaften Einrichtung für Arbeiterwohnungen wurden gut und schlecht gestaltete Gebrauchsgegenstände einander gegenübergestellt. Die meisten Präsentationen waren jedoch darauf ausgerichtet, das moderne Kunstgewerbe in einem allgemeineren Sinne zu propagieren. Die 1904 gegründete VANK (Nederlandsche Vereeniging van Ambachts- en Nijverheidskunst; „Niederländische Handwerks- und Gewerbekunstvereinigung"), die die Kunstgewerbetreibenden zusammenschließen wollte, spielte dabei eine wichtige Rolle. Seit dem Ende der zwanziger Jahre wurden auf Initiative des 1924 gegründeten BKI (Nederlandsche Bond voor Kunst en Industrie) auch industriell gefertigte Produkte im Museum präsentiert. Die bis dahin gezeigten Interieurobjekte bekannter Architekten / Designer wie Hendrik Petrus Berlage, Jac. van den Bosch, Willem Penaat, Piet Kramer und C. A. Lion Cachet waren praktisch ausnahmslos handwerklich gefertigt, was auch nicht weiter verwunderlich ist, da die Industrialisierung und die Zusammenarbeit zwischen Entwerfern und Fabrikanten in den Niederlanden nur langsam in Gang kamen.

1934 – Eine Abteilung für angewandte Kunst mit einer eigenen Sammlung entsteht

Da Künstler, Entwerfer und Fabrikanten an den frühen Ausstellungsprojekten unmittelbar beteiligt waren, wurden in diesen Ausstellungen hauptsächlich ihre eigenen Arbeiten präsentiert. Das änderte sich erst, als 1934 ein lang gehegter Wunsch in Erfüllung ging: die „Vereinigung zum Aufbau einer öffentlichen Sammlung zeitgenössischer Kunst", die ihre Sammlung bildender Kunst seit 1895 im Stedelijk Museum untergebracht hatte und das Gebäude damals noch mit verschiedenen anderen Organisationen und Sammlungen teilen musste, richtete eine Abteilung für moderne angewandte Kunst ein. Erst von diesem Moment an konnte auch in diesem Bereich eine aktive Sammeltätigkeit einsetzen. Bis dahin waren hauptsächlich niederländische Kunstgewerbeobjekte (zum Beispiel Keramik von Th. Colenbrander) erworben worden, in vielen Fällen durch eine Schenkung. Die seit dem Ende der zwanziger Jahre vorsichtig eingeschlagene — anfänglich vor allem von den Behörden angeregte — internationale Orientierung wurde nach 1934 zu einer Richtlinie Museumspolitik. Zu den frühesten Erwerbungen gehören zum Beispiel drei Möbel des dänischen Designers Jacob Kjaer, die 1937 in der Ausstellung „Deensche kunstnijverheid" (Dänisches Kunstgewerbe) im Stedelijk Museum gezeigt worden waren.

Die Sammlungspolitik war darauf ausgerichtet, Beispiele für gut gestaltete Einrichtungsobjekte zu erwerben. Bis weit nach dem Zweiten Weltkrieg wurde es auch für wichtig erachtet, dass das betreffende Objekt relativ preiswert produziert werden konnte, damit es für einen großen Teil der Bevölkerung erschwinglich war. Der Lounge Chair von Charles und Ray Eames wurde zum Beispiel im Anschluss an die 1966 gezeigte Ausstellung „50 jaar zitten" (50 Jahre Sitzen) nicht in die Sammlung aufgenommen, weil er (mit damals ca. 1.940 Gulden) für viel zu teuer gehalten wurde. Diese Kriterien waren eng an die Ideale des Modernismus angelehnt, an denen sich die Sammlung zunehmend orientierte.

1946 – Ein eigener Konservator wird ernannt

Willem Sandberg, der schon seit 1938 im Stedelijk Museum tätig war, wurde 1945 zum Direktor berufen. Während seines Direktorats stieg die Zahl der Ausstellungen stark an: dem Publikum wurde ein umfassendes Bild der internationalen Entwicklungen auf dem Gebiet der bildenden Kunst und des Designs vermittelt und zum ersten Mal wurden einzelnen Designern wie Gerrit Th. Rietveld, Arne Jacobsen oder dem Architekten / Designer F. A. Eschauzier, der verschiedene Baumaßnahmen im Stedelijk Museum realisierte, Einzelausstellungen gewidmet. Um den Anforderungen des Museums besser gerecht werden zu können, stellte Sandberg für jede Abteilung einen gesonderten Konservator ein. Paula Augustin wurde 1946 die erste Konservatorin für angewandte Kunst. Die Erweiterung des Mitarbeiterstabs hatte zur Folge, dass das Stedelijk Museum häufiger selbst die Initiative für seine Ausstellungen übernahm, auch wenn die eigentliche Organisation oft immer noch anderen Instanzen oblag. Sandbergs Interesse an Gestaltung — er war von Hause aus Grafikdesigner — äußerte sich in seinen Bemühungen um größere Möbelausstellungen und in jenen Projekten, in denen er verschiedene Disziplinen miteinander vereinte.

Die Möbel-, Glas- und Keramiksammlungen wurden unter Sandbergs Direktorat (1945-1962) stark erweitert, unter anderem durch große Schenkungen. Die Bestände an Möbeln von Gerrit Th. Rietveld sind in dieser Zeit derart angewachsen, dass sie seither als eine Besonderheit des Museums betrachtet werden können. Zusammen mit der des Centraal Museum in Utrecht gehört die Sammlung des Stedelijk Museum mit gut 110 Objekten zu den wichtigsten und umfangreichsten Rietveld-Sammlungen der Welt. Der persönlichen Affinität Paula Augustins zum Textilbereich ist es zu verdanken, dass eine Textilsammlung (Stoffe für den Wohnbereich, Kleidung) auf höchstem Niveau angelegt wurde (zur Zeit ca. 800 Objekte, von denen ungefähr drei Viertel aus den 50er und 60er Jahren stammen). Im allgemeinen kann gesagt werden, dass die Erweiterung der Sammlung eng mit den Ausstellungen, die organisiert wurden, einherging, und das ist in beträchtlichem Maße auch heute noch so.

1965 – Eine vollwertige Abteilung entsteht

Weder der folgende Direktor, Edy de Wilde, der das Museum von 1963 bis 1985 leitete, noch seine Nachfolger Wim Beeren (1985-1993) und Rudi Fuchs (1993-2003) hatten eine ebenso stark ausgeprägte Affinität zur Gestaltung wie Willem Sandberg. Paradoxerweise erhielt die Abteilung für angewandte Kunst jedoch erst 1965 ihren heutigen Umfang mit drei Konservatoren. Damit entfiel die Notwendigkeit, andere Instanzen bei der Organisation von Ausstellungen einzubeziehen. Seit Mitte der 70er Jahren wurde die Zusammenarbeit mit Universitäten und Wissenschaftlern bei der Vorbereitung von Ausstellungen wieder intensiviert, weil mittlerweile dem kunsthistorischen Kontext ein größerer Stellenwert beigemessen wurde. Von 1965 an wurde die Abteilung von dem in der Bauhaus-Tradition ausgebildeten Innenarchitekten Wil Bertheux geleitet. Er befasste sich hauptsächlich mit den Möbeln und den übrigen Bereichen der Industriedesign-Sammlung (Gläser und Keramikgeschirr, Lampen, Geräte, Bestecke, Haushaltsgegenstände u. a.). Die beiden anderen Konservatoren waren für die angewandten Künste (größtenteils Unikate oder in kleiner Serie hergestellte Objekte aus Glas, Keramik, Holz oder Metall sowie freie Textilarbeiten, industriell gefertigte Textilien und Schmuck) bzw. die grafische Gestaltung (Typografie und Plakate) zuständig. Da die Abteilung von jetzt an innerhalb der Grenzen der allgemeinen Richtlinien des Museums selbständig operieren konnte und die Besetzung der Funktionen von einer großen Kontinuität gekennzeichnet war (seit 1965 sind die drei genannten Konservatorenstellen nur ein- oder zweimal neu besetzt worden), ist die Sammlung von einer großen Geschlossenheit geprägt.

Der Modernismus ist, wie bereits gesagt wurde, die wichtigste Richtschnur gewesen. Sowohl im Ausstellungsprogramm wie auch in der Sammlung nimmt Design aus den Niederlanden, Deutschland und den skandinavischen Ländern einen besonders großen Raum ein, doch auch Italien kam regelmäßig zum Zuge.

GESCHICHTE DES MUSEUMS

Unbeschadet der bedeutenden Retrospektivausstellungen blieb das Stedelijk Museum auch in dieser Zeit ein Ort, wo neue Entwicklungen vorgestellt wurden, nicht nur im Bereich der bildenden Kunst, dem das Museum seinen internationalen Rang verdankt, sondern auch in dem des Designs. Und in einer Zeit, in der es zu den wenigen Orten gehörte, wo zeitgenössisches Design zu sehen war, hatte das natürlich einen größeren Einfluss als heute. 1966 wurde in der Ausstellung „50 jaar zitten" (50 Jahre Sitzen) zum Beispiel der Bofinger Chair (1965–1966) von Helmut Bätzner gezeigt, der erste Stuhl, der aus einem einzigen Stück Kunststoff gefertigt wurde. Diese Tradition, neue Entwicklungen aufzuzeigen, wird noch heute fortgesetzt. Im letzten Jahr organisierte das Museum die erste Museumseinzelausstellung des aus Indien stammenden und in Amsterdam lebenden Möbel- und Produktdesigners Satyendra Pakhalé (geb. 1965), der in seinem Werk auf eigenwillige Weise östliche und westliche Inspirationsquellen, handwerkliche und industrielle Materialien und Techniken vereint. Er arbeitet mit renommierten Firmen wie Cappellini, Alessi und Moroso zusammen.

Wichtige Retrospektivausstellungen, deren Begleitpublikationen inzwischen zu Nachschlagewerken geworden sind, waren zum Beispiel „De Amsterdamse School" (1975), „Industrie en Vormgeving in Nederland 1850–1950" (1985) und „Holland in Vorm" (1987, organisiert in Zusammenarbeit mit vier anderen großen Museen).

Wie geht's weiter?

Die Sammlungen zu den Bereichen angewandte Kunst, Industriedesign und Grafikdesign – zusammengenommen ca. 70.000 Objekte aus der Zeitspanne vom Ende des 19. Jahrhunderts bis heute – stellen den größten Teil des Gesamtbestandes des Museums dar, der mehr als 100.000 Objekte umfasst. Ungefähr 4.000 Inventarnummern zählen zum Bereich Industriedesign. Davon bilden die Möbel (ca. 900 Nummern, darunter viele vollständige Ensembles) international gesehen den wichtigsten Bestandteil. Da das Museum bekanntlich auch über bedeutende Sammlungen bildender Kunst verfügt (Malerei, Bildhauerei, Zeichnungen, Druckgrafik, Video, Künstlerbücher und Fotografie), ergeben sich interessante Querverbindungen, zum Beispiel zwischen der bildenden und der angewandten Kunst Picassos oder zwischen den verschiedenen Ausdrucksformen, die der Gruppe „De Stijl" zugerechnet werden (die mit Werken u. a. von Mondrian, van Doesburg, Huszar und Rietveld im Stedelijk Museum vertreten ist). Gerade in unserer Zeit, in der Grenzüberschreitungen und verschwimmende Grenzen zu einem wichtigen Thema der Künste geworden sind, stellen solche Querverbindungen einen interessanten historischen Kontext dar. Die Entwicklung im zeitgenössischen Design werden aufmerksam beobachtet und Beispiele von internationaler Bedeutung werden präsentiert, studiert und erworben.

Bereits vorhandene Linien in der Sammlung werden, so sie denn interessant bleiben, weitergeführt, neue Linien werden, falls nötig, eingeführt, und Lücken in der Sammlung werden im Rahmen der finanziellen Möglichkeiten geschlossen. Der entscheidende Bezugspunkt bleibt jedoch das Interieur: Transportmittel und große Maschinen werden aus Prinzip nicht gesammelt. Wil Bertheux schrieb 1981: „Wenn die Idee eines Entwurfs gut ist und die Ausführung damit übereinstimmt, dann ist es der Mühe wert, einem Objekt Aufmerksamkeit zu schenken. Zeigt es darüber hinaus eine eigene Charakteristik, dann sollte es einen Platz in der Sammlung eines Museums bekommen."[2] Diese Voraussetzungen sind auch heute noch gültig – die Forderung nach „Erschwinglichkeit" spielt schon seit einiger Zeit keine Rolle mehr –, und das bedeutet, dass Objekten, die die Hand des Designers deutlich erkennen lassen, der Vorzug vor anonymen Massenartikeln gegeben wird. Gelegentlich gibt es kleine Akzentverschiebungen in der Ankaufspolitik. So wurde vor einigen Jahren beschlossen, neben dem in der modernistischen Tradition stehenden funktionalistischen Design in bescheidenem Umfang auch wichtige Objekte anderer Strömungen zu erwerben. Einerseits, um ein umfassenderes Bild vermitteln zu können, und andererseits, um den Modernismus schärfer definieren zu können. In diesem Rahmen hat auf Initiative des vorletzten Konservators für Industriedesign, Reyer Kras, in den letzten Jahren beispielsweise der amerikanische „Streamline Style" Eingang in die Sammlung gefunden. Und unter der jetzigen Konservatorin wurden zwei Stühle aus der eher organischen Richtung der 60er und 70er Jahre angekauft: ein „Floris "aus der ersten Serie (1967–1968) von Günter Beltzig und „Der Colani" (1973) von Luigi Colani.

Schon Paula Augustin hatte sich darum bemüht, dass immer auch Objekte aus den Sammlungsbereichen angewandte Kunst und Design im Museum präsent waren. Da das Ausstellungsprogramm immer dichter geworden ist (in den letzten Jahrzehnten manchmal mehr als 40 pro Jahr), die räumlichen Kapazitäten des Museums jedoch gleichgeblieben sind, ist die Verwirklichung dieses Ziels immer schwieriger geworden. Da sich darüber hinaus der Schwerpunkt auf die bildende Kunst (insbesondere die Malerei) verlagerte, ist den Menschen, die das Museum nur unregelmäßig besuchen können, die Designsammlung nur wenig bekannt. Eine Sammlung, in der außer Rietveld auch Andries Copier, Arne Jacobsen, Donald Judd, Ettore Sottsass und Tapio Wirkkala, um nur einige zu nennen, mehr als angemessen repräsentiert sind, und die mit anderen international renommierten Sammlungen messen kann. Was die Möbelsammlung betrifft, kann sich jeder bald schon davon überzeugen, denn der erste Bestandskatalog, der in Kürze veröffentlicht wird, ist diesem Teilbereich der Sammlung gewidmet.

Das Stedelijk Museum befindet sich zur Zeit in einer Übergangsphase; eine neue Direktion ist angetreten, die (künstlerischen) Leitlinien werden neu formuliert, die Stadt Amsterdam stellt Überlegungen über die Position des Museums an (unter anderem über die Frage, ob das Museum eigenverantwortlich, d.h. aus der Trägerschaft der Stadt entlassen und in eine Stiftung überführt werden soll, es gibt Pläne für eine großangelegte Renovierung (das Museum schließt dafür in Kürze seine Türen und wird sein Programm in reduzierter und experimentellerer Form an einem provisorischen Standort fortsetzen), und die Möglichkeiten für eine Erweiterung werden untersucht. Einige Entwicklungen zeichnen sich schon jetzt deutlich ab: dem Design — wie auch der Fotografie — wird in der kommenden Zeit eine größere Aufmerksamkeit zuteil werden, und auch disziplinübergreifenden Projekten wird eine größere Bedeutung zukommen. Aktivitäten, die der Sammlung zugute kommen (Forschung, Erhaltung und Verwaltung), werden finanziell stärker gefördert werden. Außerdem will das Museum Allianzen mit anderen Organisationen eingehen, um künftig eine noch aktivere Rolle im kulturellen und darüber hinaus im weiteren Kontext des gesellschaftlichen Lebens spielen zu können. Die vielfältigen Aktivitäten, die dazu beitragen sollen, können sowohl innerhalb als auch außerhalb des Kontextes des Museums stattfinden. Ein gutes Beispiel für Aktivitäten außerhalb des Museums ist die Präsentation des Stedelijk Museum auf der Mailänder Möbelmesse im April 2003. Im Spazio Consolo, wo noch 23 weitere niederländische Präsentationen zu sehen waren, wurde die vom Museum produzierte DVD Talking Heads mit einer Zusammenstellung von Interviews mit bekannten Designern (darunter Ron Arad, Ingo Maurer und Karim Rashid) über das niederländische Design vorgestellt. Auch eine Talkshow über dieses Thema wurde dort organisiert.

Man darf die Schlussfolgerung ziehen, dass für die Designsammlung und für das Stedelijk Museum im Ganzen eine inspirierende Zeit angebrochen ist, in der sich beide besser profilieren werden können und (wieder) eine Position einnehmen werden, die ihnen zukommt.

I. d. R.

1 Zu einer Übersicht über die Aktivitäten des Museums von 1900 bis 1981 siehe „80 jaar wonen in het Stedelijk", Ausst.-Kat., Amsterdam (Stedelijk Museum) 1981. Siehe auch die Einleitung zum Bestandskatalog der Möbelsammlung, der 2004 veröffentlicht werden wird (NAi Uitgevers, Rotterdam).
2 „80 jaar wonen in het Stedelijk", S. 1 (Anm. 1).

HISTORY OF THE MUSEUM

Exhibitions which Aren't Collections Quite Yet

For more than a century, the Stedelijk Museum in Amsterdam has sponsored exhibitions in the applied arts and modern design.[1] The museum was opened in 1895 and five years later, the first such exhibition was held for St Lucas, the most important artists' association at the time. St Lucas presented it members' works at sales exhibitions and in their first exhibition, in 1900, they displayed furniture by the designer, H. W. Mol (his works were later forgotten).

During the first decades of its existence, the museum was usually approached from outside with programs of this type. In addition to sales exhibitions, a number of "educational" shows were organized. These were intended to influence the taste of the public at large. The best example was the exhibit Kunst aan het Volk (Art for the People) in 1905. Good and bad designs for utilitarian household items were displayed next to idealized furnishing for working class flats. However, most of the exhibitions were intended to give a more general portrayal of the modern field of applied arts. In this respect, the VANK (Nederlandsche Vereeniging van Ambachts- en Nijverheidskunt — The Dutch Association of Arts and Crafts) which was founded in 1904 played an important role. Its aim was to unite all "practitioners of arts and crafts". At the initiative of the BKI (Nederlandsche Bond voor Kunst en Industrie — The Dutch Federation for Art and Industry) which was founded in 1924, the museum began showing industrially produced items at the end of the 1920s. Until that time, well-known architects and designers like Hendrik Petrus Berlage, Jac. Van den Bosch, Willem Penaat, Piet Kramer and C.A. Lion Cachet made almost all their objects by hand. This should come as no surprise, however, because in the Netherlands, industrialization and cooperation between designers and manufacturers developed very slowly.

A Department for Applied Arts with its own Collection

Since artists, designers and manufacturers were directly involved in these early exhibitions, the shows were usually made up of their own work. This did not change until 1934 when a long held wish was fulfilled. Since 1895, the "Association to Establish a Public Collection of Contemporary Art" had kept its collection of fine art in the Stedelijk Museum where it had to share the building with several other organizations. In 1935, the association created a department for modern applied art. Pieces in the field of applied art were now actively collected. Until this time, acquisitions had generally been limited to work by Dutch artists (for example, ceramics by Th. Colenbrander). Many items which belonged to the collection had been donated. At the end of the 1920s, the authorities decided to give the collection a more international orientation and in 1934, this became official museum policy. Some of the earliest acquisitions were three pieces of furniture by Danish designer Jacob Kjaer, which were presented in 1937 by the Stedelijk Museum in an exhibition entitled Deensche kunstnijverheid (Danish Applied Arts).

The policy of the collection was to acquire examples of well-designed interior objects. Until long after World War II, it was considered important that all objects be relatively inexpensive to produce so that a large part of the population could afford them. For example, following an exhibition in 1966 called "50 jaar zitten" (50 Years of Sitting), the Lounge Chair by Charles and Ray Eames was not purchased for the collection because at the price of about 1 940 guilders, it was considered to be unaffordable for many. These criteria were based on the ideals of modernism to which the collection oriented itself more and more.

Its Own Curator

Willem Sandberg who began working for the Stedelijk Museum in 1938, was named director in 1945. During his directorship, the number of exhibitions increased tremendously and the public was given a comprehensive look at international developments in the fields of fine arts and design. For the first time, exhibitions were dedicated to the works of individual designers like Gerrit Th. Rietveld, Arne Jacobsen and architect / designer, F. A. Eschauzier who had realized various building projects for the Stedelijk Museum.

In order to better meet the Museum's needs, Sandberg appointed a curator for each department. In 1946, Paula Augustin became the first curator for applied arts. One result of this increase in staff was that the Stedelijk Museum was now able to conceive and initiate exhibitions itself, even though the actual organisation of the exhibition was sometimes under the auspices of a different authority. Sandberg's interest in design (he was a graphic designer) was expressed through his efforts to put on larger exhibitions of furniture as well as by projects which combined different disciplines.

The collections of furniture, glass and ceramics grew tremendously during Sandberg's directorship (1945-1962). This was due, among other things, to sizeable donations. The number of pieces of furniture by Gerrit Th.Rietveld increased so much during this period that it can now be seen as a unique feature of the museum. The Stedelijk Museum collection which includes about 110 objects together with the collection of the Centraal Museum in Utrecht can be considered to be the most extensive and important collection of Rietveld's work in the world. Thanks to Paula Augustin's personal affinity for textiles, the collection for furnishings and textiles is also of very high calibre (currently there are about 850 objects of which approximately three-quarters are from the 1950s and 1960s). In general, it can be said that the collection grew as the museum put on exhibitions. This is still true today.

A Qualitative Department

Neither the next director, Edy de Wilde who ran the museum from 1963-1985, nor his successors, Wim Beeren (1985-1993) and Rudi Fuchs (1993-2003) had such a strong affinity for design as Willem Sandberg. It is therefore somewhat paradoxical that the department for applied art grew to the point of having three curators in 1965. From this point on, it was no longer necessary to consult other authorities when organizing exhibitions. Since the middle of the 1970s, exhibitions have been prepared with the increased participation of universities and scientists because nowadays, art history is considered to be more important. From 1965, the department was headed by Wil Bertheux, an interior architect in the Bauhaus tradition. He was principally interested in furniture and other areas of the industrial design collection (glass and ceramic dishes, lamps, appliances, cutlery, household items, etc.). The other two curators were responsible for applied art (mostly unique items and small scale production of objects made of glass, ceramic, wood and metal as well as custom-made textile items and industrially produced textiles and jewelry), in addition to graphic design (typography and posters). Within the limits and general guidelines of the museum, the department is able to work very independently. In addition, the positions of responsibility have been characterized by great continuity (since 1965 the aforementioned curatorships have changed hands only once or twice). The collection is therefore distinguished by its unity and harmony.

As mentioned above, modernism is the most important guiding principle. Designs from the Netherlands, Germany and the Scandinavian countries are the most important; but regular contributions have also come from Italy.

HISTORY OF THE MUSEUM

Regardless of important retrospectives sponsored by the museum, the Stedelijk Museum has remained a place where new developments are introduced to the world. This is true not only in the field of fine arts to which the museum owes its international reputation but also in the field of design. The museum used to be one of the few places where contemporary design was exhibited. This aspect contributes to the historical importance of the museum. For example, in 1966 in the exhibition "50 jaar zitten" (50 Years of Sitting) the Bofinger Chair (1965-1966) by Helmut Bätzner was displayed. This was the first chair that was manufactured from just one piece of synthetic material. This tradition continues today. Last year, the museum organized the first individual exhibition in a museum of works by Satyendra Pakhalé (b. 1965) who comes from India but now lives in Amsterdam. Among other products, Pakhalé also designs furniture. His unconventional work uses eastern and western sources to unite handicrafts, industrial materials and technology. He works with well-known companies like Cappellini, Alessi and Moroso.

Publications about some of the museum's important retrospectives have become reference works. Examples include: De Amsterdamse School (1975), Industrie en Vormgeving in Nederland 1850-1950, and Holland in Vorm (1987, organized in cooperation with four other large museums).

Where Do We Go from Here?

The collections in the fields of applied art, industrial design and graphic design number about 70 000 objects and date from the end of the 19th century to the present. They make up the largest part of the museum's inventory, which totals about 120 000 pieces. In the field of industrial design, there are about 4 000 objects. Of these, it is the furniture which is the most important from an international point of view (about 1 000 pieces, including many complete ensembles). Since the museum also possesses important collections of fine arts (paintings, sculptures, drawings, decorative prints, artists' books and photographs), interesting interconnections arise between the two fields. Examples include the link between Picasso's paintings and his handicrafts as well as the interrelationship between different forms of expression which are ascribed to the De Stijl group which is represented in the Stedelijk Museum with works by Mondian, van Doesburg and Rietveld. Such interconnections represent an interesting historical context in our day and age when the ease with which we cross from one country to another has turned the fluidity of borders into an important theme in art.

Developments in contemporary design are watched closely and examples which are of international importance are exhibited, studied and acquired by the museum. Collections of older trends that remain interesting are enlarged by the museum in the same way that collections of new trends are started when it is deemed necessary. Within its financial means, the museum also endeavours to fill any holes in its collections. The most decisive factor continues to be that objects in the museum's collection must be designed for interior use; vehicles and large machines are not part of the collection on principle. In 1981, Wil Bertheux wrote, "If you have an idea for a design which you are able to implement, it is worth having a look at. If the object then has some unique characteristic, it should have a place in a museum."[2] These prerequisites are still valid today. The requirement that objects be "affordable" was abandoned quite some time ago. This means, that objects by designers who can clearly be recognized by their work are given preference over anonymous mass-produced articles. Occasionally there is a slight change in acquisitions policy. It had been the policy of the museum to only acquire functionalistic objects in the Modernist tradition. A few years ago, it was decided that modest amounts of important objects in other styles could also be added to the collection. This was done partially to obtain a more complete perspective and partially in order to give Modernism a more precise definition. It was because of this change in policy that the penultimate curator for industrial design, Reyer Kras, introduced the American "Streamline Style" into the collection. The current curator has acquired two chairs representing the more organic slant of the 1960s and 1970s. They are Floris from Günter Beltzig's first series (1967-68) and Colani (1973) by Luigi Colani.

Paula Augustin attached importance to having objects from the fields of applied art and design in the museum's collection. Because the exhibition schedule has increased (in recent times there were more than 40 per year) while the quantity of space available to the museum has remained unchanged, it has become more and more difficult to realize this goal. In addition, because the museum now concentrates on fine arts (in particular painting), visitors who only occasionally come to the museum are not usually very familiar with the design collection. It is a collection in which not only Rietveld, but also Andries Copier, Arne Jacobsen, Donald Judd, Ettore Sottsass and Tapio Wirkkala — just to name a few — are more than adequately represented. It is on a par with to other internationally renowned collections in many ways. The collection of furniture will soon bear witness to this fact. The first inventory to be published by the museum will be dedicated to this collection. In catalogue form, it will be available soon.

The Stedelijk Museum is currently in a period of transition. A new direction has been introduced, the (artistic) guidelines have been reformulated and the City of Amsterdam is pondering the status of the museum (among other things, it is considering whether or not the museum should be made independent, i.e. no longer the responsibility of the city and transferred to a foundation). There are also plans for major renovations (the museum building will soon close and exhibitions will take place on a smaller and more experimental level in a temporary location). Plans for enlarging the museum are also being studied. Some developments have already been implemented. There will be more attention given to the fields of design and photography in the future. Interdisciplinary projects will also gain in importance. Research, maintenance and administration will be better supported financially. In order to play a more active role in cultural and even socio-political events, the museum also intends to cooperate with other organizations. These pursuits will take place within as well as out-side of the museum context. A good example of an activity outside of the museum context is the presentation of the Stedelijk Museum at the Furniture Fair in Milan last April. In the Spazio Consolo where there were a total of 23 Dutch presentations, Talking Heads, a DVD produced by the museum, was presented in conjunction with a number of interviews about Dutch design with well-known designers including Ron Arad, Ingo Maurer and Karim Rashid. A talk show on this subject was also organized for the fair.

A new period of inspiration has begun for the design collection as well as for the Stedelijk Museum as a whole. Both parties will benefit from this new phase in the museum's history and both parties will (re)gain the status that befits them.

I. d. R.

1 For a review of the museum's activities from 1900-1981, see "80 jaar wonen in het Stedelijk", exhibition catalogue, Amsterdam (Stedelijk Museum), 1981. Also see the introduction to the inventory of the furniture collection which will be published in 2004 (NAi Uitgevrs, Rotterdam).
2 "80 jaar wonen in het Stedelijk", p. 1 (Anm. 1).

Barcelona

Museu de les Arts Decoratives

COLLECTION

Museu de les Arts Decoratives

DESIGNER / ARCHITECT

Jaime Tresserra

OBJECT

Cabinet / Kabinettschrank 'Samuro'

DATE

1989

MANUFACTURER

Tresserra Collection, Barcelona, 2003 version / Ausführung 2003

Museu de les Arts Decoratives de Barcelona

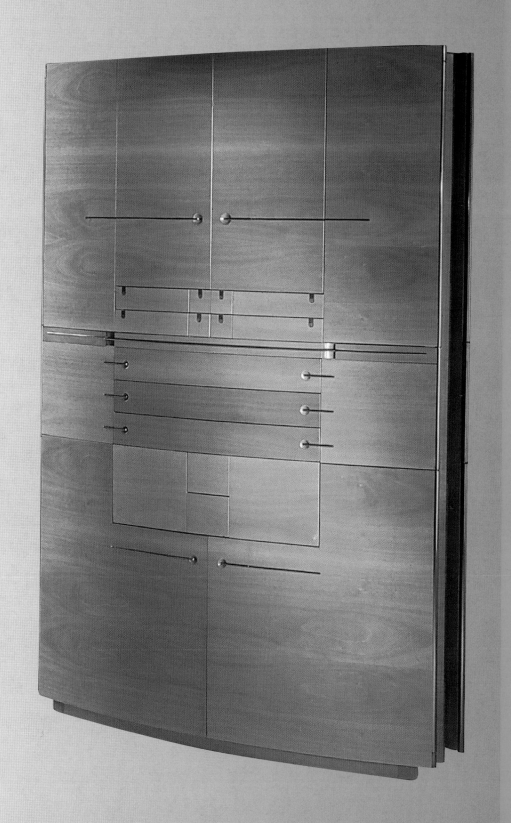

GESCHICHTE DES MUSEUMS

Das inmitten prächtiger Gärten in einer herrschaftlichen Villa untergebrachte Museu de les Artes Decoratives in Barcelona wurde 1932 eröffnet und war zunächst bis 1936 für das Publikum zugänglich. Im Jahre 1949 wurde das Museum in einen Palast im Zentrum von Barcelona verlegt, wo bis 1986 Glasobjekte, Möbel, Keramik und Miniaturen der Sammlung ausgestellt wurden.

Nach einem Dämmerschlaf wurde das Museu de les Artes Decoratives in Barcelona 1995 mit einer neuen Konzeption ebenfalls im Palau Reial in Pedralbes wiedereröffnet. Zwischen 1995 und 2000 wurde durch das Museum die erste Designsammlung Spaniens zusammengetragen: tausend spanische Designobjekte des 20. Jahrhunderts aus der Zeit zwischen 1933 bis 1999. Das Museum wird schließlich mit einer Dauer-präsentation von kunsthandwerklichen und Designobjekten wiedereröffnet, die die Zeitspanne vom 13. bis zum 20. Jahrhundert abdecken. In zusätzlichen zeitgenössischen Ausstellungen, wie zum Beispiel „Industriedesign" in Spanien werden, nach Jahrzehnten unterteilt, die bedeu-tendsten Objekte gezeigt, die in Spanien im Verlauf des 20. Jahrhunderts produziert oder gestaltet wurden.

Das Kuratorenteam des Museums entscheidet, in Zusammenarbeit mit einem Komitee von Fachleuten aus den jeweiligen Bereichen, welche Objekte im Rahmen des spanischen Designs unter soziologischen, technologischen, historischen oder ästhetischen Gesichtspunkten bedeutend sind.

Die Auswahl entspricht den vom Museum festgelegten Kriterien. Das Objekt sollte
* für die Gegenwart und Zukunft einen kulturellen Wert besitzen,
* für den häuslichen Kontext gedacht sein,
* von einem spanischen Designer gestaltet oder in Spanien von einem spanischen Unternehmen produziert sein,
* hinsichtlich Material, Technik, Formgebung oder Typologie innovativ sein.

Unter formalen Gesichtspunkten sollte das Objekt insgesamt harmonisch wirken. Einige der Objekte, die direkt in die Designsammmlung des Museums aufgenommen wurden, haben die vom ADIFAD Design-Verband alle zwei Jahre verliehenen renommierten Delta Preise gewonnen und sind somit von einer Jury bekannter Designer, Architekten, Historiker und Museumsleute ausgewählt worden. Es wurden zudem Objekte aus anderen Ländern aufgenommen, die in formaler oder technologischer Hinsicht für das spanische Design von wesentlicher Bedeutung waren. Zur Sammlung gehören sowohl Unikate (wie die Fackel für die Eröffnung der Olympischen Spiele in Barcelona im Jahre 1992) als auch die ein-fachste und am meisten genutzte spanische Erfindung: der Wisch-Mop. Er wurde von dem Luftfahrtingenieur Manuel Jalón 1956 entwickelt und ermöglichte ein Aufwischen des Bodens ohne auf die Knie gehen zu müssen.

Die Designsammlung ist in folgende Bereiche unterteilt: Möbeln, Leuchten, Haushaltsobjekte, Verpackungen, Elektrogeräte, Küchen- und Reinigungszubehör, Geschirr, Badeaccessoires, Kommunikationsdesign, Schreib- und Rauchutensilien, eine Reihe von Motorrädern und anderes. Eines der herausragenden Objekte ist der in New York produzierte Prototyp des „BKF"-Stuhls, dessen Design von der „Grupo Austral " entwickelt wurde, zu der Antoni Bonet, Juan Kurchan und Jorge Ferrari-Hordoy gehören. Seit 2001 wird ein neuer Sammlungsbestand mit ökologischen Design aufgebaut, der bis Ende 2003 in die Dauerpräsentation des Museums aufgenommen und ausgestellt wird. Im Jahr 2003 verfügte die Sammlung für Industriedesign über 1300 Objekte von 218 Designern, die von 200 unterschiedlichen Unternehmen produziert wurden. Als Dauerpräsentation dokumentiert die Sammlung einen repräsentativen Querschnitt spanischen Designs und dient zudem als Quelle für Designer, Unternehmer, Historiker und für die Öffentlichkeit. Der von 20 Autoren verfasste Bestandskatalog der Sammlung wird 2004 erscheinen.

S. V.

HISTORY OF THE MUSEUM

The Museu de les Arts Decoratives de Barcelona opened its doors in 1932 till 1936, originally situated in the Palau de Pedralbes, a manor house surrounded by magnificent gardens. It moved to a palace in the centre of Barcelona in 1949, where it exhibited its collections of glass, furniture, ceramics and miniatures until 1986.

In 1995, after a period in which it had virtually fallen dormant, the Museu de les Arts Decoratives de Barcelona re-opened to the public: on the premises of the Palau Reial in Pedralbes with a new concept. Between 1995 and 2000, the Museu assembled the first design collection in Spain: a thousand objects of 20th century Spanish design, mostly from the period 1933-1999. It was inaugurated with a permanent exhibition of decorative art and design: a chronological span ranging from the 13th to the 20th centuries. There were also some temporary exhibitions, including Industrial Design in Spain, which classified the most significant objects produced or designed in Spain in the 20th century by decade.

The museum's curatorial team (in conjunction with a specialist committee for each field) decides which objects are significant in terms of Spanish design. They consider each item's sociological, technological, historical and aesthetic importance.

Choices correspond to criteria established by the museum. In essence, each piece should:
- be an object of cultural value for the present and the future
- come from a household context
- be designed by a Spanish designer or produced in Spain by a Spanish company
- be innovative in materials, techniques, form or typology.

In essence, each object should be harmonious from a formal point of view.
Some objects that are included in the museum design collections have won a prestigious Delta prize. These are awarded every two years by the ADIFAD Design Association. Winners are selected by a jury of well-known designers, architects, historians, museum curators, etc.

The collection also has an area devoted to objects from other countries. These items should have formal or technological importance for Spanish design. The collection ranges from the most unique object (the torch for the 1992 Olympic Games) to the most humble and widely used of Spanish inventions – the mop: designed by aeronautical engineer Manuel Jalón in 1956. It allows you to clean the floor standing up and not on your knees. The design collection can be classified as follows: furniture, lighting, household items, packaging, electric appliances, kitchen and cleaning equipment, tableware, bathroom accessories, communications equipment, writing and smoking devices, a series of motorcycles, etc. One of the most outstanding objects is the prototype of the "BKF" chair designed by the Grupo Austral, formed by Antoni Bonet, Juan Kurchan and Jorge Ferrari-Hardoy and manufactured in New York. Since 2001, a new collection of Spanish "eco-designs" has been taking shape. It includes articles for respecting the environment and will be shown as part of the museum's permanent exhibition at the end of 2003 or the beginning of 2004.

As of 2003, the industrial design collection owns 1300 items by 218 designers and manufactured by 200 companies. It constitutes a permanent collection representative of Spanish design and functions as a point of reference for designers, companies, historians and the general public. A raisoné catalogue of the collection is being written by 20 authors and will be published in 2004.

S. V.

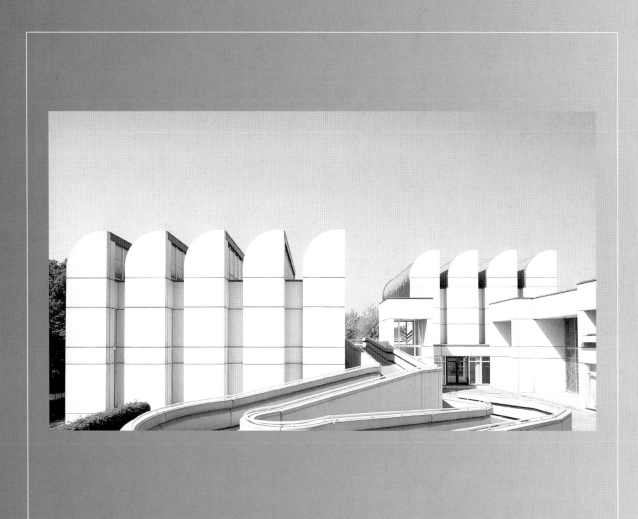

Berlin

Bauhaus-Archiv / Museum für Gestaltung
www.bauhaus.de

COLLECTION

Bauhaus-Archiv / Museum für Gestaltung

DESIGNER / ARCHITECT

Walter Gropius

OBJECT

Magazine rack from the Oeser residence
Zeitschriftenablage aus der Wohnung Oeser

DATE

1923

MANUFACTURER

Carpenter's workshop / Tischlerei Bauhaus Dessau

Museum für Gestaltung, Bauhaus-Archiv Berlin

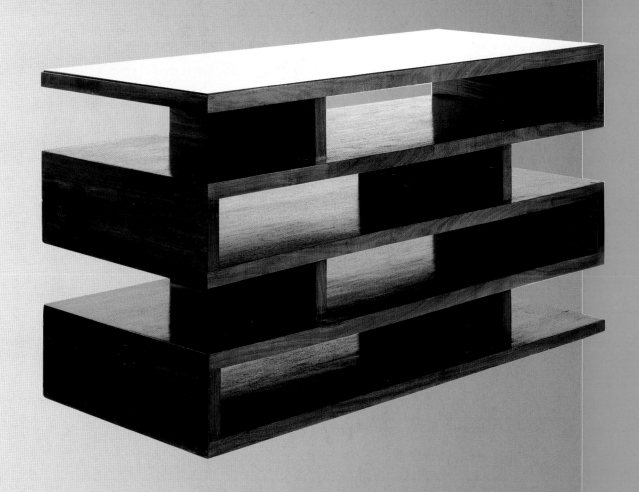

GESCHICHTE DES MUSEUMS

Bei der heutigen Popularität des Bauhauses ist es kaum mehr vorstellbar, wie viel Energie und Durchhaltevermögen aufgebracht werden musste, um eine Institution zu schaffen, die sich dem materiellen wie geistigen Erbe dieser bedeutendsten Hochschule für Gestaltung des 20. Jahrhunderts widmen sollte. Im Gründungsjahr 1960 gab es erhebliche Zweifel, ob ein Museum für eine Schule, die außerdem nur 14 Jahre – zwischen 1919 und 1933 – existierte, überhaupt eine Daseinsberechtigung habe.

Es ist Hans Maria Wingler, dem Initiator und ersten Direktor des Bauhaus-Archivs zu verdanken, dass es diese Einrichtung gibt. Zu einer Zeit, in der die Protagonisten des Bauhauses noch lebten, fand er nicht nur deren ideelle Unterstützung, sondern erhielt auch großzügige Schenkungen, z. B. sämtliche das Bauhaus betreffenden Unterlagen aus dem Besitz von Walter Gropius, die das Fundament der Sammlung bilden. Hierauf aufbauend entstand im Lauf der Zeit die weltweit umfangreichste Kollektion von Bauhaus-(Er-)Zeugnissen, die alle drei Wirkungsstätten der Schule – Weimar, Dessau und Berlin – berücksichtigt.

Seit 1979 verfügt das Bauhaus-Archiv / Museum für Gestaltung über ein eigenes Haus. Das postum realisierte Spätwerk von Walter Gropius mit der einprägsamen Silhouette seiner Shed-Dächer ist zu einem Markenzeichen Berlins geworden und seit dem Fall der Mauer hat sein innenstadtnaher Standort an Attraktivität gewonnen. Das inzwischen unter Denkmalschutz gestellte Gebäude soll in den nächsten Jahren eine dringend benötigte Erweiterung erfahren.

Nicht nur aus Gründen der Selbstständigkeit hat Walter Gropius immer darauf bestanden, dass die Institution "Bauhaus-Archiv" keine Abteilung innerhalb eines bestehenden (Kunstgewerbe-)Museums sein sollte. Denn nichts war ihm fremder als eine musealisierende Verabschiedung des Bauhauses in die Vergangenheit. Vielmehr sollte das Bauhaus-Archiv der lebendige Ort der Auseinandersetzung mit der umfassenden Idee des Bauhauses sein – für Wissenschaftler wie Formgeber gleichermaßen – und ein interessiertes Publikum erreichen, dem die Gestaltung unserer Umwelt in geistiger, sozialer und ästhetischer Hinsicht ein Anliegen ist.

Die Sammlung des Bauhaus-Archivs umfasst Gemälde, Zeichnungen und Plastiken der Meister und Schüler des Bauhauses, ferner Produkte aus allen Werkstätten der Schule vom handwerklich hergestellten Einzelstück und Prototypen bis hin zu Beispielen aus der industriellen Serienfertigung. Besonders hervorzuheben sind die umfangreichen Bestände an Möbeln, Lampen, Metallarbeiten und Keramik sowie an Textilien. Hinzu kommen Architekturzeichnungen und -modelle, außerdem eine Abteilung zur künstlerischen Fotografie.

Über den eigentlichen Schwerpunkt des Bauhauses hinaus werden auch Materialien zur Vorgeschichte und Nachfolge der Schule gesammelt – zu nennen wären das New Bauhaus in Chicago wie auch die Hochschule für Gestaltung in Ulm. Insbesondere Arbeiten aus dem Unterricht und die vom Bauhaus beeinflusste Kunstpädagogik im 20. Jahrhundert stellen hierbei ein besonderes Interesse dar. Mit Design vom Bauhaus bis heute öffnet sich das Museum den aktuellen Entwicklungen und bietet darüber hinaus die Möglichkeit, im Shop „Nützliches und mehr" käuflich zu erwerben

A. J.

HISTORY OF THE MUSEUM

Given the popularity of the Bauhaus today, it is hard to imagine how much energy and endurance was actually necessary to set up an institution intended to devote itself to the material and intellectual heritage of what was the most important 20th century college of design. When it was founded in 1960 there were considerable doubts whether there was any point in the first place in creating a museum to cover a college, and one that only existed for only 14 years, namely from 1919 to 1933.

We have Hans Maria Wingler, initiator and first Director of the Bauhaus Archiv to thank for the fact that the institution exists at all. At a time when Bauhaus protagonists were still alive he not only received their verbal support, but also generous donations, such as all the documents relating to the Bauhaus that were still in the safe hands of Walter Gropius — these records form the basis of the Collection today. And building on those foundations, in the course of time the world's most comprehensive collection of Bauhaus (documents / products) has evolved that takes into account all three locations where the college was active: Weimar, Dessau and Berlin.

Since 1979, the Bauhaus-Archiv / Museum für Gestaltung has a building of its own. With the striking silhouette of its shed roofs, Walter Gropius' late work (and it was realized posthumously) has become a Berlin landmark. Moreover, ever since the Wall came down its location close to the Central Business District has become far more attractive. The building has since been listed and over the next few years an extension wing will be added, something that is now urgently needed.

Not only for reasons of independence did Walter Gropius always insist that the "Bauhaus-Archiv" as an institution not be a department within an existing (arts and crafts) museum. For nothing was more anathema to him than to bid farewell to the Bauhaus by allocating it to the past — in a museum. Instead, he wanted the Bauhaus Archiv to be the living center of discussion on the over-arching underlying idea of the Bauhaus — for scholars and designers alike. And he wanted to reach those interested members of the general public for whom the way the environment is designed is intellectually, socially and aesthetically important.

The Bauhaus-Archiv Collection includes paintings, drawings and sculptures by the Bauhaus masters and their students, not to mention products from all the College's workshops — ranging from hand-made unique items and prototypes to examples of industrial mass manufacturing. Worthy of special mention are the broad spectrum of furniture items, luminaires, metal objects, and ceramics, as well as textiles, architectural drawings and models, and a section devoted to artistic photography.

In addition to the clear focus on the Bauhaus, we also collect materials on the history running up to its foundation and on how its ideas have been taken up since — the New Bauhaus in Chicago and the Ulm Hochschule für Gestaltung are both obvious choices here. An area of special interest in this context are works produced in class and the way in which 20th century art teaching methods were influenced by the Bauhaus. The museum also addresses current trends by showing design from the Bauhaus to the present, while also offering visitors the opportunity to purchase useful and not-so-useful objects in its shop.

A. J.

Berlin

Kunstgewerbemuseum
Staatliche Museen zu Berlin – Preußischer Kulturbesitz
www.smb.spk-berlin.de/kgm

COLLECTION

Kunstgewerbemuseum
Staatliche Museen zu Berlin – Preußischer Kulturbesitz

DESIGNER / ARCHITECT

Eckart Muthesius

OBJECT

Furniture for the Secretary's Office in the Manik Bagh Palace, India
Sekretariatsmobiliar für den Palast Manik Bagh, Indien

DATE

1931

MANUFACTURER

Carpenter's workshop / Tischlerei Johann Eckel, Berlin

Staatliche Museen zu Berlin, Kunstgewerbemuseum

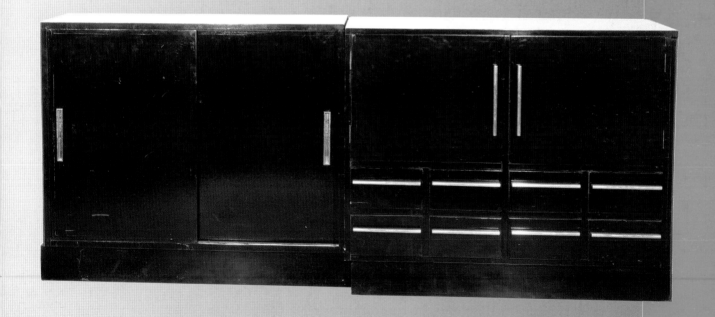

GESCHICHTE DES MUSEUMS

GRÜNDUNGSPHASE

Als das Kunstgewerbemuseum in Berlin 1867 gegründet wurde – zunächst unter dem Namen „Deutsches Gewerbe-Museum" – war es das erste Museum dieser Art in Deutschland und das dritte weltweit. Die Idee zu diesem neuen Museumstyp entsprang zunächst ökonomischen Notwendigkeiten. Mit der Zunahme industriell gefertigter Massenprodukte und den seit 1851 stattfindenden Weltausstellungen geriet das traditionelle deutsche Handwerk unter enormen Wettbewerbsdruck. Deutlich zeigte sich: wer im weltweiten Wettstreit der Handwerks- und Massenprodukte konkurrenzfähig sein wollte, musste sich den internationalen Maßstäben in Form, Funktion und Technik anpassen. Daher war es vorrangiges Ziel des neu gegründeten „Deutschen Gewerbe-Museums", an das eine Unterrichtsanstalt angegliedert war, mit einer „Vorbilder- und Mustersammlung" das Qualitätsbewusstsein und ästhetische Formgefühl im Handwerk zu schulen und zu erhöhen. Wie die zahlreichen Neugründungen von Gewerbe-Museen und -Schulen Ende des 19. Jahrhunderts zeigten, war der Bedarf nach dieser Art von „Lernstätten" in Deutschland sehr groß. Doch schon in den 20er und 30er Jahren des 20. Jahrhunderts gingen viele Sammlungen in städtische Museen oder Landesmuseen für Kunst und Kulturgeschichte auf. Nur wenige Kunstgewerbemuseen konnten sich bis heute unangefochten behaupten.

NEUAUSRICHTUNG

Das Kunstgewerbemuseum in Berlin jedoch expandierte stark und bezog 1881 das von Martin Gropius und Theodor Schmieden streng kubusförmig entworfene neue Domizil an der Prinz-Albrecht-Straße. Zahlreiche Ankäufe und Schenkungen großer privater Sammlungen und die Übereignung von Beständen der königlichen Kunstkammer ließen den Bestand des Museums schnell anwachsen und zwangen zum Standortwechsel. 1921 erfolgte dann der Umzug in das Berliner Stadtschloss, das nach dem Ende des Ersten Weltkrieges und der Abdankung Wilhelms II. leer stand. Mit diesem Umzug war die Neuausrichtung des Museums, die schon 1875 mit der Umbenennung in das „Kunstgewerbemuseum zu Berlin" begonnen hatte, endgültig abgeschlossen. Während unter dem Museumsgründer Julius Lessing die Wiederbelebung des künstlerisch hochwertigen Handwerks im Mittelpunkt gestanden hatte, verfolgte sein Nachfolger Otto von Falke – seit 1908 Museumsdirektor und seit 1920 Generaldirektor der Berliner Museen – ausschließlich wissenschaftlich orientierte Ziele. Zeitgenössisches Kunsthandwerk wurde als Sammlungsgebiet aufgegeben, die Unterrichtsanstalt ausgegliedert, das Gewerbemuseum wandelte sich zu einem Kunstmuseum. Besiegelt wurde diese Entwicklung durch die Integrierung der im Berliner Stadtschloss vorhandenen Kunstschätze des preußischen Herrscherhauses in den Bestand des Museums. Vor allem diese hochwertigen, einzigartigen Kunstwerke – aber auch die historischen Schatzkomplexe wie die mittelalterlichen Kirchenschätze, das Lüneburger Ratssilber, der Pommersche Kunstschrank, die Patriziersammlungen an Majolika, Bronzen, Silber und Porzellan und der 1935 erworbene Welfenschatz – lösten in den 30er Jahren einen enormen Besucherandrang aus, und sie begründen noch heute den Ruf des Kunstgewerbemuseums. Diskussionen über zeitgenössisches Kunsthandwerk und Industriedesign fanden nun seit den 20er Jahren außerhalb des Museums statt, nämlich im Deutschen Werkbund und im Bauhaus. Die Zielsetzung des Museums hatte sich vom Forum für zeitgenössische angewandte Kunst definitiv zu einem Bildungstempel der Kunst gewandelt.

NEUZEIT

Am Ende des Zweiten Weltkrieges war ein beträchtlicher Teil der Sammlung zerstört oder verloren gegangen. Das Kunstgewerbemuseum wurde aufgeteilt in Sammlungen West und Ost. Im Westen fand das Kunstgewerbemuseum ab 1963 zunächst seine Bleibe im Knobelsdoff-Flügel des Charlottenburger Schlosses und bezog 1985 das von Rolf Gutbrod entworfene Gebäude am Kulturforum. Im Osten wurde 1963 das Kunstgewerbemuseum im barocken Schloss Köpenick eröffnet. Mit der Zusammenführung der beiden Sammlungen 1992 nach der Wiedervereinigung verfügt das Kunstgewerbemuseum nun wieder über eine ungewöhnlich reiche Sammlung, die ein universales Bild von der frühmittelalterlichen Sakralkunst über die Meisterwerke der Renaissance, des Barock, des Rokoko, des Jugendstils und des Art Decos bis hin zu Zeugnissen der Designgeschichte vermittelt. Ab 2004 wird das Kunstgewerbemuseum aus zwei Häusern bestehen, dem Stammhaus am Kulturforum am Potsdamer Platz und dem vollständig restaurierten und instand gesetzten Schloss Köpenick.

DESIGN IM KUNSTGEWERBEMUSEUM

Es ist das große Verdienst meiner Vorgängerin Barbara Mundt, den Sammlungsbestand des Kunstgewerbemuseums wieder an die Gegenwart herangeführt zu haben. Mit der Wiederentdeckung des Jugendstils, des Art Decos und des Bauhausstils in den 60er und 70er Jahren entschied man sich für gezielte Neuankäufe. Große zeitliche Lücken konnten so geschlossen werden. Heute sammelt das Kunstgewerbemuseum unter dem Dach der Staatlichen Museen zu Berlin die ihm zugeordneten Fachgebiete. Dazu zählen sowohl das zeitgenössische Kunsthandwerk als auch das Industriedesign. Schwerpunkt ist dabei das Interieurdesign wie Möbel, Leuchten, Geschirr und Objekte aus der Bürowelt. Dabei steht der künstlerische Entwurf im Mittelpunkt, die zukunftsweisende Lösung in Bezug auf Kreativität, Material, Form und Innovation. Nur solche Produkte finden Eingang in die ständige Sammlung des Kunstgewerbemuseums, die funktional und ästhetisch überzeugen. Nicht der Gebrauchswert steht im Vordergrund, sondern der Kunstwert: die Einmaligkeit des Produktes.

Gesammelt werden ausschließlich dreidimensionale Objekte, der gesamte Bereich der zweidimensionalen visuellen Kommunikation ist der Kunstbibliothek und dem Kupferstichkabinett vorbehalten. Außereuropäisches Design befindet sich ebenfalls in anderen Museen. Das bedarf sicher einer neuen Überlegung angesichts der weltweiten Aktivitäten europäischer und außereuropäischer Designer.

AUFGABEN HEUTE

Zunächst ist es Aufgabe der Kunstgewerbemuseen zu sammeln und zu archivieren. Bezogen auf das Design bedeutet das, die Geschichte des Designs in ihren einzelnen Etappen und Strömungen zu dokumentieren und in Ausstellungen und Publikationen der Öffentlichkeit zu präsentieren. Heute jedoch sollten die Kunstgewerbemuseen verstärkt den Fokus auf neue Produkt- und Gestaltungsideen legen, ihnen eine öffentliche Plattform bieten und zu Diskussionen anregen über Themen wie die Nachhaltigkeit der Produkte, den Umgang mit den Ressourcen, die Moral der Gegenstände oder die Materialien der Zukunft. Viele Jahrzehnte lang sind diese inhaltlichen Diskussionen von den Designzentren ausgegangen. Die Situation hat sich jedoch geändert. Denn mit der Einstellung oder radikalen Kürzung der öffentlichen Förderung stehen die noch existierenden Designzentren mehr oder weniger im Dienste der Marketingabteilungen großer Unternehmen. Sie haben zu weiten Teilen ihre Unabhängigkeit verloren. In der öffentlichen Auseinandersetzung über strittige Gestaltungsfragen ist eine schmerzhafte Lücke entstanden, die die Kunstgewerbemuseen zumindest in einigen Punkten füllen könnten. Sie sollten sich als neutrale Plattform für innovative Gestaltungs- und Produktideen profilieren, aktiv an Diskussionsprozessen mitwirken und ihre Türen für den kreativen Nachwuchs öffnen, ohne jedoch den eigenen historischen Sammlungsschwerpunkt aufzugeben. Denn gerade die räumliche Nähe zu den handwerklichen Meisterwerken vergangener Epochen erzeugt eine Dynamik, die den Reiz und das besondere Ambiente der Kunstgewerbemuseen ausmacht. Neue Gestaltungsideen und aktuelle Fragestellungen müssen sich vor Jahrhunderte alten Kunstwerken behaupten. Dieses kann zu neuen Perspektiven und Interpretationsmöglichkeiten und zu einem fruchtbaren Dialog zwischen den Jahrhunderten führen. In der Erzeugung einer kreativen Spannung zwischen den vergangenen Kunst-Handwerken und den gegenwärtigen Fragestellungen in der Produkt- und Umweltgestaltung liegt die Zukunft der Kunstgewerbemuseen.

A. S.

HISTORY OF THE MUSEUM

FOUNDATION PHASE

When the Kunstgewerbemuseum in Berlin was first established in 1867 – originally under the name "Deutsches Gewerbe-Museum" – it was the first museum of its kind in Germany, and the third worldwide. The idea for this new type of museum was initially born of economic necessity. Not only the increase of industrially-produced mass products but also the world exhibitions held from 1851 onwards meant that Germany's traditional arts and crafts came under enormous competitive pressure. It became abundantly clear that anyone wishing to remain competitive in the global competition of arts, crafts and mass products was obliged to follow the international standards regarding form, function and technology. Consequently, the prime goal of the newly-founded "Deutsches Gewerbe-Museum", to which an educational institute was also attached, was to school and enhance quality awareness and an aesthetic sense for form in arts and crafts through the creation of a "collection of role models and samples". And indeed, the large number of arts and crafts museums and schools founded at the end of the 19th century demonstrated the great need for such educational centers in Germany. But as early as the 1920s and 193s many collections were assimilated into municipal or regional museums for art and cultural history. Only a handful of arts and crafts museums were able to continue operating independently until the present day.

NEW ORIENTATION

Berlin's Kunstgewerbemuseum expanded strongly, though, and in 1881 moved to new premises: an austere cube-shaped domicile on Prinz-Albrecht-Straße designed by Martin Gropius and Theodor Schmieden. Thanks to numerous acquisitions and donations of large private collections, but also the transfer of possessions from the royal Art Cabinet, the museum's collection expanded swiftly, and a change of location became imperative. In 1921, the move was made to Berlin's City Palace, which had remained empty following the end of World War I, and the abdication of Wilhelm II. This relocation coincided with the completion of the museum's reorientation, which had started as early as 1875, when it was re-named "Kunstgewerbe-Museum zu Berlin". While under the museum founder Julius Lessing, the main emphasis was on the revival of the artisan tradition, his successor Otto von Falke – who became director in 1908, and as of 1920 general director of the Berlin museums – pursued solely academic goals. Contemporary arts and crafts were abandoned as a collection focus, the college was spun off, and the arts and crafts museum was transformed into an art museum. This development was sealed by the integration into the museum collection of the art treasures formerly belonging to the ruling Prussian dynasty, and housed in Berlin's City Place. Above all these first-class, unique works of art – but also the historical treasures such as the medieval church treasures, the Councillors' silver of Lüneberg, the Pomeranian Art Cabinet, the patricians' collections of decorated, glazed earthenware known as majolica, bronzes, silver and porcelain, and the Guelf Treasure or Welfenschatz acquired in 1935 – gave rise to streams of visitors during the 1930s, and these items still account for the museum's excellent reputation today. As of the 1920s, discussions on contemporary arts, crafts and industrial design were also taking place outside the museum, namely in the German Werkbund and the Bauhaus. The objective of the museum had clearly shifted from being a forum for contemporary applied art to being an educational temple of art.

POSTWAR ERA

At the end of World War II, a considerable portion of the collection had been destroyed or lost. The museum was divided into the West and East collections. In the West of the city, the museum initially found a home as of 1963 in the Knobelsdoff wing of the Charlottenburg Palace, before moving in 1985 to the Kulturforum building designed by Rolf Gutbrod. In the East, the museum was opened in 1963 in the baroque Köpenick Palace. After reunification the two collections were also reunited in 1992: Berlin's Kunstgewerbemuseum now possesses of an unusually rich collection, which conveys a universal panorama from the sacred art of the early Middle Ages via the masterworks of the Renaissance, Baroque, Rococo, Art Nouveau and Art Deco through to items of design history. From 2004 onwards the museum will consist of two buildings: the main building in the Kulturforum at Potsdamer Platz and the completely restored and repaired Köpenick Palace.

DESIGN IN BERLIN'S MUSEUM OF APPLIED ART

Thanks to the concerted efforts by my predecessor Barbara Mundt, the collection of Berlin's museum of Applied Art was brought up to the present day. With the rediscovery of Art Nouveau, Art Deco and the Bauhaus style in the 1960s and 1970s, a decision was taken to make new acquisitions in these areas. As a result, large, chronological gaps were closed. Today Berlin's Kunstgewerbemuseum makes acquisitions in its specialized areas as an institution that comes under the aegis of the Berlin State Museums. The acquisitions include contemporary arts and crafts but also industrial design, with the emphasis being on interior design objects such as furniture, luminaires, china and office furniture. The focus is firmly on the artistic creation, the solution that points the way to the future in terms of creativity, material, form and innovation. Only products which meet these functional and aesthetic criteria are included in the permanent collection. The major consideration is not the practical value, but the artistic value, namely the uniqueness of the product.

All acquisitions are three-dimensional objects; the art library and the engravings cabinet house the entire spectrum of two-dimensional, visual communication. Non-European design is also displayed in other museums. This policy probably bears rethinking, given that European and non-European designers now work world-wide.

TODAY'S TASKS

Today, the first task of applied art museums is to make acquisitions and document them. As regards design, this means recording the individual phases and movements making up the history of design, and presenting them to the public in exhibitions and publications. However, applied art museums should today also attach greater importance to new product and design ideas, offer these a public platform, and encourage discussions on topics such as the sustainability of products, dealing appropriately with resources, the morals behind possessions, or the materials of the future. For many decades, such discussions have been initiated by the design centers. But the situation has since altered. The reason: with public sponsorship stopped altogether or at least radically cut, those design centers still operating are more or less at the beck and call of large corporations' marketing departments. In many cases, they have little independence to boast of. In the public debate on contentious design issues a painful gap has emerged that the applied arts museums can go towards filling — at least in part. They should position themselves as neutral platforms for innovative design and product ideas, become actively involved in discussion processes, and open their doors to creative newcomers, without sacrificing their own, individual historical collection specialization. After all, the very proximity to artisan masterpieces of past epochs produces a dynamic which constitutes the very attraction and particular ambience of applied art museums. When new design ideas and current issues have to assert themselves alongside centuries-old works of art, this can result in new perspectives and means of interpretation, as well as producing a fruitful dialog between the centuries. The future of applied art museums lies in the creative field of tension between past arts and crafts, and current issues in product and environmental design.

A. S.

Copenhagen

Det Danske Kunstindustrimuseet
www.kunstindustrimuseet.dk

Copenhagen

Det Danske Kunstindustrimuseet

COLLECTION

Det Danske Kunstindustrimuseet

DESIGNER / ARCHITECT

Poul Henningsen

OBJECT

Grand piano / Konzertflügel

DATE

1930

MANUFACTURER

Andreas Christensen, 1936 version / Ausführung 1936

Det Danske Kunstindustrimuseet, Kopenhagen

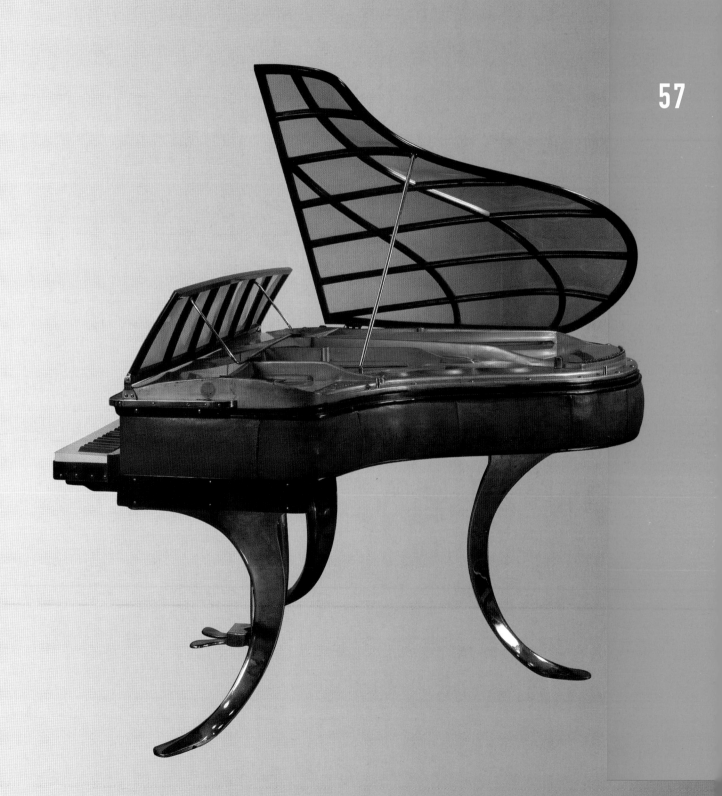

GESCHICHTE DES MUSEUMS

Das Danske Kunstindustrimuseet wurde 1890 gegründet. Es gehört insofern zur ersten Generation dieses neuen Museumstyps, der durch die Industrialisierung und die Weltausstellungen in der zweiten Hälfte des 19. Jahrhunderts angeregt wurde.

Das Danske Kunstindustrimuseet, es ist das einzig übrig gebliebene seiner Art in Dänemark, wurde von Privatpersonen ins Leben gerufen und ist somit keine von der öffentlichen Hand getragene Institution. An der Spitze der Gründungsinitiative stand der große Kunstmäzen Carl Jacobsen von den Carlsberg Brauereien sowie der Industriforeningen (der Industrieverband), der für viele Jahre vom Direktor der Den kgl. Porcelaensfabrik (Royal Copenhagen) geleitet wurde. Das Museum arbeitet wie eine staatliche Institution und deckt den gesamten dänischen Raum ab. Ziel ist es, das dänische Kunsthandwerk in seiner Entwicklung umfassend zu unterstützen und das öffentliche Interesse für hochwertiges Kunsthandwerk anzuregen.

Im Laufe seiner nun mehr als ein Jahrhundert währenden Geschichte wurde das Museum zu einem Zentrum des Wissens über Design und Kunsthandwerk, es umfasst nationale und internationale Sammlungen, ein Archiv zu dänischem Design und eine Bibliothek, die die wichtigste öffentliche Fachbibliothek für Kunst, Kunsthandwerk, Industriedesign, Grafikdesign und südostasiatische Kunst darstellt.

Im 20. Jahrhundert bildete sich in Dänemark eine spezielle Designkultur heraus, die dem Design von Alltagsobjekten, der Innenarchitektur und der Gestaltung von öffentlichen Räumen eine besondere Bedeutung beimaß. Die Entwicklungen im Bereich des Kunsthandwerks, des Möbel- und Produktdesigns, der Buch- und Plakatgestaltung sind durch die Sammlungen des Danske Kunstindustrimuseet dokumentiert worden. Mit seiner aktiven Ausstellungs- und Kommunikationspolitik spielte das Museum eine wichtige Rolle in der Entwicklung dänischer Designkonzepte. Ankäufe für die Sammlung übten ebenfalls einen erheblichen Einfluss aus. Der weitsichtige Blick auf andere Designkulturen, die Dokumentation und Kommunikation von Ereignissen und Trends der internationalen Designszene waren ein wichtiger Katalysator für kreative Prozesse in Dänemark.

Wenn man auf das 20. Jahrhundert zurückblickt, kann man die grundlegenden Veränderungen deutlich erkennen, die hinsichtlich unseres Anspruchs an Alltagsobjekte stattgefunden haben — Veränderungen, die den Einfluss der Objekte auf unsere Ideen und Wahrnehmung belegen. Während ursprünglich die Funktion im Mittelpunkt von Designfragen stand, haben wir heutzutage weitergehende Ansprüche: wir konzentrieren uns auf die zugrunde liegende Botschaft der Objekte, ihren Kultstatus und ihren Beitrag zur Gestaltung unseres Lebens. Die ursprüngliche Unterscheidung zwischen traditioneller — höher bewerteter — Kunst und dekorativer — weniger hoch bewerteter — Kunst ist obsolet und hat zu einer weniger rigiden Kategorisierung geführt.

Die Aufgabe unseres Museums ist es, diese Korrelationen zwischen der allgemeinen gesellschaftlichen Entwicklung, den ethischen und moralischen Anschauungen bestimmter Zeiten und dem Design von Alltagsobjekten aufzuzeigen.

Im Herbst 2002 wurde eine neue Dauerausstellung unter dem Titel „Visions and Fact in 20th Century Design and Crafts", im Danske Kunstindustrimuseet eröffnet. Mit dieser Ausstellung werden insbesondere die Zusammenhänge zwischen den bedeutenden Narrativen unserer Gesellschaft, den großen sozialen Ideen und Konstrukten und der Art und Weise, wie unsere Umwelt gestaltet ist, beleuchtet. Das 20. Jahrhundert wurde von schrecklichen Kriegen, Völkermord und unendlichem Leid heimgesucht, doch hat es auch der Entwicklung von Träumen Raum gegeben. Dabei spielte auch der Gedanke eine Rolle, wie Design und Architektur zu einer besseren Welt beitragen können. Ideale und uto-pische Vorstellungen von Gesellschaft sind im 20. Jahrhundert rasch aufeinander gefolgt und dies ist bis heute der Fall, wo der ökologische Landbau, Recycling und ethische Finanzberichterstattung stellvertretend für das Streben nach dem Ideal und gesellschaftlicher Verantwortung stehen.

Die ursprüngliche Intention des Danske Kunstindustrimuseet — nicht nur Entwicklungen zu verfolgen und zu dokumentieren, sondern sie auch anzustiften — besitzt bis heute ihre Gültigkeit. Das Hauptanliegen des Museums ist es, noch immer der breiten Öffentlichkeit ein Gefühl für Qualität nahe zu bringen, und auch jenen, die direkt an der Produktion beteiligt sind und somit die Zukunft mit beeinflussen. Im globalen Güterfluss unserer Tage ist ein Museum, das den Aspekt der Relevanz und Nützlichkeit von Objekten für die Gesellschaft in den Vordergrund stellt, von immenser Bedeutung. Der durch Marktwirtschaften entstehende Güterüberschuss in der westlichen Welt verlangt nach einer genauen Abwägung von wahren Bedürfnissen, Qualität und Produktion. Mit seinen Forschungs- und Kommunikationsaktivitäten widmet sich das Danske Kunstindustrimuseet insbesondere der Frage wie einzelne Objekte entwickelt wurden. Wir können nur eine kritische Haltung zum Design einnehmen, wenn wir die Entscheidungen kennen, die den Prozess der Produktentwicklung begleitet haben.

In dem modernen dänischen Sozialstaat — eines seiner Grundprinzipien ist ein menschenfreundliches Design-Ideal — steht das Danske Kunstindustrimuseet im Hinblick auf Forschung und Kommunikation der vergangenen und zukünftigen Produktkultur nicht alleine. Zur Zeit plant das Museum eine intensive Zusammenarbeit mit höheren Schulen, Universitäten, Design Colleges und dem Produktions- und Export-sektor.

Das Danske Kunstindustrimuseet arbeitet gegenwärtig daran, seinen Wissensfundus leichter zugänglich zu machen. Für die wichtigsten Bestände werden analytische Kataloge, in denen alle Sammlungsobjekte aufgeführt sind, herausgegeben. Zugleich wird eine digitale Version der Sammlungsbestände in Form einer Datenbank erstellt. So hat das Museum zum Beispiel kürzlich Bilder von großen Teilen der Plakat-sammlung im Internet veröffentlicht und eine Dokumentation wird nun in digitaler Form zusammengestellt. Eine neue Forschungsquelle im Internet, mit mehr als 10.000 Bildern dänischer Möbelstücke des 20. Jahrhunderts, ermöglicht einen repräsentativen und umfassenden Überblick über dänisches Möbeldesign dieser Periode. Neu geschaffene, offene Lagermöglichkeiten, erlauben den Zugang zu den um-fangreichen Porzellan- und Keramiksammlungen.

Diejenigen, die an der Design- und Produktentwicklung beteiligt sind, können durch den freien Zugang zu größeren Mengen an Dokumenta-tionsmaterialien in der Kartografie und Analyse zusammenarbeiten, wenn es darum geht die Veränderungen, wie sie die neuen Technologien und Ideen des 20. Jahrhunderts mit sich gebracht haben, zu bewerten. Dieses Wissen wird eine hervorragende Grundlage bilden für eine Diskussion über gemeinsam formulierte Anforderungen, die wir an die Objekte der Zukunft stellen sollten.

B. B. L.

HISTORY OF THE MUSEUM

The Danske Kunstindustrimuseet was founded in 1890, a fact which places it within the first generation of this new type of museum; a child of industrialism and the world exhibitions seen during the last half of the 19th century.

The Danske Kunstindustrimuseet, which remains the only museum of its kind in Denmark, was launched by private individuals as opposed to public-sector institutions. The initiative was spearheaded by that great art patron Carl Jacobsen from the Carlsberg Breweries and by Industriforeningen [the Association of Industries], which was headed by the director of Den kgl. Porcelænsfabrik [Royal Copenhagen] for many years. The museum acts as a state-funded specialist museum serving all of Denmark. Its objective is to support and promote Danish decorative arts by developing craftsmanship and skills, and by generating public interest in high-quality decorative arts.

During its history, spanning more than a century, the museum has become a hub of knowledge on design and the decorative arts, comprising national and international collections, a Danish Design Archive, and a library which is the main public specialist library for decorative arts, crafts, industrial design, graphic design, and South-East Asian art.

The 20th century saw the development of a special design culture in Denmark, a particular attitude to the design of everyday objects, to interior design, and to public spaces and environments. These developments within the decorative arts, furniture and product design, and book and poster art are documented in the collections of the Danske Kunstindustrimuseet. The museum has played an active role in the development of the concept of Danish design through extensive exhibition and communication activities. Purchases for the collection have also been highly influential. The museum's keen eye for other design cultures and its communication and documentation of events and trends within the inter-national design scene have served as an important catalyst for creative processes in Denmark.

Looking back on the 20th century, we can clearly see the fundamental changes that have taken place as regards our requirements for every-day objects – changes that testify to the power which objects have acquired over our ideas and perceptions. Whereas function previously took centre stage when it comes to design, we now have other demands before we are satisfied: we focus on the underlying messages of the objects, their cult status, their contributions to the way we present and stage our lives. The old distinction between traditional – superior – art and decorative – lesser – art has been abandoned, giving way to less rigid categories.

The task of our museums is to demonstrate these correlations between general developments of society, the ethical and moral outlook of particular eras, and the design of everyday objects.

The autumn of 2002 saw the opening of a new permanent exhibition at the Danske Kunstindustrimuseet entitled "Visions and Fact in 20th Century Design and Crafts". This exhibition focuses on the correlations between the grand narratives of our society, the great social ideas and constructs and the way the world around us is designed. The 20th century was fraught with wars on a horrific scale, genocides, and endless suffering, but it also gave rise to many dreams, including dreams about how design and architecture could become gateways to a better world. Ideals and Utopian models of society have come and gone in rapid succession throughout the 20th century and up until the present day, where organic farming, recycling, and ethical financial reports are emblematic of continued strivings for the ideal and of a sense of social responsibility.

The original objective of the Danske Kunstindustrimuseet — to be more than an observer and recorder of developments, and to actively affect them — remains valid today. The museum's main purpose is still to communicate a concept of quality to the wider public as well as to those directly involved in production, thereby affecting the future. The need for a museum which emphasizes relevance and usefulness to society is particularly great in the light of the global flow of goods seen today. Market economies give rise to a surplus of goods in the Western world, calling for careful consideration of real need, quality, and production. In its research and communication activities, the Danish Museum of Decorative Art focuses special attention on how individual objects are created. We can only take a critical stance on design if we understand the choices made during the product development process.

In the modern Danish welfare society, one of the foundations of which is a humanistic design ideal, the Danske Kunstindustrimuseet does not stand alone in its research and communication of past and future product culture. At present, the museum is on its way to become part of a very close collaboration between high schools, universities, design colleges, and the production and export sectors.

The Danske Kunstindustrimuseet is currently working on making its in-depth of knowledge more readily available. Analytical catalogues detailing the full range of items owned are published for the most important collections. At the same time, digital records of the museum collections are established in the form of databases. For example, the museum recently placed images of large parts of its poster collection on the Internet, and documentation is now being collected in digital form. A new Internet resource with images of more than 10 000 pieces of Danish furniture from the 20th century can provide even more expert and well-informed appreciation of Danish furniture design from the period (www.furnitureindex.dk). Newly established open storage facilities provide access to the museum's extensive collections of porcelain and ceramics.

Free access to greater quantities of documentation materials makes it possible for many stakeholders within design and product research to co-operate on charting and analyzing the results of the vast changes brought about by the new technologies and ideas of the 20th century. This knowledge will form an excellent basis for discussing the requirements we should make for the objects of the future.

B. B. L.

Ghent

Design museum Gent
www.design.museum.gent.be

COLLECTION

Design museum Gent

DESIGNER / ARCHITECT

Henry van de Velde

OBJECT

Piano seat / Klavierbank

DATE

1902

MANUFACTURER

Atelier van de Velde (?)

Design museum Gent

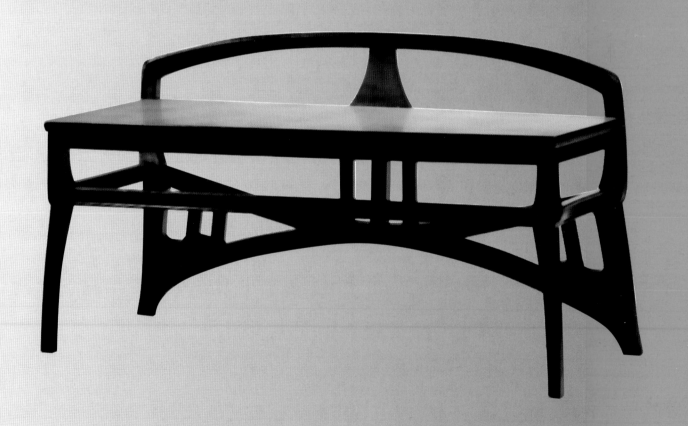

GESCHICHTE DES MUSEUMS

EIN MUSTERBEISPIEL FÜR MODERNE DESIGNER

Die Ursprünge des Design museums Gent sind der „Verenigung voor industrièle en decoratieve kunsten" (Gesellschaft für Industriekultur und Kunsthandwerk) zu verdanken, die in Gent im Jahre 1903 gegründet wurde. Zunächst befand sich die Sammlung in der Akademie der Bilden- den Künste in der Academiestraat. In den Jahren 1922-1923 wurde sie im Hotel de Coninck untergebracht, das für diesen Zweck von der Stadt Gent erworben wurde. Bereits 1958 erhielt die Stadt die Schirmherrschaft über das aus diesem Anlass auch umbenannte „museum voor Sierkunst" (Museum für Kunsthandwerk). Eine Kopie des Baugenehmigungsantrages für das Hotel de Coninck ist aus dem Jahr 1754 überliefert. Der Bau begann wahrscheinlich kurze Zeit später; auf jeden Fall weisen die Grundsteine in der Seitenwand auf das Jahr 1755 hin. Das Gebäude selbst ist ein eindrucksvolles Beispiel des charakteristischen flämischen Städtebaus des 18. Jahrhunderts. Der neue Erweiterungsbau des nunmehr auch namentlich erweiterten „museum voor Sierkunst en Vormgiving" (Museum für Kunsthandwerk und Design) wurde im Mai 1992 offiziell eröffnet. Der Entwurf stammt von dem Architekten Willy Verstraete. Die einzigartigen Exponate, die seit der Mitte der 70er Jahre beständig gesammelt und konservatorisch betreut wurden, konnten nun endlich ausgestellt werden. Dieser neue Bereich des Museums ist an sich schon sehenswert. Die Fassade aus dem 18. Jahrhundert, die den Innenhof umschließt, wurde komplett restauriert. Dahinter verbirgt sich die helle und leichte Architektur eines modernen Gebäudes. Das originelle Herzstück im Haupttrakt des Gebäudes ist ein großer hydraulischer Aufzug, der die verschiedenen Stockwerke erschließt. Die Möglichkeiten zur Einbeziehung der Besucher in ein aufregendes Spiel auf wech- selnden Ebenen ist nahezu einmalig.

Zu den „alten" Sammlungsbeständen des Museums gehören vor allem Möbel aus dem 17. und 18. Jahrhundert, die in den stilvollen Räumen des Hotel de Coninck (erbaut im Jahre 1755) ausgestellt werden. Das Prunkstück ist ein komplett erhaltener Speisesaal, in dem der hölzerne Kron- leuchter, eine Arbeit des aus Gent stammenden Bildhauers J. F. Allaert, noch immer an seinem alten Platz hängt. Andere Räume sind mit Wandgemälden aus dem 18. Jahrhundert oder mit seidenen Wandbehängen dekoriert. Mehr als zwanzig kristallene Kronleuchter aus dem 18. Jahrhundert sorgen für Licht. Man trifft auf Portraits wohlbekannter Gesichter, die an den Wänden hängen, darunter König Ludwig XVIII. von Frankreich, dessen Schreibtisch in der Sammlung französischen Mobiliars zu sehen ist. Das Design museum Gent, der neue Name entstand im Jahre 2002, verfügt über eine der großartigsten Art Nouveau Sammlungen des Landes. Sowohl die üppige Periode des Art Nouveau, mit seinen floralen Motiven und dem Spiel fließender Linien als auch die konstruktivistische Ausprägung des Stils um 1900 werden im Museum gezeigt. Neben ausländischen Designern kann man Arbeiten bedeutender belgischer Künstler sehen, wie Henry van de Velde, Victor Horta, Paul Hankar, Gustave Serrurier-Bovy und Philippe Wolfers. Art Deco und angewandte Kunst aus den Zwischenkriegsjahren wird durch Albert Van Huffel, Huib Hoste, Le Corbusier, Emile Lenoble, Jean Sala, Jean Puiforcat, Gabriel Argy-Rousseau, Maurice Marinot, Claudius Linossier, Gaston Eysselinck, Emile Ruhlman und Chris Lebeau repräsentiert. Die Sammlungen aus den 70er und 80er Jahren werden auf der einen Seite durch die wichtigeren Designer wie Pieter de Bruyne und Emil Veranneman bestimmt, auf der anderen Seite durch italienisches Design, insbesondere durch Gruppen wie Alchimia und Memphis, mit auffallend skulpturalen Möbeln in hellen, fröhlichen Farben und mit amüsanten dekorativen Elementen.

Das Design museum Gent stellt Design von Alessandro Mendini, Ettore Sottsass, Michele de Lucchi, Massimo Iosa-Ghini, Michael Graves, Marco Zanini, Martine Bedin, Nathalie Du Pasquier, Mateo Thun und anderen aus. Zudem gibt es Arbeiten von bekannten Postmodernisten zu sehen, wie Hans Hollein, Richard Meier und Aldo Rossi. Desweiteren werden Möbel-, Glas- und Keramikobjekte von Borek Sipek gezeigt. Das Design aus dem eigenen Land wird durch Kreationen von jungen Schmuck-, Möbel und Keramikdesignern repräsentiert.

Mit dem Design museum Gent wird der Versuch unternommen, drei Basisfunktionen zu erfüllen: Erwerb und Erhalt, Wissenschaft und Bildung. Neben der wissenschaftlichen und konservatorischen Arbeit möchte das Museum auch einen speziellen Bildungsauftrag erfüllen. Die Abteilung für Bildung ist das unabdingbare Bindeglied, der entscheidende Vermittler zwischen Wissenschaftlern, Historikern und Künstlern auf der einen Seite und Kindern, Schulen, Studenten und dem breiteren Publikum auf der anderen Seite. Mit dieser didaktischen Arbeit soll die Kluft zwischen dem Publikum und dem Museum verringert werden.

Das Design museum Gent besitzt ein umfangreiches Ausstellungsprogramm. Schwerpunkt ist auch hier das Design des 20. Jahrhunderts. Die Themen reichen vom Art Nouveau bis hin zu zeitgenössischem Design, wobei jeweils eine Verbindung zu den Sammlungen hergestellt wird.

L. D.

HISTORY OF THE MUSEUM

A SHOWCASE FOR MODERN DESIGNERS

The origins of Design museum Gent lie in the "Verenigung voor industriè le en decoratieve kunsten" (Industrial and Decorative Arts Society), founded in Ghent in 1903. It was first housed in the Academy of Fine Arts in Academiestraat. In 1922-1923 the collection was moved to the Hotel de Coninck, which had been bought for the purpose by the City of Ghent. It was only in 1958 that the City of Ghent also obtained the guardianship of the now "museum voor Sierkunst" (museum for decorative arts) themselves. A copy of the application for planning permission for the Hotel de Coninck has survived from 1754. Building probably commenced shortly afterwards; in any case, the anchors in the side wall bear the date 1755. The building itself is a very impressive example of the characteristic Flemish civic architecture of the 18th century. The new extension to a "museum voor Sierkunst en Vormgiving" (museum for decorative arts and design) was officially opened in May 1992. It was designed by architect Willy Verstraete. The unique pieces that have been patiently collected and preserved since the mid-1970s can now finally be exhibited. This new section of the museum is in itself a sight worth seeing. The 18th-century façade facing the inner courtyard has been completely restored. Behind it there is a light and airy modern building. The one brilliant invention is a huge hydraulic lift in the central section of the building. This makes the floors adaptable. The possibilities for the involvement of visitors in an exciting play of changing levels are almost unique.

The "old" museum collections mainly comprise 17th and 18th-century furniture displayed in the stylish interiors of the Hotel de Coninck (built in 1755). The absolute topper is the entirely original dining room, where the wooden chandelier, the work of Ghent sculptor J. F. Allaert, is still hanging in its original place. Other interiors are decorated with 18th-century murals or with silk wall-coverings. Illumination is provided by more than twenty 18th-century crystal chandeliers. There are portraits of well-known figures hanging on the walls, including King Louis XVIII of France, whose desk is also on display amidst the fine collection of French furniture. The Design museum Gent — the new name was given in 2002 — has one of the most superb Art Nouveau collections in the country. The exuberant period of Art Nouveau with its floral motifs and play of flowing lines and the more constructivist direction taken by the 1900 style are both shown in the museum. Alongside foreign designers we see the work of important Belgian artists like Henry van de Velde, Victor Horta, Paul Hankar, Gustave Serrurier-Bovy and Philippe Wolfers. Art Deco and the applied arts from the inter-war years are represented by Albert Van Huffel, Huib Hoste, Le Corbusier, Emile Lenoble, Jean Sala, Jean Puiforcat, Gabriel Argy-Rousseau, Maurice Marinot, Claudius Linossier, Gaston Eysselinck, Emile Ruhlmann and Chris Lebeau. The collections from the 1970s and 1980s are dominated on the one hand by the more important Belgian designers like Pieter De Bruyne and Emiel Veranneman, and on the other by Italian design, particularly from groups like Alchimia and Memphis, with astonishingly sculptural furniture in bright, cheerful colours and with amusing decorative elements.

The Design museum Gent exhibits designs by Alessandro Mendini, Ettore Sottsass, Michele de Lucchi, Massimo Iosa-Ghini, Michael Graves, Marco Zanini, Martine Bedin, Nathalie Du Pasquier, Mateo Thun and others. In addition to this there is work by prominent postmodernists like Hans Hollein, Richard Meier and Aldo Rossi. Important furniture, glass and ceramic creations by Bořek Šípek are also on view. Work from this country is represented by creations from young jewelry, furniture and ceramic designers.

The Design museum Gent attempts to fulfill three basic functions: acquisition and conservation, scholarly and educational. In other words, in addition to being an scholarly and conservation institute, it is also an educational medium. The educational department is the indispensable link, the essential "translation service", between the scholar, the historian or the artist on the one hand and the children, the schools, the students and the wider adult public on the other. The educational work involves activities intended to narrow the gap between the public and the museum. The Design museum Gent has a busy exhibition programme. Here, too, the emphasis is on 20th-century design.
The themes vary from Art Nouveau to contemporary design, thereby maintaining the link with the collections.

L. D.

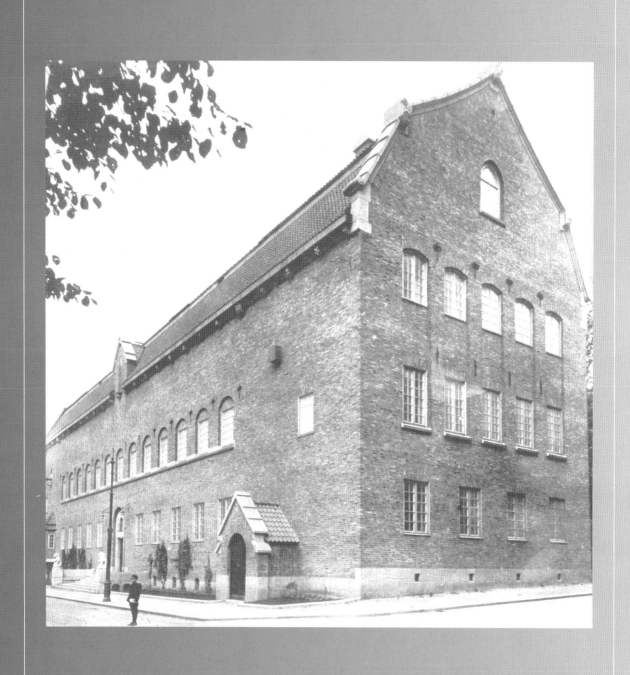

Göteborg

Röhsska museet
The Röhss Museum for Design and Applied Art
www.designmuseum.se

COLLECTION

Röhsska museet, The Röhss Museum for Design and Applied Art

DESIGNER / ARCHITECT

Erik Gunnar Asplund

OBJECT

Tubular steel chair for the Svenska Slöjdforeningen meeting chamber
Stahlrohrstuhl für Sitzungssaal der Svenska Slöjdforeningen

DATE

1931

MANUFACTURER

NK:s verkstäder, Nyköping

Rösska museet, Göteborg, Sweden

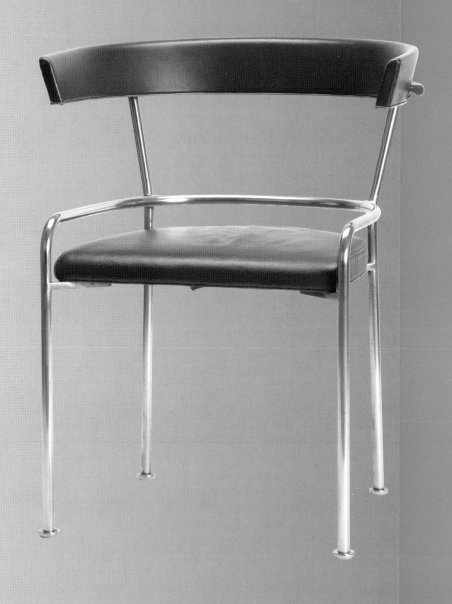

GESCHICHTE DES MUSEUMS

Sein heutiges Erscheinungsbild erhielt das Röhsska museet im Jahr 1996. Das ursprüngliche Gebäude war in Rot gestrichen, bestand aus handgefertigten Backsteinen und wurde von Carl Westman entworfen. Es wurde 1916 fertig gestellt, in dem Jahr, als man das Museum der Öffentlichkeit übergab. Die Satzungen des Museums erstellte die Stadt Göteborg im Jahre 1904. Seine finanzielle Basis erhielt das Museum 1901 durch eine Spende aus dem Nachlass von Wilhelm Röhss. In den folgenden Jahren kamen weitere Spenden durch verschiedene Personen hinzu, darunter auch Röhss' Bruder August.

Das Konzept des Röhsska museet lehnt sich an das vieler anderer europäischer Museen an, wie etwa des Victoria & Albert Museums in London und des Museums für angewandte Kunst in Wien. Es unterhält eine breite Vielfalt an Sammlungen. Zunächst bestanden sie aus älteren schwedischen und europäischen, handwerklich hergestellten, Gegenständen. Eine Sammlung japanischer Objekte wurde kurze Zeit später hinzugefügt und in den Jahren 1912-1913 machte der Botaniker Thorild Wulff im Auftrag des Museums eine Reise nach China, um eine neue Kollektion zusammenzustellen. Viele der Objekte, die er für das Museum erwarb, nehmen heute noch immer einen wichtigen Platz in der Sammlung ein.

Axel Nilsson war im Jahre 1914 der erste Kurator des Röhsska museet, allerdings hatte er schon als Berater der Museumsdirektion dazu beigetragen, dass das Gebäude funktionell und lebendig gestaltet wurde. Axel Nilsson war auch einer derjenigen, die Thorild Wulffs Reise nach China unterstützten.

Während der zwanziger Jahre begann man damit, einzigartige Handwerksgegenstände zu sammeln. 1937 wurde dem Gebäude eine von Melchior Wernstedt entworfene Ausstellungshalle hinzugefügt. Da die Zahl der Ausstellungen und die der verschiedenen Kollektionen ständig wuchs, nahm auch der Bedarf an Ausstellungsfläche zu, so dass 1950 ein Ausbau geplant wurde, der schließlich mit der Design-Halle und der Brolid-Halle seine Umsetzung fand. Ihren Namen erhielt die Halle nach ihrem Architekten, Sven Brolid. Die Kunsthochschule der Universität, die ursprünglich den Namen Slojd Gesellschaftsschule trug, existierte schon bei Gründung des Museums. Seither arbeiten beide Institutionen eng zusammen.

SAMMLUNGEN

Das Röhsska museet besitzt über 50.000 Objekte in verschiedenen Sammlungen. Zusätzlich gibt es eine Bibliothek, mit über 30.000 Bänden. Der Großteil der Sammlung besteht aus alten schwedischen und europäischen Handwerksgegenständen. Aber auch klassische griechische und römische Artefakte sind Teil der Sammlung sowie eine große Anzahl japanischer und chinesischer Stücke. Das Museum begann um das Jahr 1910, zeitgenössische Handwerksarbeiten zu sammeln. Es dauerte allerdings bis zum Jahre 1950, um eine erste Sonderausstellung zu zeitgenössischem Handwerk auf die Beine zu stellen, eine Ausstellung, die stark retrospektiven Charakter besaß. Im Rahmen der Feierlichkeiten zum goldenen Jubiläum des Museums wurde eine weitere Ausstellung zusammengestellt. Anhand von Beispielen einiger nicht-nordischer Länder sollte die aktuelle Situation in Schweden und der anderen nordischen Nationen aufgezeigt werden. Die einzelnen Sammlungen des Museums basieren nicht auf einer kulturell geschichtlichen Basis und ihr Anliegen ist es nicht, die jeweiligen Zeiten widerzuspiegeln. Stattdessen werden hohe ästhetische und technische Kriterien als Maßstab für eine Auswahl angesetzt.

Heutzutage sammelt das Röhsska museet hauptsächlich zeitgenössische Gegenstände, in den Kategorien Handwerk, Kunsthandwerk und Industriedesign — darunter in erster Linie schwedische Produkte. Aber auch solche Objekte der skandinavischen Nachbarn oder des Kontinents finden in der Sammlung Berücksichtigung, die maßgebend für den Designprozess sind.

E. W.- B.

Göteborg

Röhsska museet

HISTORY OF THE MUSEUM

The Röhsska museet was given its current appearance in 1961. The original building, clad in red hand-made brick, designed by Carl Westman, was completed in 1916 when the museum was opened to the public. The articles of association of the museum were adopted by Göteborg City in 1904. The financial foundation was a donation from the estate of Wilhelm Röhss in 1901, and in the ensuing years, further donations were made by people including his brother, August Röhss.

Organized after the examples of many European applied art museums, like the Victoria & Albert Museum in London, and Museum für angewandte Kunst in Vienna, the Röhsska museet hosts a great variety of collections. The first collections consisted of older Swedish and European handicraft. A collection of Japanese objects was soon added, and in 1912–1913 Thorild Wulff, the botanist, made a collection journey to China on behalf of the museum. Several of the objects he obtained, with the methods of the time, still have a prominent position in the museum.

Axel Nilsson was the Röhsska museet's first curator in 1914, but as an advisor to the Board, he had already contributed to designing the building as a functional and living museum. Axel Nilsson was also one of the people who promoted Thorild Wulff's journey to China.

During the 1920s, the museum began to collect unique handicraft objects. In 1937, an exhibition hall designed by Melchior Wernstedt was added to the building. As exhibition activities and collections expanded, the need for new premises increased and in the 1950s an extension was planned which resulted in the design hall and the Brolid hall, which took its name from Sven Brolid, architect of the latest extension. The University College of Arts & Crafts Design is located on the site adjacent to the Röhsska museet. It was originally called the Slojd Society School, was already established when the museum was set up, and the two institutions have always enjoyed close collaboration.

COLLECTIONS

The Röhsska museet has over 50 000 objects in its collections. In addition, there is a comprehensive library containing 30 000 volumes and a large collection of exhibition catalogues. The majority of the collection consists of old Swedish and European handicraft products, but also includes classical Greek and Roman artefacts, and material from Japan and China is well represented. The museum started to collect contemporaneous craft work about 1910, but it was not until the 1950s that a special exhibition was set up for contemporaneous craft industry, an exhibition which was mainly of a retrospective nature. Another exhibition was set up in conjunction with the museum's Golden Jubilee, whose collections were intended to reflect the current situation in Sweden and the other Nordic countries, with the aid of a few examples from non-Nordic countries. The museum's collections are not set up on a cultural history basis, i.e., to reflect their times. Instead, one of the main criteria for selection of objects has been high aesthetic and technical quality.

These days, the Röhsska museet mainly collects contemporary material in the categories of handicraft, commercial handicrafts and industrial design. Mainly Swedish products, but Nordic products together with European and First World products which have been important for design are included in the collections.

E. W.– B.

Helsinki

Designmuseo
www.designmuseum.fi

COLLECTION

Designmuseo

DESIGNER / ARCHITECT

Alvar Aalto

OBJECT

Arm chair / Sessel

DATE

Early 1930s / Frühe 30er Jahre

MANUFACTURER

Prototype / Prototyp

Designmuseo Helsinki

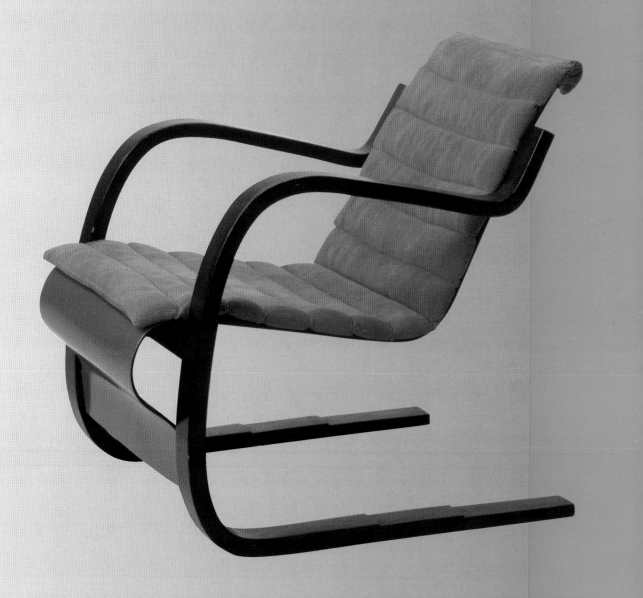

GESCHICHTE DES MUSEUMS

Das Designmuseo ist das einzige Museum in Finnland, in dem das Design ganzheitlich behandelt wird. Themen und Exponate reichen von Kunsthandarbeiten bis hin zu industriellem Design. Das Museum hat seinen Sitz seit 1978 im Zentrum von Helsinki, in einem Gebäude, das ursprünglich 1894 von Carl Gustaf Nyström als Schule entworfen wurde. In der langen und facettenreichen Geschichte des Museums war sein Wirken immer eng mit Ereignissen verknüpft, die eine grundlegende Bedeutung für die Entwicklung des finnischen Designs hatten. Auch bis heute hat es seine aktiven Beziehungen zur nationalen Designentwicklung aufrechterhalten.

Das finnische Kunstgewerbemuseum entstand auf Initiative von Carl Gustav Estlander, Professor für Ästethik an der Universität Helsinki. Ideologisches Vorbild war das von Henry Cole konzipierte Londoner Victoria & Albert Museum. Es sollte eine Modell- und Lehrsammlung zur Unterstützung der zwei Jahre zuvor gegründeten Werkschule geschaffen werden. Die Sammlung sollte weiterhin zur formschöpferischen Aufklärung dienen, indem normalen Bürgern und speziell Vertretern des Kunstgewerbes Beispiele guter Formgebung geboten wurden. Die Arbeit des Museums war von Anfang an darauf gerichtet, das Interesse am ästhetischen Niveau des Kunstgewerbes zu wecken. Andererseits war die Designentwicklung eine Folge des Wachstums der finnischen Industrie und der Verbreitung von nationalistischem Gedankengut im Land. Die Entwicklung erfuhr einen besonderen Anschub durch das Streben Finnlands nach einer unabhängigen Stellung in der internationalen Völkergemeinschaft.

Die ersten Sammlungen des Museums wurden 1873 auf der Wiener Weltausstellung angekauft. Dieses Jahr bildet so einen Meilenstein im Hinblick auf die systematische Sammlungsarbeit. Die Anschaffung der Sammlung wurde als derart wichtig empfunden, dass man sich mit einer Zeitungsanzeige an die Öffentlichkeit wandte, um Geld dafür aufzubringen. Die Sammlung umfasste 732 Gegenstände, die weitgehend auf der Grundlage ihrer Materialien ausgewählt wurden. Wegen Geldknappheit musste man sich teilweise mit einem recht bescheidenen Umfang an Gegenständen zufrieden geben; 300 Stücke etwa stammten aus Donationen. Nichts desto trotz konnten verschiedene Materialien und Techniken wie Glas-, Fayance-, Porzellan-, Holz-, Lack-, Metall-, Bucheinband- und Steinarbeiten zusammengestellt werden. Im Jahre 1875 wurde zur Trägerschaft von Schule und Museum der Finnische Kunstgewerbeverein gegründet, aus dem das Museum 1990 als selbstständige Stiftung austrat. Die Stiftung erhält heutzutage jährliche Unterstützung vom finnischen Staat. Die Museumssammlung wurde in den nach Wien folgenden Weltausstellungen weiter komplettiert, und nach und nach begann man mit dem konsequenten Sammeln von verschiedenartigen Gegenständen. Der Öffentlichkeit wurden die Exponate zum ersten Mal 1874 in der Universität Helsinki vorgestellt. Professor Estlanders ursprüngliches Ziel war es, die Ausstellungs- und Ausbildungsarbeit aller Teilgebiete der finnischen visuellen Kunst unter einem Dach zu vereinen. Die Idee wurde verwirklicht, als das Museum 1888 gemeinsam mit dem Kunstmuseum, der Werkschule sowie der Kunstakademie im Zentrum von Helsinki im sogenannten Atheneumgebäude eröffnet wurde. Das gemeinsame Wirken war für das Kunstgewerbemuseum nur von kurzer Dauer. Aufgrund von Raummangel zog das Museum 1912 aus dem Atheneum. Die darauffolgenden Jahrzehnte waren von ständigen Umzügen geprägt, die 1954 in einem Lagerhaus endeten. Der Finnische Kunstgewerbeverein, zu dessen Aufgaben neben der Museumsarbeit die internationale Bekanntmachung des finnischen Designs gehörte, konzentrierte seine Arbeit nach dem Krieg auf den Export von Ausstellungen, die deutlich die Bedürfnisse der Industrie unterstützten und das Bild Finnlands als modernen westlichen Industriestaat stärkten. Im Jahre 1978 wurde das Museum als Ergebnis der zielgerichteten Arbeit des damaligen Geschäftsführers des Finnischen Kunstgewerbevereins, Professor Herman Olof Gummerus, wiedereröffnet. Die ständigen Umzüge hinterließen natürlich ihre Spuren in der Ausstellungs- und folgerichtigen Sammlungsarbeit. Es lässt sich aber trotzdem deutlich feststellen, dass mit der Stärkung des finnischen Designs gute Formgebung auch als Ziel der Erhaltung bevorzugt wurde. Die Phasen des finnischen Designs spiegeln sich auch in den Sammlungen des Museums wieder, so dass man u. a. folgende Gesamtheiten unterscheiden kann: Anfänge der finnischen Industrialisierung, nationales Erwachen um 1900, kunsthandwerkliche Schmuckgegenstände aus den 20er Jahren, Durchbruch des Modernismus in den 30er Jahren, Produktionsanstieg und internationaler Erfolg nach dem Zweiten Weltkrieg, Techno-Optimismus der 60er Jahre und wiederbelebtes Kunsthandwerk der 70er Jahre sowie Designvielfalt der letzten Jahrzehnte mit besonderem Augenmerk auf der Bedeutung des industriellen Designs.

Heutzutage umfassen die Museumssammlungen etwa 35.000 Gegenstände. Das Museum besitzt außerdem ein umfangreiches Archiv mit mehr als 40.000 Entwürfen, ein Bilderarchiv mit mehr als 100.000 Bildern und ein digitales Designerregister mit den Angaben von eintausend finnischen Designern. Der Schwerpunkt der Sammlungen liegt auf den starken Gebieten des finnischen Designs; ausgestellt sind Gegenstände der Glaswerke Iittala und Nuutajärvi, Produkte der Porzellanfabrik Arabia, Möbel, weiterhin Textilien und Entwürfe der Freunde der Finnischen Handarbeit sowie Druckstoffe und Mode von Marimekko. Zu sehen sind auch einige bemerkenswerte Sammlungen von privaten Designern wie Gegenstände und Entwürfe von Timo Sarpaneva, Silbergegenstände vom Akademiker Bertel Gardberg und Textilien und Entwürfe der Textilkünstlerin Dora Jung. Eine große Herausforderung der letzten Jahre war, die Sammlungsdaten zur Erleichterung ihrer Nutzung digital zu bewahren. Dies ist bei den Gegenstandssammlungen schon bis zu 80 Prozent realisiert worden.

Das Bild Finnlands als eines der Pionierländer auf dem Gebiet des Designs basierte lange auf dem Erfolg des Nachkriegsdesigns und auf dem Ruf einiger legendärer Designer wie Alvar Aalto, Tapio Wirkkala, Timo Sarpaneva, Kaj Franck und Eero Aarnio. In den letzten Jahren hat aber unter Designern und auf staatlicher Ebene eine Diskussion über die Bedeutung von Design im Hinblick auf die Verbesserung von Lebensqualität und als Mehrwert im Hinblick auf die Wettbewerbsfähigkeit der Industrie begonnen. Davon ausgehend hat die finnische Regierung im Jahre 2000 ein designpolitisches Programm beschlossen. Ziel des Design 2005!-Programms ist die Verbesserung der Wettbewerbsfähigkeit durch Entwicklung von Ausbildung und Forschung in der Designbranche sowie durch Integration der Designbranche in die Entwicklung des nationalen Innovationssystems.

Das designpolitische Programm legt auch die Schwerpunktbereiche der verschiedenen Organisationen der Branche fest. Auf der Grundlage des Programms hat das Designmuseo seine zukünftigen Tätigkeitsziele wie folgt zusammengefasst: Erhaltung, Vorstellung, Dokumentierung und Erforschung der finnischen und internationalen Designkultur, Aufzeigen der gesellschaftlichen und kulturellen Einflüsse von Design in Zusammenarbeit mit anderen designfördernden Partnern, wie Industrie und Entwerfern, sowie internationale Vermarktung von finnischen Designausstellungen. In der Praxis bedeutet dies neben der traditionellen Sammlungsarbeit und Ausstellungsorganisation eine Vermehrung von nach außen orientierten Projekten und ein zunehmendes Augenmerk auf das junge Publikum und die Museumspädagogik. Ausgehend davon eröffnete das Museum im Jahre 2000 eine neuartige Ausstellungseinheit, das Designstudio, das gleichzeitig Ausstellung und Werkstatt ist. Außerdem hat das Museum mit einem EU-Projekt begonnen, in dessen Rahmen Besuche von Designern in Schulen veranstaltet werden. In der Welt der Waren wird weitgehend mit Vorstellungsbildern gehandelt und Design ist immer bedeutender geworden. Designer, ihre Ideen und Produkte funktionieren heutzutage grenz- und kulturüberschreitend und werden so zum gemeinsamen Kapital. Andererseits sind zur Erhaltung der globalen Kulturvielfalt auch Verständnis und Förderung des nationalen Charakters von Gegenstandswelt und Umwelt erforderlich. Das Designmuseo stellt seine Sammlungen aus einer finnisch-nordischen Perspektive zusammen und interpretiert auf dieser Grundlage Phänomene der Geschichte und Gegenwart des Designs.

M. A.

HISTORY OF THE MUSEUM

Designmuseo – the Finnish Museum of Art and Design – is the only museum in Finland that covers the field of design comprehensively. Its activities embrace the design sector on a broad front, from crafts to industrial design. The museum operates at a central location in Helsinki, in a building originally designed as a school by the architect Carl Gustaf Nyström in 1894. Designmuseo began operating in its present building in 1978, but it already then had a long and colorful history behind it. Its history is interwoven with events of crucial significance to the evolution of Finnish design, and the museum has to this day retained a close and active relationship with national developments in the field.

Based on the same ideological premises as the Victoria & Albert Museum in London, which was conceived by Henry Cole, Designmuseo originated from a proposal by Carl Gustaf Estlander, a professor of aesthetics at the University of Helsinki. The idea was to create a collection of models and education in Finland to support the work of the School of Arts and Crafts, which had been founded two years earlier, and to distribute education in design by providing ordinary citizens and especially applied art workers with good examples of design. The activities of the Designmuseo have been closely linked from the very start with the awakening of interest in the standard of applied arts. On the other hand, brisk activity in the field of design was a consequence both of Finland's gradually awakening industry and of the spread of nationalist concepts. The trend gained particular momentum in a small country that was seeking an independent status in the international community of nations.

The museum's first collection was acquired at the Vienna International Exhibition of 1873. That year therefore constituted a natural time limit for the acquisition of objects. The procurement of the collection at the Vienna International Exhibition was seen as so important that newspaper advertisements were placed, urging the public to contribute funds for this purpose. The collection comprised 732 objects and they were largely chosen on the basis of the materials used to make them. The lack of resources made it necessary to settle for what was in some respects a very modest set of objects and more than 300 were obtained as a donation, but the array of materials and technologies was broad, embracing items of glass, faience, porcelain, wood, lacquer and metal, as well as examples of bookbinding and stoneware. In 1875, the Finnish Society of Crafts and Design was established to maintain the activities of the school and museum; the museum detached itself from this in 1990 to become an independent foundation receiving annual grants from the state of Finland. The collection was expanded at international exhibitions after Vienna, and gradually the systematic acquisition of objects was started in other ways. The collection was first displayed to the public at Helsinki University premises in 1874. Since that time, the museum's history has been colored by moves from place to place. Professor Estlander's original intention was to get all of Finland's subdivisions of the visual arts under the same roof in respect of both the collections and teaching. This idea was realized when the museum, together with the National Gallery, the School of Arts and Crafts and the Academy of Arts were opened in 1888 in the Ateneum building in Helsinki city centre. This cohabitation of art institutions was short-lived for the Museum of Applied Arts. Shortage of space caused the museum to move out of the Ateneum in 1912 and it then lived a vagrant life that ended in 1954 when its property was put into storage. The Finnish Society of Crafts and Design, whose duties included promoting Finnish design in the international arena as well as the museum, concentrated on exporting exhibitions after the war. This clearly supported the needs of industry and strengthened the image of Finland as a modern, Western industrialised nation. The museum began a new life in 1978 when it was re-opened as a result of determined efforts by the then managing director of the Finnish Society of Crafts and Design, Professor Herman Olof Gummerus. Both the museum's exhibition work and the systematic expansion of its collections were affected by the constant moves. However, its setting of priorities as a focus of recording can also be seen as a clear choice in the collection policy as Finnish design grew in strength. The history of Finnish industrial arts is reflected in the museum's collections, in such a way that clear divisions can be seen among them. These include the early stages of Finnish industrialization, the national awakening of the early 1900s, the crafts-oriented decorative objects of the 1920s, the breakthrough of modernism in the 1930s, growth in production and international success after the Second World War, the techno-optimism of the 1960s, the comeback of crafts in the 1970s, and recent decades' diversity of design and particularly the increase in the significance of industrial design.

Today there are some 35 000 objects in the museum's collections. The museum also has an extensive archive of more than 40 000 drafts and an archive of over 100 000 pictures, as well as a digital register with information on a thousand Finnish designers. The collections naturally emphasize the strong points of Finnish design, such as objects by the Iittala and Nuutajärvi glassworks, the production of the Arabia porcelain factory, furniture, textiles and drafts by the Friends of Finnish Handicraft, and Marimekko's printed fabrics and fashion. The museum's collections also include a few significant sets of individual designers, such as a collection of objects and drawings by Timo Sarpaneva, a collection of silver objects by academician Bertel Gardberg, and a collection of textiles and drawings by textile artist Dora Jung. A great challenge for the museum in recent years has been to make the collection files easier to use by getting them into digital form. This has already been completed for 80 percent of the collections of objects.

The image of Finland as a trailblazer of design has long been based on its post-War success and on the reputation of a handful of "designer-heroes", exemplified by Alvar Aalto, Tapio Wirkkala, Timo Sarpaneva, Kaj Franck and Eero Aarnio. In the past few years, however, there has been a more widespread debate among both designers and government circles on the importance of design, both generally as a source of improvement in the quality of people's lives and as an added value for industry. On the basis of this discussion, the Finnish Council of State approved a programme on design policy in 2000. The intention of the Design 2005! programme is to enhance competitiveness by developing design education and research and by involving design in the development of the national innovation system.

The design policy programme also sets priorities for the activities of the different organizations in the sector. On the basis of the programme, Designmuseo has crystallized its own operational targets for the future as follows: recording the Finnish and international design culture, presentation, documentation, research, bringing out the social and cultural impact of design in collaboration with other parties promoting design, industry and the designer community, as well as producing exhibitions on Finnish design for international tours. In practical terms the last mentioned means, in addition to augmenting traditional collections and arranging exhibitions, reinforcing the significance of outward-oriented projects and paying particular attention to the young public and to museum pedagogy. In connection with this the museum opened a new exhibition section called Designstudio in 2000, which is both an exhibition and a workshop. Aside from this, the museum has started an EU project within the framework of which visits to schools by designers are arranged. In a world full of goods, trading today is done largely through images, and design has become even more important. With their ideas and products, designers can move easily from one country to another and are becoming a form of common capital. On the other hand, to retain global cultural diversity, the world of objects and the national characteristics of the environment need to be understood and supported. From the northern perspective of Finland, Designmuseo sets out from these starting points to do its part in building the collections and to interpret phenomena related to the history and present of design.

M. A.

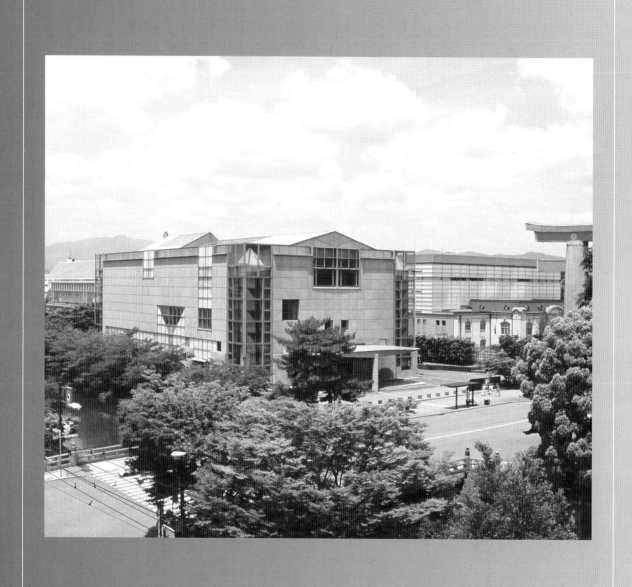

Kyoto

The National Museum of Modern Art
www.momak.go.jp

COLLECTION

The National Museum of Modern Art

DESIGNER / ARCHITECT

Shiro Kuramata

OBJECT

Coffee table / Couchtisch 'Luminous Table'

DATE

1969

MANUFACTURER

Ishimaru Co., Ltd.

The National Museum of Modern Art, Kyoto

GESCHICHTE DES MUSEUMS

ENTSTEHUNGSGESCHICHTE

Das National Museum of Modern Art, Kyoto, entstand als drittes Museum für Moderne Kunst in Japan.[1] Die Umstände, die zu seiner Gründung führten, können aber keineswegs als einfach bezeichnet werden. Im Jahr 1953, einem Jahr nach der Eröffnung des ersten staatlichen Museums für Moderne Kunst in Tokyo, dem National Museum of Modern Art, Tokyo, gab die französische Regierung die Sammlung westlicher Kunst von Kôjirô Matsukata (1865–1950), die er vor dem Zweiten Weltkrieg zusammengetragen hatte und vornehmlich impressionistische Werke aufwies, an den japanischen Staat zurück. Diese Sammlung war im Friedensvertrag von San Francisco von 1951 vorübergehend zu französische Staatseigentum erklärt worden. Der damalige Kyotoer Bürgermeister nahm die Rückgabe zum Anlass, sich für die Errichtung eines Museums in Kyoto einzusetzen, das die Sammlung beherbergen könnte. Die Realisierung dieses Museums scheiterte jedoch an den Vorstellungen der französischen Regierung, die die Sammlung Matsukata in einem Museum im hauptstädtischen Tokyo unterzubringen wünschte.[2] Die Stadt Kyoto veränderte daraufhin den ursprünglichen Plan hin zu einem Museum für Moderne Kunst und setzte sich gegenüber dem japanischen Staat für die Errichtung einer Kyotoer Dépendance des National Museum of Modern Art, Tokyo, ein. Dieses Vorhaben gelangte schließlich im Jahr 1963 zu seiner Verwirklichung.[3]

1962 renovierte die Stadt Kyoto ein Nebengebäude der Kyoto Exhibition Hall im Okazaki-Park, in dessen Zentrum der Heian-Schrein liegt, und stellte es dem Staat unentgeltlich zur Verfügung. Dort eröffnete am 1. März 1963 die Kyotoer Dépendance des National Museum of Modern Art, Tokyo. Am 27. April des gleichen Jahres wurde dort die erste Ausstellung „Contemporary Japanese Ceramic Art" and „Trend of Contemporary Japanese Painting" eröffnet. Vier Jahre später, im Jahre 1967, ging aus dieser Dépendance das eigenständige National Museum of Modern Art, Kyoto, hervor.

Dieser unentgeltlich zur Verfügung gestellte Bau aus dem Jahr 1937 erwies sich jedoch für die Aktivitäten eines Kunstmuseums aufgrund seiner ungenügenden Ausstellungsfläche und der mangelnden Räumlichkeiten zur Aufbewahrung von Kunstgegenständen als gänzlich ungeeignet. Bereits seit seiner Eröffnung war die Notwendigkeit eines Neubaus mehr als offensichtlich. Obwohl bereits 1972 die Mittel für die Untersuchung zur Errichtung eines Museumsneubaus genehmigt worden waren und auch im folgenden Jahr ein Architekt bestimmt werden konnte, dauerte es noch ganze zehn Jahre bis zur endgültigen Realisierung dieses Neubaus. Nach der Schließung und dem Abriss des alten Dépendancegebäudes 1984, auf die außerdem noch eine archäologische Untersuchung des Baugrundes folgte, konnte das von Maki Fumihiko (geb. 1928) entworfene gegenwärtige Museumsgebäude am 15. September 1986 fertiggestellt werden. Am 25. Oktober des gleichen Jahres fanden die Feierlichkeiten zum Bauabschluss und zur Eröffnungen des Neubaus statt. Am darauffolgenden Tag öffnete das Museum mit der Ausstellung „Nihon-ga, Kyoto School 1910-1930" seine Tore. Darüber hinaus konnten auch die dringend notwendigen Räume für die ständige Ausstellung in Betrieb genommen werden.

Im Zuge der Verwaltungsreformen richtete die japanische Regierung 1996 ein neues System von unabhängigen Verwaltungskörperschaften ein. Seit dem 1. April 2001 wurde das National Museum of Modern Art, Kyoto, gemeinsam mit dem National Museum of Modern Art, Tokyo, dem National Museum of Western Art, Tokyo, und dem National Museum of Art, Osaka, in einer Verwaltungseinheit zusammengefasst und führt nun als ein Teil dieser unabhängigen Körperschaft Staatlicher Kunstmuseen seine Arbeit weiter.[4]

ORGANISATIONSSTRUKTUR

Seit der Umwandlung in eine Körperschaft des öffentlichen Rechts im Jahre 2001 trägt der Generaldirektor die gesamte Verantwortung für die Belange der Museen, deren Verwaltungshauptstelle im National Museum of Modern Art, Tokyo, eingerichtet wurde. Die konkrete Museums-arbeit blieb jedoch auch weiterhin den einzelnen Museen überlassen. Auch im National Museum of Modern Art, Kyoto, arbeiten sechs Kuratoren, zugeordnet dem Leiter der Kuratorenabteilung, der wiederum dem Museumsdirektor unterstellt ist, an der Entwicklung von Ausstellungen und der Betreuung der Sammlung.

Kyoto

The National Museum of Modern Art

MUSEUMSANLAGE UND UMFELD

Das National Museum of Modern Art, Kyoto, befindet sich in einer Ecke des östlich vom Kyotoer Zentrum gelegenen Okazaki-Parks. An diesen Park in unmittelbarer Nähe von Higashiyama schließen sich im Osten die Tempelanlagen des Nanzen-ji und des Eikan-dô sowie im Süden die Tempel Shôren'in und Chion'in an. Im Norden befindet sich die Tempelanlage des Shôgoin sowie der Campus der Kyoto-Universität. Der Park selbst beherbergt neben dem Heian-Schrein verschiedene kulturelle Einrichtungen wie etwa die Kyoto Prefectural Library, die Kyoto Hall, das 1933 errichtete Kyoto Municipal Museum of Art und den Kyoto City Zoo. Durch den Park fließt ein Kanal, der vom Biwa-See gespeist wird. Besonders die im Frühling an dessen Ufern blühenden Kirschbäume und das bunt gefärbte Herbstlaub der nahen Higashiyama-Gegend machen den besonderen landschaftlichen Reiz der gesamten Anlage aus.

Im Erdgeschoss des Museumsgebäudes befinden sich eine bis zum Dach offene Eingangshalle, das Foyer, ein Café, der Museumsshop, ein Vortragssaal sowie die Räume der allgemeinen Verwaltung. Das erste Obergeschoss ist der Museumsarbeit mit dem Büro des Direktors und den Büros der Kuratoren vorbehalten. Die Räumlichkeiten für Sonderausstellungen liegen im zweiten Obergeschoss und im dritten Obergeschoss ist die ständige Ausstellung untergebracht. Pro Jahr werden etwa acht Sonderausstellungen veranstaltet. Die Exponate der ständigen Ausstellung wechseln nach Thema oder Jahreszeit fünf- bis neunmal im Jahr. Im Kellergeschoss befinden sich das Depot und die Maschinenräume für die Klimatisierung.

INHALTLICHE SCHWERPUNKTE DES MUSEUMS

Das National Museum of Modern Art, Kyoto, sieht die ihm zugedachte Aufgabe in der Überprüfung und Einordnung der Geschichte der Kunst der Moderne und ihrer Verbindung zur Gegenwart. Darüber hinaus setzt sich das Museum die Erarbeitung und Durchführung unterschiedlichster Aktivitäten zum Ziel, die zu den kommenden Entwicklungen der Kunst beitragen können. Diese Museumsarbeit umfasst die außerordentlich weiten Bereiche von Malerei, Druckgrafik, Skulptur, Kunsthandwerk, Architektur, Design etc. bis hin zu Fotografie und Film. Eine ausreichende Bearbeitung all dieser Teilbereiche der modernen Kunst innerhalb eines Museums stellt kein einfaches Unterfangen dar. Dabei sollte ein weiteres Ziel dieser musealen Aktivitäten die wesentliche Förderung der Künste in ganz Japan sein, ohne sich dabei auf eine bestimmte Region zu beschränken. Schließlich liegt unserer Auffassung nach eine weitere Aufgabe der Arbeit eines Museum für moderne Kunst in der internationalen kulturellen Verständigung durch das Medium der modernen bzw. zeitgenössischen Kunst.

Unter Berücksichtigung dieser Aspekte setzen wir bei der Arbeit im National Museum of Modern Art, Kyoto, folgende Schwerpunkte: Zunächst konzentrieren wir uns auf die „Kunst der Moderne", also auf Kunst und Kunsthandwerk aus der Zeit nach der Meiji-Restauration 1868, in Abgrenzung zum Kyoto National Museum, das Kunstgegenstände aus den Epochen bis zur Moderne zum Inhalt hat. Ein zweiter Schwerpunkt liegt auf dem Bereich Kunsthandwerk, der bereits zur Zeit der Entstehung der Dépendance ein wichtiges Thema der damaligen Museumsarbeit bildete und ein großes Anliegen der Stadt Kyoto darstellt. Drittens beschäftigen wir uns in Hinblick auf die Erfassung der gesamten historischen Entwicklung der Kunst der Moderne in Japan besonders mit der Thematisierung von Künstlern aus der Region Kansai sowie mit dem Versuch von Rückblick und Ausblick auf die künstlerischen Entwicklungen während der Moderne im Raum Kyoto. Ein weiterer Schwerpunkt liegt im Verständnis der Tendenzen innerhalb der sich stetig wandelnden Gegenwartskunst und der Aufarbeitung ihrer unterschiedlichen Ausprägungen aus einem internationalen Blickwinkel. Schließlich beschäftigen wir uns in der Bearbeitung verschiedener Teilbereiche der Kunst aus unterschiedlichen Regionen insbesondere mit der Fragestellung der „Moderne" und welche Bedeutung sie für die Gegenwart hat.

DIE SAMMLUNG

Die Erweiterung der Sammlung wird jedes Jahr durch Beratungen in der Kommission zur Auswahl von Ankauf und Stiftung von Kunstwerken beschlossen. Die Museumsmitarbeiter wählen diese Arbeiten entsprechend der Museumsausrichtung und aufgrund ihrer Forschungsschwerpunkte sowie den hierzu durchgeführten Untersuchungen aus. Gegenwärtig umfasst die Sammlung insgesamt 7088 Exponate (Stand April 2002), die sich hauptsächlich aus folgenden Teilen zusammensetzt.

GESCHICHTE DES MUSEUMS

KUNSTHANDWERK

Kunsthandwerk der japanischen Moderne

Kyoto war von 794 bis 1868 fast 1100 Jahre lang die Hauptstadt Japans. Gleichzeitig stellte sie auch das Hauptzentrum der Herstellung von Kunsthandwerk dar, in der sich die Kultur des Kaiserhofes und seit dem Mittelalter auch die bürgerliche Kultur manifestierten. Diese Tradition setzt sich bis in die Gegenwart fort. Angesichts dieser Besonderheit Kyotos sammelt das Museum hauptsächlich repräsentative Arbeiten von Kunsthandwerk der Moderne aus dem Raum Kyoto, wie z. B. Keramiken, Lacke oder Textilien.

Keramik von Kanjirô Kawai (Sammlung Kawakatsu)

Diese Sammlung, die von Ken'ichi Kawakatsu (*1892) über lange Jahre hinweg zusammengetragen wurde, kann als repräsentativ für das gesamte Lebenswerk von Kanjirô Kawai (1890-1966) gelten. Der eng mit Kanjirô Kawai befreundete Sammler stellte seine Sammlung noch zu Lebzeiten dem Museum zur Verfügung. Kanjirô Kawai, eine zentrale Figur der Volkskunstbewegung (Mingei undô), beschäftigte sich ein Leben lang mit der Herstellung von Keramik. Das Museum besitzt mit den späteren Stiftungen insgesamt 424 Stücke, die es als Sammlung Kawakatsu aufbewahrt.

Kunsthandwerk der Gegenwart

Seit der Ausstellung „International Exhibition of Contemporary Ceramic Art" von 1964 veranstaltet das Museum regelmäßig Ausstellungen mit Keramik der Gegenwart aus Japan und dem Ausland. Aus der bei diesen Gelegenheiten erworbenen oder gestifteten Arbeiten entstand eine umfangreiche Sammlung von Kunsthandwerk der Gegenwart.

MALEREI UND DRUCKGRAFIK

Japanische Kunst der Moderne

Das Museum sammelt die in traditionell japanischen Maltechniken ausgeführte, seit der Meiji-Restauration als Nihon-ga bezeichnete Malerei mit Schwerpunkt auf Maler, die in der Kyotoer Kunstszene aktiv waren. Zu den Künstlern, die die Techniken der Ölgemälde aus dem Westen mit nach Japan brachten, sie hier bekannt machten und weiterentwickelten, gehören viele Maler aus der Region Kansai, die in der Sammlung einen besonderen Platz einnehmen. Schließlich umfasst die Sammlung auch Arbeiten zeitgenössischer Kunst, etwa von Mitgliedern der Künstlergruppe Gutai, die nach dem Zweiten Weltkrieg aktiv war. Darüber hinaus besteht ein umfassender Teil der Sammlung aus japanischer Druckgrafik, die sich auf Arbeiten von Grafikern aus dem Bereich der sogenannten Sôsaku hanga (dt. Kreativer Druck) bis hin zu Arbeiten von zeitgenössischen Druckgrafikern erstreckt.

Arbeiten von Kiyoshi Hasegawa

Der in Frankreich tätige Maler und Druckgrafiker Kiyoshi Hasegawa (1891-1980) beschäftigte sich zeitlebens mit den unterschiedlichsten Drucktechniken. Als besonders herausragend gelten seine Kupferstiche. Besonders seine Rekonstruktion der Mamière-Noir-Technik für die Kunst der Moderne machten ihn weltberühmt. Das Museum erwarb seit 1972 in regelmäßigen Abständen in Kooperation mit dem Künstler Arbeiten seines Œvres, die der Künstler besonders schätzte und noch selbst auswählte. So entstand eine Sammlung, die einen Überblick auf das gesamte kreative Schaffen Hasegawas bietet. Das Museum besitzt derzeit insgesamt 180 Arbeiten, die auch fünf Ölgemälde und zwölf Zeichnungen einschließen.

Westliche Kunst der Moderne

Auch wenn die Sammlung in diesem Bereich noch sehr begrenzt ist, besitzt das Museum herausragende Arbeiten von Künstlern, die einen besonders großen Einfluss auf die Entwicklung der Kunst der Moderne in Japan ausübten. Darunter befinden sich unter anderem Arbeiten von Matisse, Picasso, Mondrian, Hannah Höch, Ernst und Schwitters. Besonders hervorzuheben ist eine vollständige Ausgabe der Edition Schwarz von Marcel Duchamps Ready-mades.

FOTOGRAFIE

Im Herbst 1986 stiftete die Firma Kyocera dem Museum eine umfassende, aus 1050 Blättern bestehende Fotografiesammlung, die von dem in Chicago ansässigen Fotografen Arnold Gilbert und seiner Frau über einen Zeitraum von 20 Jahren aufgebaut worden war. Die Gilbert Collection enthält eine Vielzahl repräsentativer Arbeiten von Meistern der modernen Fotografiegeschichte, wie etwa Ansel Adams, Cartier-Bresson oder Edward Weston. Bei fast allen Arbeiten handelt es sich um Originalabzüge aus der Hand der beiden Fotografen. Im Jahr 1993 erhielt das Museum eine weitere Stiftung, bestehend aus 261 Arbeiten von Yasuzô Nojima (1889–1964), einem der repräsentativen Fotografen der modernen japanischen Fotografie. Diese Schenkung war von den Nachlassverwaltern angewiesen worden, die sich für die Erhaltung von Nojimas Arbeiten einsetzten. Darüber hinaus kaufte das Museum nach und nach Arbeiten des berühmten Pressefotografen Eugen Smith an, so dass die Fotografiesammlung derzeit auf eine ausgewogene Zahl von 1479 Arbeiten angewachsen ist.

„DESIGN" IM NATIONAL MUSEUM OF MODERN ART, KYOTO

Hermann Muthesius, der sich gegen Ende des 19. Jahrhunderts dienstlich in Tokyo aufhielt und seine Sommerferien zu einer Reise nach Kyoto genutzt hatte, schrieb 1889 in einem Brief an seine Eltern: „Was mich aber an Kioto am meisten interessierte, sind die vielen Kunst- und Industriezweige, die dort blühen."[5] Kyoto stellte über viele Jahrhunderte das handwerkliche Zentrum Japans dar, in dem vielfältige Formen des Kunsthandwerks hergestellt wurden. Aufgrund dieser Tradition veranstaltet das Museum seit seiner Gründung zahlreiche Ausstellungen zu den Bereichen Kunsthandwerk und Design. Bereits im Gründungsjahr problematisierte etwa die Ausstellung „Exibition of Contemporary Industrial Arts and Crafts" das Thema Kunsthandwerk. In den Jahren 1965 / 66 stellte die Ausstellung „Living Art Today" die Entwicklungen in der Design-Reformbewegung nach dem Zweiten Weltkrieg in Amerika und Europa vor. 1975 wurde in Zusammenarbeit mit dem Metropolitan Museum of Art in New York die Ausstellung „Inventive Clothes 1907-1939" entwickelt, die das Problem von Kleidung und Schmuck innerhalb der Moderne behandelt, das sich von der traditionellen japanischen Textilgeschichte des Kimonos wesentlich unterscheidet.
Auch wenn dem traditionellen Kunsthandwerk Japans ein hoher Wert beigemessen wurde, stellte man es stets unter der Voraussetzung von „Gebrauch" her. In diesem Sinne könnte man die Sammlung von Kunsthandwerk der japanischen Moderne auch als Design-Sammlung bezeichnen.

Eine Vielzahl der im Museum gesammelten Arbeiten jedoch entstand nicht im Zusammenhang von Manufakturen. Diese Tatsache steht im Widerspruch zu Kyoto als industriellem Produktionszentrum von Kunsthandwerk. Auf welche Weise die Abgrenzungen und Überschneidungen der sich in der Moderne herausbildenden drei Bereiche „Kunst", „Kunsthandwerk" und „Design" in diesem Kontext zu interpretieren sind, stellt einen Problemkomplex dar, mit dem sich das Museum im Zusammenhang mit „Design" auseinander zu setzen hat.

Y. I.

1 Beim ersten Museum für Moderne Kunst in Japan handelt es sich um das Museum of Modern Art, Kamakura (gegründet 1951). Darauf folgte die Errichtung eines zweiten Museums, des National Museum of Modern Art, Tokyo (gegründet 1952).
2 Tatsächlich beschloss man daraufhin die Errichtung eines Museums für die Sammlung Matsukata in der japanischen Hauptstadt. Untergebracht in einem von Le Corbusier entworfenem Bau öffnete es als The National Museum of Western Art in Tokyo mit seiner Sammlung von westlicher Kunst des Mittelalters bis zum Impressionismus 1959 seine Tore und besteht in dieser Form bis heute.
3 Die Nationalmuseen, die Kunst und Kunsthandwerk Japans bis zur Moderne sammeln, entstanden 1872 in Tokyo, 1889 in Kyoto und 1889 in Nara.
4 Darüber hinaus wurden die drei Museen für japanische Kunst, das Tokyo National Museum, das Kyoto National Museum und das Nara National Museum, in eine Verwaltungseinheit, der unabhängigen Körperschaft der Staatlichen Museen, integriert.
5 Brief an die Eltern, 3. September 1889. In: Copy Book, Blatt 166, Muthesius-Nachlass, Werkbund-Archiv, Museum der Dinge, Berlin.

HISTORY OF THE MUSEUM

ORIGINS

The National Museum of Modern Art, Kyoto, was the third museum for modern art in Japan.[1] However, the circumstances which led to the founding of the museum were rather complicated. In 1953, one year after the opening of the National Museum of Modern Art, Tokyo, the French government returned Kôjirô Matsukata's (1865–1950) collection of Western art to Japan. The collection began with Impressionist art and had been accumulated before World War II. In the peace treaty signed in San Francisco in 1951, this collection temporarily became the property of the French government. When the collection was returned, the mayor of Kyoto took advantage of the situation by undertaking to found a museum in Kyoto which would house the collection. The museum did not materialize because the French government wanted the collection to go to a museum in the capital, Tokyo.[2] The city of Kyoto then decided to change its original plans for a museum of modern art and decided to found a branch of the National Museum of Modern Art, Tokyo. In 1963, this plan was finally realized.[3]

In 1962, the city of Kyoto renovated a building adjacent to the Kyoto Exhibition Hall in Okazaki Park where the Heian Shrine is located. The building was provided to the state free of charge. On March 1, 1963, the Kyoto branch of the National Museum of Modern Art, Tokyo was opened. On April 27 of the same year, the first exhibitions, "Contemporary Japanese Ceramic Art" and "Trends in Contemporary Japanese Painting", were opened. Four years later, in 1967, the branch museum was converted into the independent National Museum of Modern Art, Kyoto

This building proved not to have sufficient exhibition space and storage area. The need for a more suitable site had been obvious ever since the museum opened. Although the funds to define the requirements for the building of a new museum were approved in 1972 and an architect was appointed one year later, it took more than ten years before the new building was actually constructed. The building used by the branch museum was closed and torn down in 1984. After archaeological investigations of the building site, the present building – which was designed by Maki Fumihiko (b. 1928) – was finally opened on September 15, 1986 . The ceremonies to conclude the construction and inaugurate the building took place on October 25th. On the next day, the new museum opened its doors with the exhibition "Nihon-ga, Kyoto School 1910–1930". Simultaneously, the urgently needed rooms for the permanent collection were commissioned.

As part of its administrative reform measures, the Japanese government introduced a new system of independent corporate administration in 1996. Since April 1, 2001 the National Museum of Modern Art, Kyoto, the National Museum of Modern Art, Tokyo, the National Museum of Western Art, Tokyo and the National Museum of Art, Osaka have been part of the same administrative unit. The museum now carries on its work as part of the independent Corporation of National Art Museums.[4]

ORGANIZATIONAL STRUCTURE

Since becoming a public corporation in 2001, the General Director Museums is solely responsible for the affairs of all museums, whose administrative head office is now the National Museum of Modern Art, Tokyo. Each museum has remained responsible for its actual work, however. In the National Museum of Modern Art, Kyoto, there are six curators who are accountable to the head of the curator's department. He, in turn, is accountable to the Museum Director. Together, they are responsible for the conceptual and organizational side to exhibitions as well as for maintaining the collection.

LOCATION OF THE MUSEUM AND SURROUNDING AREA

The National Museum of Modern Art, Kyoto, is located in a corner of Okazaki Park, to the east of the center of Kyoto. The temple complexes Nazen-ji and Eikan-dô are located in this park very near to Higashiyama. The temples Shôren'in and Chion'in are in the south and the temple complex Shôgoin as well as the campus of Kyoto University are located in the north. In addition to the Heian Shrine, the park is also home to various cultural institutions including the Kyoto Prefecture Library, Kyoto Hall, Kyoto Municipal Museum of Art (built in 1933) and the Kyoto City Zoo.

A canal which is fed by Lake Biwa flows through the park. Cherry trees blossoming on its banks in the spring and the colors of the autumn foliage in the nearby Higashiyama region give this complex its natural charm.

On the ground floor of the museum building are an entry hall which extends to the roof of the building, the foyer, a café, the museum shop, a lecture hall and the general administrative offices. The offices of the director and the curators are on the second floor. Special exhibitions take place on the third floor and the fourth floor houses the permanent collection. Each year, approximately eight special exhibitions take place. The items on exhibit in the permanent collection are changed five to nine times per year depending on the theme and the season. Storage facilities as well as the units for heat and air-conditioning are located in the cellar.

THE MUSEUM'S FOCUS
The National Museum of Modern Art, Kyoto, perceives its function to be to explore and categorize the history of Modern art and examine its ongoing links to the present. In addition, the museum endeavors to arrange and carry out activities which will contribute to the future development of art. This aspect of the museum's work encompasses the broad fields of painting, prints, sculpture, arts and crafts, architecture and design, as well as photography and film. The proper management of so many fields of modern art by one museum is a challenging job. Another basic goal of the museum is to promote the arts in all of Japan, i.e., not to limit itself to one particular region. Furthermore, it is our opinion that it is the duty of any museum of modern art to enhance cross-cultural understanding through the use of modern and contemporary art.

With this in mind, we have established the following focal areas at the Museum of Modern Art, Kyoto: Firstly, we concentrate on "art of the Modern period", i.e., art and handicrafts from the time after the Meiji Restoration in 1868 until the present. Secondly, we place an emphasis on handicrafts. This was an important theme for the museum when it was a branch of the National Museum of Modern Art, Tokyo and it is still a matter of considerable importance for the city of Kyoto. Thirdly, without ignoring developments in Modern art from all over Japan, we place special emphasis on artists from the region of Kansai. We are especially interested in reviewing developments in Modern art in the Kyoto region and elaborating its future prospects. An additional emphasis is on understanding tendencies for change in the field of contemporary art from an international point of view. Finally, we are interested in various fields of art from different regions and in particular how they deal with the question of "modernity" and its repercussions.

THE COLLECTION
Every year the commission discusses the enlargement of the collection through acquisitions and donations. New items are chosen according to their suitability and the opportunities for research they will present. The results of investigations carried out by the museum are also considered. Currently, the museum possesses a total of 7,088 items (April 2002) which can be divided into the following categories:

HANDICRAFTS
Modern Japanese Handicrafts
For about 1,100 years (794-1868) Kyoto was the capital of Japan. Simultaneously, it was the center for the production of handicrafts. This had been a manifestation of the Imperial court and bourgeois culture since the Middle Ages and it is a tradition which continues to the present day. In light of the special characteristics of Kyoto, the museum collects representative modern handicrafts from the Kyoto area. These include ceramics, lacquer works and textiles.

HISTORY OF THE MUSEUM

Ceramics by Kanjirô Kawai (Kawakatsu Collection)
This collection was accumulated over many years by Ken´ichi Kawakatsu (born1892) and is considered representative of the life work of Kanjirô Kawai (1890-1966). It was donated to the museum by Ken´ichi Kawakatsu, who was a good friend of the artist while he was still living. Kanjirô Kawai was a central figure in the Popular Art Movement (Mingei undô) and he produced ceramics his entire life. Together with some later donations, the museum possesses a total of 424 pieces which it calls the Kawakatsu Collection.

Contemporary Handicrafts
Since the exhibition "International Exhibition of Contemporary Ceramic Art" in 1964, the museum regularly sponsors exhibitions of contemporary ceramics from Japan and overseas. A considerable collection of contemporary handicrafts has been accumulated through these exhibitions as well as from donations.

PAINTING AND DECORATIVE PRINTS
Modern Japanese Art
The museum collects paintings made using the traditional Japanese painting technique called Nihon-ga from the period after the Meiji Restoration. Emphasis is on works executed by painters who were active in the Kyoto art scene. Many of the artists who brought oil painting techniques from the West and further developed this style in Japan are from the Kansai region. Their work has a special place in the collection. The collection also includes contemporary art by artists including members of the Gutai group who were active after World War II. In addition, an important part of the collection is made up of Japanese decorative prints which include works by graphic artists from the field of Sôsaku hanga (creative prints) as well as contemporary decorative prints.

Works by Kiyoshi Hasegawa
Kiyoshi Hasegawa (1891-1980) was an artist who painted in addition to making decorative prints. He lived in France and was interested in various printing techniques. His most important works are his copper engravings. His modern versions of the Manière Noire technique made him famous all over the world. In cooperation with the artist himself, the museum regularly acquired examples of his work beginning in 1972. These pieces were chosen by the artist and they were works which he considered to be of special importance. In this way, the museum came to possess a collection which gives an overview of Hasegawa's œuvre. The collection consists of a total of 180 pieces which include five oil paintings and 12 drawings.

Western Modern Art
Even though the collection is somewhat limited in this field, the museum possesses a number of excellent works by artists who had a great influence on the development of modern art in Japan. Among them are works by Matisse, Picasso, Mondrian, Hannah Höch, Ernst and Schwitters. In this context, it is worth mentioning that the museum also possesses a complete copy of the Schwarz Edition of Marcel Duchamp's ready-mades.

PHOTOGRAPHY

In the autumn of 1986, the Kyocera company donated a comprehensive collection of photographs to the museum. The collection contains 1,050 photographs and had been compiled over 20 years by the US photographer Arnold Gilbert and his wife. The Gilbert collection contains representative works by many experts in the modern field of photography. Included are photos by Ansel Adams, Cartier-Bresson and Edward Weston. Most of the photographs are originals developed by the photographers in question. In 1993, the museum received an additional donation of 261 works by Yasuzô Nojima (1889-1964) who was one of the most representative photographers in modern Japan. This gift was authorized by Nojima's heirs who wanted to be sure that the photographer's work would be preserved. In addition, the museum has gradually acquired a number of works by well-known press photographer, Eugen Smith. The collection is well-balanced and has grown to 1,479 photographs.

"DESIGN" IN THE NATIONAL MUSEUM OF MODERN ART, KYOTO

Hermann Muthesius was in Tokyo on business at the end of the 19th century. He used his summer holiday to travel to Kyoto and in 1889 in a letter to his parents he wrote, "What interested me most about Kyoto is the way that art and industry are flourishing."[5] For many centuries, Kyoto was the center for arts and crafts in Japan. Many types of handicrafts were produced here. In light of this tradition, the museum has always sponsored many exhibitions in the fields of handicrafts and design. In the year the museum was founded, the Exhibition of Contemporary Industrial Arts and Crafts dealt with the subject of handicrafts. In the years 1965 and 1966 the exhibition "Living Art Today" presented developments in America and Europe in the design reform movement after World War II. In 1975, the exhibition "Inventive Clothes 1907-1939" was presented in cooperation with the Metropolitan Museum of Art in New York. The subject of this exhibition was modern clothing and jewelry and how these differed from the materials used for traditional Japanese kimonos.

Traditional handicrafts in Japan are highly valued and they always contain an element of "usefulness". In this respect, this handicrafts' collection which reflects Japanese modernity could also be described as a design collection.

Nevertheless, a large number of items that have been collected by the museum did not originate in a manufacturing context. This contradicts Kyoto's traditional claim to be a center for the industrial production of handicrafts. It poses a challenge for the museum to determine where the three fields of "art", "handicrafts" and "design" form clear boundaries and where they overlap today. The museum will have to try to find out how "design" fits into the picture.

Y. I.

1 The first museum of modern art in Japan was the Museum of Modern Art, Kamakura (founded in 1951). The second museum was the National Museum of Modern Art, Tokyo (founded in 1952).
2 It was indeed decided to build a museum in the Japanese capital for Matsukata's collection. In 1959, the National Museum of Western Art was opened in Tokyo with a collection of Western art ranging from the Medieval to Impressionism. It continues to exist in the same form today.
3 The national museums which collect Japanese art and handicrafts were founded in 1872 in Tokyo, in 1889 in Kyoto, and in 1889 in Nara.
4 In addition, the three museums for Japanese art, namely, the Tokyo National Museum, the Kyoto National Museum and the Nara National Museum were combined to form one administrative unit, the independent Corporation of National Museums.
5 Letter to his parents, September 3, 1889. In: Copy Book, sheet 166, Muthesius-Nachlass (Werkbund-Archiv, Museum der Dinge, Berlin).

Leipzig

Museum für Kunsthandwerk / Grassimuseum Leipzig
www.grassimuseum.de

COLLECTION

Museum für Kunsthandwerk / Grassimuseum Leipzig

DESIGNER / ARCHITECT

Ludwig Mies van der Rohe

OBJECT

Chair / Sessel 'MR 90 / Barcelona'

DATE

1929 / 1930

MANUFACTURER

Berliner Metallgewerbe Joseph Müller (1929-30) or / oder
Bamberg Metallwerkstätten Berlin-Neukölln (ca. 1931)

Museum für Kunsthandwerk / Grassimuseum Leipzig

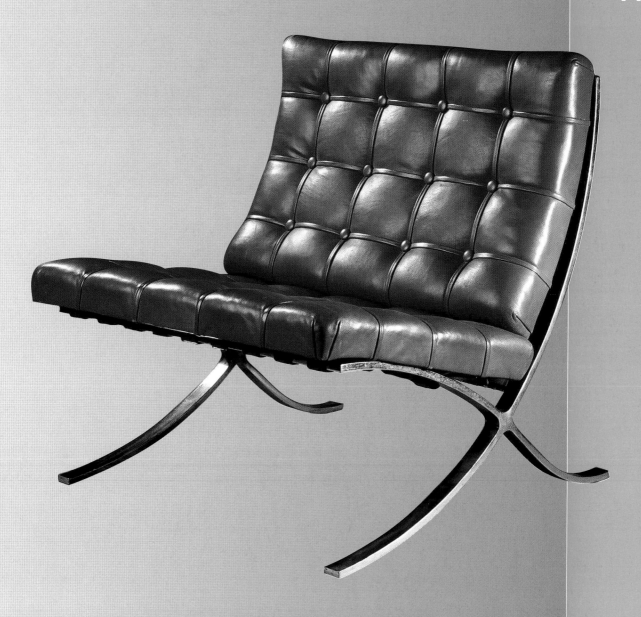

GESCHICHTE DES MUSEUMS

Als das Leipziger Kunstgewerbemuseum nach langjähriger Vorgeschichte 1874 eröffnet wurde, hatte es sich auf die Fahne geschrieben „gegen den alten Schlendrian und die klägliche Mittelmäßigkeit" der deutschen Industrie und des Handwerks zu Felde zu ziehen. Als typische Vorbildersammlung für Handwerk und Gewerbe zielte es auf die „Hebung des Geschmacks" und richtete sich auf das Studium der als nachahmenswert angesehenen „Werke der Väter". Im Jahre 1896 fand das bis dahin bescheiden untergebrachte Museum in einem nach dem Leipziger Bankier und Stifter Franz Dominic Grassi benannten Neubau im Stil der italienischen Hochrenaissance am Königsplatz, dem späteren Wilhelm-Leuschner-Platz, ein repräsentatives Domizil. Getragen und gefördert von der Elite der Leipziger Bürgerschaft entwickelte es sich unter der Leitung von Richard Graul rasch zu einem der führenden Kunstgewerbemuseen in Deutschland.

Die auf Weltausstellungen und großen Auktionen, aus privatem und städtischem Besitz sowie aus künstlerischen Werkstätten und Manufakturen erworbenen Sammlungen — vorwiegend aus dem europäischen, aber auch aus dem ost- und vorderasiatischen Raum — legen Zeugnis ab von bürgerlichem Selbstbewusstsein und Bildungsstreben in der traditionsreichen Handels- und Verlagsmetropole.

Während sich die meisten vergleichbaren Museen zu Beginn des 20. Jahrhunderts aus ihrer aktiven Rolle bei der Qualitätsvermittlung und der Förderung der zeitgenössischen Handwerks- und Industrieproduktion mehr und mehr zurückzogen, baute das Leipziger Kunstgewerbemuseum seine Position in diese Richtung kontinuierlich aus.

Nach seinem Eintreten für die Reformbewegung des Jugendstils unterstützte es in der Folgezeit Bestrebungen des Deutschen Werkbundes, die u. a. auf Materialgerechtigkeit, Zweckmäßigkeit und die schöpferische Wechselwirkung von Einzelstück und Serienprodukt gerichtet waren. Um der Forderung nach der „guten Form für alle" Nachdruck zu verleihen und Qualitätsmaßstäbe zu setzen, nutzte das Museum die Besonderheit der Messestadt.

Als Gegenpol zu den rein kommerziell ausgerichteten Leipziger Mustermessen begründete das Museum 1920 eine eigenständige Messeausstellung, die als „Grassimesse" in die Geschichte einging. Nach strengen Auswahlprinzipien wurden hier „erlesene Arbeiten des Handwerks und der Manufaktur" sowie hervorragende Industrieerzeugnisse der Öffentlichkeit vorgestellt. „Grassi" wurde zum Qualitätsbegriff und erlangte Weltgeltung.

Um dem zunehmenden Raumbedürfnis der Sammlungen und der zweimal jährlich stattfindenden Grassimesse gerecht zu werden, erfolgte von 1925 bis 1929 der Bau des „Neuen Grassimuseums" am Johannisplatz, in das auch die Museen für Völker- und Länderkunde und das neu gegründete Musikinstrumenten-Museum einzogen. Der heute denkmalgeschützte Gebäudekomplex, ein typisches Beispiel der Architektur der 1920er Jahre, verbindet funktionale Sachlichkeit mit Schmuckelementen des Art déco. Führende Künstler wie z. B. der Bauhausmeister Josef Albers wirkten an seiner Ausstattung mit. Der Zweite Weltkrieg brachte für die Arbeit des Museums gravierende Einschnitte. 1942 wurde der Großteil der Bestände ausgelagert. Das Haus selbst erlitt bei zwei Bombenangriffen schwere Zerstörungen. Nach einem verändernden und provisorischen Wiederaufbau konnte 1952 ein kleiner Teil der Schauräume wiedereröffnet werden. In den Jahren danach richtete sich eine Reihe von Sonderausstellungen insbesondere auf die Produktkultur des 20. Jahrhunderts. Der bauliche Verfall des Gebäudes schritt indessen soweit voran, dass die verbliebenen Räume der ständigen Ausstellung 1982 komplett geschlossen werden mussten.

Erst 1994 konnte in fünf neu ausgestatteten Schauräumen wieder ein kleiner Teil der Sammlungen öffentlich zugänglich gemacht werden. Trotz des maroden Bauzustandes und der mangelhaften Infrastruktur gelang es dem Museum seit 1990, seinen internationalen Ruf mit thematischen Sonderausstellungen zu historischen und zeitgenössischen Themen sowohl im Bereich der Unikatgestaltung als auch der internationalen Designgeschichte zurückzugewinnen und weiter auszubauen.

1998 wurde durch die Stadt Leipzig und den Freistaat Sachsen der Beschluss zur Sanierung des Grassimuseums gefasst. Zu Beginn des Jahres 2001 bezogen alle drei unter dem Dach des umfangreichen Gebäudekomplexes ansässigen Museen verschiedene Interimsunterkünfte. Das Museum für Kunsthandwerk führt seither sein Ausstellungs- und Veranstaltungsprogramm auf beschränkter Fläche in der Innenstadt fort.

Nach rund 40jähriger Unterbrechung gelang es 1997, die Grassimesse als Forum für zeitgenössisches Kunsthandwerk und Design mit großem, inzwischen internationalem Zuspruch neu zu etablieren. Anlässlich der Grassimesse werden jährlich vier Preise vergeben.

Voraussichtlich ab Mitte 2004 wird der Wiedereinzug in das traditionsreiche Museumsgebäude am Johannisplatz beginnen. Dort wird das Museum für Kunsthandwerk über insgesamt rund 4.000 qm Ausstellungsfläche für die Präsentation seiner Sammlungen und für die Ausrichtung von Sonderausstellungen verfügen.

2001 wurde das Grassimuseum auf Grund des internationalen Ranges seiner Sammlungen, seiner kulturellen und wissenschaftlichen Arbeit und der Einmaligkeit des Bauensembles vom Beauftragten für Kultur und Medien der Bundesregierung in die Liste besonders förderwürdiger „Kultureller Leuchttürme" Ostdeutschlands in das sogenannte „Blaubuch" aufgenommen.

E. M. H.

HISTORY OF THE MUSEUM

The Museum für Kunsthandwerk in Leipzig was opened in 1874. It chose as the words for the banner over its activities: "going to the front 'to fight the archaic ways and pathetic mediocrity' of German industry and handicrafts". In those days, a typical exhibition served to "elevate taste" and point toward the study of what was considered to be the exemplary "work of our fathers". In 1896, the museum moved to a representative new building in the style of the Italian High Renaissance and located on Königsplatz (later known as Wilhelm Leuschner Platz). It was named after Franz Dominic Grassi, a banker and philanthropist from Leipzig. The museum was maintained and supported by the leading lights of Leipzig society and under the curatorship of Richard Graul it quickly emerged as one of the leading museums of applied arts in Germany.

World-class exhibitions and grand auctions mostly concentrated on European art but there were also works from East Asia and the Near East. Artefacts came from private and municipal sources as well as collections purchased from artistic studios and manufacturers. They bear witness to the civil consciousness and desire for education in this city which is rich in the traditions of trade and publishing.

At the beginning of the 20th century, most comparable museums were no longer taking an active role in promoting contemporary handicrafts and industrial products. The Leipzig Museum für Kunsthandwerk, however, continued to enlarge its collection during this period.

After participating in the Art Nouveau reform movement, the museum supported the efforts of the Deutscher Werkbund which – among other things – strived to ensure the appropriate use of materials as well as for suitable designs and creative interaction between the manufacture of individual items and mass production. In order to bolster demands for "good style for everyone" and to set quality standards, the museum took advantage of Leipzig's special role as a trade fair city.

As a counterbalance to the purely commercial trade fairs in Leipzig, the museum founded its own trade fair exhibition in 1920. This went down in history as the "Grassi Trade Fair". "Top quality handcrafted and manufactured goods" as well as excellent industrial products which had been selected according to strict principles, were presented to the public. "Grassi" became a symbol of quality and achieved worldwide fame.

In order to meet the need for more space for its collections as well as to provide a venue for the biannual Grassi Trade Fair, the Neuen Grassi-museums on Johannisplatz was built from 1925-1929. It also housed the Museum of Ethnology and Geography as well as the newly founded Museum of Musical Instruments. The complex of buildings is under a preservation order. It is typical of the architecture of the 1920s. It combines functional objectivity with ornamental elements of Art Deco. Leading artists, such as Bauhaus expert, Josef Albers, contributed to its construction.

World War II brought grave consequences for the museum's work. In 1942, most of the contents of the museum were stored away for safe keeping. The building itself was badly damaged in two bomb attacks. After makeshift reconstruction, a small number of exhibition rooms were reopened in 1952. In the following years, a series of special exhibitions were held concentrating on 20th century consumer culture. By 1982, the building had become so dilapidated that the permanent collection had to be completely closed.

It was not until 1994 that a small portion of the collection could be reopened in five newly furbished exhibition rooms. In spite of the poor condition of the building and the unsatisfactory infrastructure in general, since 1990, the museum has worked hard to regain its international reputation with special exhibitions on historical and contemporary themes as well as in the fields of the design of unique items and the history of international design.

In 1998, the City of Leipzig and the Free State of Saxony reached an agreement on renovation of the Grassi Museum. At the beginning of 2001, each of the three museums located in the complex moved to temporary quarters. Since then, the Museum für Kunsthandwerk has continued to carry out its programme of exhibitions and events in a smaller space in the city centre.

Following an interruption of about 40 years, the Grassi Trade Fair was able to re-establish itself as a forum for contemporary handicrafts and design in 1997. This has met with international acclaim. During the Grassi Trade Fair, four prizes are awarded.

As of about mid-2004, the museum will start to move back to its traditional building on Johannisplatz. It will then have approximately 4 000 square meters of space available for the presentation of its permanent collections and special exhibits.

In 2001, the Federal Bureau of Culture and Media added the Grassi Museum to the so-called "blue book" list of "cultural flagships" in east Germany which are particularly worthy of support: thanks to its contributions to culture and scholarship as well as to the uniqueness of its building complex.

E. M. H.

London

Victoria & Albert Museum
www.vam.ac.uk

COLLECTION

Victoria & Albert Museum

DESIGNER / ARCHITECT

Stephen Richards

OBJECT

Chair / Stuhl 'Storm'

DATE

2000

MANUFACTURER

Stephen Richards

Victoria & Albert Museum, London

GESCHICHTE DES MUSEUMS

Das Victoria & Museum (V&A) wurde 1852 gegründet als Antwort auf eine Bewegung, die es sich zum Ziel gemacht hatte, die Qualität des Designs in Großbritannien zu verbessern. In den 30er Jahren des 19. Jahrhunderts wurde Großbritannien zur Freihandelszone und mit dem verstärkten Wettbewerb aus anderen Ländern, insbesondere den hochqualitativen Gütern aus Frankreich, wurden sich die Regierung und Hersteller zunehmend der Tatsache bewusst, dass es einen gewissen ökonomischen Druck gab, britische Produkte für den Markt attraktiver zu gestalten. Ein Regierungsausschuss befasste sich 1835 mit der Bedeutung der Beziehung von Kunst und Industrie. Die Regierung initiierte verschiedene Maßnahmen, um die Situation zu verbessern und 1836 wurde in diesem Rahmen die erste Staatliche Kunstgewerbeschule in London gegründet, in den 40er Jahren des 19. Jahrhunderts folgten weitere Schulen in anderen Städten des Landes. Prinz Albert von Sachsen-Coburg, der Gemahl von Königin Victoria, engagierte sich ganz besonders für diese Vorhaben. Er versammelte um sich eine Schar von Beratern, die die Agenda der Kunstgewerbereform auf unterschiedliche Weise vorantrieb. Um Herstellern, Entwerfern und der Öffentlichkeit die Möglichkeit zu bieten, britische Produkte mit denen anderer Länder vergleichen zu können, wurde 1851 die erste große internationale Weltausstellung in Joseph Paxtons Kristallpalast im Hyde Park veranstaltet. Im darauf folgenden Jahr, 1852, wurde das Museum of Manufactures (auch Museum of Ornamental Art genannt) gegründet, dem auch die Kunstgewerbeschule angeschlossen war. Die Konzeption des Museums berief sich deutlich auf die Reformansätze. Die ihm zugedachte pädagogische und didaktische Rolle wurde in enger Verbindung zur angeschlossenen Schule gesehen.

Zu den ersten Ankäufen des Museums gehörten neue Produkte von der Weltausstellung, die angesichts der Eröffnung des Museums im darauf folgenden Jahr erworben wurden als auch historische und zeitgenössische Objekte, die in früheren Jahren für die Studenten der Kunstgewerbeschule als Anschauungsbeispiele zusammen getragen wurden. Henry Cole, einer der Hauptorganisatoren der Weltausstellung, wurde der Direktor der Abteilung für angewandte Kunst des staatlichen Ressorts für Kunsterziehung. Das neue Museum war Teil seines Aufgabenbereichs und es war zuerst im Gebäude des Ressorts untergebracht. 1857 wurde das Museum an den heutigen Standort verlegt und in South Kensington Museum umbenannt. Erst 1899 erhielt es den Namen Victoria and Albert Museum.

Henry Cole glaubte fest an die Rolle des Museums als einer Institution mit Bildungsauftrag. Seiner Überzeugung nach sollte dessen Einfluss ein so breit wie möglich gefächertes Publikum erreichen. In einer beispiellosen Aktion und gegen einige Widerstände öffnete er das V&A an Sonntagen und Abenden, um den Angehörigen der Arbeiterklasse den Museumsbesuch zu ermöglichen. Ab 1866 sorgte er zudem für die Eröffnung von Restaurants ('Refreshment Rooms'), eines davon wurde von William Morris entworfen und von seiner Firma ausgeführt. Sein Ziel war es, die Formgebung britischer Produkte aus künstlerischer Sicht zu verbessern, indem er Studenten, Kunsthandwerkern, Designern und Herstellern Beispiele des besten historischen und zeitgenössischen Kunstgewerbes vor Augen führte. Durch deren geschmackspädagogische Schulung erhoffte er sich eine Verbesserung des Geschmacks der breiten Öffentlichkeit. Coles Initiative fand Nachahmer in der ganzen Welt, vom Museum für angewandte Kunst in Wien bis zum Metropolitan Museum of Art, die nach dem direkten Vorbild des V&A gegründet wurden. Es gibt kein Museum, dass in seinem Ansatz öfter kopiert wurde als das V&A. Nach Coles Pensionierung im Jahr 1873 waren seine Nachfolger weniger darum bemüht, neue Objekte zu sammeln, sondern trugen schwerpunktmäßig eine enzyklopädische Sammlung angewandter und in einigen Kategorien auch bildender Kunst, hier insbesondere Skulpturen, zusammen. Obwohl auch Cole herausragende Beispiele kunsthandwerklicher Objekte vom späten Mittelalter bis zum 18. Jahrhundert gesammelt hatte, verband er dies immer auch mit dem Erwerb zeitgenössischer Objekte. Seine Nachfolger konzentrierten sich lediglich auf die Vergangenheit. Zwischen dem 19. Jahrhundert und 1960 erfolgte der Erwerb zeitgenössischer Objekte nur episodisch. Auch wenn das Museum eine umfangreiche Schenkung von Art Nouveau Exponaten nach der Pariser Weltausstellung von 1900 übertragen bekam und im allgemeinen zeitgenössische Grafiken und Plakate sammelte, galt die Priorität nicht länger dem Aufbau einer zeitgenössischen Sammlung. 1960 schließlich setzte sich die Abteilung, die für die Ausstellungszirkulation im Land verantwortlich war, dafür ein, dass man an das ursprüngliche Engagement des Museums anknüpfte, zeitgenössisches Design zu sammeln; dies wurde in den folgenden Jahrzehnten entsprechend ausgeweitet.

Das heutige V&A fühlt sich der Auffassung Henry Coles tief verpflichtet, dass ein Museum einen grundlegenden Bildungsauftrag zu erfüllen hat, indem es einem breiten Publikum gewidmet ist und in Coles Sinne den Schwerpunkt des Interesses auf zeitgenössischem Design legt, wie es heute entwickelt und verkauft wird. Eine erneute Bestätigung dieses Konzepts ergab sich durch Forschungsarbeiten zur Geschichte des V&A in den achtziger und frühen neunziger Jahren sowie aus dem Bestreben, den Bedürfnissen von Studenten und Professionellen aus dem Kunst- und Designbereich – das heißt denjenigen, die dem zeitgenössischen Design Gestalt geben – nachzukommen. Während sich das V&A nicht länger als eine Institution sieht, die die Öffentlichkeit zwischen ‚gutem' und ‚schlechtem' Geschmack zu unterscheiden lehrt – zumindest nicht im Rahmen dieser Begrifflichkeit –, werden jedoch immer noch Objekte gesammelt, die hinsichtlich der Geschmacksfrage eine Vorreiterposition einnehmen, anstatt einer ästhetischen Vorgabe lediglich zu folgen. Es werden Kunst- und Designobjekte zu allen wichtigen künstlerischen Strömungen gesammelt, so aus Europa (ab 300 n. Chr.), aus Asien (alle Perioden), Nordamerika (nach der europä-ischen Besiedelung) und in geringerem Umfang auch aus Australasien: Möbel, Textilien, Mode, Keramik, Glas, Metallarbeiten, Skulpturen (hauptsächlich vor 1914), Grafiken, Grafikdesign, Zeichnungen, Gemälde, Fotografie, Entwurfszeichnungen und Modelle, Tapeten, Bücher und in vielen, aber nicht allen Kategorien, Produktdesign. Hinter dieser Auflistung verbirgt sich der Geist der ehemaligen pädagogischen Abteilung der Staatlichen Kunstgewerbeschule, mit dessen viktorianischem Erbe das V&A zugleich kämpft aber aus ihm auch Inspiration zieht. Während der Erwerb von historischen Objekten größere öffentliche Aufmerksamkeit erfährt und eine intensivere Finanzierung erfordert, handelt es sich bei den meisten Ankäufen durch das V&A um zeitgenössische Objekte. Dies ist seit einigen Jahren der Fall und das Ergebnis einer bewusst strategischen Entscheidung.

Die Sammlung der Gegenwart des V&A bildet mit den ausgestellten historischen Objekten ein zeitliches Kontinuum. Die Verbindung zwischen modernen Objekten und einer großen historischen Sammlung bietet einen Rahmen, der sich wesentlich von Institutionen unterscheidet, die lediglich mit modernen oder zeitgenössischen Exponaten befasst sind. Die ästhetischen, technischen und historischen Kriterien, die für die Sammlung historischer Objekte zugrunde gelegt werden – insbesondere mit der Betonung der Geschichte ihrer Provenienz –, sind so weit wie möglich auf zeitgenössische Ankäufe übertragen worden. Das V&A erwirbt regelmäßig Objekte direkt von Designern, Ausstellern, Künstlern, Herstellern und Einzelhändlern, um jeweils das Neueste aus Design und Kunst zeigen zu können und um eine gleichgewichtete Sammlung aufrechtzuerhalten. Durch den Ankauf sowie die Ausstellung und Erforschung historischer Objekte wird diese zusätzlich komplettiert, die dank ihres Lebens als gekaufte und benutzte Objekte eine entsprechend facettenreichere Geschichte besitzen. Bei historischen Objekten sind es oftmals die damaligen Berichte, das Wissen über die Umstände ihrer Besitzer, einschließlich der gesellschaftlichen, kulturellen und ökonomischen Zusammenhänge, die so wertvoll sind. Es ist völlig angemessen, für das Sammeln neuer oder aus jüngster Zeit stammender Objekte, die gleichen Rahmenbedingungen zugrunde zu legen. Das V&A verfügt über einen Ausstellungsbereich, der der Gegenwart gewidmet ist und in dem Ausstellungen gezeigt wurden wie „Milan in a Van" (die neuesten Möbel, direkt von der Mailänder Möbelmesse 2002 entliehen) und „Give and Take" (Interventionen zeitgenössischer Künstler in den Galerien des V&A). Mit dem Programm „Fashion in Motion" werden regelmäßig Modenschauen im Museum veranstaltet. Die derzeitige Ausstellung zur Gegenwart (bis Januar 2005) heißt „Zoomorphic" und untersucht die Verwendung tierischer Formen in der zeitgenössischen Architektur.

Im Rahmen des Engagements des V&A für das Design der Gegenwart entsteht der von Daniel Libeskind entworfene Erweiterungsbau in Form einer Spirale für das V&A, ein Gebäude, das ganz dem zeitgenössischen Design und Kunsthandwerk, der Mode, Fotografie und Architektur sowie den grafischen Kunstrichtungen gewidmet ist. Die Spirale ist mit ihrer dramatischen Struktur und der Verkleidung aus von Hand gefertigten, glänzenden Fliesen ein anschauliches Beispiel hochmodernen Designs und ausdrucksstarkes Symbol für das Engagement des V&A, das das Beste aus Design und Kunst der Gegenwart zu unterstützen weiß. Wie zu Zeiten Henry Coles ist die äußere Gestaltung des Museums selbst auch heute wieder ein Mittel, die Debatte und die zeitgenössische Praxis zu befruchten.

C. W.

HISTORY OF THE MUSEUM

The Victoria & Albert Museum (V&A) was founded in 1852 as a direct response to the movement to improve the quality of design in Britain. In the 1830s, Britain had become a free-trade nation and, with increased competition from abroad, especially from high-quality French goods, government and manufacturers gradually came to realize that there was an economic imperative to make British products more saleable. In 1835, a parliamentary committee discussed the importance of "the connection between arts and manufactures". The government began a series of actions to improve the state of affairs and, in 1836, the first Government School of Design was founded in London, followed, in the 1840s, by schools in other regional cities. Prince Albert of Saxe-Coburg, consort of Queen Victoria, was significantly active in this enterprise. He gathered round him a circle of advisers who pushed forward the design reform agenda in a variety of ways.

In an effort to allow British manufacturers, designers and the public to see Britain's manufactures in relation to a range of goods made in other countries, The Great Exhibition of the Works of Industry of all Nations opened in 1851 in Joseph Paxton's Crystal Palace in Hyde Park. In the following year, 1852, the Museum of Manufactures (also called the Museum of Ornamental Art) was founded, incorporating the School of Design. The museum was clearly based on reforming principles. The educational and didactic role intended for it was clearly signalled by its close association with the School of Design.

The Museum's first acquisitions included new goods selected from the Great Exhibition, purchased in anticipation of the museum's opening the following year, as well as historical and contemporary objects collected in previous years for the Schools of Design as exemplars to the students. One of the key organisers of the Great Exhibition, Henry Cole, became the first General Superintendent of the Department of Practical Art, the government body responsible for art education. The new museum was part of its remit and it was in the Department's building that the new museum was first located. In 1857 the museum moved to its current site and was re-named the South Kensington Museum. It was only in 1899 that it received its new name as the Victoria and Albert Museum.

Henry Cole believed passionately in the museum's role as a institution of public education. He believed that its influence should reach the widest possible audience. In an unprecedented move, and against some opposition, he opened the V&A on Sundays and in the evenings, to enable working class people to visit. He included restaurants ("refreshment rooms") from 1866, one designed by William Morris's young firm. His main aims was to improve the design of British goods from an artistic perspective by showing examples of the very best of historical and contemporary design and craftsmanship to students, artisans, designers and manufacturers. He felt that if their taste and knowledge could be improved, public taste as a whole would be raised.

Cole's enterprise was influential throughout the world with many institutions, from Vienna's Museum für angewandte Kunst to New York's Metropolitan Museum of Art, founded in direct imitation of the V&A. No museum had spawned more imitators than the V&A.

After Cole's retirement in1873, his successors were less committed than he was to collecting new objects and the museum concentrated on forming an encyclopaedic collection of the decorative and, in some categories, the fine arts, sculpture especially. Though Cole had collected exquisite examples of decorative art from late Medieval through the 18th century, he had always combined this with collecting the present day. His successors concentrated only on the past. Between the late 19th century and 1960 the collecting of the contemporary was episodic. Though the museum accepted the gift of a large number of Art Nouveau objects from the Paris Exhibition of 1900, and generally collected contemporary prints and posters throughout the 20th century, the interest in contemporary collecting was no longer a priority. In the 1960s, the department responsible for sending exhibitions around Britain – the Circulation Department – renewed the museum's commitment to collecting recent design and this expanded substantially in the decades that followed.

The V&A of today is deeply committed to Henry Cole's vision of a museum devoted to public education, to the widest possible audience and to an emphasis on the contemporary – new designs made and sold today. The recent reaffirmation of that commitment resulted, in part, from a period of research into the history of the V&A in the 1980s and early 1990s and from the desire to address the needs of an unusually large audience of students and professionals in the art and design fields – to those who shape contemporary design.

While the V&A no longer views its role as one of educating public taste to discriminate between "good" or "bad" – at least not in those terms – it generally still collects objects which can be said to lead rather than follow taste. It aims to collect design and art from all the major artistic traditions of Europe (after 300 AD), Asia (from all periods), North America (after the European settlement) and, to a lesser extent, Australasia in the following categories: furniture, textiles, fashion, ceramics, glass, metalwork, sculpture (mainly before 1914), prints, graphic design, drawings, painting, photography, design drawings and models, wallpaper, books and, in many though not all categories, product design. This list carries with it the ghost of the original teaching departments of the Government School of Design as the V&A both struggles with and draws inspiration from its Victorian legacy.

While acquisitions of historical objects receive more publicity and require more funding, most of what the V&A collects is contemporary. This has been the case for some years, the result of a conscious policy decision.

The V&A's contemporary collections form a part of a continuum with the historical objects it displays. The link between modern objects and a great, historical collection provides a framework demonstrably different from institutions which deal only with the contemporary or with the modern. The aesthetic, technical and historical criteria used for collecting old things – especially an emphasis on a history of ownership – is extended as much as possible to contemporary acquisitions. While the V&A regularly acquires objects directly from designers, makers, artists, manufacturers and retailers – in order to exhibit for our public the very newest in design and art – it balances this with a desire to own, study and display objects which possess a richer, more multi-faceted history gained through life in the marketplace. With historical objects it is often the contemporary record, the knowledge of the circumstances of ownership including social, cultural and economic context, that is valued. It is entirely appropriate to use a similar framework for collecting recent and new things.

The V&A has a dedicated Contemporary Space which has hosted exhibitions including "Milan in a Van" (the newest furniture borrowed directly from the Milan furniture fair in 2002) and "Give and Take" (interventions by contemporary artists in the V&A galleries). A programme of "Fashion in Motion" regularly brings fashion shows into the museum itself. The current Contemporary exhibition (until January 2005) is "Zoomorphic", a display investigating the use of animal forms in contemporary architecture.

The V&A's commitment to contemporary design underlies plans to erect Daniel Liebeskind's "Spiral", a building devoted to contemporary design and crafts, fashion, photography, architecture and the graphic arts. Exemplifying the challenges of modern design, the Spiral, with its dramatic structure and glittering hand-crafted tile cladding, will be a powerful and highly visible symbol of the V&A's commitment to encourage and promote the best in contemporary design and art. As in the time of Henry Cole, the design of the museum itself is used once again as a means of encouraging debate and inspiring contemporary practice.

C. W.

Miami Beach

The Wolfsonian – Florida International University
www.wolfsonian.fiu.edu

COLLECTION

The Wolfsonian – Florida International University

DESIGNER / ARCHITECT

Paul Theodor Frankl

OBJECT

Bookcase / Bücherschrank 'Skyscraper'

DATE

1926

MANUFACTURER

Frankl Galleries, New York (?)

The Wolfsonian – Florida International University, Miami Beach, Florida

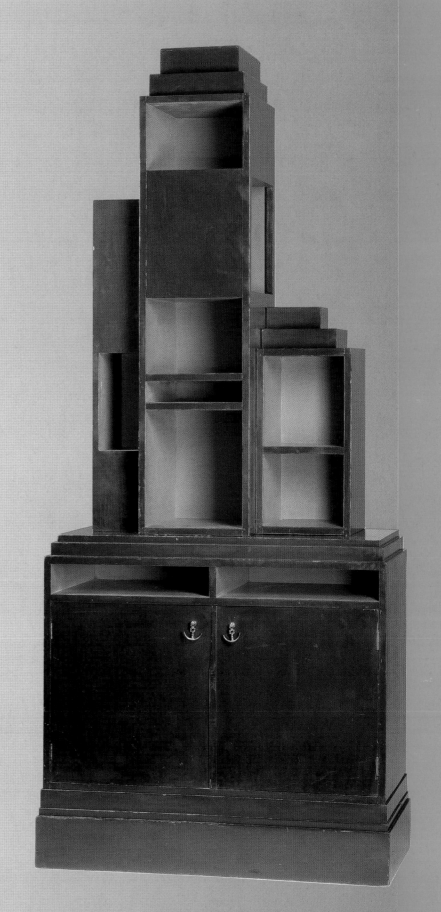

GESCHICHTE DES MUSEUMS

Die Wolfsonian-Florida International University ist Museum und Forschungszentrum in einem. Anhand von Gegenständen wird hier die Suggestivkraft von Kunst und Design vermittelt, was es heißt, modern zu sein. Es soll die Geschichte der sozialen, historischen und technologischen Entwicklungen erzählt werden, aus der unsere Welt hervorgegangen ist. Aber vor allem will das Museum Menschen ermutigen, die Welt mit anderen Augen zu sehen. Die faszinierende Sammlung aus der Epoche der Moderne (1885-1945) vermittelt auf eindrucksvolle Weise die Fortschritte der Industrialisierung und demonstriert die Art und Weise, in der Design die menschliche Erfahrung nicht nur vermittelt, sondern auch prägt. Das Wolfsonian Institut hat ein umfangreiches akademisches und öffentliches Programm entwickelt, mit dem es ein Publikum erreichen kann, das so breit und vielgestaltig ist wie seine Sammlung. Ausstellungen und Veranstaltungen sollen dem Publikum die Gelegenheit geben, sich mit den Themen der Sammlung zu identifizieren sowie deren historische Bedeutung und ihre Relevanz für die heutige Zeit zu erkennen .

Museen sind unschätzbare Quellen für die Erforschung und Wertschätzung fremder Kulturen, anderer Welten und ferner Zeiten. Obwohl wir dort auch historischen Epochen begegnen, die dunkle Zeiten heraufbeschwören, erinnern sie uns an die Größe und Schöpfungskraft des menschlichen Geistes. Museen eröffnen auch erstaunliche Einblicke in die vielfältige Weise, in der Kunst und Künstler Einfluss auf unsere Wahrnehmungen und Urteile nehmen, wie sie unsere Lebenswelt gestalten.

Gestaltete Gegenstände aus dem Bereich der schönen Künste, dem Kunsthandwerk, dem Grafikdesign und dergleichen können dabei der Schlüssel sein zu vielen Geschichten, die von menschlichen Motivationen, Überzeugungen, Intentionen und Ideen erzählen. Sie eröffnen der kollektiven Interpretation wertvolle Einsichten jenseits des geschriebenen Wortes. Die Wolfsonian Collection vermittelt mit ihrem kuratorischen Konzept Verständnishilfen und die spezielle Sprache, um die Bilderwelten zu verstehen, die zu unseren Tagesereignissen gehören. Die Symbole mögen sich nicht stark verändert haben und vielleicht auch nicht die Rolle der Gestalter, was sich jedoch geändert hat, sind die historischen Umstände und vor allem die Art und Weise der Vermittlung von Bildern. In den Nachrichten, die wir in den Massenmedien empfangen, vor allem in Zeiten politischer Konflikte, vermitteln sich auch machtvolle Bilder nationaler Identität und Geschlossenheit, politischer und wirtschaftlicher Positionen, Toleranz und Intoleranz — um nur einiges zu nennen.

Die Wolfsonian Collection möchte beim Betrachter Wertschätzung für die einfachen Gegenstände des Lebens erzeugen und eine stärkere Sensibilität dafür, in welcher Weise Gegenstände und Bilder aus Massenproduktion eingesetzt werden können, um soziale, politische und technologische Entwicklungen zu beeinflussen. Das Publikum soll bei Betrachtung der Sammlung zu einem vertieften Verständnis dieser Zusammenhänge kommen und einen kritischen Blick auf die heutige Gesellschaft entwickeln. Wir hoffen, dass der Betrachter eine feinere Wahrnehmung für die Nuancen, die uns gewöhnlich entgehen, bekommt — für die das Leben prägenden sozialen und kulturellen Elemente, die in unserem Alltag selbstverständlich geworden sind.

Die Wolfsonian Collection

Die Wolfsonian Collection wurde 1986 gegründet, um die Mitchell Wolfson Jr. Collection zu bewahren, zu dokumentieren und auszustellen — eine Zusammenstellung von über 80.000 Objekten. Die Sammlung beinhaltet vor allem Ausstellungsstücke nordamerikanischer und europäischer Herkunft aus dem Zeitraum von 1885 bis 1945. Sie umfasst verschiedene Bereiche: Möbel, Industriedesign, Glas, Keramik und Metallverarbeitung, seltene Bücher, Zeitschriften, Alltagsgegenstände, Arbeiten auf Papier, Malerei, Textilien und Medaillienkunst. Als Nationen am stärksten vertreten sind die USA, Großbritannien, Deutschland, Italien, die Niederlande und die ehemaligen GUS-Staaten.

Die Zusammenschau der Objekte soll Schlüsselentwicklungen in der Geschichte des Designs veranschaulichen, die Wechselwirkung zwischen Designentwicklung und allgemeiner kultureller Entwicklung, wie Design industriellen Fortschritt nicht nur geprägt hat, sondern von diesem auch geprägt wurde – und die Rolle von Marketingstrategien.

Zu den Besonderheiten der Wolfsonian Collection gehört die größte öffentlich zugängliche Sammlung der britischen Aesthetic und Arts and Crafts Bewegungen (1870–1910) ausserhalb Großbritanniens. Hier finden sich wichtige Beispiele der Arbeiten von William Morris, Christopher Dresser, C. R. Ashbee, M. H. Baillie Scott, Ernest Gimson und Charles Rennie Mackintosh. Es gibt auch eine bedeutsame Abteilung, die Objekte aus der Ursprungszeit des modernen Designs in Deutschland zeigt. Hier finden sich Ausstellungsstücke von Mitgliedern der führenden Künstlerkolonien, Werkstätten und Designergruppen: die Darmstädter Künstlerkolonie, die Vereinigten Werkstätten in München und der Deutsche Werkbund. Besonders erwähnenswert ist eine Möbelgarnitur von August Endell und eine vielgestaltige Sammlung von Objekten von Peter Behrens und Joseph Maria Olbrich. Italienische und holländische Ausprägungen des Jugendstils (1890–1910) – Nieuwe Kunst und Stile Floreale – sind ebenfalls beachtlich vertreten. Hierzu gehören Möbel, Kunsthandwerk, stilecht möblierte Räume wie z. B. das komplett von Agostino Lauro eingerichtete Doppelwohnzimmer und eine Inneneinrichtung von Theodoor Nieuwenhuis. Was diese Epoche des holländischen und italienischen Kunsthandwerks betrifft, so besitzt das Museum die größte Sammlung außerhalb Italiens und der Niederlande.

Auch das amerikanische Industriedesign ist gut mit Ausstellungsstücken wie Kameras, Uhren, Radios, Grammophonen und Plattenspielern repräsentiert. Nahezu alle Pioniere des Industriedesigns sind vertreten, darunter Walter Dorwin Teague, Donald Deskey, Kem Weber und John Vassos. Die Sammlung beinhaltet ebenfalls eine besonders wertvolle Auswahl von Objekten aus dem Bereich der Druckwerbung: Plakate, Grafiken, Gestaltungspatente, Handelskataloge und Muster.

In der Wolfsonian Collection befindet sich ebenso eine bemerkenswerte Sammlung politischer Propaganda des 20. Jahrhunderts aus Deutschland, Italien, Großbritannien, den Niederlanden und den USA. Dazu gehören Grafiken, Zeichnungen, Bücher und Veröffentlichungsreihen und Objekte, die den Aufstieg und Fall faschistischer Bewegungen in diesen Ländern dokumentieren. Grafiken aus Russland, Mitteleuropa (vor allem aus der ehemaligen Tschecheslowakei und Ungarn) und Spanien dokumentieren auf wichtige und ungewöhnliche Weise die Geschichte der Propaganda im 20. Jahrhundert. Die Zusammenschau eröffnet erstaunliche Einblicke in die Gemeinsamkeiten der Bildwelten, auch bei politisch gegensätzlichen Systemen.

Zusätzlich besitzt das Museum eine große Menge von Arbeiten der Works Progress Administration (WPA) und des Federal Art Projects in USA. Obwohl diese Sammlung in den USA nicht einzigartig ist, kann sie doch nicht nur wegen der Menge, sondern auch wegen der außerordentlichen Qualität der Objekte einen gewissen Rang beanspruchen. Weite Bereiche werden umfasst: Skulptur, Malerei, Keramik, Lithografie, Radierung und Plakat. Einen Schwerpunkt bilden Zeichnungen und Entwürfe für Wandgemälde in Postämtern.

Einen anderen Sammlungsschwerpunkt bilden Gegenstände, die auf internationalen Messen und Weltausstellungen seit 1851 gezeigt oder speziell dafür produziert worden sind. Hier bietet die Wolfsonian Collection eine exzellente Zusammenstellung derartiger Gegenstände, zu denen nicht nur Kataloge, seltene Bücher, Möbel, Skulpturen und Gemälde gehören, sondern auch Alltagsgegenstände wie Halstücher, Postkarten, Prospekte, Spielzeuge und Aschenbecher. Mit all ihren nationalen Implikationen gehören diese Objekte zu den interessantesten Exemplaren ihrer Art auf der Welt.

GESCHICHTE DES MUSEUMS

Des Weiteren besitzt die Wolfsonian Collection eine eindrucksvolle Zusammenstellung von Objekten aus der Reisebranche: Plakate, Drucke, Bücher, Spielzeuge, Muster und Gebrauchsgegenstände – ehemaliges Werbematerial für Ozeandampfer, Flugzeuge, Zeppeline und Züge.

Der Bibliotheksbestand im Wolfsonian Museum umfasst seltene Bücher und Nachschlagewerke, Zeitschriften und eine große Sammlung an Gebrauchsartikeln wie z. B. alte Postkarten, Anzeigen, Kalender, Handzettel, Etiketten, Streichholzschachteln sowie weitere Gegenstände, die alle als kulturelle Zeugnisse gesammelt wurden und in denen sich die Zeit spiegelt, in der sie entworfen wurden. Es ist eine unerschöpfliche Quelle für alle, die sich für Design, Kunstgeschichte und Alltagskultur interessieren und deren Einbettung in die ästhetischen und sozialen Bewegungen Europas und Nordamerikas.

Besonders stark vertreten sind holländische, deutsch-, italienisch- und englischsprachige Materialien. Seltene Bücher und Objekte aus Frankreich, der Schweiz, Russland, der tschechischen Republik und Ungarn gehören ebenfalls dazu und werden ergänzt durch vielfältige Querverweise. Ihre Stärken zeigt die Bibliothek vor allem im bibliophilen Bereich, bei illustrierten Ausgaben, Buchgestaltung und Typografie. Dazu gehört eine hervorragende Sammlung von Publikationen des italienischen Futurismus, holländische Buchbinderkunst der Nieuwe Kunst sowie surrealistische Buchumschläge aus Russland bzw. der ehemaligen Tschechoslowakei. Es gibt Propagandamaterialien aus beiden Weltkriegen und aus dem spanischen Bürgerkrieg, Materialien von nationalen und internationalen Messen und Ausstellungen, zu regionalen, volkstümlichen und modernistischen Bewegungen in Kunsthandwerk und Architektur, Literatur zu Reise- und Transportwesen, „New Deal"-Programmhefte, Dokumente zu öffentlichen Bauarbeiten und Stadtplanung, Werbematerialien wie z. B. Musterbücher, Anzeigen und Kataloge.

Von der privaten Sammlung zur öffentlichen Ausstellung

Die Wolfsonian Collection trat am 11. November 1995 erstmals im großen Stile an die Öffentlichkeit, und zwar mit der Eröffnung der großen Wanderausstellung „The Arts of Reform and Persuasion, 1885–1945", in der erstmals die Tiefe und thematische Spannweite der Sammlung ersichtlich wurde. Das Museum zog in ein Gebäude mediterranen Stils aus dem Jahre 1927, ein ehemaliges Lagerhaus, das 1992 renoviert und zu einem siebenstöckigen hochmodernen Domizil mit 5.202 qm ausgebaut wurde. 1997, nach der Schenkung an den Staat Florida durch Mitchell Wolfson jr., wurde die Wolfsonian Collection der Florida International University angegliedert.

Diverse Ausstellungen folgten: „Pioneers of Modern Graphic Design" (1997), „Public Works und Drawing the Future: Designs for the 1939 New York World's Fair" (1998), „Leading 'The Simple Life': The Arts and Crafts Movement in Britain, 1880–1910" (1999), „Print, Power and Persuasion: Graphic Design in Germany, 1890–1945", „Dreams and Disillusion: Karel Teige and the Czech Avant-Garde" (2001), „From Emperors to Hoi Polloi: Portraits of an Era, 1851–1945" (2002), „Weapons of Mass Dissemination: The Propaganda of War" (2003).

Das Wolfsonian Institut verwaltet ein Stipendienprogramm, organisiert den Zugang zur Sammlung und spielt eine entscheidende Rolle in der Association of Research Institutes in Art History. Mit Publikationen und Ausstellungen wird die Arbeit der Sammlung fortgesetzt. Neben den Büchern zu den Ausstellungen gibt das Wolfsonian Institut seit 1986 das preisgekrönte Periodikum „The Journal of Decorative and Propaganda Arts" heraus, um die wissenschaftliche Aufarbeitung von „Kunst- und Designfragen in den Schlüsseljahren von 1875 bis 1945" zu fördern.

Eine Stärke des Wolfsonian Instituts ist die Fähigkeit, seine Sammlung als Bildungsgegenstand nutzbar zu machen und für die Entwicklung von Lehrplänen auf lokaler und nationaler Ebene einzusetzen. Es besteht eine starke und dauerhafte Zusammenarbeit mit den Miami-Dade County Public Schools, dem viertgrößten Schulverbund in den USA.

Das fächerübergreifende Programm „A Page at a Time" führt Lehrer aus dem sprachlichen Bereich, der bildenden Kunst und der Gesellschaftslehre zusammen, die die Sammlung und die Personalresourcen des Museums nutzen, um Schüler verschiedenster Herkunft im Bereich visueller Bildung zu unterrichten. Nachdem sie mit Objekten aus der Sammlung und vor allem mit der Bibliothek vertraut geworden sind, erarbeiten die Schüler eigenständig Themen wie z. B. „Konflikt" oder „Intoleranz" in ihren eigenen Kunstwerken oder Schreibprojekten.

Das „Artful Truth-Healthy Propaganda Arts Project" wurde vom Wolfsonian Insitut entwickelt und organisiert, unterstützt von der Abteilung für Gesundheitsbewusstsein und Tabak des Gesundheitsministeriums in Florida. Diese neuartige Bildungsinitiative lehrt Schüler in der vierten bis sechsten Klasse am Beispiel der Tabakwerbung, wie man suggestive Strategien in Kunst, Design und Werbung durchschaut. Das „Artful Truth-Heathy Propaganda Arts Project" stellt den Lehrern und Erziehern Unterrichts- und Übungsmaterial zur Verfügung, um im Klassen-raum die visuelle Bildung zu vermitteln, die den Schülern zu einer schärferen Urteilskraft verhilft, damit sie zu kultivierten und kritischen Bürgern werden. Nachdem die Wolfsonian Mitarbeiter dieses richtungsweisende Curriculum über einen Zeitraum von drei Jahren ent-wickelt hatten, gestalteten sie eine Website, die das Material für Lehrer und Schüler aus aller Welt zugänglich macht (www.artfultruth.org).

„Artful Citizenship" wird als neues Bildungsprogramm ständig weiterentwickelt, wobei es auf die Erfolge der vorangegangenen Arbeit aufbaut. Kürzlich wurde der Initiative vom U.S. Bildungsministerium ein Etat von nahezu einer Million Dollar zugesprochen. Das angestrebte Curriculum will die Wolfsonian Collection für den Sozialkundeunterricht in der dritten bis fünften Klasse nutzbar machen — mit den beiden Schwerpunkten Bürgerrecht und Bürgertugenden. Nach drei Jahren stetiger Weiterentwicklung rechnet man damit, dass dieses Pilotprojekt Vorbildfunktion auf nationaler Ebene bekommt. Denn als ein Museum, das sich zum Ziel gesetzt hat, Aspekte des modernen Lebens zu erforschen und zu vermitteln, sieht das Wolfsonian Museum seine Aufgabe auch darin, die analytischen und künstlerischen Fähigkeiten von Schulkindern zu entwickeln — die einzige Resource, die letzten Endes für die Gestaltung unserer Zukunft verantwortlich sein wird.

M. L.

HISTORY OF THE MUSEUM

The Wolfsonian — Florida International University is a museum and research center that uses objects to illustrate the persuasive power of art and design, explore what it means to be modern, and tell the story of the social, historical, and technological changes that transformed our world. Above all, the museum encourages people to see the world in new ways. Its fascinating collection of objects from the Modern era (1885–1945) celebrates the industrial age, and demonstrates how design shapes and reflects human experience. The Wolfsonian has developed an extensive array of academic and public programs to reach audiences as broad and varied as its collection. Exhibitions and activities have been designed to provide the public with opportunities to identify and contemplate the historical significance of collection themes and their relevance to the world today.

museums are invaluable resources for examining and appreciating other cultures, other worlds, and other times. Frequently, we must encounter historical periods that conjure up the darkest of circumstances. And yet museums remind us of the greatness that the human spirit is capable of creating. museums also provide incredible insights into the multiple roles that art and artists have played in creating our perceptions, our judgments, and in shaping the eras in which we live. Material artifacts — the fine arts, decorative arts, graphic design, and ephemera — are repositories of many stories, documenting man's motivations, opinions, intentions, and ideas. Examined collectively, they provide valuable insights that cannot be found in written form.

The Wolfsonian's collection and contextual curatorial approach can provide the tools and vocabulary to help read and understand the images emerging out of current events. The symbols may not have changed much, nor has the role of the image maker. What has changed is the historically specific circumstance and the methods of transmitting images. The mass-produced messages we receive, especially during periods of conflict, are powerful images of national identity, unity, political and economic policy, and tolerance and intolerance, to name a few.

The Wolfsonian hopes to engender an appreciation of ordinary objects and enhance the understanding of how objects and mass-produced images have been used to effect social, political, and technological change. By examining these objects, we hope museum visitors will come away with a heightened sensitivity to these relationships and apply their critical thinking skills to contemporary society. We hope that they may better apprehend the nuances that frequently escape us — the life-changing social and cultural elements that we take for granted every day.

The Wolfsonian Collection

The Wolfsonian was founded in 1986 to exhibit, document, and preserve the Mitchell Wolfson Jr. Collection, an assemblage of over 80 000 objects. The collection contains artifacts primarily of North American and European origin, dating from 1885 to 1945. It comprises a variety of media: furniture; industrial design; glass, ceramics, and metalwork; rare books; periodicals; ephemera; works on paper; paintings; textiles; and medallic art. The nations most comprehensively represented are the United States, Great Britain, Germany, Italy, the Netherlands, and Russia / the Soviet Union. The objects are interpreted to explore key issues in design history — the way design has both altered and been altered by cultural change, industrial innovation, and strategies of persuasion.

Among The Wolfsonian's specialties is the largest public collection outside the United Kingdom of the British Aesthetic and Arts and Crafts movements (1870-1910). Among The Wolfsonian's pieces are important examples by William Morris, Christopher Dresser, C. R. Ashbee, M. H. Baillie Scott, Ernest Gimson, and Charles Rennie Mackintosh.

The museum's collection of objects associated with German Design Reform (1880-1910) is significant. It includes examples by members of the leading art colonies, workshops, and design associations: the Darmstadt Art Colony, Vereinigte Werkstätten in Munich, and Deutsche Werkbund. Particularly noteworthy are a suite of furniture by August Endell and a wide variety of designs by Peter Behrens and Joseph Maria Olbrich.

Dutch Nieuwe Kunst and Italian Stile Floreale — Italian and Dutch manifestations of the movement commonly known as Art Nouveau dating to the period 1890-1910 — are also notable, and include furniture, decorative arts, and whole period rooms, such as a double parlor with complete furnishings by Agostino Lauro and an interior by Theodoor Nieuwenhuis. The museum's holdings of Dutch and Italian decorative arts of this period are among the largest outside the Netherlands and Italy.

American industrial design (1915-1940) is well represented, with items such as cameras, clocks, radios, and phonographs. Most of the pioneers of industrial design are represented, including Walter Dorwin Teague, Donald Deskey, Kem Weber, and John Vassos. The collection also contains an extremely valuable selection of materials pertaining to print advertising: posters, graphic designs, patent models, trade catalogs, and samples.

The Wolfsonian contains an extraordinary collection of 20th-century German, Italian, British, Dutch, and United States political propaganda, including prints, posters, drawings, books and serial holdings, and objects that document the rise and demise of these nations' fascist movements. Graphic arts from Russia / the Soviet Union, middle Europe (particularly the former Czechoslovakia and Hungary), and Spain provide important and unusual documentation for the history of propaganda in the 20th-century. Taken together, these collections can contribute to innovative comparisons of shared imagery among countries with very different political systems. In addition, the museum holds an enormous collection of designs produced by the Works Progress Administration (WPA) and the Federal Art Project in the United States. Although these collections are not unique in the United States, The Wolfsonian's holdings are unusual for the vast quantity and the exceptionally good quality of the objects. The range of media is broad — sculpture, paintings, ceramics, lithographs, etchings, and posters — with special strength demonstrated in such areas as drawings and studies for post office murals.

Another central element of the collection is materials produced for or exhibited in world's fairs and expositions since 1851. The Wolfsonian collection remains unique as an all-inclusive compilation of world's fair materials, encompassing catalogs and rare books, furnishings, sculpture, paintings, and ephemera (such as scarves, postcards, pamphlets, toys, and ashtrays). Imbued with nationalistic implications, these objects stand out as some of the best examples of their kind in the world. The Wolfsonian also holds an impressive array of travel-related posters, prints, books, toys, models, paintings, and ephemera — objects that had once promoted ocean liners, airplanes, zeppelins, and trains.

The Wolfsonian's library holdings include rare books and reference works, periodicals, and a large collection of ephemeral items, including vintage postcards, advertisements, calendars, leaflets, labels, matchbook covers, as well as a variety of other formats, collected and preserved as cultural artifacts that reveal the times in which they were created. It is a rich resource for scholars interested in design, art history, material culture, and the aesthetic and social movements of Europe and North America.

HISTORY OF THE MUSEUM

It is particularly strong in German-, Italian-, English-, and Dutch-language materials. Rare books and artifacts from France, Switzerland, Russia / the Soviet Union, the Czech Republic, and Hungary also are in evidence and are complemented by an extensive reference collection. Library holdings are especially strong in materials relating to fine-press and illustrated editions; book design and typography, including superb collections of Italian Futurist publications; Dutch Nieuwe Kunst bookbindings, and Czech and Russian Constructivist and Surrealist book covers; propaganda from the world wars and the Spanish civil war; materials from world's fairs and national and international expositions; regional, folk, and Modernist movements in the decorative arts and architecture; transportation and travel literature; New Deal programs, public works, and urban planning; and advertising material, including sample books, advertisements, and catalogues.

A Collection Evolves from the Private to Public Sphere

The Wolfsonian's full-scale public facility was officially inaugurated on November 11, 1995, with the opening of the major touring exhibition "The Arts of Reform and Persuasion, 1885-1945", which demonstrated, for the first time, the depth and breadth of the Wolfsonian collection and its concomitant themes. The museum took residence in a 1927 Mediterranean-Revival building, a one-time storage warehouse, which underwent renovation and expansion in 1992 to become a 7-story, 56 000 state-of-the-art facility. In 1997, The Wolfsonian became a division of Florida International University, following Mitchell Wolfson Jr.'s sq. foot. donation of his collection to the State of Florida.

Temporary exhibitions have continued with "Pioneers of Modern Graphic Design" (1997); "Public Works and Drawing the Future: Designs for the 1939 New York World's Fair" (1998); "Leading 'The Simple Life': The Arts and Crafts Movement in Britain, 1880-1910", (1999); "Print, Power and Persuasion: Graphic Design in Germany, 1890-1945"; and "Dreams and Disillusion: Karel Teige and the Czech Avant-Garde" (2001); "From Emperors to Hoi Polloi: Portraits of an Era, 1851-1945" (2002); and "Weapons of Mass Dissemination: The Propaganda of War" (2003).

The Wolfsonian administers a competitive fellowship program, facilitates collections access, and plays a leading role in the Association of Research Institutes in Art History. Publications, like exhibitions, are an extension of the collection. Besides producing exhibition-related books, The Wolfsonian publishes the award-winning "The Journal of Decorative and Propaganda Arts", founded in 1986, to promote original scholarship on art and design issues for the pivotal years 1875 to 1945.

One of the Wolfsonian's significant strengths is its ability to use the collection to develop educational tools and curricula for local and national dissemination. The Wolfsonian demonstrates a strong ongoing commitment to the Miami-Dade County Public Schools, the fourth-largest school system in the United States.

The multidisciplinary program "A Page at a Time" involves educators from literature, visual arts, and social studies who use the museum's collection and staff resources to teach visual literacy to schoolchildren from demographically diverse schools. After becoming familiar with objects from the museum's collection, especially its library materials, students explore such themes as conflict and intolerance in their own artwork and writing projects. The "Artful Truth-Healthy Propaganda Arts Project" was organized and developed by The Wolfsonian and supported by the State of Florida's Department of Health, Division of Health Awareness and Tobacco. This innovative educational initiative teaches 4th- through 6th-grade students how to recognize and interpret persuasive messages conveyed by art, design, and advertising using tobacco marketing as a case study.

The "Artful Truth–Healthy Propaganda Arts Project" provides educators with the tools and training to teach visual literacy in the classroom, where students are learning to develop the critical thinking skills that will make them more sophisticated and discerning citizens. After the Wolfsonian staff had developed this trend-setting curriculum over a 3-year period, they created a Web site (www.artfultruth.org) for teachers and students to access materials from anywhere in the world.

"Artful Citizenship" is a new educational program currently being developed, and which builds on the strengths of the previous outreach efforts. The initiative recently received approximately one million dollars in funding from the U.S. Department of Education. The proposed curriculum will use the Wolfsonian collection to address 3rd- through 5th-grade social studies content, focusing particularly on citizenship and character education. After three years of continual development, this pilot program is expected to function as a national model. As a museum whose mission it is to interpret what it means to be modern, The Wolfsonian also recognizes its role in developing the analytical and artistic abilities of schoolchildren — the unique resource that will ultimately be responsible for creating the future.

M. L.

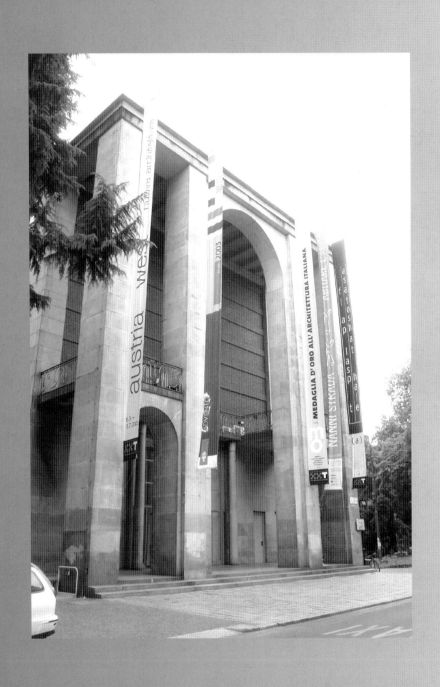

Milan

Fondazione 'La Triennale di Milano'
www.triennale.it

COLLECTION

La Triennale di Milano

DESIGNER / ARCHITECT

Joe Colombo

OBJECT

Seating system / Sitzsystem 'Tubo'

DATE

1969-1970

MANUFACTURER

Flexform, 2003 version / Ausführung 2003

La Triennale di Milano

GESCHICHTE DES MUSEUMS

Die 1923 gegründete, ursprünglich als Biennale und später als Triennale stattfindende Ausstellung für Kunsthandwerk wurde ab 1931 an ihren heutigen Austragungsort, den Palazzo dell'Arte im Parco Sempione verlegt, der von Giovanni Muzio entworfen und in einem Zeitraum von achtzehn Monaten vom Herbst 1931 bis Frühling 1933 erbaut wurde.

Die Triennale ist in dieser Zeit zu einem Spiegel der italienischen Kultur und Gesellschaft geworden. Im Rahmen internationaler Schauen, Konferenzen und Forschungsprojekte wurden jeweils aktuelle Entwicklungen aus dem Bereich Design aufgegriffen — einschließlich architektonischer und städtebaulicher Projekte sowie serienproduzierter, kunsthandwerklicher oder auch handgemachter Objekte.

1999 wurde die Triennale in eine Stiftung umgewandelt, um den Kompetenzbereich auf Mode und Kommunikationselektronik auszuweiten. Im Jahr 2001 hat der Aufsichtsrat der Stiftung beschlossen, die Triennale in eine drei Jahre während Dauerausstellung zu überführen. Die Ausstellungen der „Drei-Jahres-Triennale" bieten die Möglichkeit einer umfassenderen Darstellung der jeweils ausgewählten Themen, wobei die einzelnen Ausstellungen von unterschiedlicher Länge sind und zu verschiedenen Terminen beginnen. Der Palazzo dell'Arte, dessen Grundstruktur im wesentlichen unverändert blieb, verfügt über vier große Ausstellungsbereiche.

Die Gesamtfläche beträgt 12.000 m², während die Ausstellungsflächen sich über 8.000 m² erstrecken. Michele de Lucchi, der mit der Neugestaltung und Restaurierung der Publikumsbereiche der Triennale beauftragt wurde, hat dem Erdgeschoss ein neues Gesicht verliehen. Dabei wurden nicht nur die ursprünglich von Giovanni Muzio gestalteten Räume restauriert, sondern auch die öffentlichen Bereiche im Rahmen eines strategischen Plans aufgewertet.

Dauerpräsentation der Sammlung italienischen Designs

Dank der Erfahrungen mit verschiedenen großen Ausstellungen, die im Rahmen der Triennale in vorangegangenen Jahren organisiert wurden, konnten in die Dauerpräsentation im Laufe der Jahre viele neue Objekte aufgenommen werden, bei deren Auswahl man jedoch jeweils den Blick auf die Ausstellung als kohärente Gesamtkonzeption gerichtet hielt. Erst im April 1997 war die Dauerpräsentation der Öffentlichkeit übergeben worden.

Die Exponate der Sammlung stammen aus den unterschiedlichsten Designbereichen, einschließlich Möbeln, Leuchten, elektronischen Produkten, Küchenutensilien, Transportmitteln und Kinderspielzeug. Die Sammlung ist gegenwärtig auf einer 2.000 m² großen Fläche in unmittelbarer Nachbarschaft der Fakultät für Industriedesign des Politecnico di Milano untergebracht. Sie bietet alle Voraussetzungen für periodische Ausstellungen zu bestimmten Themen aus unterschiedlichen Blickwinkeln, die in den Ausstellungshallen des Triennale Palastes nach einem Rotationsprinzip gezeigt werden, um die Sammlung auf immer wieder neue, lebendige und dynamische Weise zu präsentieren.

S. A.

HISTORY OF THE MUSEUM

Established in 1923 as a biennial event of decorative arts, in 1931 the Triennale was transferred to its current venue in Milan's Parco Sempione, the Palazzo dell'Arte, specifically designed by Giovanni Muzio and built over a period of 18 months from autumn 1931 to spring 1933.

Since then, it has been a mirror of Italian culture and society, picking up and developing — through international expositions, conferences and research projects — emerging themes in the field of design, including architecture, city planning, and objects, be they mass-made or the handiwork of craftsmen.

More recently, the Triennale, turned into a Foundation in 1999, extended its own scope to include fashion and audio-visual communications. In 2001, the Board of Directors of the Foundation decided to transform the Triennale EXPO into an event lasting for three years. The exhibitions of "The Three-Year Triennale", delving deeper into the selected theme, are punctuated by as many inaugurations and are of varying lengths. The building, Palazzo dell'Arte, whose overall organization has been left substantially unchanged, has four main exhibition spaces.

The total area is 12 000 sq. meters, while exhibition areas measure about 8 000 sq. meters. Michele de Lucchi, in charge of the project for restructuring and restoring the communal areas of the Triennale, has given the ground floor a new look. A solution that not only aims to restore the spaces originally designed by Giovanni Muzio, but that also becomes a part of a strategic plan to improve the areas dedicated to the public.

Permanent Collection of Italian Design

Constituted and opened to the public in April 1997, thanks to the experience gained from several large exhibitions organized by the Triennale in previous years, the Permanent Collection has been enriched over the years by new objects selected according to a logic always dedicated to creating a coherent and significant whole.

The Collection counts pieces belonging to the most various branches of design, including furniture, lighting, electronic products, kitchen utensils, means of transport and children games. The Collection is currently housed in a 2 000 sq. meters space adjacent to the Faculty of Industrial Design at the Politecnico di Milano and offers the basis for periodic thematic and monographic exhibitions-each time from a different perspective, which are presented in the exhibition halls of the palace of Triennale on rotation in a manner that tends to re-examine the Collection itself in ever newer, livelier and more dynamic ways.

S. A.

Montreal

Musée des beaux-arts de Montréal
The Montreal Museum of Fine Arts
www.mbam.qc.ca

COLLECTION

Musée des beaux-arts de Montréal
The Montreal Museum of Fine Arts

DESIGNER / ARCHITECT

Karim Rashid

OBJECT

Coffee table / Beistelltisch 'Aura'

DATE

1990

MANUFACTURER

Zeritalia, 1999

The Montreal Museum of Fine Arts, Liliane and David M. Stewart Collection, gift of Zeritalia

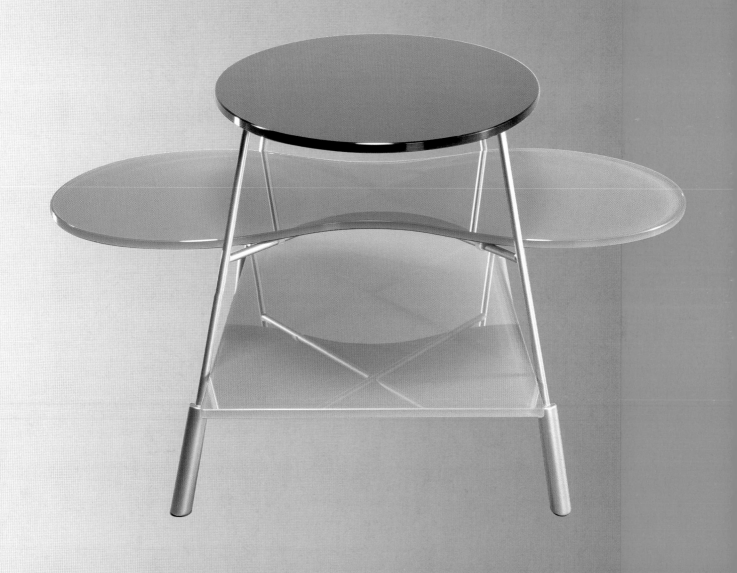

GESCHICHTE DES MUSEUMS

In den letzten 143 Jahren hat das Musée de Beaux-Arts de Montréal / Montreal Museum of Fine Arts eine der herausragendsten enzyklopädischen Sammlungen Nordamerikas mit über 30.000 Objekten von der Antike bis heute zusammengetragen. Im Jahre 1860 gegründet — neun Jahre vor dem Metropolitan Museum of Art in New York und zehn Jahre vor dem Museum of Fine Arts in Boston — gilt das Engagement des Museums vor allem seinem Bildungsauftrag. Das Museum ist durch finanzielle und künstlerische Schenkungen — von einzelnen Kunstwerken bis zu ganzen Sammlungsbereichen, die den Bestand zunehmend vergrößert haben — beträchtlich gewachsen. Dazu gehören Kunsthandwerk, kanadische Kunst, Grafiken und Zeichnungen, Gemälde alter Meister, moderne und zeitgenössische Kunst, antike Textilien sowie die weltgrößte Sammlung japanischer Weihrauchdosen.

Das Musée de Beaux-Arts de Montréal ist nicht nur hinsichtlich seiner umfassenden Gemälde- und Skulpturensammlung einzigartig, sondern auch im Hinblick auf seine großen Bestände an Kunsthandwerk und Design von der Renaissance bis heute. Die Qualität der Sammlung, deren erste Ankäufe in das Jahr 1916 fallen, ist zum großen Teil F. Cleveland Morgan zu verdanken, dem über viele Jahre der Ausbau der Sammlung angewandter Kunst am Museum oblag.

Zum kanadischen Kunsthandwerk gehören traditionelle Möbel, einschließlich edler Büfetts aus Kiefernholz, Kommoden, Stühle und Kanapees. Beispiele für das kunsthandwerkliche Geschick kanadischer Künstler sind die religiösen und für das häusliche Umfeld entworfenen Silberarbeiten von berühmten Silberschmieden wie Paul Lambert, Samuel Payne, François Ranvoyzé und Laurent Amiot. Daneben finden sich in der Sammlung zeitgenössische Keramik, Glas und Schmuck von kanadischen Künstlern, die für ihre innovativen und kunstfertigen Objekte berühmt sind.

Eine weitere wichtige Gönnerin des Museums ist Lucile Pillow, deren Sammlung englischen Porzellans aus dem 18. Jahrhundert heute eine der Stärken des Museums darstellt. Zum Bestand gehören 256 Gruppen von Chelsea, Worcester, Derby und Wedgwood Objekten. Im Jahre 1948 hinterließ David M. Parker dem Museum seine wertvolle Sammlung antiker Spitze sowie ein großzügiges Stiftungsgeld, das half, den Bestand an Textilien so zu erweitern, dass dieser heute internationale Anerkennung erfährt. Interessant sind auch die Beispiele erlesener Möbelstücke und eine umfangreiche Sammlung europäischer Keramik, die von Majolika aus dem 15. Jahrhundert bis zu Delftware und Meissen, Sèvres, Doccia und Berliner Porzellan aus dem späten 17. Jahrhundert reicht. Zudem gibt es eine große Sammlung mit europäischem Glas aus dem 18. und 19. Jahrhundert.

Am 1. Januar 2000 kam das Museum in den Besitz der 'Liliane and David M. Stewart Collection', eine der berühmtesten Sammlungen für Design und Kunsthandwerk in Nordamerika. Die Stewarts gründeten das Montreal Museum of Decorative Arts — eine Sammlung von internationalem Rang, bestehend aus 6.000 Objekten von 1935 bis heute, Möbeln, Schmuck, Plakaten, Textilien, Lampen, Keramik, Glas, Metallarbeiten usw. Aufgrund dieser ausserordentlichen Schenkung gehört das Musée de Beaux-Arts de Montréal zu den führenden Museen für angewandte Kunst auf dem nordamerikanischen Kontinent.

Viele der großen Namen der Moderne sind repräsentiert, einschließlich Alvar Aalto, Marcel Breuer, Charles und Ray Eames, Isamu Noguchi und Eero Saarinen. Die Vorreiterfunktion, die die skandinavischen Künstler im internationalen Design in den späten 40er und 50er Jahren spielten, wird ablesbar. Die vielen Beispiele italienischen Designs belegen dessen Bedeutung, da mit den in der Mitte des 20. Jahrhunderts populär gewordenen Entwürfen die Farbe, das Dekorative und der Humor in das Design zurückkehrten und die Grundsätze der Moderne herausgefordert wurden. Zu den kürzlich erworbenen Exponaten gehören zeitgenössische Objekte einer neuen Generation von Designern wie Ron Arad, David Palterer, Tejo Remy von Droog Design, Fabio Novembre und Karim Rashid, die zu den Vorreitern der internationalen Szene zählen.

Durch verschiedene, groß angelegte Ausstellungen zieht das Museum seit 1980 ein großes Publikum an. Es kommen Besucher aus Kanada und der ganzen Welt und das Museum erhält den Platz auf der internationalen Bühne, der ihm zusteht.

Eine Auswahl der Ausstellungen: „Pablo Picasso: Meeting in Montreal", „Leonardo da Vinci, Engineer and Architect", „Marc Chagall", „Salvador Dalí", „The 1920's: The Age of the Metropolis", „Lost Paradise: Symbolist Europe", „René Magritte", „George Segal", „Alberto Giacometti", „Monet in Giverny: Masterpieces from the Musée Marmottan", „Structure and Surface: Contemporary Japanese Textiles", „Triumphs of the Baroque: Architecture in Europe, 1600–1750", „From Renoir to Picasso: Masterpieces from the Musée de l'Orangerie", „Hitchcock and Art: Fatal Coincidences", „Édouard Vuillard, Post-Impressionist Master" und „Ruhlmann: Genius of Art Deco".

D. C.

135

HISTORY OF THE MUSEUM

Over the past 143 years, the Montreal Museum of Fine Arts has assembled one of North America's finest encyclopedic collections, totalling over 30 000 objects, from antiquity till now. Founded in 1860, nine years before the Metropolitan Museum of Art in New York and ten years before the Museum of Fine Arts in Boston, the Montreal Museum of Fine Arts is guided by a commitment to educate the citizens it serves. The museum has grown largely through gifts of money and works of art — from a single piece to an entire collection — that have substantially increased its holdings. It includes Decorative Arts, Canadian Art, Prints and Drawings, paintings of old Masters , Modern and Contemporary art, as well as important collections of ancient textiles, and the world's largest collection of Japanese incense boxes.

The Montreal Museum of Fine Arts is unique in having not only an extensive collection of paintings and sculpture, but also a large decorative arts and design collection from the Renaissance to the present. Much of the credit for the quality of this collection, whose first acquisitions were made in 1916, must go to F. Cleveland Morgan. For many years, he played a decisive part in enriching the museum's decorative arts collection.

The Canadian decorative arts encompasses traditional furniture, including handsome pine buffets, commodes, chairs and canapés. Religious and domestic silverware created by such noted silversmiths as Paul Lambert, Samuel Payne, François Ranvoyzé and Laurent Amiot attests to the skill and craftsmanship of early Canadian artisans. The collection also includes contemporary ceramics, glass and jewellery by Canadian artists renowned for their innovative, well-crafted objects.

Another of the museum's great benefactors is Lucile Pillow, whose collection of 18th-century English porcelain is one of the museum's strengths. The collection consists of 256 groups of Chelsea, Worcester, Derby and Wedgwood pieces. In 1948, David M. Parker bequeathed a valuable collection of antique lace as well as a generous endowment, which helped ensure the museum's textile holdings international recognition.

Other points of interest are examples of fine furniture and an extensive collection of European ceramics that ranges from 15th-century majolica pottery to late 17th-century Delftware and Meissen, Sèvres, Doccia and Berlin porcelain. A large collection of 18th- and 19th-century glassware from across Europe is also featured.

On January 1, 2000, the museum took possession of one of the most prestigious design and decorative art collections in North America, the Liliane and David M. Stewart Collection. The Stewarts founded the Montreal Museum of Decorative Arts, and the collection, international in scope, comprises 6 000 objects from 1935 to today, furniture, jewellery, posters, textiles, lamps, ceramics, glass, metalwork and so forth. This exceptional gift means that the Montreal Museum of Fine Arts now ranks among the leading decorative arts museums in North America.

Many of the great names of modernism are represented, including Alvar Aalto, Marcel Breuer, Charles and Ray Eames, Isamu Noguchi and Eero Saarinen. The leading role played by Scandinavian artists in the development of international design in the late 1940s and 1950s is highlighted as well. Many pieces reveal the contribution of Italian designers who, rising to prominence after the mid-20th century, challenged the tenets of Modernism by bringing back bright color, decoration and humor. Recent acquisitions feature contemporary works by a new generation of designers, including Ron Arad, David Palterer, Tejo Remy of Droog Design, Fabio Novembre and Karim Rashid, who have become leaders on the international scene.

Since the 1980s, the museum has kept conquering a large audience through several large-scale exhibitions: "Pablo Picasso: Meeting in Montreal", "Leonardo da Vinci, Engineer and Architect", "Marc Chagall", "Salvador Dali", "The 1920s: The Age of the Metropolis", "Lost Paradise: Symbolist Europe", "René Magritte", "George Segal", "Alberto Giacometti", "Monet in Giverny: Masterpieces from the Musée Marmottan", "Structure and Surface: Contemporary Japanese Textiles", "Triumphs of the Baroque: Architecture in Europe, 1600-1750", "From Renoir to Picasso: Masterpieces from the Musée de l'Orangerie", "Hitchcock and Art: Fatal Coincidences", "Édouard Vuillard, Post-Impressionist Master", and "Ruhlmann: Genius of Art Deco" to name but a few, draw visitors from across Canada and around the world, earning the museum its rightful place on the international stage.

D. C.

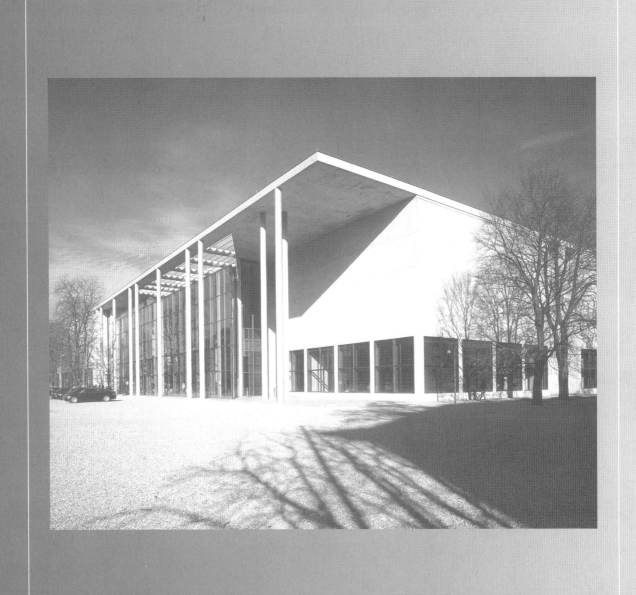

Munich

Die Neue Sammlung
Design in der Pinakothek der Moderne
www.die-neue-sammlung.de

COLLECTION

Die Neue Sammlung, Design in der Pinakothek der Moderne

DESIGNER / ARCHITECT

Malcolm Sayer / William Lyons

OBJECT

Sportscar / Sportwagen 'Jaguar E-Type'

DATE

1961

MANUFACTURER

Jaguar Cars Ltd., Coventry

Die Neue Sammlung, Staatliches Museum für angewandte Kunst

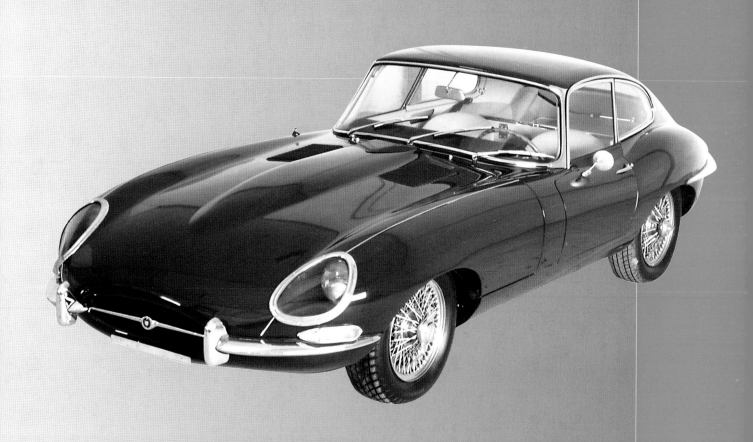

GESCHICHTE DES MUSEUMS

Die Neue Sammlung zählt mit über 60.000 Objekten der Bereiche Industrial und Product Design, Graphic Design und Kunsthandwerk zu den führenden Museen für angewandte Kunst des 20. und 21. Jahrhunderts. Mit der Gründung des Deutschen Werkbundes 1907 in München und seinem Ideengut verknüpft, begann damals der Aufbau einer „Modernen Vorbildersammlung", die zum Kern der Museumsbestände wurde. In Erkenntnis der Unabdingbarkeit industrieller Produktionsmethoden konzentrierte sich die Sammeltätigkeit von Anfang an auf beispielhaft gestaltete „moderne" Dinge des alltäglichen Gebrauchs, also das, was man heute als Design bezeichnen würde — in bewußter Abkehr der historistischen Praxis der meisten Kunstgewerbemuseen.

1925 wurde Die Neue Sammlung als Staatsinstitution etabliert, firmierte aber zunächst noch als „Abteilung für Gewerbekunst" des Bayerischen Nationalmuseums, bis 1929 der charakteristische und verpflichtende Name „Neue Sammlung" gefunden wurde. Der reformerisch-idealistische Ursprung und die avantgardistischen Sammlungsziele prägen das Museum — bei allen Akzentverschiebungen — bis heute. Das „Neu" im Namen dieses Staatlichen Museums für angewandte Kunst signalisiert programmatisch die Hinwendung zur Gegenwart, die Internationalität und das Beharren auf zukunftweisender gestalterischer Qualität. So läßt sich das Phänomen „Die Neue Sammlung" wohl am besten aus dem umstürzlerischen und kosmopolitischen Geist der zwanziger Jahre verstehen: Die Neue Sachlichkeit, das Neue Bauen, die Neue Typografie waren parallele Erscheinungen.

Das Museum war seit 1925 provisorisch in einem Gartentrakt des Bayerischen Nationalmuseums untergebracht. Kurt Schwitters bewunderte 1928 die schon damals beachtlichen Museumsbestände in diesen unzulänglichen Räumen. Der Gründungsdirektor resignierte im selben Jahr, weil der versprochene Neubau nicht verwirklicht wurde, und folgte einem Ruf nach Berlin. Kurz danach gerieten die progressiven Ausstellungen der Neuen Sammlung in die Schusslinie nationalsozialistischer Politik; so etwa diffamierte der Völkische Beobachter 1930 die Ausstellung „Der billige Gegenstand" als „Anpreisung der Ramschware der Warenhäuser". 1933 wurde der zweite Direktor, der Entwerfer Wolfgang von Wersin, auf die Unterstellung hin, er sei Jude, entlassen, 1934 die Leitung des Hauses dem Bayerischen Nationalmuseum übertragen. Ausstellungsthemen und Erwerbungen spiegelten nun die Ideologie der Machthaber wider. Zahlreiche Sammlungsgegenstände wurden damals Waisenhäusern zugeteilt oder zu Schleuderpreisen verkauft, der Bestand um ein Viertel gemindert.

Von 1940 bis 1946 geschlossen, wurde Die Neue Sammlung 1947 aus dem Zwangsverband mit dem Bayerischen Nationalmuseum gelöst und als selbstständiges Haus mit der Bezeichnung „Museum für angewandte Kunst in München" und einer Ausstellung über „Moderne französische Keramik" wiedereröffnet. Während die Sammlung immer weiter wuchs und internationales Renommee erlangte, gestattete die Raumnot keine dauerhafte Präsentation der „permanent collection" und zwang zu einem unablässigen Reigen an Wechselausstellungen, um das Haus im Fokus der Aufmerksamkeit zu halten. Besondere Betonung lag auf aktuellen, häufig auch grenzüberschreitenden Themen, so etwa die Ausstellung über „Max Bill" 1957, „Oskar Schlemmer und die abstrakte Bühne" 1961, „Architektur der Vergänglichkeit — Lehmbauten der Dritten Welt" 1981, „Künstlerplakate" 1990, „Marcello Morandini" 1993, „Arne Jacobsen" 1994, „Process — A Tomato Project Munich" 1998.

Heute gehört Die Neue Sammlung — das Staatliche Museum für angewandte Kunst in München — zu den international führenden Museen für angewandte Kunst und Design. Industrial und Product Design bilden seit eh und je einen besonderen Schwerpunkt. Dazu kommen die verschiedenen Bereiche des Kunsthandwerks sowie Graphic Design und Fotografie. Darüber hinaus wurden in den letzten Jahrzehnten ganz neue Sammlungsgebiete aufgebaut, etwa Computer Culture, der Bereich Sportgeräte, die Sonderabteilung Japan, die für unsere Zeit so charakteristische Systementwicklung oder das Fahrzeugdesign in einzelnen, formal beispielhaften Entwicklungen. Allein von 1980 bis 2003 hat sich die Anzahl der Objekte fast verdreifacht.

Ob vor der zwangsweisen Schließung in der Nazizeit oder seit 1945: Neubaupläne tauchten auf und verschwanden wieder in den Schubladen. Aus der steten Forderung nach adäquater Unterbringung entstand erst 1990 der Entschluss für zwei Neubauten: das Neue Museum in Nürnberg — eröffnet im April 2000 — und die Pinakothek der Moderne in München — eröffnet im September 2002. Mit der Pinakothek der Moderne ist erstmals eine umfassende Dauerausstellung aus den Beständen der Neuen Sammlung möglich geworden, die die facettenreiche Geschichte und Entwicklung der angewandten Kunst des 20. und 21. Jahrhunderts einer breiten Öffentlichkeit anschaulich machen kann, und dies in einem Haus, in dem vier Museen freie Kunst, Grafik, Architektur und Design gattungsübergreifend unter einem Dach darstellen.

Im Neuen Museum, dem Staatlichen Museum für Kunst und Design in Nürnberg zeigt Die Neue Sammlung in Reaktion auf die Sammlung Kunst, deren Schwerpunkt in der zweiten Hälfte des 20. Jahrhunderts liegt, mit der Sammlung Design einen ganz spezifischen Ausschnitt ihrer großen internationalen Bestände. Ein Ausschnitt, der in Konzentration auf die Zeit von 1945 bis zur „Schnittstelle 2000" in signifikanten Beispielen Zeittypik und visionäre Tendenzen vor Augen führt, freie Spiele der gestalterischen Phantasie oder Objekte, die auf die eine oder andere Weise Utopien enthalten, die vielleicht sogar einmal als stilistische Sackgassen galten, von deren Unruheherd jedoch belebende Impulse mit enormer Wirkung ausstrahlten, wie es etwa beim Pop und Anti Design der 60er Jahre oder später bei Alchimia und Memphis zu beobachten ist.

Die Gründung der Neuen Sammlung folgte einer Vision. „Humanisierung der Gesellschaft durch Gestaltung" nannte ein früherer Direktor dieses Ziel. Wir mögen heute zwar nicht mehr an diesen Traum glauben, der sich in den Objekten manifestiert. Als Reflexe dieser Vision stehen jedoch diese Gegenstände gestalterischen Wollens nach fast einem Jahrhundert des Sammelns nun erstmals in den neuen Museen in München und Nürnberg für ein internationales Publikum zur Diskussion.

F. H.

HISTORY OF THE MUSEUM

With over 60 000 objects from the fields of industrial and product design, graphic design and the applied arts, Die Neue Sammlung is one of the leading museums for 20th and 21st century applied art. The idea behind setting up the museum was closely linked to the ideals and foundation of Deutscher Werkbund in Munich in 1907. From that time onwards the creation of a "modern collection of exemplary items" began, which became the core of Die Neue Sammlung's Collection. In view of the indispensability of industrial production methods, from the very outset the emphasis was on acquiring "modern" everyday objects with an exemplary design. This marked a conscious break with the practice followed by most arts and crafts museums of the day.

In 1925, Die Neue Sammlung was established as a museum by the state, and was initially known as the "Commercial Arts Department" of the Bavarian National Museum, until it was given the apt name "Die Neue Sammlung" in 1929 indicating the desired thrust of the Collection. Though there might have been shifts of emphasis the reformist-idealist origins and general avant-garde intentions continue to influence the museum's work to this very day. The fact that this State Museum of Applied Arts and Design includes the word "neu / new" in its name clearly signals its agenda: the focus on the present, on an international reach and the insistence on trailblazing design quality. As such, the phenomenon "Die Neue Sammlung" can probably be best understood in the context of the subversive and cosmopolitan mindset of the 1920s: New Realism, New Architecture, and New Typography were parallel movements.

As of 1925, the museum was provisionally accommodated in a garden wing of the Bavarian National Museum. In 1928, Kurt Schwitters admired the already considerable museum collection in these inadequate premises. That same year the founding director resigned himself to the situation not improving: the promised new building did not materialize, and he left to take up an appointment in Berlin. Not long afterwards, Die Neue Sammlung's progressive exhibitions came under fire from Nazi politics. For instance, the newspaper "Völkischer Beobachter" referred in 1930 to the exhibition "Der billige Gegenstand" (The Cheap Object) as "praise for the cheap rubbish in department stores". In 1933, the second director, designer Wolfgang von Wersin, was dismissed for allegedly being a Jew. In 1934, the management of the Neue Sammlung was given over to the Bavarian National Museum. Exhibition topics and acquisitions henceforth reflected the ideology of the Nazi rulers. Numerous collection items were allocated to orphanages or sold at ridiculously cheap prices and the Collection was reduced by a quarter.

Closed from 1940 until 1946, Die Neue Sammlung was released in 1947 from its compulsory alliance with the Bavarian National Museum, and re-opened as an independent institution named "Museum for Applied Art in Munich" with its premiere exhibition on "Modern French ceramics". Although the Collection continued to expand, and gained international prestige, lack of space still did not allow for ongoing presentation of the "permanent collection", and necessitated an incessant series of temporary exhibitions in order to keep attention focused on the museum. Special emphasis was placed on current topics, whereby these were often interdisciplinary in nature, such as the show on "Max Bill" 1957, "Oskar Schlemmer and the abstract stage" 1961, "Architecture of Transience — Clay Buildings in the Third World" 1981, "Posters by Artists" 1990, "Marcello Morandini" 1993, "Arne Jacobsen" 1994, "Process — A Tomato Project Munich" 1998.

Today, Die Neue Sammlung — the State Museum of Applied Arts and Design in Munich — is one of the world's leading museums for applied arts and design. Industrial and product design have always formed a special focal topic. Then there are the various fields of applied art, not to mention graphic design and photography. In addition, totally new collection fields were assembled in recent decades, such as computer culture, sport equipment, Japanese design, systems development (so typical of today), or individual exemplary aspects of automobile design. Between 1980 and 2003 alone, the number of objects has almost tripled.

Both before the forced closure of the museum during the Nazi period and after 1945, plans for new buildings emerged, but were immediately shelved once more. It was not until 1990 that the constant call for adequate premises led to the decision to have two new buildings: Neues Museum in Nuremberg — opened in April 2000 — and Pinakothek der Moderne in Munich — opened September 2002. At Pinakothek der Moderne it is possible for the first time to hold a permanent exhibition featuring Die Neue Sammlung items, and to present the many-sided history and development of applied art in the 20th and 21st centuries to a broad public. What is even more astounding: this is achieved in a building in which four museums present cross-disciplinary exhibitions on the liberal arts, graphic art, architecture and design — under a single roof.

Neues Museum, the State Museum for Art and Design in Nuremberg, has an art collection which focuses on the second half of the 20th century. It is in response to this that Die Neue Sammlung is presenting a design collection there with a highly specific selection from its varied international holdings. A selection which in concentrating on the time from 1945 up to the "turning point 2000" shows us significant examples of typical phenomena of the day as well as visionary trends, free experimentation of artistic imagination or objects that contain utopias in one way or another which might even once have been considered a stylistic dead-end, and yet functioned as lively stimuli that had an incredible impact, as can be observed in the Pop and Anti-Design of the 1960s or later in Alchimia and Memphis.

Die Neue Sammlung was founded in pursuit of a vision. "Humanizing society through design" was the way one of our directors described this goal. Today, we may no longer believe in this dream, something that manifests itself in objects. And yet almost a century after the collection was established, the items of artistic striving displayed here are the visible signs of that vision and are now on show for the first time in the new museums in Munich and Nuremberg, where an international audience will no doubt ponder over them.

F. H.

New York

Cooper-Hewitt, National Design Museum
Smithsonian Institution
www.ndm.si.edu

COLLECTION

Cooper-Hewitt, National Design Museum, Smithsonian Institution

DESIGNER / ARCHITECT

Frank O. Gehry

OBJECT

Side chair / Stuhl

DATE

1970

MANUFACTURER

Easy Edges Inc, New York

Cooper-Hewitt-Museum, The Smithsonian Institution's National Museum of Design

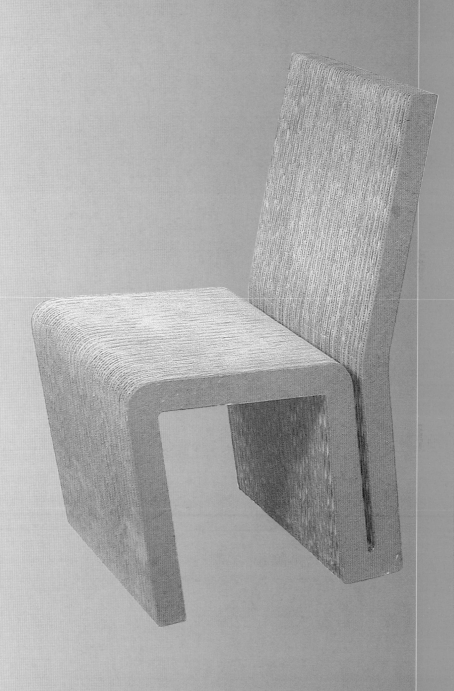

GESCHICHTE DES MUSEUMS

Als Cooper Union Museum for the Arts of Decoration (für angewandte Kunst) wurde das spätere National Design Museum in New York offiziell im Mai 1897 eröffnet. Das Museum befand sich in Lower Manhattan, im vierten Stock der Cooper Union for the Advancement of Science and Art, die 1859 von Peter Cooper als freie Schule für Bedürftige gegründet worden war, unabhängig davon, welcher ethnischen Gruppierung, Konfession, Hautfarbe oder welchem Geschlecht sie angehörten. Cooper hatte geplant, ein Museum an die Schule anzuschließen, dieser Plan sollte jedoch erst von seinen Enkeltöchtern — Sarah, Eleonor und Amy Hewitt — in die Tat umgesetzt werden.

Auf ihren Auslandsreisen lernten die Schwestern Hewitt das Musée des Arts Decoratifs in Paris und das South Kensington Museum (das spätere Victoria & Albert Museum) in London kennen. Sie hatten diese beiden Institutionen vor Augen als sie beschlossen, für dieses Land eine 'visuelle Bibliothek des Designs' zu schaffen. Eifrig trugen sie Knöpfe, Bronzepferde, seltene Textilien, Zeichnungen und Grafiken, Möbel, Hutschachteln, Vogelkäfige, Teigformen, Spitze, Glas und zahllose andere ornamentale oder kunsthandwerkliche Objekte zusammen. Die Schwestern waren der Auffassung, dass die amerikanische Tradition aus der europäischen Kultur erwachsen.

So wurden während der 20er und 30er Jahre durch das Museum vor allem Beispiele des europäischen Kunsthandwerks aus dem 16. bis hin zum frühen 19. Jahrhundert zusammengetragen. Stile wie Renaissance und Gotik wurden besonders geschätzt und entsprechend dokumentiert, sowohl in der ursprünglichen als auch in der eklektizistischen Form des Historismus, dennoch wurden bevorzugt Objekte des Barock und Rokoko, neoklassische Gegenstände und exotische Chinoiserien gesammelt.

In den 40er und 50er Jahren wurde dem Design von Seiten des Museums eine größere Bedeutung beigemessen. Design wurde nunmehr aus unterschiedlichen Blickwinkeln einer Neubewertung unterzogen. Es wurde über den Sinn und Zweck von Design debattiert, die Praxis hinter-fragt und die Designausbildung überprüft. Design zu entwerfen, wurde immer mehr zu einer professionellen Tätigkeit. Entsprechend bemühte man sich von Seiten des Museums um den Aufbau einer zeitgenössischen Designsammlung. Mit der Ausstellung 'Elements of Design' im Jahr 1955 demonstrierte das Museum erstmals den neuesten Stand seiner konzeptuellen Zielsetzungen der Öffentlichkeit.

96 Objekte aus der Sammlung wurden in fünf Gruppen vorgestellt, wobei jede Gruppe ein visuelles Schlüsselelement wie Farbe, Ober-flächenbeschaffenheit, Liniengebung, Rhythmus oder Form zum Thema hatte. Mit diesem Ansatz wurden jene Eigenschaften hervorgehoben, die zur Gesamterscheinung eines Objekts beitragen. Zudem wurden ästhetische Überlegungen, die für den Designer wichtig waren, auf diese Weise zur Diskussion gestellt. Die Geschichte des Objekts, sein Herstellungsort, seine Funktion und sein Stil blieben im Hintergrund. Beleuchtet wurde lediglich die gestalterische Formensprache.

In den 60er Jahren spiegelte sich der liberale Geist der Zeit in den Schenkungen der Sammler an das Museum wider. Das Eklektizistische war allgegenwärtig. Doch gleichzeitig zeichneten sich Veränderungen auf einer ganz anderen Ebene ab: 1963 musste die Cooper Union bekannt geben, dass sie nicht länger das Museum finanzieren könne. Das Cooper Union Museum for the Arts of Decoration, das seit 1897 bestand, wurde für die Öffentlichkeit geschlossen.

Ein Ausschuss zur Rettung des Cooper Union Museums gründete sich, und es begann die Suche nach einem neuen Standort. 1967 kam das Smithsonian Institut zu Hilfe. Ein Jahr später erhielt das Institut von der Carnegie Corporation das Angebot, das Museum in der Andrew Carnegie Villa unterzubringen.

Neun Jahre später, am 6. Oktober 1976 wurde das Cooper Union Museum for the Arts of Decoration offiziell in der renovierten Carnegie Villa als Cooper-Hewitt Museum, The Smithsonian Institution's National Mueum of Design wiedereröffnet. Anstatt die Sammlungen vorzustellen, zog man es vor, ein Statement zum Thema Design in einer Ausstellung zu präsentieren. Man stellte traditionelle Vorstellungen über Design, die Beziehung zwischen Form und Funktion und sogar die Bedeutung des Begriffs Design zur Diskussion und es trat eine vielversprechende neue Haltung zutage. Das Cooper-Hewitt Museum unternahm den Versuch, Herstellungsprozesse von der Idee bis zur Frage des Materials darzustellen, die Rolle des Designers als Entscheidungsträger ebenso aufzuzeigen wie die unterschiedlichen Lösungsmöglichkeiten, die sich bei der Gestaltung eines Stuhls oder einer Lampe ergeben.

Seit dieser Zeit hat das Museum in seiner Sammlungstätigkeit einen Schwerpunkt darauf gelegt, den Designprozess vom ursprünglichen Konzept bis zum realisierten Objekt zu dokumentieren. Idee und Intention des Designers, die Fähigkeit aus den zur Verfügung stehenden Materialien auszuwählen und sich diese durch entsprechende Werkzeuge und Technologien zu Nutze zu machen als auch Formgebung und Funktionalität wurden grundlegende Sammlungskriterien des Cooper-Hewitt Museums. Als National Design Museum hat das Cooper-Hewitt enorm an Bedeutung gewonnen. Die Zukunft unserer Umwelt, die Lebensqualität und die Art und Weise, wie sich Design auf unser Alltagsleben auswirkt, sind Themen, die jeden betreffen und in diesem Sinne erkennt das Museum seine Verantwortung als Vermittler im Designprozess. Dieser Aspekt kommt im Ausstellungsprogramm des Cooper-Hewitt Museums deutlich zum Tragen wie zum Beispiel bei der nationalen Design Triennale, mit der bahnbrechende Entwicklungen und zukünftige Perspektiven der Designpraxis, von der Architektur bis zum Interior- und Produktdesign sowie Grafikdesign und Mode vorgestellt werden.

Die Sammlungen des Cooper-Hewitt Museums sind heute wieder eine wichtige Quelle für Studenten, Designer und Wissenschaftler und das Museum ist zu einem lebendigen Forum geworden, über das das Publikum in einen Dialog über Design eintreten kann.
(Cooper-Hewitt, National Design Museum, Smithsonian Institution)

HISTORY OF THE MUSEUM

The Cooper Union Museum for the Arts of Decoration was officially opened on May 1897. The museum was located in Lower Manhattan on the fourth floor of the Cooper Union for the Advancement of Science and Art, founded in 1859 by Peter Cooper, as a free school for the "respectable needy", regardless of race, creed, color, or sex. Peter Cooper had intended to include a museum as part of his school, but it remained for his granddaughters — Sarah, Eleonor and Amy Hewitt — to finish his work.

The Hewitt sisters' travels abroad had taken them to the Musée des Arts Decoratifs in Paris and the South Kensington Museum (now Victoria & Albert Museum) in London, and it was with these two institutions in mind that they set out to create a visual library of design for this country. Zealously they garnered buttoms, bronze mounts, rare textiles, drawings and prints, furniture, bandboxes, bird cages, food molds, lace, glass, and countless other forms of decoration and ornament.

It was the Hewitt sisters' opinion that European accomplishments should provide the foundations on which our own tradition would grow. Throughout the 1920s and 1930s the museum concentrated on assembling examples of the major European styles of decoration from the 16th to the early 19th century. The Renaissance and Gothic styles were appreciated and documented, both in their original and revival forms, but the favored and most eagerly collected styles were the Baroque, Rococo, and Neoclassical, along with the exotic expressions of chinoiserie.

In the 1940s and 1950s, the museum's understanding of design broadened. European and American Modernist thinking had matured, and design was being reexamined from every angle. Its purpose was debated, its practices were reconsidered, and design education was overhauled. Design became a profession, and its practitioners, professionals. So the museum set out to build a collection of contemporary design. The staff of the museum thought about the objects in its collections differently and exhibited them in a new way.

The 1955 exhibition "Elements of Design" was a demonstration of the museum's updated outlook. Ninety-six objects from the collection were arranged in five groups, each group representing a key visual element of design color, surface, line, rhythm, and form. This approach high-lighted features that contribute to the overall appearance of an object, and it also brought to the fore aesthetic considerations that had been important to the designer. The history of the object, its place of manufacture, its function, and its style all receded into the background. The spot-light was on the formal language of design.

During the 1960s, the interests and tastes represented in collectors' gifts to the museum reflected the liberal spirit of the times themselves. Eclecticism was the order of the day. But the 1960s also brought change of another order to the museum. In 1963, Cooper Union announced that it could no longer afford to operate the museum. And the doors of the Cooper Union Museum for the Arts of Decoration, which had been open to all since 1897, were closed. A Committee to Save the Cooper Union Museum was formed, and the search began for a new home. In 1967, the Smithsonian Institution came to the rescue. In 1968, the Carnegie Corporation offered the Smithsonian the Andrew Carnegie Mansion as the museum's new home.

On October 6, 1976, the Cooper Union Museum for the Arts of Decoration was formally re-opened in the renovated Carnegie Mansion as Cooper-Hewitt Museum, The Smithsonian Institution's National Museum of Design.

Rather than show its collections, the museum decided to make a statement about design itself. Traditional beliefs about design, relationships between form and function, and even the meaning of the word design were challenged, and an exciting new attitude was revealed. Cooper-Hewitt had embarked on an exploration of the design process in an effort to understand the transformation of ideas and materials, the role of the designer as decision-maker, and the solutions and possibilities inherent in designing a chair, a lamp, or the environment.

Since that time the museum has concentrated on building its collections by documenting the design process, from initial concept to realized object. Designers' ideas and intentions, their skill in selecting from the array of materials available to them, and their success in manipulating materials with tools and technology are all assessed, along with appearance and function, when determining the suitability of objects for Cooper-Hewitt's collections.

As the National Museum of Design, Cooper-Hewitt's role has expanded greatly. The future of the environment, the quality of life, and the way which design affects everyday living are issues of universal concern, and the museum recognizes its responsibility as an advocate in the design process. This is clearly manifested in the Cooper-Hewitt's exhibition program, such as the "National Design Triennial" which looks breaking developments and future horizons across the fields of design practice, from architecture and interiors to product design, graphic design, and fashion.

Cooper-Hewitt's collections are a vital resource for students, designers, and scholars, and the museum has become a lively forum through which the general public can engage in a dialogue on design. (Cooper-Hewitt, National Design Museum, Smithsonian Institution, New York)

New York

The Metropolitan Museum of Art
www.metmuseum.org

COLLECTION

The Metropolitan Museum of Art

DESIGNER / ARCHITECT

Frank Lloyd Wright

OBJECT

Concrete Block from the Charles Ennis House
Betonblock vom Charles Ennis House

DATE

1924

MANUFACTURER

unknown / unbekannt

The Metropolitan Museum of Art, Anonymous Gift, in honor of Antonio David Blanco, 1984 (1984.447)

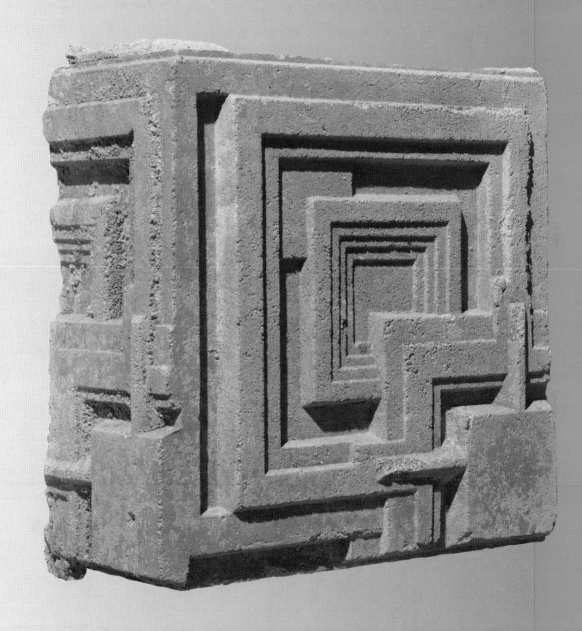

GESCHICHTE DES MUSEUMS

Das zeitgenössische oder moderne Design hat seit der Gründung des Metropolitan Museums im Jahre 1870 immer eine wichtige Rolle gespielt. Die Gründungsstatuten des Museums sahen eine Institution vor, die das Studium der schönen Künste sowie deren Anwendung in der Herstellung und im praktischen Leben fördern und weiterentwickeln sollte. Daher wurden früh zeitgenössische Objekte von Herstellern in New York City gesammelt und ausgestellt. 1880 wurde eine Schule für Industrielle Kunst gegründet, wobei das Gründungskuratorium die Auffassung vertrat, dass Amerika von der ausländischen Produktion schöner Objekte in jedem Bereich der Industrie unabhängig werden muss. Wenn die amerikanische industrielle Kunst mit der aus den europäischen Ländern gleichziehen will, kann dies nur durch ausgebildete Handwerker geschehen. Mit der Erweiterung der Schule jedoch gingen deren Bedürfnisse und die des Museums auseinander — 1894 wurde sie schließlich geschlossen. An ihrer Stelle entstand 1907 eine Abteilung für Angewandte Kunst unter der Leitung von Wilhelm R. Valentiner, der in Deutschland ausgebildet worden war. In dieser Abteilung wurde dem Design von den Kuratoren allmählich die Bedeutung eines Ausstellungsgegenstandes beigemessen. Doch mit Ausbruch des Ersten Weltkrieges waren US-amerikanische Designer vom europäischen Design abgeschnitten. Das Museum versuchte, diese Lücke zu füllen, indem es einen Vize-Kurator für Angewandte Kunst (Joseph Breck), und eine Fachkraft für Industrielle Kunst (Richard Bach) anstellte. Dank dieser beiden Mitarbeiter wurden fortan moderne Designobjekte vom Museum gesammelt und ausgestellt. 1917 entstand eine alljährliche Ausstellungsreihe der Arbeiten zeitgenössischer Designer und Hersteller. Man beschränkte sich auf Objekte, deren Inspirationsquelle Kunstwerke aus den Sammlungen des Metropolitans darstellten. Aber schon 1924 umfasste die Ausstellung etwa 900 Objekte, die allesamt hervorragende Beispiele für zeitgenössisches Design waren. In der Zwischenzeit, im Jahr 1922, hatte Edward C. Moore Jr. dem Museum Gelder zur Verfügung gestellt, die für den Erwerb zeitgenössischer Designobjekte bestimmt waren. Erst durch sie wurde der Ankauf wichtiger Jugendstil- und Art Deco-Objekte möglich. Während der späten 20er Jahre gab es eine Reihe von Ausstellungen zu zeitgenössischer angewandter Kunst aus dem Ausland: zu nationalen Schulen (z. B. 1927 Schweden) oder auch zu bestimmten Werkstoffen und Materialien (z. B. 1928 zur Keramik). Dieses goldene Zeitalter des Designs erreichte seinen Höhepunkt mit der Ausstellung „The Architect and the Industrial Arts" im Jahre 1929, die einen neuen und anspruchsvollen Ausstellungstypus charakterisierte. Es wurden komplette Zimmereinrichtungen ausgestellt, die moderne US-amerikanische Architekten entworfen hatten, darunter Eliel Saarinen und Raymond Hood. Frank Lloyd Wright hatte man zwar eingeladen, ein Musikzimmer zu entwerfen, jedoch nahm er dieses Angebot nicht an.

Die alljährlichen Ausstellungen fanden bis in die 30er Jahre sporadisch bis 1940 statt, als die 15. Ausstellung die letzte sein sollte. Damals richtete sich in New York das Hauptaugenmerk in Sachen Design auf das 1929 gegründete Museum of Modern Art. 1933 wurden die wissenschaftlichen Abteilungen des Metropolitan umstrukturiert und die Abteilung für Angewandte Kunst in drei neue Abteilungen aufgeteilt: Mittelalter, Renaissance, Moderne, und American Wing. Keiner der Kuratoren hatte viel für zeitgenössische Formgebung übrig. Während der 40er Jahre verlagerte sich das Interesse von der angewandten Kunst zur Kostümkunst, was 1946 zur Gründung des Costume Institute führte.

Erst 1967 mit der Gründung der Abteilung für Zeitgenössische Kunst — 1970 wurde sie in Abteilung für Kunst des 20. Jahrhunderts umbenannt und später in Abteilung für Moderne Kunst — hat das Metropolitan erneut sein klares Interesse für moderne und zeitgenössische Kunst und Gestaltung bekundet. In diesem Jahr wurde durch das Museum auch das berühmte Fenster-Triptychon aus Frank Lloyd Wrights Avery Coonley Playhouse von 1912 angekauft. Fünf Jahre später, im Jahre 1972, erwarb das Museum das gesamte Francis Little Haus, das Wright 1912-1915 in Wayzata im Bundesstaat Minnesota gebaut hatte. Dieser Ankauf ist im Zusammenhang der Erweiterungspläne des American Wing zu sehen, der Raum für die amerikanische Kunst und Architektur des 19. und des frühen 20. Jahrhunderts schaffen sollte. Das Musikzimmer aus Wrights Haus mitsamt der ursprünglichen Inneneinrichtung ist nun als Dauerausstellung im American Wing zu besichtigen. Seitdem sind auch viele andere Werke des größten US-amerikanischen Architekten (der zugleich als einer der besten Designer gilt) erworben worden, u. a. der elegante, mit einem geometrischen Muster versehene und aus Gussbeton geformte Textilblock aus dem Charles Ennis House in Los Angeles von 1924, der in Nürnberg zu sehen ist.

M. H. H. / L. A. F.

HISTORY OF THE MUSEUM

Contemporary or modern design has played a role at the Metropolitan ever since the museum was founded in 1870. The original charter called for establishing a museum for the purpose of encouraging and developing the study of the fine arts, and the application of arts to manufacture and practical life. Accordingly, during the earliest years, objects of contemporary manufacture in New York City were collected and exhibited. A school of industrial arts was established in 1880, the trustees opining that the time had certainly arrived when America should cease to be dependent upon the foreign production of beautiful works in any and every department of industry... If American industrial art is to rank with that of European countries, it can only be by having educated artisans. However, as the school expanded, its needs and those of the museum diverged; in 1894 the school was closed. In its stead, in 1907, a Department of Decorative Arts was established under the direction of the German trained Wilhelm R. Valentiner; and it was there that design would, in due course, become a factor in the curatorial shere of the museum.

With World War I, US Designers no longer had access to European design, and the museum undertook to fill that void, hiring an Assistant Curator of Decorative Arts (Joseph Breck), and an Associate in Industrial Arts (Richard Bach). Under these two men, the museum became remarkably active in collecting and exhibiting modern design. Beginning in 1927 they mounted a series of annual exhibits of the work of contemporary designers and manufacturers. The first modest show was limited to objects inspired by works in the museum's collection. By 1924, the annual included some 900 objects representing the best examples of contemporary design. Meanwhile, in 1922, Edward C. Moore, Jr. had given funds specifically for the acquisition of contemporary decorative arts, making possible the purchase of important Art Nouveau and Art Deco objects. During the late 1920s, there were a series of exhibits of contemporary applied arts from abroad, some devoted to national schools (for example, Sweden in 1927), others to specific materials (for example ceramics in 1928). This golden age of design may be said to have culminated in 1929 with "The Architect and the Industrial Arts", a new and ambitious type of exhibition incorporating complete room settings by modern American architects including Eliel Saarinen and Raymond Hood. Frank Lloyd Wright was invited to submit a music room, but did not.

The annual exhibitions continued, sporadically, during the 1930s, until the last one, the 15ᵗʰ, in 1940; but by then in New York the locus of interest in contemporary design had shifted to the Museum of Modern Art (founded 1929). In 1933, the Metropolitan's curatorial departments were reorganized and the Department of Decorative Arts divided into three — Medieval, Renaissance and Modern, and the American Wing — none with much of a stake in contemporary design. During the 1940s, there was a shift of interest from the applied arts to costume art; the Costume Institute was founded in 1946.

It was not until 1967, with the establishment of a Department of Contemporary Art (in 1970 renamed the Department of 20th Century Art, and later the Department of Modern Art), that the Metropolitan again evinced a compelling interest in modern and contemporary art and design. In that year the museum acquired the famous window triptych from Frank Lloyd Wright's Avery Coonley Playhouse of 1912. Five years later, in 1972, in anticipation of an addition to the American Wing to house American art and architecture of the 19th century and the beginning of the 20th, the museum acquired Wright's entire Francis Little House from Wayzata, Minnesota (1912–1915). The music room from the house, with all its original furnishings, is now permanently installed in the American Wing. Over the intervening years, much else by America's greatest architect (and one of her greatest designers) has also been acquired, including the elegant geometrically patterned textile block, of cast concrete, from the Charles Ennis House in Los Angeles of 1924, on loan to this exhibition.

M. H. H. / L. A. F.

Oslo

Kunstindustrimuseet i Oslo
www.kunstindustrimuseet.no

COLLECTION

Kunstindustrimuseet i Oslo

DESIGNER / ARCHITECT

Hans Brattrud

OBJECT

Chair / Stuhl 'Scandia Senior'

DATE

1956 / 1957

MANUFACTURER

Hove Møbler, Stordal 1959

Kunstindustrimuseet i Oslo

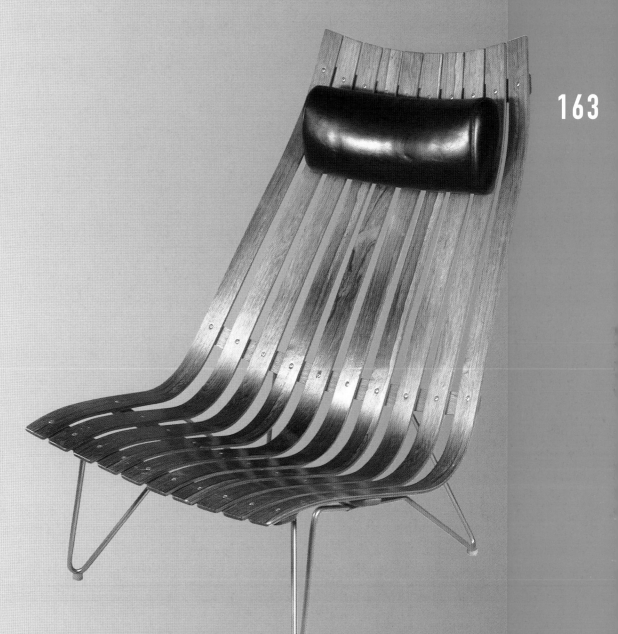

GESCHICHTE DES MUSEUMS

Das Kunstindustrimuseet wurde 1876 gegründet und ist eine der ältesten Institutionen dieser Art. In den vergangenen Jahrzehnten hat das Museum eine umfassende historische Sammlung von ungefähr 50.000 Objekten zusammengetragen. Unter den norwegischen Exponaten nehmen hier vor allem die alten Tapisserien eine herausragende Stellung ein. Bemerkenswert in diesem Zusammenhang ist insbesondere der Baldishol Gobelin, der um das Ende des 12. Jahrhunderts entstand. Die große Sammlung norwegischer Königsgewänder ist ebenfalls einmalig.

Das Museum verfügt über einzigartige Beispiele norwegischen Kunsthandwerks, hervorzuheben sind hier vor allem die Sammlungen von Silber, Glas und Fayencen aus dem 18. Jahrhundert und Plique-à-Jour Emaillen um 1900. Norwegisches, skandinavisches und internationales Design und Kunsthandwerk ist mit bis zu 15.000 Objekten gut repräsentiert. Im Jahr 2001 wurde das Museum vom Kultusministerium zum Designmuseum Norwegens ernannt. Im Juli 2003 wurde das Haus mit vier weiteren Museen in Oslo unter dem Überbegriff The National Museum of Art zusammengelegt. Zur Zeit wird erneut eine umfassende Ausstellung mit Design und Kunsthandwerk vorbereitet.

W. H.

HISTORY OF THE MUSEUM

The Museum of Decorative Arts & Design was founded in 1876 and is one of the oldest museums of its kind in Europe. Over the decades the museum has built up comprehensive historical collections of approximately 50 000 objects. Among the Norwegian highlights the old tapestries must be considered exceptional. The Baldishol tapestry from the end of 1100s deserves special mention. The large collection of Royal Norwegian apparel is also unique.

The museum houses the most exquisite examples of Norwegian applied art — emphasizing the outstanding collections of 18th century silver, glass and faience, and plique-à-jour enamels from around 1900. Contemporary Norwegian, Scandinavian and international design and crafts are well represented, amounting to about 15 000 objects. In 2001, the museum was appointed Norway's design museum by the Ministry of Culture. In July 2003, the museum merged with four other museums in Oslo under the heading The National Art Museum. The museum is currently remounting a comprehensive design and crafts exhibition.

W. H.

Paris

Centre national d'art et de culture Georges Pompidou
Centre de création industrielle
www.cnac-gp.fr

COLLECTION

Centre national d'art et de culture Georges Pompidou
Centre de création industrielle

DESIGNER / ARCHITECT

Pierre Chareau

OBJECT

Standard lamp / Stehlampe 'La Réligieuse'

DATE

1923

MANUFACTURER

Louis Dalbet, Paris

Centre Georges Pompidou, Musée National d'Art Moderne / Centre de création industrielle

COLLECTION

Centre national d'art et de culture Georges Pompidou
Centre de création industrielle

DESIGNER / ARCHITECT

Pierre Paulin

OBJECT

Seating system / Sitzsystem 'La déclive'

DATE

1968

MANUFACTURER

Mobilier International, France / Frankreich

Centre Georges Pompidou, Musée National d'Art Moderne, Centre de création industrielle

GESCHICHTE DES MUSEUMS

Als Ende 1991 der damalige Präsident des Centre Pompidou, Dominique Bozo, die Verschmelzung des Musée national d'art moderne mit dem Centre de création industrielle (CCI) forderte, nahm man sich diesem Abenteuer voller Enthusiasmus und in voller Unschuld an. Bereits im Jahre 1973, anlässlich der Integration des CCI in das Centre Georges Pompidou, hatte man Überlegungen über den eigentlichen Auftrag dieses neuen Museumsbereichs angestellt, der zum einen ein „Design-Observatorium" in Gestalt von thematischen oder monografischen Ausstellungen sein, und zum anderen die Möglichkeit einer historischen und ständigen Designsammlung bieten sollte. Aber es fehlten die Mittel. Mit dieser Verschmelzung, die gut zwanzig Jahre später erfolgte, konnte man davon ausgehen, dass das CCI einerseits zwar seine Autonomie verlieren, die angewandten Künste dagegen Gelegenheit finden würden, zum Bestand bildender Kunst am Centre zu gehören, und andererseits die Zusammenstellung der Designsammlung vielleicht eine Möglichkeit sein konnte, um das damals umstrittene CCI zu stärken. Anstatt sich in überflüssigen und verzweifelten Spitzfindigkeiten zu verlieren, zog man daher vor, sich „wie der kleine Däumling im Wald" auf die Suche nach jenen Objekten zu machen, auf die jeder Design-Historiker verweist und die nach allgemeiner Ansicht geschichtsträchtig sind.

Die vordringlichste Aufgabe bestand also darin, einen klaren Rahmen festzulegen und ein Feld abzustecken, das sich von dem des Musée des Arts décoratifs unterschied. Als Kriterium wurde das für die Serienfertigung bestimmte Design festgelegt, wobei das grundlegende Prinzip darin bestand, dass jedes Objekt der verwirklichten oder nicht verwirklichten Absicht seines Designers entsprechen musste, es in Tausenden von Exemplaren herzustellen. Ausgehend von dieser Definition wurde die industrielle Serienproduktion in hohem Maße abgedeckt — angefangen vom Haushaltsdesign bis hin zum Militärdesign; diese Präsenz von Designobjekten an einem Ort der Kultur wurde zum Teil als starke Provokation gewertet. Aber das Centre Pompidou mit seinem prototypartigen Gebäude als Sinnbild für das Ende der 60er Jahre besitzt eine derart starke Suggestivkraft, das es auf vollkommen natürliche Weise dazu auffordert, sich mit allen Formen der Kreativität zu befassen, und das Industriedesign des 20. Jahrhunderts gehört unzweifelhaft dazu.

Im letzten Jahrzehnt des Jahrhunderts eine Sammlung mit Designobjekten des 20. Jahrhunderts zusammen zu tragen — während es früher bereits zahlreiche Gelegenheiten gab, dies zu tun —, mit dem unvermeidlichen Vorbild des New Yorker Museum of Modern Art im Hinterkopf, hatte gleichwohl einen enormen Vorteil: weil die Geschichte bereits zum Teil geschrieben war, wurde die Auswahl der wichtigen Designer des Jahrhunderts für uns in erheblichem Maße erleichtert. Es war zum Beispiel nicht mehr möglich, sich der Präsentation der funktionalistischen Bewegung der sechziger Jahre anhand der Zusammenarbeit von Bellini und Olivetti, Rams und Braun oder Noyes und IBM anzunähern, ohne die Bewegungen und die Designer herauszustellen, die ihnen in Italien innerhalb der Gruppen Archizoom und Superstudio radikal widersprochen hatten. Ebenso war es nicht möglich zu ignorieren, dass die Szene der achtziger Jahre im Zeichen des „Nouveau Design" unter der Leitung von Memphis in Mailand stand und dass sich in Frankreich das Talent von Philippe Starck zeigte, der dann die neunziger Jahre dominierte. Einen eigenen Designbereich innerhalb des Musée national d'art moderne zusammen zu stellen, war natürlich mit einigen Zwängen verbunden. Und sei es auch nur im Hinblick auf die übrigen Sammlungen — Malerei, Bildhauerei, Grafik, Fotografie, Architektur —, deren Nachbarschaft zu einer extrem rigorosen Auswahl zwang. Die Designsammlung sollte in der Tat auf Grund ihrer Originalität und ihrer Besonderheiten einen eigenen und einzigartigen Charakter besitzen, der sich aus der sowohl historischen, als auch formalen Qualität der ausgewählten Objekte ergab. Aus diesem Grunde bestand die seit 1992 verfolgte Strategie darin, Schwerpunkte im Umfeld der „Klassiker" der Design-Geschichte zu schaffen und zu entwickeln. Die Anstrengungen bezogen sich zunächst auf den Ankauf von Objekten aus der „historischen" Epoche, wie sie von den Designern der Moderne konzipiert worden sind (Charlotte Perriand, Jean Prouvé, René Herbst, Pierre Chareau u. a.). Gleichzeitig durfte diese Sammlung ihre Rolle als „Observatorium" mit dem Auftrag, das Klima des zeitgenössischen Designs zu erfassen, nicht vernachlässigen. So hat sie auch junge Designer der Gegenwart, wie Matali Crasset, Ronan Bouroullec oder Konstantin Grcic aufgenommen, deren Schöpfungen zu Objekten mit stark emotionalem und poetischem Ausdruck geführt haben, die weit vom Funktionalismus der 60er Jahre entfernt sind.

Auch wenn die Designsammlung letztlich mit einiger Verspätung in Angriff genommen worden ist, hat der weltweite Bekanntheitsgrad des Centre Georges Pompidou in all diesen Jahren dennoch dafür gesorgt, dass wir auf einen nicht nachlassenden Enthusiasmus gestoßen sind. Designer und Industrie haben uns stets zur Seite gestanden, um uns zu helfen, Nachforschungen anzustellen und Objekte aufzutreiben und zu verschaffen, die uns fehlten und auch heute noch fehlen. Mit einigen von ihnen — und nicht den unbedeutendsten — verbinden uns seither Freundschaften, wobei ihre Unterstützung mit unseren Bemühungen auf dem Gebiet der Ausstellungen einherging. Ettore Sottsass — tief berührt von der Tatsache, dass unser erster Ankauf seinen Schöpfungen galt —, machte uns eine bedeutende Schenkung, etwas, was er zuvor noch nie getan hatte: Seine Keramiken aus den 60er Jahren, die lackierten Holzmodelle der Serie „Yantra" und fünfzehn Originalzeichnungen aus der Memphis-Periode haben dem Museum nicht nur auf diese Weise einen einzigartigen Fundus geschaffen, sondern spiegeln zudem das kreative Universum dieses Vorreiters des italienischen Designs wider. Ganz anders bei Charlotte Perriand: entsprechend unserer Absicht, dass das CCI nur einige wenige Objekte in die Sammlung aufnehmen wollte, empfahl sie uns die ihrer Ansicht nach wichtigen und überließ uns Möbel aus ihrem Atelier. Die allererste Erwerbung des CCI erfolgte dann aber auf einer Auktion im Herbst 1991 in Monaco und unter relativ abenteuerlichen Bedingungen: Dominique Bozo wurde erst drei Tage vor dem Termin über eine Versteigerung informiert, die sich u. a. auf Möbel aus dem Hause E. 1027 von Eileen Gray bezog. Es gelang ihm, den staatlichen Kulturfonds von der Bedeutung eines Ankaufs zu überzeugen, und uns schließlich, ein Ensemble, bestehend aus neun Einzelelementen zu erwerben, dessen Kohärenz einen der Schätze der Sammlung darstellt. Im Laufe der Zeit ist die sich konstituierenden Designsammlung schließlich auch zu einem Konservatorium geworden.

Auch heute ist das Abenteuer unverändert spannend geblieben, und die Projekte sind noch immer ebenso zahlreich, denn unser Auftrag, der noch lange nicht abgeschlossen ist, zwingt uns dazu, eine Vielzahl von Lücken zu schließen: das betrifft sowohl die skandinavischen Länder (Arne Jacobsen, Poul Kjaerholm), als auch Japan, bei denen Ensembles der bedeutendsten Designer noch ergänzt werden müssen (Sori Yanagi, Shiro Kuramata, Isamu Noguchi), oder auch die USA im Bereich der Bewegung des Streamline, die in den 30er Jahren als Antwort auf die Krise von 1929 sehr wichtig gewesen ist. Geschehen wird dies anhand von Ankäufen, Ausstellungen — wenngleich das Risiko, wage-mutige und provokative Ausstellungen zu zeigen oder vorzubereiten ein wenig verschwunden ist — oder auch von Begegnungen, denn man darf die Rolle der Netzwerke, Zufälle oder Begeisterungen nicht unterschätzen.

Der Tradition der interdisziplinären Offenheit des Musée national d'art moderne verpflichtet, wollen wir gleichzeitig auf dem Wege einer soli-den wissenschaftlichen Forschung weitermachen, indem wir im Rahmen des Möglichen — und das ist leider nur selten der Fall — das Umfeld der ausgewählten Objekte wiedergeben und eine Kaufpolitik praktizieren, die sich auf Zeichnungen, Kataloge und nunmehr auch auf Videos erstreckt — Elemente, die dem Objekt eine neue und zugleich vollständigere Lesart verleihen und eine Einschränkung auf das Konzept des Kunstobjekts vermeiden. Unser Ziel besteht auch und vor allem darin, beim Betrachter die Vorliebe für das zeitgenössische Design zu weck-en, oder (zumindest) die Lust sich mit ihm zu beschäftigen — (M.-L.J. in: La collection de design du Centre Georges Pompidou, Paris 2001)

M.-L.J.

HISTORY OF THE MUSEUM

When, at the end of 1991, the then President of the Centre Pompidou, Dominique Bozo, called for the merger of the Musée national d'art moderne and the Centre de création industrielle (CCI), the adventure was greeted with great enthusiasm and in total innocence. As early as 1973, on the occasion of the integration of the CCI into the Centre Georges Pompidou, there had been discussion as to the real purpose of this new museum section, which on the one hand was to be a "design observatory" in the form of exhibitions with a particular theme, or monographs, and on the other was to provide an opportunity for a permanent, historical design exhibition. However, the financial resources were simply lacking. As a result of the merger, which came about some twenty years later, it was safe to assume that the CCI would, on the one hand, lose its autonomy, but that applied art, on the other, would find a place in the permanent collection of fine arts at the Centre, meaning that the creation of the design collection could provide a means of strengthening the position of the CCI, which at the time was in dispute. Instead of getting bogged down by superfluous and despairing splitting of hairs, we preferred to set out like little Tom Thumb in the woods, in search of those objects that are constantly being referred to by design experts, and which are generally considered to be of historical value.

The most pressing task at hand was therefore to establish a framework and outline a field of activity that differed from that of the Musée des Arts décoratifs. The criterion agreed upon was the design of mass-produced objects, whereby the basic principle was that each object had to fulfill its designer's intention of producing the article in thousands, irrespective of whether this actually happened. This definition covered a very broad spectrum of industrial mass production — beginning with household goods and extending as far as military design; the fact such design objects were on display at a cultural venue was in itself considered highly provocative. The Centre Pompidou, however, its prototype-like building the very symbol of the end of the 1960s, possesses such suggestive powers that it prompts us in a perfectly natural manner to address all forms of creativity, and 20th-century industrial design is doubtless one of them.

At the same time, compiling a collection of design objects in the last decade of the century (there had been ample opportunities to this at an earlier stage) — with the unavoidable model of the Museum of Modern Art in New York at the back of our minds was an extremely attractive proposition. Since its history had already partly been written, the process of selecting the important designers of the last century was made considerably easier for us. It was, for example, no longer possible to consider presenting the functionalist movement of the 1960s on the basis of the cooperation between Bellini and Olivetti, Rams and Braun or Noyes and IBM, without referring to the movements and the designers in Italy who had forcibly contradicted them from among the ranks of groups such as Archizoom and Superstudio. Just as it was impossible to ignore the fact that in the 1980s scene, when „Nouveau Design" prevailed, the way was led by Memphis in Milan and France saw the emerging talent of Philippe Starck, who went on to dominate the 1990s. Putting together an individual design section within the Musée national d'art moderne naturally enough involved some obligations, even if it were only with regard to the other collections — painting, sculpture, graphics, photography, architecture — the proximity of which forced us to employ an extremely rigorous selection procedure. By means of its originality and its special features, the design collection was indeed meant to have its own unique character, which emerged from both the historical as well as the formal quality of the selected objects. For this reason, the strategy that has been pursued since 1992 has involved creating and developing a focus on the "classics" of design history. Efforts were initially channeled into purchasing objects from the "historical" epoch, as conceived by Modernist designers (Charlotte Perriand, Jean Prouvé, René Herbst, Pierre Chareau, etc.). At the same time, the collection was not to neglect its "observatory" role of capturing the sentiments in contemporary design. Thus it has also included young designers of the present time, such as Matali Crasset, Ronan Bouroullec or Konstantin Grcic, whose creations have led to objects that are powerfully expressive in the emotional and poetic sense, a far cry from 1960s functionalism.

Even though we were somewhat late in finally addressing the topic of the design collection, the fact that the Centre Georges Pompidou was known throughout the world has ensured over the years that we have been greeted with undiminished enthusiasm. Designers and industry stood by us at all times in order to help conduct research and locate and procure objects, which we were missing or are still missing today. Some of them — among them some of the more important — have become firm friends, whereby their support goes hand in hand with our efforts in the area of exhibitions. Ettore Sottsass — deeply moved by the fact that our first purchase was one of his objects — made us a significant donation, something he had never done before: His ceramics from the 1960s, the painted wooden models of the "Yantra" series and fifteen original drawings from the Memphis period have thus not only provided the museum with unique stocks, but also reflect the creative universe of this trailblazing Italian designer. With Charlotte Perriand things were totally different: in line with our intention that the CCI include only a few objects in the collection, she recommended to us what she considered to be the most important, and gifted us some furniture from her studio. The very first acquisition by the CCI, however, took place at an auction in fall 1991 in Monaco and under quite bizarre circumstances: Dominique Bozo only learned of the auction of, among other things, furniture from Eileen Gray's E. 1027 house three days before it was due to take place. He managed to convince the central government Cultural Fund of the importance of making such a purchase and was successful in acquiring for us an ensemble, consisting of nine individual pieces, whose coherence is one of the treasures of the collection. Over the course of time the design collection that was gradually taking shape has indeed developed into an observatory.

And even today the adventure has lost nothing of its excitement and the projects have remained just as numerous, because our work, which is by no means completed, forces us to close a number of gaps: this applies as much to the Scandinavian countries (Arne Jacobsen, Poul Kjaerholm), as it does to Japan, from where ensembles of the most important designers are still waiting to be completed (Sori Yanagi, Shiro Kuramata, Isamu Noguchi), and even the USA — as regards the Streamline movement, which was highly important in the 1930s as a response to the 1929 Great Depression. This will take place through acquisitions, exhibitions — even if the willingness to risk staging or preparing bold, provocative exhibitions has diminished somewhat. And it will also take the form of encounters, since one cannot underestimate the role played by networks, chance, or enthusiasm.

Bound by the tradition of interdisciplinary openness at the Musée national d'art moderne, we want at the same time to continue our sound academic research. We will thus, within the framework of what is possible (which is unfortunately very seldom the case) and present the environment in which the objects selected arose. To this end, we will pursue an acquisitions policy which extends to sketches, catalogues and videos as well — elements, which give an object a new, more complete interpretation, without limiting it to the concept of an artistic object. Our aim is also and above all, to kindle in the observer a love of contemporary design, or (at least) the wish to address the topic...
(M.-L.J. in: La collection de design du Centre Georges Pompidou, Paris 2001)

M.-L.J

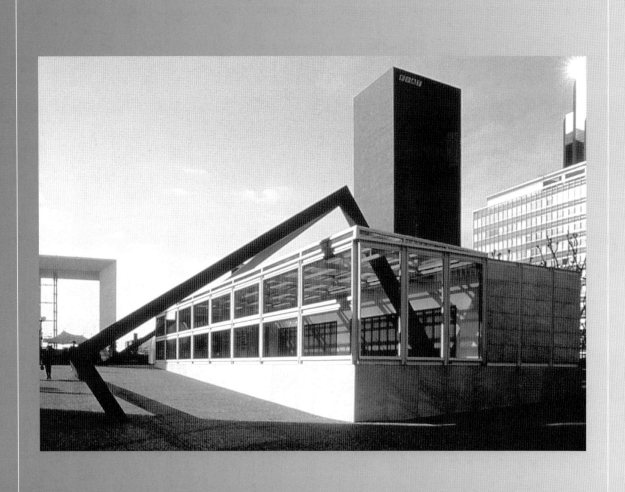

Paris

Fonds national d'art contemporain (Fnac)
www.fnac.culture.gouv.fr

COLLECTION

Fonds national d'art contemporain (Fnac)

DESIGNER / ARCHITECT

Oliver Mourgue

OBJECT

Recliner / Liegesessel 'Boulum'

DATE

1969

MANUFACTURER

La société Arconas, Ontario, 1993

Fonds national d'art contemporain / interne

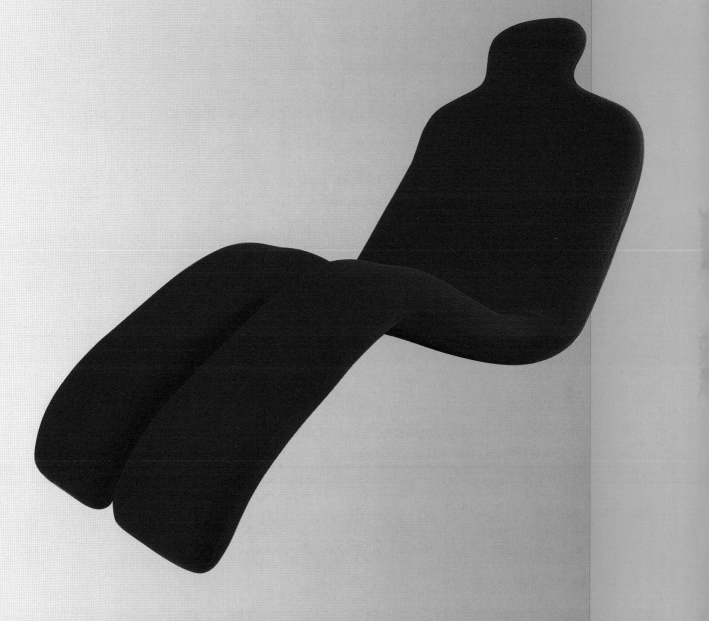

GESCHICHTE DES MUSEUMS

Die Sammlung mit dem Titel „Schöne Künste, industrielle Fertigung und Kunsthandwerk" des Fonds national d'art contemporain (Fnac) ist, wie die Fnac selbst, ein Erbe der Kulturpolitik des französischen Staates am Ende des 19. Jahrhunderts. Im Rahmen des „Büro für künstlerische Gestaltung" wurden lebende Künstler engagiert und deren Kunstwerke erworben. Die Sammlung „Schöne Künste, industrielle Fertigung und Kunsthandwerk" (sprich „Design") ist 1981 neben den Sammlungen „Plastiken" und „Fotografie" gegründet worden. Seitdem ist sie mit ihrer eigenen zuständigen Kommission und ihrem eigenen Budget ausgestattet.

Die Kommission, die alle drei Jahre neu zusammengestellt wird, besteht aus Mitgliedern der Verwaltung, außenstehenden Persönlichkeiten, Journalisten, Designern, Experten und Konservatoren. Seit ihrer Gründung sind um die 5.500 Ausstellungsstücke zeitgenössischer Kunst erworben worden, die hauptsächlich aus dem Zeitraum zwischen 1975 und heute stammen. Zur gleichen Zeit geboren wie die „Memphis"-Kreation von Ettore Sottsass von 1981, ist die Kollektion zum großen Teil als ein Spiegel der europäischen Situation zu sehen. Wie die gesamte Sammlung des Fnac selbst besitzt die Sammlung Design keinen festen Ausstellungsort, sondern sie beteiligt sich an der Leih- und Verwahrungspolitik des Fnac (2.000 bis 2.500 Leihgaben pro Jahr).

Die nicht der Kommission zugehörigen Mitglieder haben uns häufig zu dem Titel der Kollektion „Schöne Künste, industrielle Fertigung und Kunsthandwerk" befragt. In der Tat lässt die Nebeneinanderstellung und Sedimentierung dieser Begriffe erahnen, wie schwierig es ist, das Operationsfeld einzukreisen. Für einige erscheint dieser Titel ebenso fremd, wie es eine Kommission der „Schönen Künste und der Plastiken" wäre.

Die Zusammenführung der drei Begriffe „Schöne Künste, industrielle Fertigung und Kunsthandwerk" kann uns dennoch helfen, die Umrisse der Kollektion einzukreisen.

Der Begriff der Schönen Künste hilft uns die Kollektion hinsichtlich ihrer Typen zu benennen. Indem man ihn im Sinne von le Corbusier in „Die Schönen Künste der heutigen Zeit" benutzt, beschreibt er das Gebiet der Innenausstattung. In diesem Sinne bezieht er sich auf „decorum", das auf Geschmack verweist und nicht auf „decoratio", die Ausschmückung[1]. Aus dieser Sicht ist die Kollektion des Fnac tatsächlich eine Kollektion der Schönen Künste: Sie besteht hauptsächlich aus Möbeln, Leuchtern, Tischlereien, Teppichen etc.

Der zweite Begriff, der im Titel erscheint, die industrielle Fertigung, lädt uns dazu ein, die Kollektion aus der Sicht ihrer Produktionsweise zu betrachten. Der Begriff, der in den 50er Jahren aufkam, charakterisierte eine industrielle Fertigung großen Stils und wurde im Zusammenhang mit neuen Techniken und neuen Materialien speziell in der Massenproduktion gebraucht. Zugleich vereint der Begriff die Erschaffung und die Produktion in einem globalen, kollektiven Schaffungs- und Produktionssinne. Hinsichtlich dieser Einschränkung ist „die industrielle Fertigung" an sich nur zu einem geringen Teil in die Kollektion miteingegangen.

Dagegen ist die industrielle Fertigung im weiteren Sinne, d.h. einschließlich kleiner und mittelgroßer Fertigungsserien sowie deren Techniken und traditionellen Werkstoffe, das Herzstück der Kollektion.

Das Kunsthandwerk, der dritte Teil des Titels, deckt einen Bereich ab, dessen Definition etwas kontrovers ist. Die einen verbinden Kunsthandwerk mit traditionellen Hochschulen und technischen Arbeiten, wie die Tischlerei und das Arbeiten mit Glas und Keramik. Viele andere wiederum verbinden Kunsthandwerk mit „Artisten und Künstlern" deren Berufe im Laufe des 20. Jahrhunderts neu geschaffen wurden. Im zeitgenössischen Sinne sind kunsthandwerkliche Berufe durch die Einheit von Kreation und Produktion charakterisiert, die nicht seriell, wie bei der industriellen Kreation und Produktion, sondern individuell sind.

Schließlich möchten wir auf einen Begriff kommen, der unserem Titel fehlt. Der Begriff des Designs bezeichnet eine Art der Schöpfung, die sowohl von Produktion als auch von künstlerischer Gestaltung unabhängig ist. Man kann also die Heftigkeit der Debatte in diesen Kommissionen besser verstehen, so kontrovers die verschiedenen Ansichten erscheinen. Allerdings kann man erahnen, dass diese verschiedenen Ansichten das Herz selbst des Designs sind. Es wäre also möglicherweise unvorsichtig, diese außer Acht zu lassen.

Um die Beschreibung der Umrisse der Sammlung anhand ihres Titels abzuschließen, kann man sagen, dass sie angesichts zahlreicher anderer Kollektionen durch eine große Auswahl sowohl verschiedener Produktionsweisen (im Gegensatz zur Kollektion des MOMA in New York, dessen Schwerpunkt lange Zeit auf der technischen Innovation lag) als auch der Typologien (im Gegensatz z. B. der Vitra Kollektion, die ausschließlich dem Stuhl gewidmet ist) charakterisiert ist.

Dieses breit gefächerte Erwerbsfeld ist heute einer der Trümpfe der Fnac-Kollektion „Design". Und die zuständigen Kommissionen arbeiten daran, dieses Feld immer weiter auszudehnen.

C. C.

1 René Lesné, L'art décoratif in arts sécoratifs, arts appilqués, métiers d'art, design, Les Villages 1998, édition Hazan/Industries françaises de l'ameublement.

HISTORY OF THE MUSEUM

The collection entitled "Fine Arts, Industrial Production and Handicrafts" which is sponsored by the Fonds national d'art contemporain (Fnac) is, like the Fnac itself, a legacy of the cultural policies of the French government at the end of the 19th century. Within the framework of the "Office for Artistic Design", living artists were provided with employment and their work was consciously purchased. The collection "Fine Arts, Industrial Production and Handicrafts" (i.e. design) was instituted in 1981 — at the same time as the collections "Sculptures" and "Photography". Since then it has been equipped with its own commission and budget.

The commission is reconstituted every three years. It is made up of members of the administration, independent public figures, journalists, designers, experts and curators. Since the collection was set up, about 5 500 exhibition items have been acquired. They are mostly from the period between 1975 and the present. The collection came into being at the same time that Ettore Sottsass launched "Memphis" in 1981. It should be regarded as a reflection of the situation in Europe.

As with the entire collection of the Fnac, the design collection does not possess its own exhibition space. It adheres to the loan and custody policies of the Fnac (2 000–2 500 loans per year).

Members who do not belong to the commission have often asked us about the name "Fine Arts, Industrial Production and Handicrafts". The juxtaposition and stratification of these terms make it possible to see how difficult it is to define this collection's field of operation. To some, the name seems just as odd as a commission for "Fine Arts and Sculptures".

Be that as it may, linking the three expressions "Fine Arts, Industrial Production and Handicrafts" does help define the parameters of the collection. The expression "fine arts" refers to the items involved. Le Corbusier spoke of "today's fine arts". By this, he meant the field of interior decorating. He referred to "decorum" which is an allusion to taste and not to "decoratio" which is an allusion to decoration[1]. In this respect, the Fnac collection is indeed a collection of fine arts — it is made up mainly of furniture, chandeliers, wooden objects, carpets, etc.

The second term in the name of the collection, "Industrial Production", is an invitation to consider the means of production. This expression was coined in the 1950s. At that time, it characterized large scale industrial manufacturing which used modern technology and modern materials for mass production. This expression combines the concepts of creation and production and turns them into a global collective entity. This limited understanding of "industrial production" is only partially relevant to the collection.

Industrial production can also be used in a broader sense to include small and medium sized production series as well as any technology and traditional materials needed. In this sense, industrial production is the core of the collection.

Handicrafts, the third part of the name, refers to a field with a somewhat controversial definition. Some people associate handicrafts with traditional schools and technical work like carpentry and the production of glass and ceramics. Others associate handicrafts with "artists and craftsmen" whose work was redefined in the course of the 20th century. Nowadays, the work of craftsmen is characterized by a unity of creation and production which, unlike industrial creation and production, is not serial but maintains its individuality.

Finally, we would like to mention a term which is missing from our name. "Design" characterizes a type of creation which is independent of production and artistic form. One can imagine the intensity of the debates in the commission and the controversy surrounding various points of view. Of course, one can also presume that these different points of view are at the heart of the controversy over "design". It would be unwise to forget this point.

This discussion of the framework of the collection based on its name can be concluded by pointing out that this collection — rather differently from numerous other collections — is characterized not only by many different means of production (the New York MoMA's collection, for example, has for many years emphasized technical innovation) but also by various typologies (in contrast to the Vitra collection, for example, which is dedicated exclusively to chairs).

In today's world, this broadly-based field of acquisition is one of the trump cards of the Fnac "Design" collection. The commission is working to expand the collection even further.

C. C.

1 René Lesné, L'art décoratif in arts sécoratifs, arts appilqués, métiers d'art, design, Les Villages 1998, édition Hazan/Industries françaises de l'ameublement.

Prague

Uměleckoprůmyslové museum v Praze
Museum of Decorative Arts

COLLECTION

Uměleckoprůmyslové museum v Praze
Museum of Decorative Arts

DESIGNER / ARCHITECT

Pavel Janak

OBJECT

Chair / Stuhl

DATE

1911-12

MANUFACTURER

unknown / unbekannt

Uměleckoprůmyslové museum v Praze, Museum of Decorative Arts in Prague

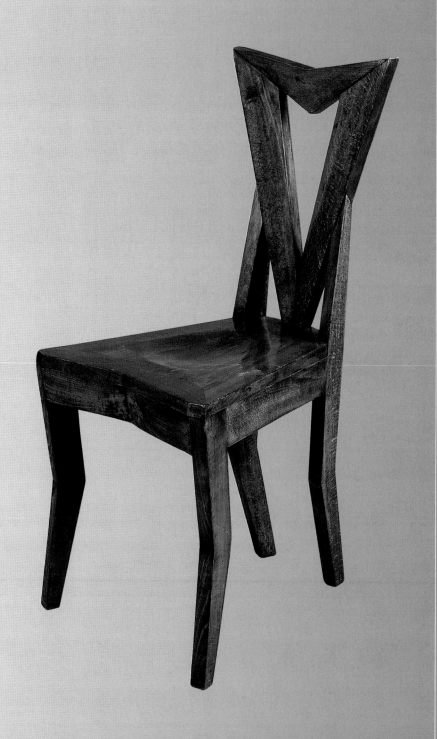

COLLECTION

Uměleckoprůmyslové museum v Praze
Museum of Decorative Arts

DESIGNER / ARCHITECT

Pavel Janak

OBJECT

Bookcase / Bücherschrank

DATE

1912-13

MANUFACTURER

PUD (Prazké umelecké dilny)

Uměleckoprůmyslové museum v Praze, Museum of Decorative Arts in Prague

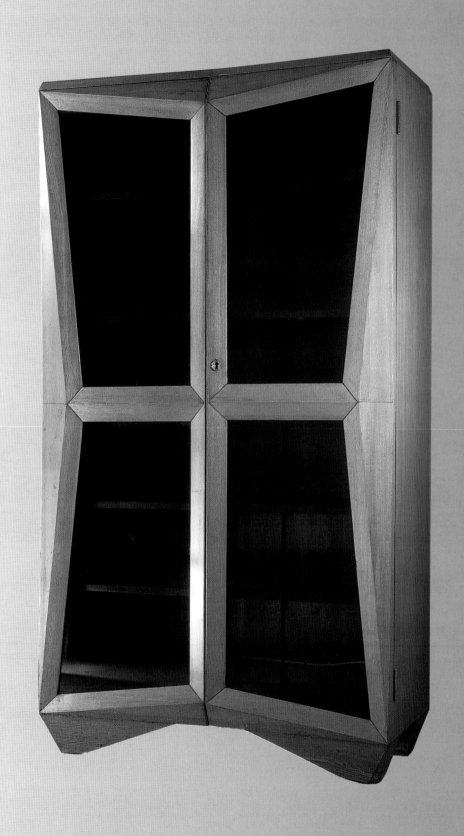

GESCHICHTE DES MUSEUMS

Das Uměleckoprůmyslové museum (UPM) wurde nach langjährigen Bemühungen im Jahre 1885 gegründet. Es folgte dem Vorbild zahlreicher europäischer Kunstgewerbemuseen, deren didaktische Ausrichtung auch für das Prager Museum grundlegend sein sollte. Die Objekte der Sammlung sollten als Vorlage und Inspiration für die Handwerker dienen, um die entstehende industrielle Produktion ästhetisch zu beinflussen und zu verbessern. Es ist daher kein Zufall, dass der erste Direktor des neuen Museums Karel Chytil sich aktiv an der theoretischen Disskusion um die Begrifflichkeiten Kunst und Industrie, Kunstgewerbe usw. beteiligte.

Im Rahmen dieses Vorhabens arbeitete das UPM mit der gleichzeitig eröffneten Prager Kunstgewerbeschule zusammen. Das Museumsgebäude wurde im Jahre 1900 fertiggestellt. Es war das letzte Werk des Architekten Josef Schulz (Josefa Schulze) im Stil der Neorenaissance, als der Jugendstil bereits die Formgebung beherrschte. Zu diesem Zeitpunkt waren die böhmischen Erblande bereits auf der Weltausstellung in Paris vertreten. Ein von Jan Kotera (Jan Kötery), einem Wegbereiter der tschechischen Moderne, geschaffenes Interieur war dort für die Prager Kunstgewerbeschule zu besichtigen. Zusammen mit einem weiteren Ensemble der Architekten Jan Koula (Jana Kouly) und Josef Fanta (Josefa Fanty) mit dem Titel „tschechisches Interieur" wurden die Stücke bereits im nachfolgenden Jahr im UPM ständig ausgesstellt. Neben verschiedenen Ausstellungen organisierte das UPM, oft in Zusammenarbeit mit der 1908 nach dem Vorbild der Wiener Werkstätten gegründeten Werkstättengemeinschaft „Artěl", auch zahlreiche Wettbewerbe, welche die Produktionen modernen Kunsthandwerks unterstützen sollten. Die Leitung des Museums oblag in dieser Zeit F. A. Borovský. Bekannt als Kenner von Antiquitäten konzentrierte er sich jedoch primär auf die historischen Zusammenhänge als auf die beschriebenen Veränderungen im Bereich der zeitgenössischen Formgebung. Innerhalb Böhmens hatte die Moderne einen fruchtbaren Nährboden, zumal das „moderne" Denken mit dem Streben nach nationaler Selbstständigkeit verbunden war. Dies spiegelt sich im tschechischen Kubismus wider, der — einzigartig durch seine dreidimensionale Ausrichtung — besonders in Architektur und Inneneinrichtung zum Ausdruck kam.

Nach der Gründung der Tschechoslowakei im Jahre 1918 unterstützten die Mitarbeiter des Museums die Entwicklung eines neuen nationalen Stils. In diesem kamen die kubistischen Formen des sog. „Rondokubismus", einer Spätphase des Kubismus, mit Elementen eines volkstümlichen Dekorativismus sehr oft zum Ausdruck. Auch hier trat das Museum ein, indem es versuchte, mit Hilfe von Ausstellungen und Wettbewerben Anregungen für die industrielle Fertigung insbesondere von Porzellan, Textil und Glas zu gewinnen. 1923 konnte - initiiert von Karel Herain (Karla Heraina), zunächst Kustode und ab 1934 Direktor — am Museum ein „Musterraum" eingerichtet werden, der zu engen Kontakten mit Entwerfern und Herstellern führte. Der tschechoslowakische Werkbund, eine Vereinigung von Theoretikern und Künstlern, präsentierte hier in regelmäßigen Ausstellungen neue Produkte, die im direkten Kontakt zwischen künstlerischem Entwurf und Ausführung entstanden waren. Auf diese Weise wuchs der Bekanntheitsgrad der angewandte Kunst in der breiten Öffentlichkeit und unterstützte so deren Verkauf. Diese enge Zusammenarbeit zwischen UPM und zeitgenössischer handwerklicher und künstlerischer Fertigung rückte das Museum in eine wichtige Position. Im tschechoslowakischen Werkbund arbeitete Herain unter anderem mit Ladislav Sutnar zusammen, der heute als Wegbereiter des modernen Designs anerkannt ist. Sutnar war ausserdem Direktor der „Krasna jizba" in Prag, einer Verkaufsstelle von Einrichtungsgegenständen, die heute zu den Klassikern ästhetisch und funktional hochwertigen Designs gehören. Designobjekte dieser Periode sind in unseren Sammlungen stark vertreten. Sie stammen teils aus zeitgenössischen teils aus späteren Aquisitionen. Die Tradition des tschechoslowakischen Funktionalismus bestimmte noch lange — nicht nur in den Jahren des Zweiten Weltkrieges aber mit gewissen Einschränkungen bis in die 50er Jahre — die Designproduktion. Der Erfolg der Tschechoslowakei auf der Weltausstellung in Brüssel 1958 bewirkte einen neuen Druchbruch. Er eröffnete den tschechoslowakischen Entwerfern wenigstens die Möglichkeit, neue Anregungen zu gewinnen. Auch für das UPM wurde es nun wieder möglich, sich verstärkt mit gutem Design zu beschäftigen. Dies galt sowohl für die Ausstellungs- und Erwerbungstätigkeit als auch für die Teilnahme an der Gestaltung repräsentativer Auftritte im Ausland wie in Brüssel und im Jahr zuvor auf der IX. Triennale in Milano.

Die verheissungsvolle Entwicklung wurde allerdings unmittelbar darauf eingeschränkt. Das UPM wurde für zwölf lange Jahre der Organisation der Nationalgalerie unterstellt. Eine eigenständige Tätigkeit war nicht mehr möglich, einige Teile der historischen Sammlungen wurden in andere Institutionen überführt. Schließlich führte das Jahr 1968 zur Rückgabe der Autonomie des Museums. Es ist dem damaligen Direktor Jiri Setlik (Jiřiko Šetlíka) zu verdanken, dass auch das Engagement im Bereich des Designs wieder aufgenommen wurde. Durch die Einrichtung einer eigenständigen Abteilung für angewandte Kunst der Gegenwart, Design und Architektur und die Anstellung spezialisierter Fachkräfte wurde ein wissenschaftliches Arbeitsfeld geschaffen, in dem auf die historische Erforschung wie auf den Bezug zur zeitgenössischen Produktion von Design großer Wert gelegt wurde. Von diesen Ergebnissen profitiert das Museum bis heute. In der Zeit der sog. Normalisierung (im Jahre 1972 wurde Jiri Setlik abberufen) hatte das UPM aufgrund von Renovierungsarbeiten keine ständige Ausstellung. Die Konservatoren konnten unter Leitung der Kunsthistorikerin Dagmar Hejdova (Dagmar Hejdové) um so intensiver der Bearbeitung der Sammlungen und der Erarbeitung von Ausstellungsprojekten mit begleitenden Katalogen nachgehen. Die von Milena Lamarova (Milenou Lamarovou) konzipierte Ausstellung „Design und Kunststoffe" im Jahre 1972 wurde noch in den zeitweilig gemilderten politischen Verhältnissen geplant. Das UPM konnte hierbei unter anderem erstrangige Objekte italienischen Designs erwerben. Im Jahre 1976 wurde die von Olga Herbenova (Olga Herbenovou) vorbereitete Ausstellung „Tschechisches kubistisches Interieur" gezeigt. Darauf folgte 1978 die Schau zum „Tschechischen Funktionalismus 1920-40". 1985 präsentierte das UPM anlässlich des Jubiläums der Museumsgründung „Ein Jahrhundert des Designs", wo das Verhältnis des Museums zur zeitgenösischen Designentwicklung dargestellt wurde. Mit leichten Einschränkungen der Zensur bezüglich der Präsentation unerwünschter Persönlichkeiten wie z. B. Ladislav Sutnars wurde hier die Entwicklung des tschechoslowakischen Designs im internationalen Kontext nachvollzogen. Weiter folgte im Jahre 1988 die von Milena Lamarova konzipierte Ausstellung „Fünfziger Jahre: angewandte Kunst und Design", die durch die ersten spürbaren Anzeichen der „Perestrojka" vom November 1989 möglich wurde. Eine der ersten Ausstellungen des Jahres 1990 widmete sich dem tschechoslowakischen Design der Postmoderne, das eigentlich bis zu diesem Zeitpunkt von offizieller Seite nicht anerkannt wurde. Schrittweise konnten wir nun der Öffentlichkeit das Werk bekannter, im Ausland lebender Persönlichkeiten wie beispielsweise Bořek Šípek und die Entwicklung des Designs in anderen Ländern nahe bringen. Der pädagogische Vermittlungsgedanke des Museums war wieder lebbar.

Die Sammlungserwerbungen aus der zweiten Hälfte des 20. Jahrhunderts des UPM (in Hinblick auf die zeitgenösische Produktion) spiegeln in ihrer Zusammensetzung stets auch die zeitlich entsprechende politische Situation wieder. Jeder Moment der politischen Entspannung nach dem kommunistischen Umsturz des Jahres 1948 veranlasste zu dem Versuch, sich aktiv am internationalen Geschehen zu beteiligen, die heimische Produktion zu beeinflussen oder „gutes Design" zu erwerben. Paradoxerweise ist dies heute noch schwieriger umsetzbar. Das gilt besonders für die Aufgabe des Museums, zwischen Design und Fertigung zu vermitteln und den allgemeinen „Lebens-Stil" zu beeinflussen. Das breite Angebot und die Konkurrenz einflußreicher Firmen erschweren es oft – dies gilt gleichermaßen für den heimischen Erzeuger wie für den Verbraucher, sich auf dem Markt zu orientieren. Die Einführung von gutem Design in die Produktion hängt von vielen Faktoren ab – wie der Finanzierung oder dem meist individuellen Anliegen, die Qualität der Ware durch gutes Design zu verbessern. In der letzten Zeit mehren sich (leider) die Aquisitionen qualitativ hochwertiger Produkte aus aufgelösten Betrieben wie beispielsweise im Bereich der kleineren Glashütten; kleine Keramik – oder Textilhersteller kämpfen ebenfalls ums Überleben.

Wir streben daher eine enge Zusammenarbeit mit Fachschulen an, die sich professionell mit Design auseinandersetzen. Darüber hinaus beteiligen wir uns als Mitglieder von Fachgremien an Wettbewerben. Die Konservatoren der einzelnen Sammlungsbereiche arbeiten im Rahmen ihrer Möglichkeiten mit den bildenden Künstlern zusammen, unterstützen die Präsentation ihrer Werke, vermitteln zwischen Entwerfer und Hersteller und versuchen die Sammlungen zu vervollständigen. Dabei entsteht dasselbe Problem wie überall: für direkte Ankäufe fehlen die finanziellen Mittel. Die Sammlung kann daher in vielen Bereichen weiter kein vollständiges Bild ihrer Zeit wiedergeben.

H. K.

HISTORY OF THE MUSEUM

After many years of effort paving the way for it, in 1885 the Uměleckoprůmyslové Museum (UPM) was finally established. It followed the role model of many European applied arts museums, whose didactic thrust was also fundamental to the Prague museum. The items in the collection were intended to serve as models and inspiration for craftsmen, with the aim of aesthetically influencing and improving the emerging industrial production. As such it is no coincidence that the first director of the new museum, Karel Chytil, took an active part in the theoretical discussions around the topics of art and industry, and applied arts.

In this context, the UPM collaborated with the Prague School of Arts and Crafts which opened around the same time. The museum building was completed in 1900. It was the final work designed by architect Josef Schulz (Josefa Schulze) in the Neo-Renaissance style, even though Art Nouveau was already highly predominant. At this time, the Bohemian dominions were already represented at the World Exhibition in Paris. Jan Kotera (Jana Kotěry), a pioneer of the Czech Modernist movement, represented the Prague Arts and Crafts School with one of his interiors. This work, together with another ensemble by architects Jan Koula (Jana Kouly) and Josef Fanta (Josefa Fanty) entitled "Czech Interior", became part of the UPM's permanent collection just one year later. Alongside various exhibitions, the UPM also organized numerous competitions, often in collaboration with the Workshops' Association established in 1908, which modeled itself on the Viennese Werkstätten. The competitions were designed to foster the production of modern applied art. During this period, the museum was under the management of F. A. Borovský. Known as a connoisseur of antiques, he concentrated primarily on the historical background rather than on the aforementioned changes in the field of contemporary design. The Modernist movement found a fruitful breeding ground in Bohemia, all the more so since the "modern" concept was also connected with efforts to achieve national independence. This is also reflected in Czech cubism, which – unique in its three-dimensional execution – was particularly expressed in architecture and interior decoration.

Following the foundation of Czechoslovakia in 1918, the museum staff supported the advancement of the new, national style. The latter often included Cubist froms of the so-called "Rondocubism", a late phase of Cubism, together with elements of a traditional decorativism. By organizing exhibitions and competitions the museum was active in providing inspiration for industrial production, especially of porcelain, textiles and glass. In 1923, on the initiative of Karel Herain (Karla Heraina), who was first custodian and as of 1934 director of the museum, a model room was set up, which led to close contacts with designers and manufacturers. It was here that the Czech Werkbund, an association of theorists and artists, regularly presented their new products, which were born from the direct contact between artistic creation and implementation. As a result, applied art became better known to a wide public, which in turn increased sales of such products. The close cooperation between the UPM and contemporary crafts and artistic production placed the museum in an important position. In the Czech Werkbund, Herain cooperated amongst others with Ladislav Sutnar, who is recognized today as the pioneer of modern design. In addition, Sutnar was director of the "Krasna jizba" in Prague, a store selling furnishings, which today number amongst the classics of high-class aesthetic and functional design. Design objects of this period form a focal point in our collections, and originate partly from contemporary, and partly from later acquisitions. The tradition of Czech functionalism continued to influence design production not only in the years prior to World War II, but also to a lesser extext through to the 1950s. Czechoslovakia's success at the World Exhibition in Brussels in 1958 precipitated a new breakthrough: it gave Czech designers a limited opportunity at least to gain new inspiration. As for the UPM, it was also able once more to occupy itself more intensively with excellent design. This was not only the case for its exhibiting and acquisition activities; it also became involved in designing the nation's presentations abroad, not only in Brussels but also one year earlier at the IXth Triennial in Milan.

However this promising development was nipped in the bud shortly afterwards. The administration of the UPM came under the National Gallery for twelve years. Consequently, it was no longer able to act independently, and some items from its historical collections were even transferred to other institutions. Finally, in 1968 the museum regained its autonomy.

It is thanks to the director of the time, Jiři Šetlik, that the museum resumed its efforts in the area of design. Specifically, an independent department for contemporary applied art, design and architecture was set up, and the hiring of staff specialized in these areas spawned an academic field of activity, in which equal importance was placed on historical research as on maintaining contacts to the contemporary production of design. Today, the museum continues to benefit from this shift of emphasis. During the so-called normalization period (in 1972 Jiri Setlik was dismissed), the UPM did not have a permanent collection on account of renovation work. However, this allowed the curators to devote themselves more intensely to upkeep of the collections and the conception of exhibition projects with accompanying catalogs under the direction of art historian Dagmar Hejdova (Dagmar Hejdové). The exhibition "Design and Plastics" conceived by Milena Lamarova (Milena Lamarorvou) in 1972 was planned during a period in which the political situation eased somewhat. This allowed the UPM to acquire, amongst other things, first-class objects of Italian design. In 1976, the exhibition prepared by Olga Herbenova (Olga Herbanovou) and entitled "Czech Cubist Interiors" was shown. It was followed in 1978 by the show on "Czech Functionalism 1920-40". Then in 1985, the UPM presented "A Century of Design", to mark the 100th anniversary of the museum's opening, and which summarized the relationship of the museum to contemporary developments. Though censors made some restrictions on what could be shown, not wishing to include the works of such unfavored personalities as Ladislav Sutnar, the exhibition presented Czech design in an international context. Then in 1988 the show conceived by Milena Lamarova: "Fifty Years of Applied Art and Design", went ahead, enabled by the first signs ("perestroika") of the change that would take place in November 1989. One of the first exhibitions in 1990 was devoted to Czech Post-Modern Design, which was not officially acknowledged at this time. Gradually, we were able to acquaint the public with the work of renowned figures living outside Czechoslovakia such as Borek Sípek, but also the development of design in other countries. The museum's original pedagagogic orientatation had been revived.

UPM's choice of objects from the second half of the 20th century always reflects the political situation prevailing at the time. When the political situation eased following the Communist coup in 1948, the museum sought to become involved in international events, to influence domestic production and to make acquisitions of "exemplary design". Paradoxically, these goals are more difficult to achieve today. This is particularly true for the task of the museum to negotiate between designers and production, or to influence "lifestyle" in general. The broad spectrum of products together with the competition of influential firms often make it difficult for both producer and consumer to orientate themselves on the market. Introducing excellent design into production depends on many factors including financing, or the individual desire to employ design to improve product quality. More recently, there has been an increasing tendency for the museum to acquire high-quality products which originate from companies obliged to cease business. Smaller glassworks, small ceramics or textile makers are all fighting for survival.

For this reason, we seek close cooperation with schools which explore design in a professional manner. In addition, we also participate in competitions as members of specialist committees. The curators of the individual collection areas cooperate as far as possible with the artists in question, assist with the presentation of their works, negotiate between designers and manufacturers, and attempt to complete the collections. Here we face the problem which many now have to contend with: we lack the funds to make direct purchases. Sadly, this means that in many areas the collection can no longer present a complete picture of its time.

H. K.

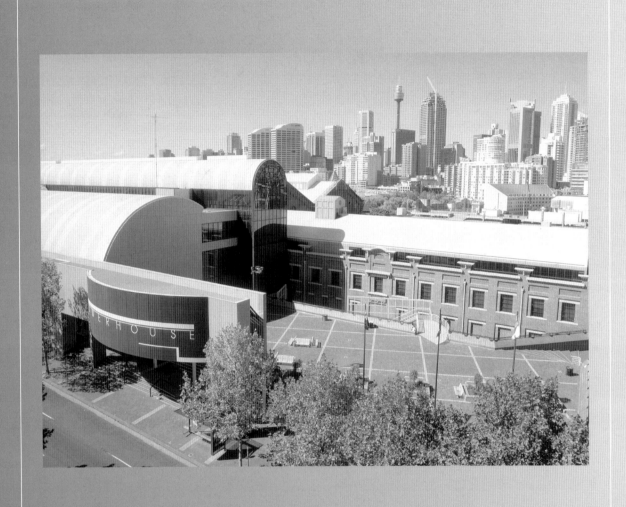

Sydney
Powerhouse Museum
www.phm.gov.au

COLLECTION

Powerhouse Museum

DESIGNER / ARCHITECT

Marc Newson

OBJECT

Chair / Sitzmöbel 'Embryo Chair'

DATE

1988

MANUFACTURER

De De Ce, Sydney, Australia

Powerhouse Museum, Sydney

GESCHICHTE DES MUSEUMS

Das Powerhouse Museum, ehemals Museum of Applied Arts & Sciences, ist Australiens wichtigstes Museum für Design. Sammlung, Ausstellungen und Forschungsarbeit spannen hier einen Bogen über alle Aspekte des zeitgenössischen Designs. Dabei greift man auf eine 125jährige Tradition zurück im Sammeln und Ausstellen von Wissenschaft, Industrie, Design, Kunsthandwerk und angewandter Kunst.

Die aus ca. 400.000 Stücken bestehende Sammlung umfasst nicht nur Musikinstrumente, Plastiken und zeitgenössisches Kunsthandwerk und Design, sondern auch Dampflokomotiven, Haushaltsgeräte und Ausstellungsstücke aus Biotechnologie und Raumfahrt, wobei die historische Spannweite vom Jahr 2000 v. Chr. bis zum neuesten Entwicklungsstand reicht. Obwohl der Schwerpunkt auf Objekten australischer Herkunft liegt, ist die Ausrichtung der Sammlung international.

Das Powerhouse Museum, so wie wir es heute kennen, wurde 1880 als Technik-, Industrie- und Hygienemuseum gegründet und geht auch in seinem heutigen Erscheinungsbild noch auf das typisch viktorianische Interesse an Forschung, Bildung und wissenschaftlich-technischem Fortschritt zurück.

Die entscheidende Idee für das neue Museum entstand unter dem Eindruck des spektakulären Erfolgs der Internationalen Weltausstellung in Sydney 1879, für die im Königlichen Botanischen Garten der großartige Garden Palace gebaut wurde (Architekt James Barnet). Angelehnt an die erste Weltausstellung in London 1851 wurde in Sydney eine eindrucksvolle Reihe der aktuellsten Neuigkeiten aus Technologie und Kunst aus aller Welt gezeigt.

Nach der Schließung dieser Ausstellung konnte das Museum viele Ausstellungsstücke für seine Sammlung erwerben. Gleichzeitig wurden die oberen Galerien des Garden Palace zur ersten Heimstatt für das neue Museum. Das ehrgeizige Ziel war — exemplarische Sammlungen aller ökonomisch verwertbaren Materialien zu erstellen, sei es aus dem Tier- Pflanzen- oder Mineralienreich vom Rohmaterial über die verschiedenen Stadien der Verarbeitung bis zum fertigen Produkt bzw. Gebrauchsartikel.[1] Tausende von Rundschreiben wurden an Herstellerfirmen in der ganzen Welt verteilt mit der Bitte um Produktionsmuster, Fachzeitschriften, Preislisten, Patentmodelle und Entwürfe. Von Anfang an sollte das Museum ein Museum fürs Volk sein — „im Interesse breiter Bevölkerungsschichten und zu deren nachhaltigem Nutzen" — ein Bildungsangebot z. B. Für Bauern, Händler, Ingenieure und Architekten, die keine anderen Informationsquellen hatten.[2]

Tragischerweise ging fast der gesamte frühe Bestand der Sammlung verloren, als der Garden Palace 1882 abbrannte. Der erste Kurator des Museums, Joseph H. Maiden (1881–1898), machte sich jedoch unerschrocken daran, die Sammlung wieder neu aufzubauen; Enthusiasmus und Engagement waren so groß, dass bis 1889 wieder 30.000 Ausstellungsexponate zusammenkamen.

Die Ausrichtung der Weltausstellung in Sydney 1879 und die Gründung des Technik-, Industrie- und Hygienemuseums waren zwei wichtige Initiativen, die auf den Wunsch der Öffentlichkeit eingingen, am wissenschaftlichen und technologischen Fortschritt teilzuhaben, was dann auch die örtliche industrielle Entwicklung beschleunigen sollte. Diese Entwicklung galt als unabdingbar für den Ausbau der wirtschaftlichen Grundlagen und als notwendige Voraussetzung für die angestrebte australische Unabhängigkeit.

1893 wurde das Museum in Technological Museum umbenannt und residierte nun in einem neuen, von William Kemp entworfenen Gebäude neben dem Sydney Technical College eine Verbindung, die auch darin zum Ausdruck kam, dass das Museum nun mit seinen Exponaten die Collegevorlesungen unterstützte. Die zu diesem Zwecke gezeigte Ausstellung umfasste kunsthandwerkliche Keramik und Metallarbeiten, Möbel, Textilien, Holz- und Gesteinsproben, Werkzeuge, Maschinen und fertige Produkte, wissenschaftliche Apparate, Münzen, Uhren und Waffen.

Obwohl ein Großteil der frühen Sammlung aus Europa stammte, lag der programmatische Schwerpunkt darauf, landeseigene Materialien zu erwerben, die von zukünftigem ökonomischen Nutzen sein konnten, sowie Gegenstände aus heimischer Produktion, um eigene Erfolge zu zeigen. Außerdem wurden auch aus den Nachbarregionen, insbesondere aus Japan, China und dem Pazifik, Ausstellungsstücke zusammengetragen.

Zu Beginn wurden Artefakte wie Meissen-, Worcester- und Doultonkeramik, aber auch Metall-, Glasarbeiten und Möbel als Beispiele für Meisterwerke der seriellen Fertigung angeschafft. Es war vor allem die ökonomische Bedeutung ihrer Herstellung und ihres Designs, die hier wahrgenommen und vorgestellt wurde. Begrenzte Mittel, die Abgeschiedenheit von den Hauptproduktionszentren und fehlender kuratorischer Sachverstand, was die angewandte Kunst betraf, sowie die starke Interessensausrichtung auf Produktionsprozesse führten dazu, dass die erste kunsthandwerkliche Sammlung bzw. die erste Sammlung angewandter Kunst konservativ war und viele stilistische Schlüsselentwicklungen nicht berücksichtigte.

Die politischen, ökonomischen und sozialen Faktoren, die 1901 zur Gründung eines unabhängigen australischen Staates führten, spiegeln sich in der Entwicklung des Museums, seiner Sammlung und seiner Ausstellungen zu Beginn des 20. Jahrhunderts. Der neue Kurator Richard Thomas Baker (1898–1921) beschloss, dass das Museum — neben seinem Schwerpunkt auf Produktionsprozesse — auch Objekte von ästhetischer Bedeutung sammeln und ausstellen sollte, und zwar vorzugsweise Kunsthandwerk und angewandte Kunst australischer Herkunft.

Im Zuge der Gründung des Commonwealth of Australia 1901 und dem nun aufkeimenden Nationalstolz wurde Baker ein glühender Befürworter nationaler Ressourcen und Produkte. Großen Einfluss auf Baker und das Museum hatte zu dieser Zeit Lucien Henry, ein in Frankreich geborener Künstler, der wegen seiner Rolle in den Pariser Kommunardenaufständen 1871 nach Neukaledonien ins Exil geschickt worden war und anschließend von 1879–1891 in Sydney lebte. Dort spielte er eine führende Rolle in der Kunsterziehung am Sydney Technical College und verfocht hier seine Vision einer Verbindung von Kunst und industrieller Produktion, die ein spezifisches Design hervorbringen sollte, das nicht nur von der australischen Umgebung inspiriert, sondern auch Ausdruck australischer Nationalität widerspiegeln sollte.

Von Henrys Visionen ermutigt, gründete Baker die neue Abteilung Australian Flora Applied to Art, in der Kunsthandwerk und angewandte Kunst zu sehen war, die in Form und Dekor von Australiens Flora und Fauna inspiriert wurde. Baker publizierte viel und unterstützte aktiv die „Förderung australischer Designentwürfe von australischen Staatsbürgern, die von großer Wichtigkeit sind für die Entwicklung australischen Selbstbewusstseins und eines genuin australischen Designs."[3]

Was das Interesse des Museums an Objekten von ästhetischer Bedeutung betrifft, so war seine Ausrichtung jedoch immer international. In den 20er Jahren wurde der New South Wales Applied Arts Trust eingerichtet und damit beauftragt, die Sammlungsaktivitäten historisch zu systematisieren. Seine Mitglieder trugen fast 300 Objekte aus aller Welt zusammen, jedes beispielhaft in Design und Herstellungsweise. Geprägt von der Epoche der Arts & Crafts–Bewegung in Großbritannien und vom aufkeimenden Interesse an industriellem Design, reicht die Spannweite der Sammlung nun von bäuerlicher Stickerei aus Osteuropa bis zu den Metallarbeiten eines Georg Jensen.

Bakers Nachfolger Arthur de Ramon Penfold (1927–1955) sah die angewandte Kunst im Museum als einen Bereich an, der der Förderung von handwerklichem Können und künstlerischem Geschmack dient, indem hier die Geschichte und Entwicklung der angewandten Künste aller Nationen zu allen Zeiten veranschaulicht wird (1928). Penfold schrieb dem Museum die Aufgabe zu, den ungeheuerlichen technologischen Fortschritt einer sich rapide verändernden Welt zu reflektieren.

GESCHICHTE DES MUSEUMS

Trotz der Schwierigkeiten in der Weltwirtschaftskrise in den 30er Jahren und im Zweiten Weltkrieg gelang es dem Powerhouse Museum, einige entscheidende Anschaffungen zu machen. So erkannte er die Bedeutung der schnell wachsenden Kunststoffindustrie und stellte die umfassendste Sammlung von Kunststoffobjekten in Australien zusammen. In den 50er Jahren stellte das Museum neue Erfindungen aus, wie z. B. den ersten Fernsehapparat in Australien, Neonröhren und Kunstfasern.

Die 1979 beschlossene Entwicklung zum Powerhouse Museum ist die jüngste und wohl spektakulärste Renaissance des Museums. Vom preisgekrönten Lionel Glendenning innerhalb der Außenmauer des ehemaligen Ultimo Power House konzipiert, öffnete das Powerhouse Museum 1988 mit einem Museumskonzept, das die prägende Rolle des Designs für das ganze Museumserlebnis in den Mittelpunkt rückt: Architektur, Inneneinrichtung, Grafik, Ausstellungen, Beleuchtung, Akustik, Multimedia etc.

Diese umfangreichere Neuentwicklung erlaubte es dem Museum, bestimmte Lücken in seiner Sammlung durch ein Anschaffungsprogramm für neue Ausstellungen zu schließen, vor allem im Bereich des zeitgenössischen Designs.

Design ist ein übergeordnetes Thema, das alle Sammlungsbereiche verbindet: Ingenieurwesen und Design, Informationstechnologie, Wissenschaften, Transport und Kommunikation, australisches und internationales Kunsthandwerk und Design, australische Geschichte und Gesellschaft sowie einheimische Kultur und Geschichte.

Viele Ausstellungsstücke in der Abteilung Ingenieurwesen und Design zeigen die Arbeit von Industriedesignern, z. B. Geräte, Fahrzeuge, Produktionsmaschinen, wissenschaftliche und medizinische Instrumente. Einige davon werden komplettiert durch die entsprechenden Verpackungs- und Werbematerialien, die die Verbindung von Design und Marketing von Industrieprodukten veranschaulichen. Bei anderen Produkten wiederum ist der Designprozess dokumentiert durch beigefügte Zeichnungen, Entwürfe, Modelle, Prototypen und Kopien der Eintragungen von Entwürfen oder Patenten. In einigen Fällen konnten Designarchive erworben werden, die das Gesamtwerk bekannter australischer Designer dokumentieren. Durch die Zusammenarbeit mit dem Australian Design Awards Program werden jedes Jahr herausragende Beispiele modernen Produktdesigns für die Sammlung gewonnen.

Die Abteilung für Kunsthandwerk und Design ist eine unerschöpfliche Quelle für heimische und auswärtige Designer und Studenten. Sie bietet verschiedene Zugänge zu den Themen Gestaltung und Herstellung – von traditionellen Techniken bis zu einmaligen Studio-Stücken, limitierten Auflagen und multipler Produktion. Die Ausstellung umfasst die ästhetische, soziale und technologische Bedeutung der wichtigsten Strömungen, Epochen und Stilrichtungen des australischen und internationalen Designs im Spiegel der Arbeiten bekannter einzelner Designer, Firmen und Gruppen. Die Sammlung über den Zeitraum nach 1945 hat ihre Stärke in den Designarchiven. Einige Arbeiten entstanden im Auftrag der Sammlung, so z. B. Marc Newsons 'Embryo chair' (1988).

Es gehört zum Konzept, als Ergänzung zu dem Produkt selbst auch Gegenstände zu erwerben, die den Entwurfsprozess und die Herstellung illustrieren, wie z. B. Skizzen, Werkzeug, Materialien und Studioausrüstung. In den Ausstellungen sollen die Entstehungsprozesse von der ersten Idee bis zur Vollendung vermittelt werden.

Die Bemühungen des Museum, das Thema Design an eine breitere Öffentlichkeit zu vermitteln, haben im Laufe des letzten Jahrzehnts verschiedene neue Formen angenommen. Von großer Bedeutung ist das museumspädagogische Programm, das eng mit dem Pflichtcurriculum Design und Technologie an den Grundschulen und weiterführenden Schulen verbunden ist. Des Weiteren gehören natürlich Designstudenten zum Kernpublikum — neben einer Reihe von Berufsgruppen aus den Bereichen Architektur, Innenarchitektur, Mode, Textilbranche, Grafik, Keramik, Multimedia und Theater.

Die ständigen Wechselausstellungen in der Design Gallery sollen Fortschritte im Design fördern und besondere Leistungen würdigen. Hier finden jährlich Ausstellungen statt, in denen studentische Wettbewerbssieger ihre Arbeiten aus den Bereichen Design, Technologie und Modedesign zeigen können. Auch die ständigen Ausstellungen „Success & Innovation; Ecologic: creating a sustainable future; Transport; Space und Cyberworlds" beschäftigen sich alle mit der Rolle des Designs.

Ein Hauptereignis im jährlichen Programm ist die Sydney Design Week, die gemeinsam mit Medienanstalten ud Designorganisationen ausgerichtet wird, um Design bei einem breiteren Publikum populär zu machen. In einer Vielfalt von Ausstellungen, Vorlesungen, Wettbewerben, Seminaren und Tagungen begegnen sich australische und internationale Designer und Designstudenten in einem öffentlichen Rahmen, in dem Design als Berufsfeld, Arbeitsprozess und Produkt vermittelt werden soll.

Auch mit seinem Publikationsprogramm erreicht das Powerhouse Museum immer neue Zielgruppen, die sich für Design interessieren, so z. B. mit seiner Website und den dazugehörigen in Kooperation entwickelten Links. Die umfangreichste davon ist „Australia innovates: an online guide to innovation in Australia's industries".

Seit seinen Ursprüngen im Jahre 1879 in Zusammenhang mit der Weltausstellung in Sydney war das Powerhouse Museum stets darum bemüht, ein Museum fürs Volk zu sein, eine kulturelle Fundgrube mit Kunst- und Industrieprodukten, durch die sich Besucher aus allen Bereichen des Lebens inspirieren lassen können. Das übergreifende Thema ist dabei seit 125 Jahren Design, ein Thema mit vielen Facetten: wirtschaftlicher und industrieller Fortschritt, Funktionalismus, nationale Identität, Modernität, kulturelle Verschiedenheit, Internationalität, neue Medien, eine kulturelle Renaissance und die Frage der Nachhaltigkeit — alles Themen, die in den verschiedenen Sammlungen des Museums aufgegriffen werden.

Design ist ein wichtiges Mittel, mit dem wir diversen Herausforderungen einer ständig komplexer werden Wirklichkeit begegnen können. Auch in Zukunft wird das Powerhouse Msueum dazu beitragen, dass diese zentrale Rolle des Designs für die Gestaltung unserer Zukunft erkannt wird.

J. S.

1 Technological Industrial and Sanitary Museum general reports, 1878—1889
2 Annual Report of the Committee of Management: Technological, Industrial and Sanitary Museum, 1881 (Sydney: Government Printer, 1882)
3 Technological Museum Annual Report, 1914 (Sydney: Government Printer, 1915)

HISTORY OF THE MUSEUM

The Powerhouse Museum, formally the Museum of Applied Arts & Sciences, is Australia's pre-eminent museum of design. Its collection, research and exhibitions span all facets of contemporary design, based on a 125-year history of collecting and exhibiting science, technology, industry, design, decorative and applied arts.

The collection of 400 000 artefacts covers items as varied as musical instruments, plastics, contemporary craft and design, steam loco-motives, domestic appliances, biotechnology and space hardware. The earliest artefacts date from 2000 BC while the most recent are absolutely current. There is a strong focus on Australian-made and provenanced material but the collection is international in scope.

Established in 1880 as the Technological, Industrial and Sanitary Museum, the Powerhouse Museum, as it is now known, owes its foundations to the Victorian era's commitment to inquiry, education and scientific and technological advances.

Inspiration for the new museum came from the spectacular success of the Sydney International Exhibition of 1879 for which the magnificent Garden Palace (architect James Barnet) was constructed in Sydney's Royal Botanic Gardens. Building on the legacy of the Great Exhibition held in London in 1851, the Sydney International Exhibition presented an impressive array of the latest in technology and art from around the world.

Following the closure of the Sydney International Exhibition the new museum acquired many of the exhibits for its collection and the upper galleries of the Garden Palace were converted into the museum's first home. The ambitious goal was "to collect together typical collections of all materials of economic value belonging to the animal, vegetable and mineral kingdoms from the raw material through the various stages of manufacture to the final product or finished article ready for use."[1] In addition, thousands of circulars were distributed to manufacturing firms all over the world seeking specimens of manufacture as well as trade journals, price lists, patent models and drawings. From the beginning the museum was to be a museum for the people — "one of interest and lasting service to the mass of the population" providing instruction to people such as pastoralists, tradesmen, engineers and architects who had no other source of information.[2]

Tragically almost all of the early collection was lost when the Garden Palace was destroyed by fire in 1882. Undaunted, the museum's first curator Joseph H Maiden (1881-1898), proceeded to assemble the collection anew and such was the enthusiasm and commitment that by 1889 over 30 000 specimens had been amassed.

The holding of the Sydney International Exhibition in 1879 and the establishment of the Technological, Industrial and Sanitary Museum were important initiatives in meeting local demands for access to scientific and technological advances that would spearhead local industrial development. Such developments were seen as essential to broadening the base of the economy and a necessary prerequisite to establishing Australia as an independent country.

By 1893, the museum was renamed the Technological Museum and housed in a new building designed by William Kemp next to the Sydney Technical College, a relationship which was expressed formally with the museum presenting exhibits to support the college's curricula. The scope of the collection on display encompassed decorative ceramics and metalwork, furniture, textiles, timber, wood and mineral samples, hand tools, machinery and manufactured products, scientific apparatus, coins, clocks and arms.

While much of the early collection was from Europe there was a express emphasis on acquiring local materials which had potential economic value as well as the products of local industry to demonstrate success. Furthermore, there was active collecting of artefacts from neighboring regions, particularly Japan and China, as well as the Pacific.

At the outset "works of art" such as Meissen, Worcester and Doulton ceramics and, examples of metal work, glass and furniture were acquired as exemplifying the best of industrial production. Their display and interpretation emphasized the economic relevance of their manufacture and design. Limited funds, distance from key centers and a lack of curatorial expertise in applied arts as well as the focus on processes of production meant that the early applied and decorative arts collection was conservative and incomplete in its representation of key stylistic developments.

The political, economic and social factors influencing the move towards the federation of Australia into a single nation in 1901 are clearly evident in the development of the museum's collection and displays in the early 20th century. The museum's new curator Richard Thomas Baker (1898–1921) determined that, in addition to its emphasis on manufacturing processes, the museum should actively collect and exhibit "objects of aesthetic merit" with an emphasis on Australian applied and decorative arts.

With the founding of the Commonwealth of Australia in 1901 and burgeoning national pride, Baker became an ardent promoter of Australia's natural resources and products. A profound influence on Baker and the museum at this time was Lucien Henry, a French-born artist sentenced to exile in New Caledonia for his role in the Paris Commune uprisings of 1871 and then resident in Sydney from 1879–1891. Here, Henry played a leading role in art education at Sydney Technical College, championing his vision of art applied to industry to create a form of design inspired by the Australian environment and expressive of the Australian nation.

Encouraged by Henry's vision, Baker initiated a new display, "Australian Flora Applied to Art", which showed objects of applied and decorative arts inspired by Australia's native flora and fauna in their form and decoration. He also published extensively and actively promoted the "encouragement of Australian designs from Australian subjects, [which] is of great importance toward forming an Australian spirit and a school of Australian design."[3]

The museum's concern with "objects of aesthetic merit" was always international in scope and by the 1920s the New South Wales Applied Arts Trust had been set up to develop a systematic historical approach to collecting. Its members assembled almost 300 objects from all over the world, each exemplary in design and manufacture. Formed in a period influenced by the Arts and Crafts movements and by an emerging interest in design in industry, the collection's scope ranged from peasant embroidery from Eastern Europe to the metalwork of Georg Jensen.

Baker's successor Arthur de Ramon Penfold (1927–1955) defined the applied arts as a field essential to "the promotion of craftsmanship and artistic taste by illustrating the history and development of the applied arts of all nations and all times" (1928). Penfold determined that the museum should reflect the tremendous technological advances of a rapidly changing world and, despite the difficulties of the 1930s depression and World War II Penfold succeeded in making several defining acquisitions. Recognising the importance of the fast-growing plastics industry he assembled the most comprehensive display of plastics in Australia, and in the 1950s the museum displayed new inventions such as the first television in Australia, neon tubes and synthetic fibers.

The development of the Powerhouse Museum, announced in 1979, has been the museum's most recent and most spectacular renaissance. Designed by award-winning architect Lionel Glendenning around the shell of the former Ultimo Power House, the Powerhouse Museum opened in 1988 with a stated emphasis on the importance of design in defining the whole museum experience: architecture, interiors, graphics, exhibitions, sound, lighting, multimedia and so on.

HISTORY OF THE MUSEUM

This major redevelopment allowed the museum to address significant deficiencies in its collection through an acquisition program to support the new exhibitions, particularly those showcasing contemporary design and innovation.

Design is a major unifying theme across all collection fields: Engineering and Design; Information Technology; Sciences; Transport and Communication; Australian and International Decorative Arts and Design; Australian History and Society and Indigenous Culture and History.

Many artefacts in Engineering and Design reflect the input of industrial designers, for example appliances, vehicles, production machinery, scientific and medical instruments. A number of these are accompanied by packaging and promotional materials which show the links between the design and marketing of industrial products. The design process of some products in the collections is recorded through accompanying sketches, drawings, models, prototypes, and copies of design registrations or patents. In some cases, design archives have been acquired which document the work and achievements of notable Australian designers. Current examples of outstanding product designs are collected each year through collaboration with the Australian Design Awards program.

The Decorative Arts and Design collection provides a rich resource for local and international designers and students. It encompasses various approaches to designing and making — from traditional technologies to one-off studio pieces, limited series and multiple production. The scope reflects the aesthetic, social and technological significance of major Australian and international movements, periods and styles through the endeavours of notable individuals, companies and groups. Design archives are a strength of the post-1945 collection. Several works have been specifically commissioned for the collection including Marc Newson's Embryo chair (1988).

Significantly, artefacts which illustrate the process of design and making such as sketches, tools, materials and studio equipment are also acquired with the completed work. Exhibitions include artefacts illustrating ideas, process and making so as to demonstrate how the work was achieved.

The museum's role in promoting design to the wider community has greatly diversified over the last decade or so. Of paramount importance is its educational program, which is closely linked to the design and technology curriculum mandatory through primary and secondary schooling. Tertiary design students are also a key audience across a range of disciplines from architecture and interior design, to fashion, textile, graphic, ceramic, multimedia and theatre design.

The permanent Design Gallery is dedicated to a changing program of exhibitions which celebrate and encourage achievements in design. There are also annual displays of award winning students' work in design and technology and fashion. The museum's permanent exhibitions: Success & Innovation; Ecologic: creating a sustainable future; Transport; Space and Cyberworlds all represent themes exploring the role of design.

A major annual program is Sydney Design Week, a partnership with media and design organizations to promote design to a wide and diverse audience. A range of exhibitions, lectures, competitions, seminars and study days involving Australian and international designers, design students, the design profession and the general public is a key strategy to promote design as a profession, process and product.

The Powerhouse Museum has extended its reach to audiences interested in design through its publishing program, Web site and linked sites it has developed in partnership, of which the most comprehensive is "Australia innovates: an online guide to innovation in Australia's industries".

Since its origins in the 1879 Sydney International Exhibition, the Powerhouse Museum has striven to be a museum of the people, providing a cultural storehouse for the products of art and industry that would instruct and inspire visitors from all walks of life. Design has been the unifying theme over the past 125 years, a theme with many different facets including economic and industrial advancement, functionalism, national identity, modernism, cultural diversity, internationalism, new media, cultural renaissance and sustainability — all expressed in the museum's diverse collection.

The Powerhouse Museum will continue to promote the centrality of design as a means of shaping the future to meet diverse demands in an increasingly challenging world.

J. S.

1 Technological Industrial and Sanitary Museum general reports, 1878–1889
2 Annual Report of the Committee of Management: Technological, Industrial and Sanitary Museum, 1881 (Sydney: Government Printer, 1882)
3 Technological Museum Annual Report, 1914 (Sydney: Government Printer, 1915)

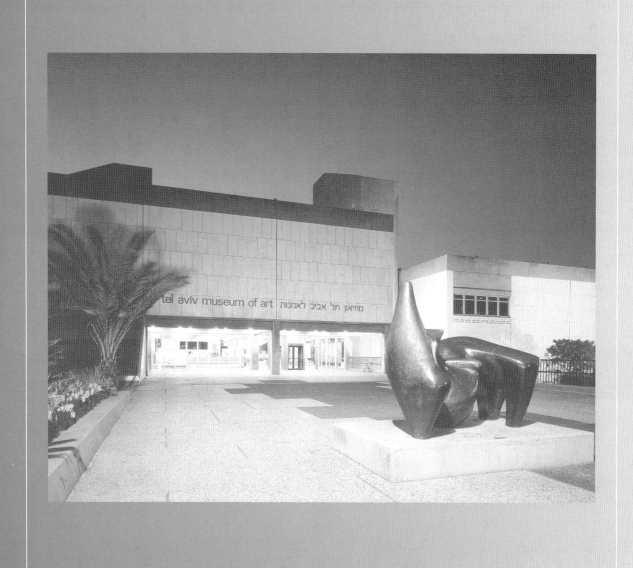

Tel Aviv

Tel Aviv Museum of Art
www.tamuseum.com

COLLECTION

Tel Aviv Museum of Art

DESIGNER / ARCHITECT

Alaya Serfaty

OBJECT

Lamp / Lampe 'Aqua Regia 3'

DATE

1996

MANUFACTURER

Aqua Creations, Tel Aviv / New York

Collection of the Tel Aviv Museum of Art

GESCHICHTE DES MUSEUMS

Das Tel Aviv Museum of Art besteht seit 1932 als modernes Kunstmuseum. Innerhalb dieses Rahmens wurden diverse Ausstellungen zur Architektur organisiert, u. a. durch den Architekten- und Ingenieursverband. In der Zeit vor 1980 wurden nur wenige Design- bzw. Architektur-projekte von Kunstmuseen verfolgt, womöglich weil kunsthistorisch geschulte Kuratoren sich selten im Bereich Design oder Architektur heimisch fühlten. Die Abteilung Design und Architektur des Tel Aviv Museum of Art (D & A-Abteilung) besteht aus dem Kurator und seinem Assistenten. Die Abteilung wurde in den späten 80er Jahren gegründet, also zu einer Zeit, als das Design boomte. Seitdem hat die Abteilung zwei bis drei Ausstellungen im Jahr organisiert, die entweder vom Museum selbst initiiert oder von anderen Institutionen als Leihgaben übernommen wurden. Es wurden moderne oder zeitgenössische israelische und internationale Designer und Architekten vorgestellt oder Gruppen- und the-matische Ausstellungen veranstaltet. Dazu zählten israelische Designer wie Ron Arad und Chanan de Lange (beide Industriedesigner) und Deganit Stern Schocken (Schmuckdesigner) sowie eine Ausstellung mit Stadtbezug unter dem Titel „Design on Design", die sich mit Design-sprache beschäftigte. International renommierte Designer, die hier vorgestellt wurden, waren u. a. Gaetano Pesce, Charles und Ray Eames, Tibor Kalman (visuelle Kommunikation), Fernando und Huberto Campana, Hussein Chalayan/Martin Margiela (Modedesigner) sowie „100 Master-pieces from the Vitra Design Collection". Im Hinblick auf Architektur hat die Abteilung Ausstellungen zu den Architekten Zvi Hecker und Lars Spuybroeck organisiert, außerdem „Public Space — Gardens of Tel Aviv" und „Israel Architecture 1948–1973 — The Israel Project".

Noch stehen die Gebiete Design und Architektur nicht gleichrangig neben den hauptsächlichen Arbeits- und Ausstellungsbereichen im Museumsprogramm, aber 2003 haben sich neue Perspektiven im Museum eröffnet, insbesondere in der D & A-Abteilung. Das Tel Aviv Museum of Art will ein neues Gebäude errichten, und einer der drei Flügel wird dann dem Bereich Design und Architektur gewidmet sein. Damit wird die Abteilung ihre Sammlung als Dauerausstellung zeigen können und die Anzahl und Größe der Ausstellungsräume wird sich erhöhen.

Die Ergebnisse des international ausgerichteten Wettbewerbs für das neue Gebäude wurden am 8. Juli 2003 vorgestellt; gewonnen hat der Entwurf von Preston Scott Cohen, Professor für Architektur an der Universität Harvard. Der erste Teil des Wettbewerbs war israelischen Architekten vorbehalten, während in einem zweiten Schritt die Vorschläge von sechs israelischen Architekten mit denen von drei eingeladenen internationalen Architekten konkurrierten: Gigon Guyer Architekten, Schweiz; SAANA Ltd. — Kazuyo Sejima und Ryue Nishizawa & Associates, Japan; Preston Scott Cohen Architects, USA. Die israelischen Teilnehmer in dieser zweiten Phase waren Ada Karmi-Melamede und Ram Karmi Architects, Israel; Chayutin Architects, Bracha; Michael Chayutin, Israel. Das Museum versucht nun Gelder einzuwerben, um die Baukosten decken zu können. Bis vor kurzem hatte die D & A-Abteilung keinen eigenen Ankaufetat für Objekte, und die Sammlung bestand aus Schenkungen von Designern und Herstellern, unter anderem Konstantin Grcic, Shigeru Ban, Frank Gehry, Jean Nouvel, Enzo Mari, Tal Gur, Ayala Serfati, Ingo Maurer, Ron Gilad, Yaakov Kaufman, Ron Arad.

Die Frage nach der zukünftigen Strategie der Abteilung erfordert eine komplexe Antwort. In der Designwelt geht es nicht mehr länger nur um Fragen des ästhetischen Genusses oder um ein Nachdenken über Funktionalismus. Designstrategien und die Diskussion über eine architek-tonische Kultur erhalten heute Impulse aus der Kunst, denn die Grenzen zwischen den Disziplinen sind durchlässig geworden. Designer benutzen mittlerweile visuelle Erzählplattformen, denen sie private Erinnerungen, Träume und Fantasien sowie in Form verwandelte und über-tragene politische Aspekte hinzufügen. Israelisches Design ist im Fluss, es schwankt zwischen den Gegensätzen persönlicher und globaler Ideologien und zwischen theoretischen Forschungsprojekten, zwischen emotional und politisch gefärbten Vorhaben; es umfasst nicht nur Improvisation, sondern auch modernstes Hightech — vom einmaligen Produkt bis zur Serienherstellung. Während andernorts die digitalen Infrastrukturen zu animierten, im Fluss befindlichen Objekten geführt haben, befasst sich das israelische Design eher mit den organischen und physischen Eigenschaften des Materials. Auch die Aspekte von Tragbarkeit und Mobilität, wo funktionale Lösungen gefragt sind, spielen eine Rolle. Die Moderne wird einer Neubewertung unterzogen und das Interesse an ihr nimmt wieder zu. Israelische Designer arbeiten in einem Modus des Keine-Zeit-Habens, was zu schnellen, intuitiven Lösungen führt.

M. Y.-H.

HISTORY OF THE MUSEUM

The Tel Aviv Museum of Art has been operating since 1932 as a modern art museum. Within this framework, several architecture exhibitions have taken place, organized by the Association of Architects and Engineers, or initiated by others. Very few design / architecture projects were executed within art museums prior to the 1980s. This is perhaps due to the fact that curators with an art-history background have rarely grown into the domain of design and architecture.

The Department of Design and Architecture at the Tel Aviv Museum of Art consists of a staff of one curator and one assistant curator. The department was founded in the late 1980s, an era in which there was an explosion in design. Since then; 2–3 exhibitions have been organized annually, initiated by the museum or on loan from other institutions. The scope includes modern and contemporary shows of Israeli and international designers and architects, as well as group and thematic exhibitions. Among them Israeli designers Ron Arad and Chanan de Lange — industrial designers — and Deganit Stern Schocken, a jewelry artist, as well as a local exhibition entitled "Design on Design", concerned with the language of design. International designers shown include Gaetano Pesce, Charles and Ray Eames, Tibor Kalman (visual communication), Fernando and Huberto Campana, Hussein Chalayan / Martin Margiela (fashion), and "100 Masterpieces from the Vitra Design Collection". In architecture, the department held shows of architects Zvi Hecker and Lars Spuybroeck, as well as "Public Space — Gardens of Tel Aviv" and "Israel Architecture 1948–1973 — The Israel Project".

We are still a long way from having these two disciplines as major and equal partners on the museum's agenda and exhibition schedule, but 2003 has brought new horizons to the museum and especially to the D&A Department. The Tel Aviv Museum of Art is planning a new building in which one of the three wings will be dedicated to design and architecture. This will enable the department to show its collection on a permanent basis, and increase thesize of its exhibition spaces and the number of exhibition halls.

The results of the international competition for the new building were presented on July 8, 2003, and the winning project was that of Harvard Professor of Architecture Preston Scott Cohen. The initial stage of the competition was open to Israeli architects, while the second stage set 6 Israeli architects against three invited international architects — Gigon Guyer Architects, Switzerland, SAANA Ltd; Kazuyo Sejima and Ryue Nishizawa & Associates, Japan; and Preston Scott Cohen Architects, USA. The Israeli contestants in the final stage were Ada Karmi-Melamede and Ram Karmi Architects, Israel, and Chayutin Architects, Bracha and Michael Chayutin, Israel. The museum is now in the process of raising funds to cover the building costs. Until recently, the D&A Department had no budget for acquisitions, and the collection was built from donations of designers and manufacturers. Among them Konstantin Grcic, Shigeru Ban, Frank Gehry, Jean Nouvel, Enzo Mari, Tal Gur, Ayala Serfati, Ingo Maurer, Ron Gilad, Yaakov Kaufman, Ron Arad and others.

Questions regarding future Department policy are complex. The design universe is no longer only a question of aesthetic pleasure or a reflection on functionalism. Design strategies and the architecture cultural debate are stimulated by art, and the boundaries between the fields have become permeable. Nowadays, designers use visual story-telling platforms loaded with private memories, dreams, fantasies, and political issues transformed and translated into form. Israeli design is in flux, oscillating between conflicting personal and global ideologies and between theoretical research-based projects to ones with emotional and political affinities, ranging from improvization to the cutting edge of high-tech and from a one-of-a-kind items to industrially manufactured articles. While elsewhere, digital infrastructures have led to the creation of animated, fluid objects; local design is more tied to the organic and physical qualities of the material. Issues of portability and mobility, where functional solutions are required, are also apparent. Modernism is being reassessed and enjoying renewed interest. Israeli designers operate out of a no-time syndrome leading to immediate, intuitive solutions.

M. Y.-H.

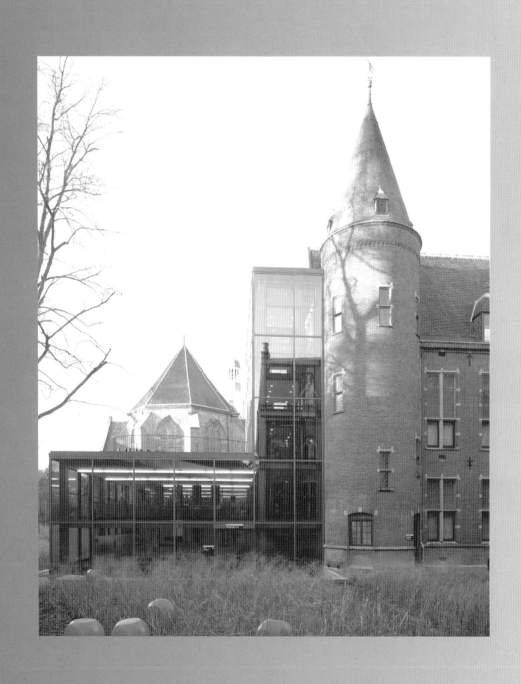

Utrecht

Centraal Museum
www.centraalmuseum.nl

COLLECTION

Centraal Museum

DESIGNER / ARCHITECT

Jurgen Bey

OBJECT

Bench / Bank 'Gardening Bench'

DATE

1999

MANUFACTURER

Droog Design, Amsterdam, 2003

Centraal Museum, Utrecht

GESCHICHTE DES MUSEUMS

Vor 165 Jahren eröffnete der Bürgermeister von Utrecht auf dem Dachboden des Rathauses eine Ausstellung einiger Hundert Gemälde, von Werken der Bildhauerkunst, der Druckgrafik und Kupferstich-Kunst, von Zeichnungen und anderen Objekten, die für die Geschichte der Stadt von großer Bedeutung waren. Der Katalog kostete 25 Cent, und für Frauen war der Eintritt kostenlos.

Bis in die Mitte des 20. Jahrhunderts hinein war diese lokalhistorische Perspektive bestimmend für die Sammlungstätigkeit des Museums. Die Abteilung für angewandte Kunst nahm innerhalb der Sammlung einen relativ großen Raum ein, weil die historischen Lebensverhältnisse der Utrechter Bevölkerung dem Publikum an Hand von Stilzimmern präsentiert wurden. In dem Maße, wie sich die regionalen Unterschiede im Laufe der Jahrhunderte verringerten, verminderte sich auch der spezifisch Utrechter Charakter der Sammlung, der ihr dennoch bis heute erhalten geblieben ist: eigenwillig und mit Künstlern, die in den Niederlanden und international nicht repräsentiert sind.

Die Sammlung ist inzwischen auf ca. 50.000 Objekte angewachsen. Glücklicherweise war Utrecht bereits in der römischen Zeit eines der wichtigsten kulturellen Zentren in den Niederlanden und durch die Jahrhunderte eine inspirierende Umgebung für Künstler aller Art. Die Konzentration auf die regionale Kunstproduktion ging nie auf Kosten der Qualität. Um 1600 führten zum Beispiel die Silberschmiede Adam und Paulus van Vianen einen neuen, innovativen Stil ein: den Ohrmuschelstil. Nachdem er in vielen anderen europäischen Städten gearbeitet hatte, kam Paulus an den Hof Rudolfs II. in Prag. Sein Bruder Adam blieb sein Leben lang in Utrecht, doch sein Einfluss auf die internationale Gold-schmiedekunst war deshalb keineswegs geringer.

In dieser Hinsicht gleicht er einem anderen Bürger der Stadt, dem berühmten Gerrit Thomas Rietveld. Auch dieser „einfache" Handwerker hat mit seinen revolutionären Entwürfen einen nachhaltigen Einfluss auf die künstlerischen Entwicklungen im 20. Jahrhundert ausgeübt.

Aus seinem Verantwortungsbewusstsein für die Utrechter Künstler heraus organisierte das Centraal Museum 1958 die erste Rietveld-Retrospektive. In diesem Jahr erschien auch die erste wissenschaftliche Publikation über sein Werk, verfasst von dem Amerikaner Theodore Brown. Der Neubewertung, die die Gruppe De Stijl in Amerika erfuhr, war es mit zu verdanken, dass Rietvelds Stern auch in seinem eigenen Land aufzugehen begann. Nach Ablauf der Ausstellung schenkte Rietveld dem Museum einen großen Teil der ausgestellten Stücke. Aus dieser Schenkung sollte sich die größte Rietveld-Sammlung der Welt entwickeln. In Einklang mit der Utrechter Sammlungspolitik wurden auch die Künstler, Architekten und Designer aus Rietvelds näherer Umgebung in die Sammlung integriert. Viele von ihnen — darunter van Ravesteijn, van Leusden, van der Leck und Uijterwaal — praktizierten in den Jahren zwischen 1915 und 1930 eine experimentelle Gestaltung, die formal und ideologisch stark von De Stijl beeinflusst war. Während andere Museen sich in ihrer Sammlungspolitik auf die bildende Kunst dieser Periode konzentrierten, besitzt das Centraal Museum eine prachtvolle Möbelsammlung aus dem Umfeld von De Stijl.

Einen zweiten Impuls erhielt die Rietveld-Sammlung, als Frau Schröder beschloss, ihr Haus, das 1924 von Rietveld entworfen und gebaut wor-den war, nach ihrem Tod unter die Verwaltung des Centraal Museum zu stellen. Nach Abschluss der Restaurierungsarbeiten wurde das Haus 1987 der Öffentlichkeit zugänglich gemacht. Nicht nur das Rietveld-Schröder-Haus, sondern auch Schröders Archiv und ihre Möbel wurden dem Museum anvertraut. Diese Schenkung war der unmittelbare Anlass für eine umfassende wissenschaftliche Untersuchung des Rietveld-schen Werks, die 1992 in einer großen Retrospektive und der Veröffentlichung des vollständigen Werkverzeichnisses mündete („Het volledige werk"). Seit dieser Zeit gilt Utrecht als die Rietveld-Stadt, und das Centraal Museum als das Wissenszentrum über diesen Architekten. Im Jahr 2000 wurde das Schröder-Haus in die Weltkulturerbeliste der UNESCO aufgenommen, und seit 2002 verwaltet das Museum noch zwei weitere Rietveld-Häuser aus den frühen 30er Jahren.

Innerhalb der Sammlung des Centraal Museum liegt der Schwerpunkt auf der experimentellen Seite im Œuvre Rietvelds. Seit den 80er Jahren wurde diese Tendenz auf die Sammlungspolitik der Abteilung für angewandte Kunst und Gestaltung generell ausgedehnt. Das Museum erwirbt hauptsächlich Arbeiten junger niederländischer Designer, die in ihrer experimentellen Formgebung die herrschenden Auffassungen, Trends und Stile zur Diskussion stellen. Im Kontext der umfassenden Präsentation des niederländischen Designs der Nachkriegszeit, die unter dem Titel „Holland in Vorm" 1987 von fünf großen Museen organisiert wurde, hat sich das Centraal Museum mit der Ausstellung „Gemengd Nieuws" (Vermischte Neuigkeiten) der Aktualität angenommen. 1996 hat das Centraal Museum Utrecht als einziges Museum weltweit die damalige „Droog Design"-Kollektion erworben. Man beschränkte sich dabei nicht auf die Auswahl einiger weniger Stücke, da das Museum die Meinung vertritt, dass der gesamten Kollektion ebenso große Bedeutung zukommen sollte, wie die Qualität jedes einzelnen Stückes.

Ende der 90er Jahre bekam das Museum die einmalige Chance deutlich zu machen, wie wichtig die Gestaltung generell für die Erfahrung und Wahrnehmung unserer Umgebung ist, und wie bemerkenswert insbesondere die neuesten Entwicklungen im niederländischen Design sind. Von 1995 bis 1999 wurde das Museum umgebaut und erweitert. Zum Abschluss der Arbeiten wurden eine Reihe von Aufträgen für die Gestaltung einzelner Gebäudeteile oder Inventarobjekte an niederländische Gestalter vergeben. Verschiedene Künstler, Architekten und Designer wurden in dieses Projekt einbezogen. Richard Hutten richtete das Museumsrestaurant „De Refter" („Das Refektorium") und den Museumsshop ein. Arnout Visser en Erik Jan Kwakkel entwarfen das Geschirr, Jurgen Bey gestaltete eine aus Kokon-Möbeln zusammengesetzte Wandverkleidung für den Rietveld-Flügel und Viktor & Rolf entwarfen die neue Personaluniform: einen Levi-Jeansanzug mit einer grünen bestickten Schärpe. Design war nicht mehr nur in den Vitrinen zu sehen, sondern wurde in das Gesamtkonzept des Museums integriert.

Droog Design ist inzwischen in der internationalen Avantgardeszene zu einem Begriff geworden. Eine Reihe von niederländischen Designern hat sich international einen Namen gemacht. Das Centraal Museum wird sie auch in Zukunft im Auge behalten und ihre Arbeiten ankaufen. Gleichzeitig sind unsere Antennen auf eine neue Generation ausgerichtet, die sich in unserer Zeit der Globalisierung nicht ausschließlich aus niederländischen Designern zusammensetzt, wohl aber eine in der niederländischen Tradition des experimentellen und konzeptuellen Designs verankerte Mentalität aufweist. Ein Design, das die Welt und ihre Werte zur Diskussion stellt. Eine Formgebung, wie sie Rietveld vorschwebte, und damit schließt sich der Kreis.

I. v. Z.

HISTORY OF THE MUSEUM

It was 165 years ago that, in the attic of the town hall, the mayor of Utrecht opened an exhibition of several hundred paintings, sculptural works, prints, sketches and other objects, which were of immense importance in the history of the town. The catalogue cost 25 Cents, and admission was free of charge for women.

Until the middle of the 20th century the museum's activities with regard to its collection focused on local aspects. Within the collection itself the applied art section occupied a relatively large area, since historical rooms provided the general public with an insight into the living conditions of the Utrecht population through the ages. Just as regional differences dwindled over the course of centuries, so too the specific Utrecht character of the collection became less pronounced, even though it is still much in evidence to day: self-willed, and presenting artists not represented in the Netherlands or in the international arena.

Since then, the collection has grown such that it now encompasses some 50 000 objects. Fortunately, as early as Roman times Utrecht had been one of the most important cultural centers in the Netherlands, and throughout the centuries had provided an inspirational setting for all manner of artists. The focus on regional artistic production was never at the expense of quality. Around 1600 for example, two silversmiths, Adam and Paulus van Vianen introduced a new innovative style: the auricle style. Having already worked in several other European cities, Paulus was employed at the court of Rudolph II in Prague. His brother Adam stayed in Utrecht all his life, but his influence on international goldsmith's art was just as great.

In this respect he can be compared with another of the town's citizens, the famous Gerrit Thomas Rietveld. With his revolutionary designs, this "simple" craftsman also had a lasting influence on 20th century artistic developments.

Out of a sense of responsibility towards the Utrecht artists, in 1958 the Centraal Museum staged the first Rietveld retrospective. That year also witnessed the publication of the first scholarly work about his oeuvre, by the American Theodore Brown. The re-evaluation that the De Stijl group experienced in America was one of the reasons for Rietveld's home country gradually coming to appreciate him as well. Once the exhibition was over, Rietveld donated several of the exhibits to the museum, making it the largest collection of its kind in the world. As part of the policy of collecting practiced in Utrecht, those artists, architects and designers who moved in circles close to Rietveld were also included in the exhibition. Between 1915 and 1930 many of them — van Ravesteijn, van Leusden, van der Leck and Uijterwaal to name but a few — engaged in experimental design that in terms of form and ideology was heavily influenced by De Stijl. Whereas it is the policy of other museums to focus on the fine arts of this period, the Centraal Museum owns a magnificent collection of furniture revolving around De Stijl.

The Rietveld collection received a second lease of life when Mrs. Schröder decided that upon her death her house, which Rietveld had designed and built in 1924, be placed under the administration of the Centraal Museum. Once restoration work had been completed in 1987, the house was opened to the public. As well as her house, Mrs. Schröder also bequeathed the furniture in it as well as her archives to the museum. This donation directly prompted extensive academic research into Rietveld's output, leading in 1992 to a large-scale retrospective and the publication of a directory of his entire works ("Het volledige werk"). Since then Utrecht has been considered to be the Rietveld town, and the Centraal Museum the center of knowledge about the architect. In 2000 the Schröder house was included in the UNESCO World Heritage List, and since 2002 the museum has been administering a further two houses designed by Rietveld in the early 1930s.

Within the Centraal Museum collection itself, the focus is on the experimental side of Rietveld's work. Since the 1980s, this trend has also been extended to cover the Department of Applied Art and Design's general policy on collection. The museum primarily acquires works by young Dutch designers who question prevailing theories, trends and styles in their experimentation. In the context of the extensive presentation of post-war Dutch design in 1987, which was organized by five large museums and was entitled "Holland in Vorm", the Centraal Museum with its "Gemengd Nieuws" (Mixed News) addressed itself to the current trend of the day. In 1996, the Centraal Museum in Utrecht was the sole museum worldwide to acquire the "Droog Design" collection. The museum did not restrict itself to a few selected examples, as it is of the opinion that the reasoning behind the collection as a whole is of just as much importance as the quality of each individual piece.

At the end of the 1990s the museum was given the unique opportunity to illustrate just how important design in general is for the way in which we experience and perceive our surroundings, and how remarkable in particular the latest developments in Dutch design are. Between 1995 and 1999 the museum was converted and extended. To round out the work, a series of contracts for the design of individual sections of buildings and objects making up the inventory were awarded to Dutch designers. Various artists, architects and designers were involved in the project. Richard Hutten fitted out "De Refter" ("The Refectory"), the museum restaurant, as well as the museum shop. Arnout Visser and Erik Jan Kwakkel designed the crockery, Jurgen Bey designed a wall decoration made up of Kokon furniture for the Rietveld wing and Viktor & Rolf designed a new uniform for the staff: a Levi's jeans suit with a green embroidered sash. Design was not just confined to the showcases; it permeated the museum's overall concept.

Droog Design has advanced to become a fixed element in international avant-garde circles. A host of Dutch designers have made a name for themselves on the international stage. The Centraal Museum will continue to keep an eye on them in the future and purchase their works. At the same time we are casting our glance towards a new generation, which in these times of globalization does not consist solely of Dutch designers, but does indeed demonstrate a mentality that is firmly anchored in the Dutch tradition of experimental and conceptual design. A design form which questions the world and its values. A design form which Rietveld envisaged, which brings us full circle.

I. v. Z.

Vienna

MAK – Österreichisches Museum für angewandte Kunst
www.mak.at

COLLECTION

MAK – Österreichisches Museum für angewandte Kunst

DESIGNER / ARCHITECT

Otto Wagner

OBJECT

Table for the dispatch room of 'Die Zeit'
Tisch für das Depechenbüro 'Die Zeit'

DATE

1902-03

MANUFACTURER

unknown / unbekannt

MAK – Österreichisches Museum für angewandte Kunst, Wien

GESCHICHTE DES MUSEUMS

FLUCHTPUNKT MUSEUM

Kunst ist die Erforschung der Formen menschlicher Sinnlichkeit und Wahrnehmung. In einer Situation des gesellschaftlichen Wandels ist sie Ort der Entwicklung von Strategien zur Gestaltung des zukünftigen Lebensraums. Das Museum findet seine Position in diesem Prozess in der Ermöglichung und Fundierung der künstlerischen Produktion.

Das Museum hat dem Künstler in der Begegnung von Sammlung und Experiment die Möglichkeit zur Positionierung seiner Fragestellungen im Rahmen der gesellschaftlichen Bedürfnisse zu gewähren. Dies unterstreicht die besondere Bedeutung der Sammlung für die Kontinuität und der zeitgenössischen Kunst für die Orientierung.

Mit diesen Erkenntnissen hat sich das MAK als Forschungsstätte der gesellschaftlichen Erkenntnis und als Laboratorium künstlerischer Produktion etabliert. 1864 als k. k. Österreichisches Museum für Kunst und Industrie gegründet, ist es seither eine vitale Institution zwischen Praxis und Lehre, Kunst und Industrie, Produktion und Reproduktion. Mit dem Umbau wurde 1986 das Markenzeichen MAK etabliert und entsprechend einem risikofreudigen, unbürokratischen Denken eine grundlegende Neudefinition eingeleitet. Im Zuge dessen wurde die ursprüngliche Ausrichtung verstärkt und zugleich radikal erweitert: Die Intervention der Künstler selbst schafft die Verhältnisse. Hier wird heute das entwickelt, worauf das Morgen sich gründet.

Zugleich ist das MAK ein Ort wissenschaftlicher Forschung zu allen Fragen der Produktion, Vermittlung, Erhaltung und Neuorientierung von Kunst. In der Gestaltung der Schauräume durch namhafte zeitgenössische Künstler wie Barbara Bloom, Eichinger oder Knechtl, Günther Förg, Gangart, Franz Graf, Jenny Holzer, Donald Judd, Peter Noever, Manfred Wakolbinger, Heimo Zobernig, Sepp Müller, Hermann Czech und James Wines / SITE wurde der Dialog zwischen historisch Vorgefundenem und experimentellem Entwurf vorbildhaft realisiert.

Das MAK ist als Museum zugleich ein Laboratorium, in dem eine grenzüberschreitende Auseinandersetzung zwischen angewandter und freier Kunst, Architektur und Design stattfindet. Künstler, Architekten und Designer erproben neue Formen der ästhetischen Produktion und loten die Grenzen zwischen Kunst, Kultur und alltäglichem Lebensraum aus. Wenn die Wirklichkeit in ihrem Wandel begreifbar gemacht werden soll, so sind „künstlerische Freizonen", wie sie das MAK zu bieten versucht, von elementarer Notwendigkeit. Nicht die ästhetische Produktion im Sinne einer kritischen Auseinandersetzung mit einer sich permanent im Wandel befindenden Gesellschaft bestimmt heute die Wahrnehmung von sozialer, politischer und kultureller Wirklichkeit, sondern das Erfinden neuer Formen der Unterhaltungs- und Freizeitkultur. Diese unreflektierte Entwicklung macht auch vor Museen bei der Wahl ihrer Ausstellungs- und Veranstaltungsprogramme nicht Halt. Im Gegenteil, im „Kalten Krieg" um höhere Besucherzahlen mutieren Ausstellungen und Veranstaltungen immer mehr zu „Handlangern" des Entertainments.

Das MAK hat dieser „Versuchung" stets bewusst widerstanden und in den vergangenen Jahren Ausstellungen präsentiert, die heute kaum mehr zu realisieren sind. Diese Präsentationen, wie zum Beispiel „Donald Judd. Architektur" (1991), „Vito Acconci. The City Inside Us"(1993), „Philip Johnson. Turning Point" (1996), „Bruno Gironcoli. Die Ungeborenen" (1997), „James Turrell. the other horizon" (1998), „Franz West. Gnadenlos" (2001), „Richard Artschwager. The Hydraulic Door Check" (2002) oder „Zaha Hadid. Architektur" (2003), wurden gemeinsam mit den Künstlern — oft über viele Jahre hinweg — geplant und erarbeitet. Gerade Ausstellungen dieser Art sind eine Trademark des MAK und dieses Haus wird sich — auch unter Bedingungen, die immer weniger Raum für das unverzichtbare Experiment zulassen — nicht daran hindern lassen, den eingeschlagenen Weg fortzusetzen.

„Experiment und Tradition" ist der Leitgedanke, dem sich das MAK verpflichtet fühlt und den es mit seinen Ausstellungs- und Veranstaltungsaktivitäten immer wieder unter Beweis stellt. Mit der Ausstellung „KNOTEN symmetrisch_asymmetrisch. Die historischen Orientteppiche des MAK und Filminserts der Gegenwart" (2002) hat die Künstlergruppe Gangart eine Begegnung zwischen der einzigartigen historischen Sammlung des MAK und den Perspektiven zeitgenössischer Kunst realisiert, die nicht nur die Bedeutung der Sammlung zeigt, sondern auch das Potenzial ihrer Positionierung in der Gegenwart darstellt. Der programmatische Ansatz, zeitgenössische Künstler einzuladen, sich kritisch mit den traditionellen Sammlungsbeständen des MAK auseinander zu setzen, bedeutet auch, unsere Existenz, unsere Vorstellungen und Sehnsüchte einzubeziehen, um gleichfalls neue Blickpunkte und Erfahrungen zu ermöglichen.

Mit Einrichtungen wie der MAK NITE© wird den neuen Medien und neuen gesellschaftlichen Tendenzen eine Plattform in diesem Kontext zur Verfügung gestellt. Der Design-Info-Pool ist bereits der Versuch einer zusammenfassenden Weiterführung der historischen Sammlungstätigkeit des Hauses im internationalen Kontext.

Gleichzeitig hat das MAK weitere interdisziplinäre Projekte entwickelt — das MAK Artists and Architects-in-Residence Program, die Design-Showcases©, die MAK-Akademie und CAT Open —, in denen Künstler, Architekten, Designer und Wissenschaftler ihre Ideen frei von „Quotenzwang" und „Geschmacksdiktat", oft unter Miteinbeziehung von neuen Medien und Technologien, im MAK realisieren können. Mit diesen Programmen ist es auch gelungen, ein neues Publikum — vor allem jüngere Besucher — zu begeistern.

Im öffentlichen Raum ist das MAK mit zeitgenössischer Kunst und Architektur in vielfältiger Form präsent: „Stage Set" von Donald Judd, das „Wiener Trio" von Philip Johnson, die „Vier Lemurenköpfe" von Franz West, „the other horizon / Skyspace" von James Turrell in Wien sowie „METRO-Net Ventilation Shaft" von Martin Kippenberger in Los Angeles.

Mit dem Projekt „CAT – Contemporary Art Tower" soll aus dem Gefechtsturm im Arenbergpark Wien das internationale Zentrum für zeitgenössische Kunst entstehen. Dieses „Mahnmal der Barbarei" in seiner einzigartigen Verbindung mit avantgardistischer Architektur und richtungsweisendem Programm wird der für Wien unerlässliche Ort zeitgenössischer Kunst.

Das MAK ist eine Schnittstelle globaler Kommunikation. Internationale Kooperationen, wie beispielsweise mit dem Architekturmuseum Schussev in Moskau, und das MAK Center for Art and Architecture, Los Angeles sind notwendiger universeller Rahmen für künstlerische Produktionen. Förderprogramme wie das Stipendiatenprogramm „Artists and Architects-in-Residence" in Los Angeles stellen die materielle Unabhängigkeit künstlerischer Produktion sicher.

In einer kontinuierlichen Konfrontation zeitgenössischer Produzenten mit den vorhandenen Sammlungen sollen die adäquaten Formen der angewandten Kunst, der Architektur, von Design und neuen Medien hinterfragt werden. Durch entsprechende Kooperationen soll der Übergang aus der reflektierten Tradition in die Herausforderung Zukunft geschaffen werden.

GESCHICHTE DES MUSEUMS

Als „work in progress" versteht sich das MAK als ein Ort, an dem geforscht wird und vor allem: an dem gemeinsam geforscht werden kann. Der Schwerpunkt liegt dabei im Experiment, dessen Anordnung durch die Geschichte beschrieben ist. Das Museum ist der ultimative Übersetzungsapparat, der die Produktionen einzelner über Generationen und Grenzen hinweg in die Gegenwart und Zukunft zu vermitteln vermag. Es fungiert kraft seiner Verbindung zum Gewesenen als Projektionsfläche und utopischer Antizipationsmechanismus. Darin artikuliert es die Alternative zur Kapitulation vor dem Geschäftsmodell der Unterhaltungsindustrie und dem Lebensmodell der Erlebnis- und Abenteuergesellschaft.

Das Museum hat seine Funktion als Ort der Erkenntnis frei von äußeren Einflüssen wahrzunehmen und weiter zu entwickeln, indem es den Diskurs über die Formen menschlicher Wahrnehmung vorantreibt. Da es entlang der Grenzen navigiert, die Kunst und Erkenntnis von den unzähligen modischen Formen von Konsum, Unterhaltung und Erlebnis trennt, ist es durch die Artikulation qualitativer Bewertungskriterien zentrales Forum des Widerstands gegen den Bedeutungsverlust im Zuge der verallgemeinerten Beliebigkeit.

Soll das Museum weiterhin als Ort der Vermittlung zwischen Kunst und Publikum bereitstehen, so darf es nicht nur ein Ort der Dinge sein. Es muss zu einem Ort werden, an dem das entsteht, worin wir uns und unsere Möglichkeiten reflektieren und erkennen können. Das bestimmt die unverrückbare Position des MAK.

P. N.

HISTORY OF THE MUSEUM

227

MUSEUM AS FOCUS

Art is about researching forms of human sensuality and perception. In a situation where society is changing, art is a place where strategies for forming future living space are realized. The museum has a role in this process in that it enables and funds artistic production.

The museum must give the artist the possibility of positioning his questions within the framework of social needs in his confrontation with both collection and experiment. This underlines the particular importance of the collection for a sense of continuity and of contemporary art for a sense of orientation.

Based on these tenets, the MAK has established itself as a place of research into social cognition and as a laboratory for artistic production. Founded in 1864 as the Imperial and Royal Austrian Museum of Art and Industry, the MAK has pursued a continued commitment to combining practice and theory, art and industry, production and reproduction. In conjunction with alteration work undertaken in 1986, the MAK brand name was established, introducing a fundamentally new definition that went hand in hand with an outlook that was un-bureaucratic and happy to engage in risk. As a result the original focus was consolidated and at the same time radically expanded: the intervention of the artists themselves creates the conditions. The powerful ideas created here today will serve as models for tomorrow.

At the same time, the MAK is a place of scholarly research into all issues relating to producing art, familiarizing the public with it, preserving it, and giving it a new sense of direction. The dialogue between the historical and experimental projects has been realized in exemplary fashion by the design of the exhibition rooms by such renowned contemporary artists as Barbara Bloom, Eichinger oder Knechtl, Günther Förg, Gangart, Franz Graf, Jenny Holzer, Donald Judd, Peter Noever, Manfred Wakolbinger, Heimo Zobernig, Sepp Müller, Hermann Czech and James Wines / SITE.

As a museum the MAK is simultaneously a laboratory in which an interdisciplinary confrontation between applied and fine arts and architecture and design takes place. Artists, architects and designers try out new forms of aesthetic production and plumb the boundaries between art, culture and everyday living space. If the reality in the process of change is to be made comprehensible then the "zones of artistic freedom" such as those the MAK tries to offer are an elemental necessity. It is not aesthetic production in the sense of a critical confrontation with a changing society that determines the perception of social, political and cultural reality nowadays, but the invention of new forms of entertainment and leisure-time culture. This unreflected development does halt the museum and its choice of either exhibition or event program. On the contrary, in the "Cold War" of increasing visitor numbers, exhibitions and events mutate more and more to the henchmen of entertainment.

The MAK had consciously resisted this "temptation" and over the last few years has presented exhibitions that almost certainly could not be realized today. These presentations e.g., "Donald Judd. Architecture" (1991); "Vito Acconci. The City Inside Us" (1993); "Philip Johnson. Turning Point" (1996); "Bruno Gironcoli. The Unbegotten" (1997); "James Turrell. the other horizon" (1998); "Franz West. Merciless" (2001); "Richard Artschwager. The Hydraulic Door Check" (2002) or "Zaha Hadid. Architecture" (2003) were planned and worked out together with the artists, often over many years. It is exactly this kind of exhibition that is MAK's trademark and this house will continue on the path it started out on notwithstanding conditions in which there is less and less space for such indispensable experimentation.

HISTORY OF THE MUSEUM

"Experiment and Tradition" is the guiding thought to which the MAK feels committed, and it is proved time and time again with its exhibition and event activities. With the show "KNOTS symmetric_asymmetric. The MAK's Historical Oriental Carpets and Film Inserts of the Present", the artist group Gangart realized an encounter between the unique historical collection and the perspectives of contemporary art. This not only shows the importance of the collection but also the potential for its positioning in the present. The programmatic approach of inviting contemporary artists to concern themselves critically with the MAK's traditional collection also means taking into account our existence, our ideas and our longings in order to enable new points of view and experiences.

In this context, installations such as MAK NITE© provide a platform for new media and new trends in society. The Design Info Pool is an attempt at an all-embracing continuation of the historical collection of this institution in an international context.

At the same time the MAK developed interdisciplinary projects — MAK Artists and Architects-in-Residence Program, MAK NITE©, DesignShowcases©, MAK AKADEMIE and CAT Open — in which artists, architects, designers and scientists can realize their ideas, often including new media and technologies and free from "ratings" and "dictated taste". This program has been successful in stimulating the enthusiasm of a new public, comprised, above all, of young people.

The MAK is represented in the public domain in a variety of cases by its contemporary art and architecture: Donald Judd's „Stage Set," Philip Johnson's "Wiener Trio", James Turrell's "the other horizon / Skyspace", Franz West's "Four Lemurheads" in Vienna, as well as Martin Kippenberger's "METRO-Net Ventilation Shaft" in Los Angeles.

Transforming a World War II anti-aircraft tower in Vienna's Arenbergpark, the Contemporary Art Tower (CAT) will be an international art center, showcasing important contemporary projects. Through its unique avant-garde architecture and pioneering program, this "monument of barbarism" will become Vienna's foremost venue for contemporary art.

The MAK is a hub of emerging global communication. International cooperation projects, for example with the Schussev Museum of Architecture in Moscow, and the MAK Center for Art and Architecture in Los Angeles provide the requisite universal framework for artistic productions. Sponsored programs such as the "Artists and Architects-in-Residence" scholarship program in Los Angeles ensure that artistic productions enjoy independence in terms of material resources.

By means of ongoing confrontation between contemporary art producers and existing collection holdings, the appropriate forms for applied art, architecture, design and new media are questioned. Corresponding cooperation projects serve to enable a transition from reflected tradition to the challenge that the future presents.

Vienna MAK – Österreichisches Museum für angewandte Kunst

At MAK there is "work in progress", and the museum sees itself as a place where research work is undertaken and, above all, where research work can be undertaken together with others. The focus here lies in experimentation, the order of which is described by history. The museum is the ultimate translation apparatus, able to transpose individuals' productions over generations and across borders to the present time and the future. By virtue of its link to what has once been, it functions as a projection surface and utopian anticipation mechanism. In this it expresses an alternative to capitulating to the business model that is the entertainment industry and the model for life that is a society geared to experience and adventure.

The museum must continue to develop as a place of awareness, free of external influences, by advancing the discourse between the interplay of experience and perception. Since it navigates along the borders that separate art and awareness from innumerable forms of fashionable consumption, the museum's articulation of qualitative assessment makes it a central forum for resistance against the widespread loss of meaning pandemic in contemporary popular culture.

If the museum is to continue to be available as a place of mediation between art and the public, it cannot be simply a place full of things. It must become a place where something emerges in which we reflect on and recognize the opportunities open to art. This is the unalterable position of the MAK.

P. N.

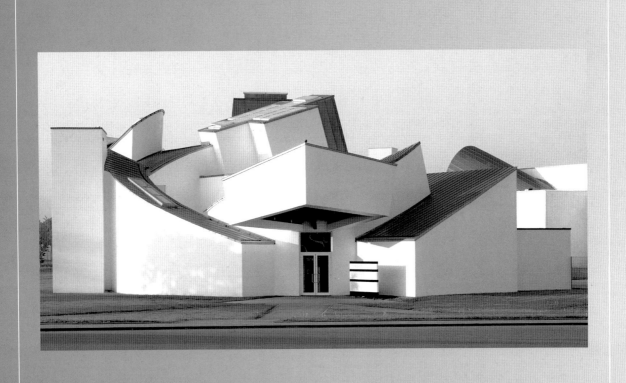

Weil am Rhein

Vitra Design Museum
www.design-museum.de

COLLECTION

Vitra Design Museum

DESIGNER / ARCHITECT

Marc Newson

OBJECT

Chaiselongue / Liege 'MN-01LC1 Lockhead Lounge'

DATE

1985 / 1986

MANUFACTURER

Idée Tokyo, since / ab 1986

Vitra Design Museum, Weil am Rhein

Weil am Rhein
Vitra Design Museum

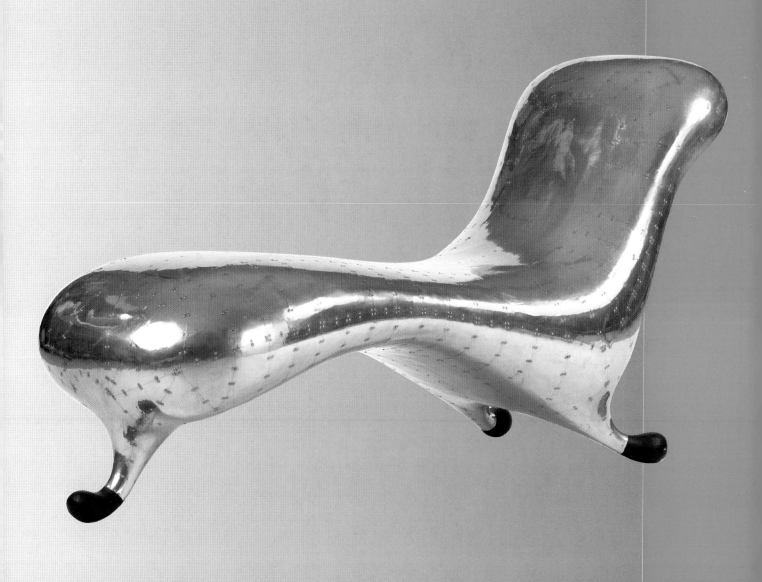

GESCHICHTE DES MUSEUMS

Design hat in den letzten beiden Jahrzehnten über seine primäre Aufgabe der Formgebung hinaus auch durch seine identitäts- und sinn-stiftende Funktion enorm an Bedeutung gewonnen. Diese Entwicklung spiegelt sich auch in der Gründung neuer Designmuseen wider, die sich damit thematisch zwischen den traditionsreichen und bereits etablierten Museen für Angewandte Kunst und den ebenfalls schon länger bestehenden Designzentren positionieren. Während die Sammlungsschwerpunkte der Ersteren meist in der Zeit vor dem 20. Jahrhundert und weniger im Bereich des Industriedesigns liegen, sehen Letztere ihre Aufgabe eher in der kommerziellen Promotion aktueller Designprodukte als in historisch fundierter Analyse.

Die Gründungen der ersten Designmuseen fallen aber auch in eine Zeit, in der sich Museumspraxis und Ausstellungsbetrieb generell im Umbruch befinden. Nolens volens sind wirtschaftliche Erwägungen dabei eine, wenn nicht die treibende Kraft. Gefordert sind neue Möglichkeiten der Eigenfinanzierung, die zugleich inhaltliche Unabhängigkeit garantieren. „Mehr Besucher!" ist eine Zielvorgabe, der mit einer zunehmenden Frequenz publikumswirksamer Wechselausstellungen entsprochen werden soll. „Mehr verkaufen!" lautet ein anderer Vorschlag zur finanziellen Selbsthilfe, so begegnet man in immer größeren Museumsshops einem austauschbaren Warenangebot. Expressive Architektur verspricht zusätzliche Besucher — und Konsumenten — also ringen immer aufwändigere und aufregendere Museumsneubauten mit den Ausstellungen um Aufmerksamkeit.

In diesem Spannungsfeld hat das erst 14 Jahre alte Vitra Design Museum seinen ganz eigenen Weg beschritten. Die Voraussetzungen dafür waren günstig. Das Museum entstand 1989 aus der privaten Initiative des Unternehmers Rolf Fehlbaum in Kooperation mit dem Gründungs-direktor Alexander von Vegesack. Bis heute unterliegt es daher keinerlei kommunalen oder staatlichen Vorgaben. Die finanzielle Unterstützung des Unternehmens Vitra sichert den Tagesbetrieb, ohne dass damit inhaltliche Auflagen, wie etwa die Aufarbeitung und Darstellung der Firmengeschichte, verbunden wären. Im Gegenteil, mit internationalem Design und Architektur ist das Themenfeld für Ausstellungen bewusst weit gesteckt. Die daraus resultierende Handlungsfreiheit und Flexibilität nutzt das Museum für eine außergewöhnlich dynamische Entwicklung und Diversifizierung seiner Aktivitäten, die zur fundierten Vermittlung guten Designs und nebenbei auch noch zur Eigenfinanzierung beitragen. Sie reichen heute von der Konzeption internationaler Wanderausstellungen über Entwicklung, Herstellung und Vertrieb museumseigener Produkte, über Ausstellungs- und Modellbau bis hin zu einem edukativen Programm, das von internationalen Designern und Architekten inhaltlich getragen wird.

Wichtigstes Standbein bleibt dabei die Sammlung des Museums, die auf den beiden privaten Sammlungen von Rolf Fehlbaum und Alexander von Vegesack aufbaut. Als eine der größten Sammlungen industriellen Möbeldesigns erhebt sie dennoch keinen Anspruch auf Vollständigkeit: Innovative Formen, Materialien und Konstruktionstechniken gehören zu den zentralen Auswahlkriterien. So spannt sich der Bogen von den frühen Bugholzstühlen, über Stahlrohr- und Sperrholzmöbel, die Schaumstoff-Wohnlandschaften der 1960er und 70er Jahre und die Entwürfe der Postmoderne bis hin zum zeitgenössischen Möbeldesign. In Serie produzierte Stücke überwiegen, doch auch Prototypen und „one-offs" werden gesammelt. Wiederholt präsentierte das Museum Auszüge aus seiner Sammlung in temporären Ausstellungen. Besonders erfolgreich war die Ausstellung „100 Masterpieces", die in Europa, Japan, Australien und den USA gezeigt wurde und deren Katalog — mittlerweile in fünf Sprachen übersetzt — als ein Standardwerk zum Thema Stuhldesign gilt. Eine Auswahl von Sammlungsstücken wird permanent im Feuer-wehrhaus von Zaha Hadid gezeigt, das sich auf dem Firmengelände befindet. Monografische Ausstellungen widmeten sich Designern und Architekten, deren Entwürfe Sammlungsschwerpunkte bilden, darunter Frank Lloyd Wright, Mies van der Rohe oder Verner Panton. Seinen Nachlass, wie auch die von George Nelson, Alexander Girard und Harry Bertoia befinden sich im Archiv des Museums. Jedoch nicht nur die Klassiker, sondern auch zeitgenössische Designer stellte das Museum, das heute 65.000 Besucher pro Jahr nach Weil am Rhein zieht, einem breiten Publikum vor.

Themenausstellungen — zur Geschichte der individuellen Mobilität oder des mobilen Wohnens — oder eine Präsentation wie die der APOC-Kollektion Issey Miyakes in Berlin erweitern das durch die Sammlung definierte Spektrum und unterstreichen zugleich den weit gefassten Designbegriff, der vom Vitra Design Museum vertreten wird: Design als Prozess, mit dem funktionale und formal überzeugende Lösungen für praktische Probleme, aber auch für komplexe Zusammenhänge gefunden werden; Design als eine die Alltagskultur prägende, identitäts-stiftende Disziplin ohne fest umrissene Grenzen, die mit Architektur, Kunst und Mode in fruchtbarem Austausch steht; Design als ein Spiegel technischen Fortschritts und allgemeiner sozio-kultureller Tendenzen.

Neben den Ausstellungen des Museums erwies sich auch sein weißer, kubistisch anmutender Bau von Frank O. Gehry — der erste, den der amerikanische Meister in Europa realisierte — von Beginn an als Publikumsmagnet. Heute verbinden viele Museumsbesucher den Gang durch die Ausstellung mit einer Architekturführung über das Betriebsgelände der Firma Vitra, auf dem der Konferenzpavillon von Tadao Ando und die Feuerwache von Zaha Hadid zu den Highlights zählen. Zuletzt ergänzten zwei mobile Bauten, die in enger Beziehung zur Sammlungs- und Ausstellungstätigkeit des Museums stehen, den Vitra-Architekturpark: Eine geodätische Kuppel des Ingenieurs und Visionärs R. Buckminster-Fuller und eine demontierbare Tankstelle das Konstrukteurs Jean Prouvé, dessen Möbel in der Sammlung prominent vertreten sind.

Der expressive Gehry-Bau hat sich in jahrelanger Praxis als überraschend wandlungsfähig und vielseitig bespielbar erwiesen. Dank außergewöhnlicher Inszenierungen von Hausdesigner Dieter Thiel und von Gestaltern wie Bruce Mau, Hodges & Fung oder Robert Wilson ent-falten die Räume mit jeder neuen Ausstellung eine andere atmosphärische Wirkung. Die Ausstellungen können neben der ausdrucksstarken Architektur bestehen, ohne von ihr erdrückt zu werden. Mit ihrer dem jeweiligen Thema gemäßen Ausstellungsarchitektur, bieten sie ein originäres räumliches Erlebnis.

Die aufwändigen temporären Bauten dafür werden von der museumseigenen Werkstatt gefertigt. Sie sind stets zerlegbar und reisefähig konstruiert, da fast alle Ausstellungen des Vitra Design Museums weltweit auf Reisen gehen. Die Transportfähigkeit und Adaptierbarkeit an verschiedenste Galerieräume fließen von Beginn an in die Ausstellungsplanungen ein. Für die Organisation der Ausstellungstourneen ist eine eigene Abteilung zuständig. Partnermuseen übernehmen — gegen Gebühr — eine schlüsselfertige Ausstellung. Vorrangig sind es Museen für Bildende Kunst, die die Ausstellungen präsentieren, aber auch in Architekturmuseen und Museen für Angewandte Kunst werden sie gezeigt. Und dies nicht nur in Europa, sondern auch in den USA, in Lateinamerika und Japan, was die gestiegene Aufmerksamkeit, die Design weltweit entgegengebracht wird, unterstreicht.

Sein internationales Netzwerk pflegt das Vitra Design Museum mit einer jährlich stattfindenden Museums-Konferenz, die in Kooperation mit den jeweiligen Gastgeber-Museen organisiert wird und bei der zukünftige Projekte bereits in der Entwicklungsphase potentiellen Über-nahmepartnern vorgestellt werden können.

Um in einer der lebendigsten europäischen Metropolen vertreten zu sein und zugleich während der oft über mehrere Jahre andauernden Tourneen einen fixen Übernahmepartner zu haben, gründete das Vitra Design Museum im Jahr 2000 eine eigene Dependance in Berlin. Längst werden im Vitra Design Museum Berlin jedoch auch eigene Projekte verwirklicht: Die Ausstellung „Design Berlin" etwa stellte Arbeiten der innovativen Berliner Design- und Architekturszene vor und war Programmteil des vom Vitra Design Museum Berlin mit initiierten Design Mai, der in diesem Jahr erstmals stattfand.

GESCHICHTE DES MUSEUMS

Dennoch bleibt Weil am Rhein der Hauptsitz des Museums. Von dort aus werden in Kooperation mit dem Centre Pompidou auch die Workshops organisiert, die seit 1995 jeden Sommer in der französischen Charente stattfinden. Inzwischen arbeiten dort jedes Jahr mehr als 300 Teilnehmer von Juni bis September in einwöchigen Workshops unter der Leitung bekannter Designer und Architekten zu von diesen ausgewählten Themen. Studenten aus der ganzen Welt knüpfen Kontakte zu potentiellen Arbeitgebern und lernen die Arbeitsweise etablierter Büros kennen, jenen wiederum bieten die Workshops einen Pool frischer, neuer Ideen. Das Museum pflegt damit nicht nur seine intensiven Kontakte zur zeitgenössischen Designszene und zu Designhochschulen, sondern erhält dadurch auch oft wertvolle Impulse für neue, aktuelle Ausstellungsthemen.

Auf Designklassiker hingegen konzentriert sich das Vitra Design Museum als Produzent. Hier wird nicht nur die Mehrzahl der Ausstellungskataloge selbst verlegt, sondern auch eine umfangreiche Kollektion von Stuhl-Miniaturen und eine wachsende Serie von Re-Editionen produziert. Mit Originalstücken aus der Sammlung als Anschauungsobjekte und Planzeichnungen aus dem Archiv als Vorlage sind deren absolute Maßstabs- und Detailtreue garantiert. So gab der dreidimensionale Nachlass von Charles und Ray Eames — quasi das Herzstück der Sammlung — nicht nur Anlass zu einer Ausstellung in Kooperation mit der Library of Congress, sondern auch zu einer Reihe von Re-Editionen. Auch die Neuauflagen von Entwürfen George Nelsons oder Verner Pantons konnten auf Grundlage der dem Museum überantworteten Nachlässe entwickelt werden. Anlässlich der in Zusammenarbeit mit der Isamu Noguchi Foundation New York konzipierten Ausstellung „Isamu Noguchi — Sculptural Design" legte das Museum nicht nur einige von dessen Entwürfen neu auf, sondern produzierte sie sogar zum Teil erstmals in Serie. Die Entwicklung der Prototypen erfolgt dabei stets im Haus, in der eigenen technischen Abteilung. Miniaturen und Re-Editionen stehen damit in engem Bezug zur Sammlung des Museums, heben sich vom üblichen Museumsshop-Angebot ab und tragen mit den Ausstellungen zur Vermittlung guten Designs bei.

Neueste Ergänzung der Museumsaktivitäten ist eine Restauratorenwerkstatt, die Anfang des Jahres 2003 in Kooperation mit der Axa Art Versicherung eingerichtet wurde. Die Restauratorin — mit Ausbildung in Köln und Boston — widmet sich unter anderem der Erforschung und Entwicklung praxisbezogener Methoden zur Konservierung von Kunststoffmaterialien, die im Industriedesign Verwendung fanden.

Im Vitra Design Museum, wo einst alles mit einer Hand voll Enthusiasten begann, sind heute über 80 Mitarbeiter beschäftigt. Vorzeigekarrieren und akademische Titel spielen dabei eine geringere Rolle als gemeinhin üblich. Neben Kunsthistorikern arbeiten im Museum Kulturwissenschaftler, Schreiner, Kunstmaler, Architekten, Historiker, Landschaftsgärtner, Betriebswirte, Grafiker und Modellbauer. Sie kommen aus Deutschland Italien, Frankreich, Spanien, Kenia, England, Polen, den USA und der Ukraine und sorgen für eine internationale Arbeitsatmosphäre. Flache Hierarchien und räumliche Nähe erlauben den intensiven Austausch zwischen den einzelnen Bereichen und schaffen Synergieeffekte. In praktischen Belangen kann das Museum somit außergewöhnlich selbstständig, spontan und flexibel handeln. Mit seinen vielfältigen, sich gegenseitig befruchtenden Aktivitäten pflegt das Vitra Design Museum sein internationales Netzwerk und nimmt auf mehreren Ebenen eine aktive Rolle in der Vermittlung klassischen und zeitgenössischen Designs und benachbarter Disziplinen ein.

A. v. V. / J. E.

HISTORY OF THE MUSEUM

In the last two decades design has - in addition to its primary task of creating designs also gained enormous importance in its function as a means of conveying identity and fastening meaning. This development is also reflected in the establishment of new design museums, which position themselves in terms of exhibition topics between the highly traditional and already established museums for applied art, and the equally established design centers that have been around somewhat longer. While the formers' collections tend to focus on the time prior to the 20th century and less on the field of industrial design, the latter view their task more in the commercial promotion of current design products rather than analyses within a historical setting.

However, the foundation of the first design museums also coincides with a time in which museum operation and exhibition business are generally undergoing radical changes. This inevitably includes commercial considerations although they represent one, if not the driving force in this context. What is needed are new means of self-financing, which simultaneously ensure museums remain free to choose their exhibition topics themselves. "More visitors!" is one objective that is to be achieved by running those exhibitions that attract the public — namely temporary exhibitions — more often. "Sell more!" is another proposal aimed at securing greater self-financing, and explains why ever larger museum stores stock a range of interchangeable products. Striking architecture also draws greater numbers of visitors — and consumers — which is why increasingly complex and fascinating new museum buildings are vying for attention.

These factors make up the framework within which the Vitra Design Museum, which is only 14 years old, has charted its own, highly individual course. The situation augured well. Set up in 1989, the museum was established as a private initiative by entrepreneur Rolf Fehlbaum in cooperation with founding director Alexander von Vegesack. And today it continues to operate free of any local or government restraints. The financial support of the company Vitra secures its day-to-day running, without this backing involving conditions such as working up and presenting the company history. On the contrary, the scope of topics — international design and architecture — is kept deliberately wide. The museum benefits from the resulting freedom of action and flexibility: its diverse and highly dynamic activities foster the effective communication of what makes excellent design, while also contributing to the museum's financing. Today, these activities range from the design of international traveling exhibitions via the development, production and marketing of the museum's own products, via exhibition and model construction through to an educational program, which involves international designers and architects.

The most important pillar remains the museum collection, which was built up from the two private collections of Rolf Fehlbaum and Alexander von Vegesack. Although one of the largest collections of industrial furniture design, it does not seek to cover every conceivable aspect: key selection criteria are innovative shapes, materials and production techniques. As such, it extends from the early bentwood chairs, via tube steel and plywood furniture, the foam rubber landscapes of the 1960s and '70s, not to mention Postmodern creations through to contemporary furniture design. Though there is a dominance of items produced as series, prototypes and "one-offs" are also collected. The museum frequently presents selected items from the Collection to show in temporary exhibitions. The show "100 Masterpieces", which was exhibited in Europe, Japan, Australia and the United States, and whose catalogue has since been translated into five languages — is considered a standard work on the subject of chair design. A selection of items from the collection is on permanent show in the Fire House designed by Zaha Hadid, and which is located on the firm's grounds. Monographic shows have dealt with designers and architects whose work features prominently in the Collection, including Frank Lloyd Wright, Mies van der Rohe or Verner Panton. The latter's estate but also those of George Nelson, Alexander Girard and Harry Bertoia are housed in the museum archives. But the museum that today draws 65 000 visitors a year to Weil am Rhein has not only showcased such classic figures to a wide public but also contemporary designers.

HISTORY OF THE MUSEUM

Topical shows — on the history of man's mobility or nomadic living styles — or a presentation such as Issey Miyake's APOC-collection in Berlin, expand the scope of the Collection and simultaneously underscore the broad definition of design represented by the Vitra Design Museum: design as a process that finds functionally and formally convincing solutions for practical problems but also for complex matters; design as a discipline which colors everyday culture, and lends identity but without recourse to sharply drawn outlines, and which enjoys a fruitful exchange with architecture, art and fashion; design as a mirror of technical progress and general socio-cultural trends.

Not only the exhibitions put on by the museum draw the crowds: a white, cubist-looking building by Frank O. Gehry — the first the brilliant American architect built in Europe — has attracted visitors from the start. Today, many people combine their visit to the museum with a tour of the architecture park on the Vitra company premises, of which the conference pavilion by Tadao Ando and the Fire Station by Zaha Hadid number amongst the highlights. More recently, two mobile buildings have been added to this Park, which are closely connected to the collecting and exhibition activities of the museum: A geodesic dome by engineer and visionary R. Buckminster-Fuller, and a mobile gas station by designer Jean Prouvé, whose furniture features prominently in the Collection.

In its long years of use, the striking Gehry building has proven surprisingly versatile, and lends itself to diverse exhibitions. Thanks to the extraordinary exhibition architecture produced by in-house designer Dieter Thiel but also designers such as Bruce Mau, Hodges & Fung or Robert Wilson, the rooms evolve a different atmospheric effect with every new show. The exhibitions retain their personality, and are not overwhelmed by the expressive architecture. With exhibition architecture to suit each individual topic, they provide an original spatial experience.

The sophisticated temporary structures this necessitates are produced in the museum's own workshop. They are always made to be easily dismantled and packed for traveling, since virtually all Vitra Design Museum shows go to destinations around the world. Indeed, ease of transport and adaptability to a wide range of gallery premises are criteria included from the outset in exhibition planning. A special department handles the organization of exhibition tours. Partner museums take delivery — for a fee — of a turnkey exhibition. The exhibitions are primarily shown in fine art museums, but also occasionally in architectural museums or applied art museums. And, not only in Europe, but also in the United States, in Latin America and Japan, which underscores the greater interest design is attracting worldwide.

The Vitra Design Museum cultivates its international network by holding an annual museum conference, organized in cooperation with the respective host museums, and at which future projects can be shown to potential partners while they are still at the development phase. It was with a view to being present in one of Europe's most lively cities, and at the same time having a set partner museum for tours that often extend over several years that in 2000 the Vitra Design Museum opened a branch in Berlin. However, for some time now the Vitra Design Museum Berlin has also realized its own projects: For instance, the exhibition "Design Berlin" featured works from the innovative Berlin design and architecture scene, and formed part of the "Design May" event, which was partly initiated by the Vitra Design Museum Berlin, and took place for the first time this year.

For all that, Weil am Rhein remains the museum's head office. It is from here in cooperation with the Centre Pompidou that workshops are organized, which have been run every summer in Charente, France since 1995. Every year more than 300 people attending one-week workshops between June and September work on topics selected by the reputed designer or architect running their course. Students from all over the world form contacts to potential employers, and become familiar with how established offices approach their work, while the latter benefit by being exposed to a pool of fresh, new ideas. Workshops not only allow the museum to cultivate its intensive contacts to the contemporary design scene and design schools, but also often provide it with valuable impetus for new, current, exhibition subjects.

As regards design classics, however, the Vitra Design Museum concentrates on being a producer. Not only does it publish the majority of exhibition catalogues but also an extensive collection of miniature chairs and a growing series of re-editions. Since it has originals in the Collection to act as models, and drawn plans in the archives to consult, the miniatures are sure to be both true to the original and to scale. Indeed, the three-dimensional estate by Charles and Ray Eames — in effect the centerpiece of the Collection — not only gave cause for an exhibition in cooperation with the Library of Congress but also for a series of re-editions. What is more, it was possible to develop the re-editions for designs by George Nelson or Verner Panton on the basis of the estates made over to the museum. To mark its show "Isamu Noguchi — Sculptural Design" conceived in collaboration with the Noguchi Foundation New York, the museum not only created some re-editions of his work but also produced some of them in series for the first time. These prototypes are always developed in-house, in the museum's own technical department. Miniatures and re-editions are thus closely connected with the museum collection, set themselves apart from the customary products on sale in museum stores, and consequently help — alongside the shows — to communicate what makes excellent design.

A restoration workshop is the latest addition to museum activities. Set up at the start of 2003 in cooperation with insurance firm Axa Art Versicherung, the restorer — who was trained in Cologne and Boston — devotes herself among other things to the research and development of practical methods of conserving those plastics typically employed in industrial design.

The Vitra Design Museum, which started off with a mere handful of enthusiasts, now employs a staff of 80. Brilliant careers and academic titles tend to play less of a role than is normally the case. Alongside art historians the museum is home to cultural scholars, carpenters, artists, architects, historians, landscape gardeners, economists, commercial artists and model builders. They hail from Germany, Italy, France, Spain, Kenya, England, Poland, the United States and the Ukraine, and make for an international working atmosphere. Flat hierarchies and close working facilities allow an intensive exchange between the various fields, and create synergy effects. In practical matters the museum is able to act with unusual independence, spontaneity and flexibility. Through activities so diverse that one area inspires another, Vitra Design Museum cultivates its international network and assumes an active role at several levels in communicating to the public classic and contemporary design as well as related disciplines.

A. v. V. / J. E.

Weimar

Stiftung Weimarer Klassik und Kunstsammlung,
Bauhaus-Museum
www.swkk.de

COLLECTION

Stiftung Weimarer Klassik und Kunstsammlungen,
Bauhaus-Museum

DESIGNER / ARCHITECT

Marcel Breuer

OBJECT

Slatted-frame chair / Lattenstuhl

DATE

1923

MANUFACTURER

Prototype / Prototyp

Stiftung Weimarer Klassik und Kunstsammlungen, Bauhaus-Museum

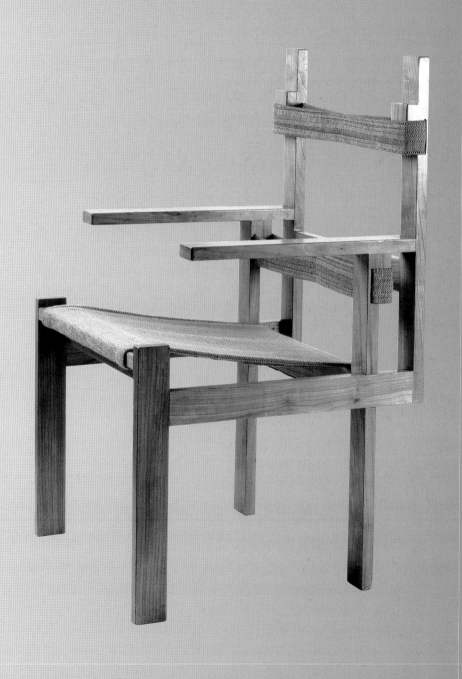

GESCHICHTE DES MUSEUMS

Weimar besitzt nicht nur die Kunstschulbauten Henry van de Veldes, die als Wirkungsstätten des Bauhauses 1996 zum UNESCO-Weltkulturerbe erklärt worden sind, sondern auch die älteste und einzige autorisierte Bauhaus-Sammlung der Welt. Walter Gropius als Direktor des Staatlichen Bauhauses und Wilhelm Köhler als Museumsdirektor hatten 1925 mehr als 160 Designklassiker aus allen Bauhauswerkstätten für die Staatlichen Kunstsammlungen zu Weimar 1925 ausgewählt. Die Anfänge der Bauhaus-Kollektion reichen bis in die Gründungstage des Bauhauses, in das Frühjahr 1919 zurück, als Köhler Werke von Studierenden ausstellte und druckgrafische Arbeiten von Johannes Itten, Karl Peter Röhl oder Eberhard Schrammen für die Kunstsammlungen erwarb. Nach zahlreichen Sonderausstellungen zur deutschen und europäischen Moderne von Edward Munch bis zu Heinrich Campendonck und von Franz Marc bis zu Lyonel Feininger richtete Köhler im Anschluss an die große Bauhaus-Ausstellung vom Sommer 1925 die Dauerausstellung „Kunst der Lebenden" ein, in deren Mittelpunkt die Meister des Bauhauses standen. Paul Klee stellte 18 Werke von 1914 bis 1925 zusammen, darunter die Gemälde „Komposition mit Fenstern" (1919) und „Fest der Astern" (1921). Feininger beteiligte sich mit elf Gemälden von 1911 bis 1921, darunter „Niedergrunstedt" (1919) und „Gelmeroda VIII" (1921), sowie fünf Zeichnungen. Wassily Kandinsky war mit fünf Gemälden aus seiner frühen Werkphase 1910–1912 vertreten. Darüber hinaus gelang es Köhler, die Sammlung des Bauhäuslers Paul Citroen mit 17 Werken der europäischen Moderne — Gemälde von Carlo Carrà, Luigi Russolo, Gino Severini oder Wassily Kandinsky sowie Handzeichnungen von Alexander Archipenko, Marc Chagall und Emil Filla — als Leihgabe an die Kunstsammlungen zu binden. Bis 1925 baute Wilhelm Köhler eine imposante Sammlung mit mehr als 650 Werken zur Klassischen Moderne auf.

Das Jahr 1950 markierte das Ende der Moderne in Thüringen. NSDAP-Mitglied Wilhelm Frick veranlasste als Innen- und Bildungsminister die Schließung der Bauhochschule unter Leitung von Otto Bartning als Bauhaus-Nachfolginstitut ebenso wie die Schließung der Abteilung für moderne Kunst mit mehr als 70 Werken an den Staatlichen Kunstsammlungen zu Weimar. Die Klassische Moderne wurde in die Magazine verbannt, die zahlreichen Leihgaben an die Künstler zurückgegeben. Die noch verbliebene Kollektion moderner Kunst wurde bei der bekannten „Aktion Entartete Kunst" 1937 fast vollständig vernichtet. Mehr als 450 Werke wurden beschlagnahmt, darunter acht Gemälde, vier Plastiken, 27 Handzeichnungen und allein 185 Druckgrafiken von Lyonel Feininger. Nur 47 der beschlagnahmten Druckgrafiken kehrten 1947 an das Museum zurück. Die Werkstattarbeiten des Bauhauses konnten vor dem Zugriff der „Kunstkommission" gerettet werden, da sie durch den Museumsdirektor Walther Scheidig uninventarisiert in unscheinbare Kisten verpackt worden waren.

Unmittelbar nach dem Ende des Zweiten Weltkriegs, als auch in Weimar ernsthaft an der Wiedereröffnung des Bauhauses gearbeitet wurde, stellte Scheidig wieder Bauhaus-Exponate aus. Die stalinistische Kulturdoktrin setzte diesen hoffnungsvollen Ansätzen 1948 ein Ende. Erst zweieinhalb Jahre nach Stalins Tod wurden die Bauhaus-Werkstattarbeiten Ende 1955 zum ersten Mal inventarisiert. Es bedurfte in der damaligen DDR eines weiteren Jahrzehnts, bevor Walther Scheidig 1966 das Buch „Bauhaus Weimar. Werkstattarbeiten 1919–1924" publizieren und 1967 die erste Ausstellungstournee durch Finnland organisieren konnte. 1969 fand die erste Bauhaus-Ausstellung in Weimar nach 1925 statt, die zur Initialzündung für die Bauhausforschung an der Hochschule für Architektur und Bauwesen, der heutigen Bauhaus-Universität, sowie eine rege Ausstellungs- und Sammlungstätigkeit an den Kunstsammlungen zu Weimar werden sollte. In den folgenden zwei Jahrzehnten wurden mehr als 20 Bauhaus-Ausstellungen in Weimar präsentiert und eine Reihe von Expositionen im Ausland von Rom bis Moskau und von Brüssel bis Prag organisiert.

Von Weimar gingen auch die Impulse zur Restaurierung des Bauhaus-Gebäudes in Dessau 1964 und 1974 aus, ebenso wie die Einrichtung eines wissenschaftlich-kulturellen Zentrums am Bauhaus Dessau mit einer eigenen Bauhaus-Sammlung seit 1976 (heute Stiftung Bauhaus Dessau).

Seit 1976 werden an der Hochschule für Architektur und Bauwesen Weimar internationale Bauhaus-Kolloquien organisiert, die zahlreiche Kontakte zu ehemaligen Bauhäuslern vermittelten und zum Ausbau der Weimarer Bauhaus-Sammlungen beitrugen. Ein deutsch-deutsches Signal setzte Georg Muche bereits 1974, als er den Kunstsammlungen zu Weimar Gemälde und Handzeichnungen aus seiner Weimarer Bauhaus-Zeit übereignete. So wuchs die Bauhaus-Kollektion durch Schenkungen und Ankäufe bis zur Wende 1989 wieder auf 800 Exponate an, ohne im Bereich der bildenden Kunst die Qualität der 1920er Jahre erreichen zu können.

Unter dem Direktorat von Rolf Bothe konnte der Autor seit 1992 die Bauhaus-Bestände an den Kunstsammlungen zu Weimar auf mehr als 9.000 Werke vergrößern. Dazu trug besonders die Eröffnung des Bauhaus-Museums im Mai 1995 bei, in dem ständig über 500 Werke der Moderne von 1900 bis 1950 präsentiert werden und regelmäßig Sonderausstellungen stattfinden, die jährlich 60.-120.000 Besucher anziehen. Die internationale Ausstrahlung wurde durch solche Projekte wie „Das frühe Bauhaus und Johannes Itten" mit Stationen in Berlin und Bern 1994 / 95 sowie eine Bauhaus-Exposition in Prag 1997 / 98 ebenso gestärkt wie durch die Zusammenarbeit bei großen Ausstellungen in Tokio, Kyoto, Mailand, Valencia, Berlin oder Los Angeles.

Dadurch konnten auch die langjährigen Kontakte zu ehemaligen Bauhäuslern und ihren Familien intensiviert und ihre Bereitschaft zu großzügigen Schenkungen, Stiftungen und Dauerleihgaben geweckt werden. Allein die Karl Peter Röhl-Stiftung umfasst mehr als 5.500 Werke aus allen Schaffensperioden sowie wichtige Arbeiten von Lehrenden und Studierenden am Weimarer Bauhaus. Die Schenkung der Bauhäuslerin Eva Weininger aus New York beinhaltet 85 Arbeiten ihres Mannes Andor Weininger, die Donation. Heinrich Brocksieper 91 Werke. Wichtige Werkgruppen übereigneten die Familien von Lyonel Feininger, Johannes Itten, Gyula Pap, Margit Tery-Adler, Magda Langenstraß-Uhlig, Eduard Gillhausen, Friedrich Wilhelm Bogler, Eberhard Schrammen, Walter Determann, Johannes Driesch, Erich Dieckmann, Thyra Hamann-Hartmann oder Kurt Kranz. Bedeutende Teilnachlässe konnten als Dauerleihgaben an die Kunstsammlungen zu Weimar gebunden werden, so von Walter Determann, Kate Ulrich, Theobald Emil Müller-Hummel, Hans Fricke, Alma Siedhoff-Buscher und Magda Langenstraß-Uhlig. Schließlich konnten durch zielgerichtete Ankäufe wichtige Lücken im Sammlungsbestand geschlossen und mit zwei Gemälden von Feininger („Dröbsdorf", 1927) und Klee („Wasserpark im Herbst", 1926) an die bedeutende Sammlung der 1920er Jahre erinnert werden. Durch das herausragende Engagement der Bauhäuslerfamilien mit ihrem weltweiten Netzwerk, die Kulturstiftung der Länder, den Förderverein der Kunstsammlungen und zahlreiche Einzelpersönlichkeiten entwickelte sich das Bauhaus-Museum zu einem dynamischen „Bürgermuseum", das ein facettenreiches Bild des Bauhauses als bedeutendster Avantgardekunstschule des 20. Jahrhunderts vermittelt. Dazu tragen auch die langjährigen partnerschaftlichen Kontakte zu den beiden anderen deutschen Bauhaus-Museen, dem Bauhaus-Archiv Berlin und der Stiftung Bauhaus Dessau, bei, ebenso wie Forschungsprojekte mit den Universitäten in Weimar, Jena, Halle und Kiel.

Die Bauhaus-Sammlungen werden durch bedeutende Kollektionen zum Schaffen Henry van de Veldes und seiner Kunstgewerbeschule im Zeitraum von 1900 bis 1915 sowie zur Staatlichen Hochschule für Handwerk und Baukunst unter Leitung von Otto Bartning von 1926 bis 1950 ergänzt, die mit zahlreichen Bauhaus-Absolventen als Lehrende die Ideen des Bauhauses weiterentwickelten und modifizierten.

Die weiterhin rasant wachsenden Sammlungsbestände und das ungebrochene Publikumsinteresse begründen die Planungen zur Erweiterung oder zum Neubau des Bauhaus-Museums in Weimar.

GESCHICHTE DES MUSEUMS

Die Museumslandschaft der Industrienationen hat sich in den letzten drei Jahrzehnten rasant entwickelt. Nicht nur in den Metropolen gehörte es zum guten Ton, sich teilweise aufwändige Museumsneugründungen und Erweiterungsbauten für renommierte Museen zu leisten. Auch in den neuen Bundesländern bemüht man sich, die Defizite im Museumsbereich abzubauen, wie der Neubau für das Museum der Bildenden Künste in Leipzig zeigt. Der Nachholbedarf im Freistaat Thüringen erscheint besonders groß, will man den Anschluss an die nationale und internationale Entwicklung nicht verpassen und Chancen für die Bereiche Bildung, Kultur und Tourismus nicht verspielen. Mittlere internationale Kunstausstellungsprojekte, die überregionale Ausstrahlung erlangen, beginnen heute bei Ausstellungsflächen ab 1.000 Quadratmetern. Die Anforderungen an Sicherheit, Licht- und Klimatechnik sowie der Ausstattungsstandard steigen ebenso wie die Erwartungen der Besucher nach medialer Vermittlung und angemessener Präsentation.

Im Städteverbund Erfurt-Weimar-Jena bietet sich Weimar für einen Kunstmuseumsneubau an, da hier nicht nur die reichsten Kunstsammlungen Thüringens in der „Stiftung Weimarer Klassik und Kunstsammlungen" vereint sind, sondern auch ein Netzwerk von Kulturinstituten von der Bauhaus-Universität bis zum Thüringischen Hauptstaatsarchiv und vom Thüringer Designzentrum bis zu Kulturvereinen und Künstlern Bedarf an Ausstellungsmöglichkeiten in einer „Kunsthalle" anmelden, die ebenso von Kulturträgern des gesamten Freistaates genutzt werden könnte.

Wenn man das Staatliche Bauhaus in Weimar als Avantgardeinstitut mit einer schöpferischen Methode begreift, als eine Schule des Erfindens, in der Kreativitätstraining und Teamwork auf der Basis konsequenter Werkstattausbildung („Laboratorien für die Industrie" / Gropius) stattfand, können heute Überlegungen für ein Museum der Zukunft in Weimar gelingen, die an die Moderne in Weimar 1900 bis 1950 anknüpfen und sie mit aktuellen Tendenzen in Wissenschaft, Kultur und Kunst verbinden. So sollte ein modernes „Ausstellungshaus" mit mindestens 2.000 Quadratmetern Ausstellungsfläche konzipiert werden, das mit seinen variablen Bauhaus-Präsentationen mit heutigen Innovationen in Kunst und Technik in einen spannenden Dialog treten und der Wachstumsdynamik der Sammlung mit gegenwärtig etwa 10.000 Exponaten Rechnung tragen kann.

Seit etwa zwanzig Jahren werden in Weimar — und besonders an der Bauhaus-Universität — die Diskussionen um den besten Standort für ein Bauhaus-Museum in Weimar geführt und zahlreiche Studien und Projekte erarbeitet. Aufbauend auf den Nutzungserfahrungen des Bauhaus-Museums in der ehemaligen Kunsthalle am Theaterplatz wurden diese Untersuchungen durch die Kunstsammlungen zu Weimar mit ihrem Förderverein zu einer Machbarkeitsstudie verdichtet, die Anfang 2002 veröffentlicht worden ist. Darin werden die Vorzüge des Standortes zwischen Theaterplatz und Geleitstraße herausgearbeitet, der eine neue West-Ost-Erschließung der Innenstadt initiiert. Darüber hinaus würde ein Museumsneubau an dieser Stelle nicht nur eine Bombenlücke aus dem Zweiten Weltkrieg schließen, sondern das Wittumspalais und das Gebäude der Musikhochschule / Saal Am Palais mit ihren Freiflächen zu einem Ensemble verknüpfen. Dabei spielt auch das Deutsche Nationaltheater mit der Gedenktafel von Walter Gropius für die Weimarer Verfassung als politischer und künstlerischer Ort eine wichtige Rolle für die Standortentscheidung für ein künftiges Bauhaus-Museum / Haus der Moderne.

Von mutigen Impulsen und einer Initialzündung durch Bund, Freistaat und Stadt wird die Bereitschaft potenzieller Sponsoren, des weltweiten Netzwerks der Bauhäuslerfamilien und vieler Freunde der Kunst bei der aktiven Förderung dieses Projektes abhängen.

M. S.

HISTORY OF THE MUSEUM

Weimar is not only the site of Henry van de Velde's School of Arts and Crafts, which was the centre of the Bauhaus movement and which was added to UNESCO's World Heritage List in 1996. It is also the location of the oldest and only authorized Bauhaus collection in the world. In 1925, Walter Gropius, as director of the Bauhaus School and Wilhelm Köhler, as museum director, chose more than 160 classic designs from an array of Bauhaus studios for the National Art Collection in Weimar. The Bauhaus collection goes back to the founding days of the movement in the spring of 1919. At that time, Köhler exhibited works by various students. He also purchased decorative prints by Johannes Itten, Karl Peter Röhl and Eberhard Schrammen. Following numerous special exhibits of German and European modern art which included works by Edward Munch, Heinrich Campendonck, Franz Marc and Lyonel Feininger, Köhler inaugurated a permanent exhibition entitled "Art of the Living". It revolved around masters of the Bauhaus School and was unveiled after an extensive Bauhaus exhibit in the summer of 1925. From 1914-1925, Paul Klee assembled 18 pieces including the paintings "Composition with Windows" (1919) and "Festival of Asters" (1921). Feininger participated with 11 paintings made between 1911 and 1921. These included "Niedergrunstedt" (1919) and "Gelmeroda VIII" (1921). He also contributed five drawings. Wassily Kandinsky was represented with five paintings from his early period (1910-1912). In addition, Köhler was able to obtain a number of works for the museum on loan. Paul Citroen, who was a member of the Bauhaus School, loaned 17 examples of modern European art to the museum. These included paintings by Carlo Carrà, Luigi Russolo, Gino Severini and Wassily Kandinsky; in addition to drawings by Alexander Archipenko, Marc Chagall and Emil Filla. By 1925, Wilhelm Köhler had assembled an impressive collection with more that 650 classical modern works of art. 1930 signalled the end of Modernist art in Thuringia. The Ministry of the Interior and the Ministry of Education were headed by Nazi party member Wilhelm Frick. He ordered the closing of the Bauhochschule, the academy which had followed the Bauhaus School and which was directed by Otto Bartning. Frick also closed the modern art section of the National Art Collection of Weimar which contained more than 70 works of art. Magazines were forbidden to print articles about classic modern art and the numerous items on loan were returned to their respective owners. The remaining collection of Modernist art was almost completely destroyed during the notorious campaign to eliminate degenerate art in 1937. More than 450 works of art were confiscated. These included eight paintings, four sculptures, 27 drawings and 185 decorative prints by Lyonel Feininger. Only 47 of the confiscated prints found there way back to the museum in 1947. Pieces that were in the Bauhaus workshop were saved from the "art commission" because they were not inventoried and Walther Scheidig, the museum director, packed them away in inconspicuous boxes.

Immediately after World War II, a serious effort was made to reopen the Bauhaus School. At this time, Scheidig exhibited a number of Bauhaus pieces. However, Stalinist cultural doctrines put an end to these plans in 1948. In was not until two and one-half years after Stalin's death, in 1955, that the Bauhaus workshop items were inventoried for the first time. In the former East Germany, it took Walther Scheidig another ten years to publish his book "Crafts of the Weimar Bauhaus" (1966) and it was not until 1967 that the exhibition was able to go to Finland on its first tour. In 1969, the first Bauhaus exhibit since 1925 took place in Weimar. This initiated a rash of Bauhaus research at the University for Architecture and Building (now called Bauhaus University). There was a sudden increase in the number of exhibitions and interest in collecting work for Weimar's museums intensified. During the following two decades, more than 20 Bauhaus exhibitions took place in Weimar. There were also a number of expositions in foreign cities which included Rome, Moscow, Brussels and Prague.

Due to efforts which originated in Weimar, the Bauhaus building in Dessau was restored in 1964 and 1974. In addition, in 1976 a scientific and cultural centre with its own Bauhaus collection was established in Dessau. Today it is know as the Bauhaus Dessau Foundation.

HISTORY OF THE MUSEUM

Since 1976, international colloquiums have been held at the University of Architecture and Building in Weimar. These help maintain contact to former Bauhaus devotees. They also serve to enlarge the Bauhaus collections in Weimar. In 1974, Georg Muche made a contribution from one Germany to the other when he donated paintings and drawings from his time in Weimar. By reunification in 1989, the Bauhaus collection had grown to about 800 items through gifts and purchases. Nevertheless, the fine arts collection did not have the same quality that it had achieved in the 1920s. Under the directorship of Rolf Bothe, the collections in Weimar have been increased to more than 9000 pieces since 1992. This increase was particularly made possible by opening the Bauhaus Museum in May, 1995. The museum has a permanent exhibition of more than 500 works from 1900-1950. It also regularly sponsors special exhibitions and receives between 60 000-120 000 visitors annually. The museum's international reputation has been enhanced by such projects as "Early Bauhaus and Johannes Itten" which was exhibited in Berlin and Bern in 1994-1995 as well as by a Bauhaus show in Prague in 1997-1998. The museum has also collaborated on exhibits in Tokyo, Kyoto, Milan, Valencia, Berlin and Los Angeles.

Long-lasting contacts to former Bauhaus devotees and their families have been intensified. This encourages assistance in the form of generous gifts, foundations and permanent loans. For example, the Karl Peter Röhl Foundation possesses more than 5 500 pieces from all periods as well as important works by both teachers and students from the Weimar Bauhaus school. Eva Weininger of New York has donated 85 pieces by her husband, Andor Weininger and Heinrich Brocksieper has given the museum 91 works. The families of Lyonel Feininger, Johannes Itlen, Gyula Pap, Margit Tery-Adler, Magda Langenstraß-Uhlig, Eduard Gillhausen, Friedrich Wilhelm Bogler, Eberhard Schrammen, Walter Determann, Johannes Driesch, Erich Dieckmann, Thyra Hamann, Hartmann and Kurt Kranz have conveyed important collections to us. Inherited works have also been permanently loaned to the collection in Weimar. These come from Walter Determann, Kate Ulrich, Theobald Emil Müller-Hummel, Hans Fricke, Alma Siedhoff-Buscher and Magda Langenstraß-Ulrich. Finally, specific purchases have been able to close some gaps in the collection. For example, a painting by Feininger ("Dröbsdorf", 1927) and a painting by Klee ("Water Park in Autumn", 1926) are evocative of the quality of the collection in the 1920's. The outstanding support of Bauhaus families and their worldwide network in addition to the Provincial Cultural Foundation, the Association for the Promotion of Art Collecting, and numerous individuals has helped the Bauhaus Museum develop into a dynamic "museum of the citizenry" which reflects the many nuances of Bauhaus as the most influential avant-garde school of art in the 20th century. Long-standing contacts with the two other Bauhaus museums in Germany, the Bauhaus Archives in Berlin and the Bauhaus Dessau Foundation as well as research projects with the Universities of Weimar, Jena, Halle and Kiel have also played an important role.

The Bauhaus collections are enhanced by important works which go back to Henry van de Velde's School for Arts and Crafts (1915-1920) and the University of Handicrafts and Architecture which was directed by Otto Bartning from 1926-1950. Many graduates of these institutions taught the ideas of the Bauhaus movement and contributed to its further development and modification.

The collections continue to grow rapidly and public interest has been on the increase. This necessitates either expanding the present facility or building a new Bauhaus museum in Weimar.

Interest in museums has developed at a swift pace in industrialized countries in the last three decades. The establishment of new and costly museums as well as the expansion of renowned facilities has not been restricted to big cities. There have been considerable efforts to decrease the shortage of museums in the former East Germany. The new building for the Fine Arts Museum in Leipzig is a good example. As the rest of the country (and indeed the world) develops its opportunities for education, culture and tourism, it is especially important to make up for this deficit in Free the State Thuringia if we do not want to be left behind. In order to attract nationwide interest, medium-sized projects for international art exhibits require a minimum of 1000 sq meters. In addition, demands for security, lighting, heating, ventilation and furnishings have increased. Visitors also expect modern utilization of media technology and buildings which convey an appropriateness of purpose.

Within the metropolitan region made up of Erfurt, Weimar and Jena, Weimar is the most suitable location for a new art museum. In Weimar, the most valuable art collections in Thuringia have been brought together by the "Foundation for Weimar Classicism and Art Collections". The city also has a network of cultural institutions made up of the Bauhaus University, the Thuringian State Archives, the Thuringian Design Centre and various art associations. An "Art Center" would meet our artists' needs for exhibition space and could be used by sponsors from all over Thuringia.

The Bauhaus movement in Weimar was an avant-garde institution using creative methods; a school of invention which stressed creative training and teamwork based on practical and consistent education in the workshop (Gropius described it as "laboratories for industry"). Our considerations today for a museum of the future in Weimar will come to fruition if the museum combines the principles of modern art in Weimar from 1900-1950 with current developments in science, culture and art. Plans should be made for a modern museum with at least 2 000 sq meters of exhibition space. It should be designed to juxtapose the adaptability of Bauhaus exhibitions with up-to-date innovations in art and technology. In addition, it must be able to cope with the dynamic rate of growth of the collection which now counts more than 10 000 items.

Discussions about the best location for a Bauhaus museum have been going on in Weimar (in particular at the Bauhaus University) for about 20 years. Numerous designs and projects have been proposed. At the beginning of 2002, the museums of Weimar and their supporting sponsors published a feasibility report which is based on these proposals and on the experience of the Bauhaus Museum which has been housed in the Kunsthalle on the square, Theaterplatz. It includes a discussion of the advantages of building the new museum between Theaterplatz and Geleitstrasse which would contribute to the development of the east / west axis of the town centre. It would fill a hole left by the bombs of World War II and create the opportunity to turn the Wittumspalais and the building used by the Academy of Music, Saal Am Palais, as well as the adjoining space into an ensemble. The German National Theater and its plaque by Walter Gropius in memory of the constitution of Weimar are of great political and artistic significance for the city. The theatre must play a role in the decision-making process on the location of a future Bauhaus Museum / Museum of Modern Art. Potential sponsors include a worldwide network of Bauhaus devotees and their families as well as many other patrons of the arts. Their willingness to support this project will depend on decisive action by federal government, the State of Thuringia and the City of Weimar.

M. S.

Wellington

Museum of New Zealand Te Papa Tongarewa
www.tepapa.govt.nz

COLLECTION

Museum of New Zealand Te Papa Tongarewa

DESIGNER / ARCHITECT

Warwick Freeman

OBJECT

Brooch / Brosche

DATE

1990

MANUFACTURER

Warwick Freeman

Museum of New Zealand Te Papa Tongarewa

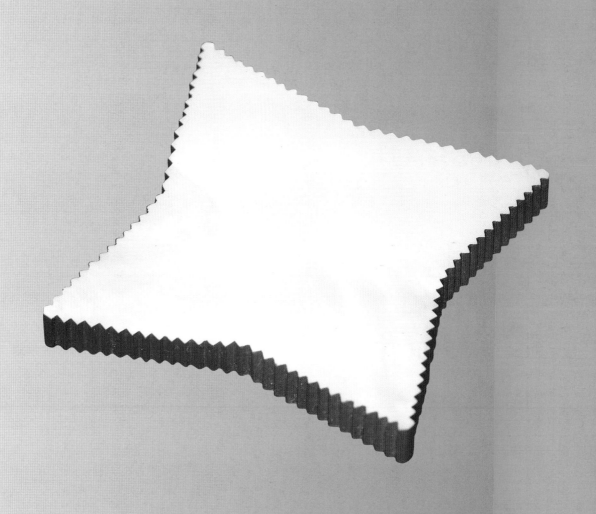

GESCHICHTE DES MUSEUMS

Das Konzept des Museum of New Zealand Te Papa Tongarewa beruht auf der Verschmelzung dreier ideeller Aspekte, die sich in einer gemeinsamen Sammlung präsentieren:

- Papatuanuku (Die Erde, auf der wir leben),
- Tangata Whenua (Denen, die mit dem Recht der ersten Entdeckung zum Land gehören) und
- Tangata Tiriti (Denen, die mit dem Recht des Waitangi Vertrages zum Land gehören).

Die Zusammenführung der Sammlungen zur Erforschung neuer Deutungsansätze ist eine Schlüsselstrategie, die den erzählerischen Ansatz der Ausstellungskonzeptionen unterstützt. Die gemeinsame Sammlung des Museums wird in vielerlei Hinsicht als wichtigste Quelle bei der Gewinnung unterschiedlichster und neuer Erkenntnisse über die nationale Identität Neuseelands genutzt.

Zu den Sammlungen gehören Maori taonga, kulturelle und künstlerische Arbeiten aus dem Pazifik, Kunstwerke, historische Objekte, Archivmaterial und Gegenstände aus der natürlichen Umwelt.

Obwohl Designaspekte in vielen Bereichen der Te Papa Sammlungen ihren Ausdruck finden, wurden westliche Kunsthandwerks- und Designobjekte der historischen Sammlung zugeordnet.

Der Schwerpunkt der Kunsthandwerks- und Designsammlung des Museum of New Zealand Te Papa Tongarewa liegt auf Arbeiten, die in Neuseeland entworfen und hergestellt wurden. Eine breite Palette von Objekten — historische und zeitgenössische — wurde zusammengetragen. Darunter Schmuck, Keramik, Glas, Arbeiten aus Metall, Mode, Textilien und Industriedesign.

Te Papa verfügt zudem über internationale Beispiele aus den Bereichen Kunsthandwerk und Design. Diese Exponate wurden vor allem in die Sammlung aufgenommen, wenn sie einen Beitrag zur kulturellen Identität Neuseelands leisten oder wenn sie eine Vergleichsfunktion einnehmen.

Hervorzuheben sind des weiteren die umfangreichen Archivbestände zu Künstlern, Kunsthandwerkern, Designern und Galerien.

A. L.

HISTORY OF THE MUSEUM

The Concept Statement for the Museum of New Zealand Te Papa Tongarewa includes the vision of unified collections expressed through the three concepts of

- Papatuanuku (The earth on which we live)
- Tangata Whenua (Those who belong to the land by right of first discovery) and
- Tangata Tiriti (Those who belong to the land by right of the Treaty of Waitangi)

The integration of collections to explore new meanings is a key strategy underpinning Te Papa's narrative approach to exhibitions. The unified collections of the museum are managed as a total resource that is drawn upon in new and varied ways to present insights into New Zealand's national identity.

The collections incorporate Maori taonga, cultural and artistic works from the Pacific, works of art, historical objects, archival material and items from the natural environment.

Although design is an element expressed in many areas of Te Papa's collections, Western decorative arts and design objects are concentrated in the history collection.

The primary focus of the Te Papa's Decorative Arts and Design Collection is work designed and made in New Zealand. A broad range of media — historical and contemporary — is collected, including jewellery, ceramics, glass, metalwork, fashion, textiles and industrial design.

Te Papa also holds international examples of Decorative Arts and Design. Such items are actively sought where they have contributed to New Zealand's cultural identity, or if they serve a useful comparative function.

An additional strenght of Te Papa's collections is its significant holdings of archives relating to artists, craftspeople, designers and galleries.

A. L.

Zürich

Museum für Gestaltung Zürich, Design-Sammlung
www.museum-gestaltung.ch

COLLECTION

Museum für Gestaltung Zürich, Design-Sammlung

DESIGNER / ARCHITECT

Alois Rasser

OBJECT

Chair made of corrugated cardboard / Wellkarton-Stuhl

DATE

1969

MANUFACTURER

Kunstgewerbeschule Zürich (?)

Museum für Gestaltung Zürich, Design-Sammlung

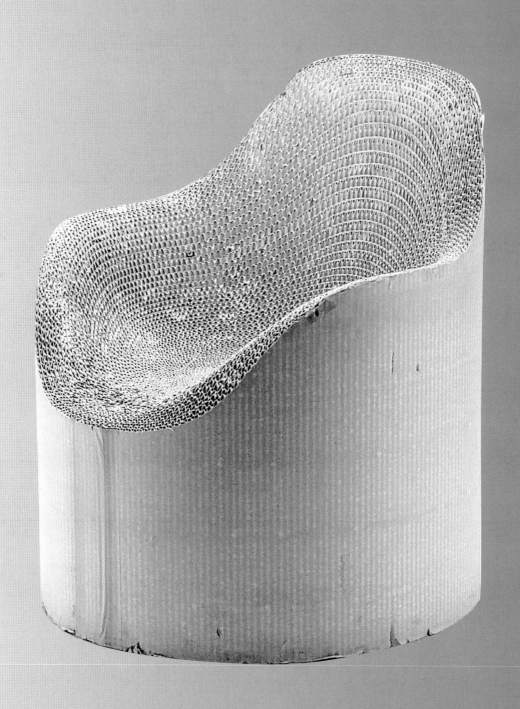

Zürich

Museum für Gestaltung

GESCHICHTE DES MUSEUMS

Mit dem Gründungsjahr 1987 ist die Designsammlung die jüngste von vier Sammlungen des Museums für Gestaltung Zürich (MfGZ), welches ihr als Partner der Hochschule für Gestaltung und Kunst Zürich (HGKZ) ein einmaliges kulturelles Umfeld eröffnet. Thematisch verwandt mit der seit 1875 existierenden Kunstgewerbesammlung umfasst die Designsammlung in Ergänzung zu dieser aber keine kunsthandwerklichen Unikate, sondern seriell hergestellte (oder mit diesem Ziel entworfene) Gegenstände seit 1900. Im Blickpunkt des Interesses stehen dabei die Sicherung und die wissenschaftliche Aufarbeitung wichtiger Schritte in der formalen Ausbildung von Produkten schweizerischer Provenienz aus der Wohn-, Arbeits- und Freizeitsphäre. Ein wichtiges Standbein bilden die aus Bundesmitteln getätigten Ankäufe, welche als Deposita der Eidgenossenschaft betreut werden.

Die geografische Beschränkung auf die Schweiz wird dort aufgebrochen, wo die Konfrontation mit signifikanten ausländischen Fabrikaten zu einem fruchtbaren Dialog über das nationale Designschaffen führt.

Neben den Objekten selbst umfasst die Designsammlung eine Diathek und ein Archiv für Schweizer Design. Letzteres setzt sich zusammen aus Prototypen, Entwurfszeichnungen, Gebrauchsanweisungen, Prospekten, Quellentexten und anderem Dokumentationsmaterial. Hinter diesem dreispurigen Ansatz steckt der Anspruch, die Frage nach Gestaltungsqualitäten in die Betrachtung von technologischen, soziokulturellen, wirtschaftlichen und ökologischen Kriterien einzubinden. Dieser sammlungsspezifische Fokus erklärt, warum hier das anonyme Alltagsprodukt gleichberechtigt neben dem Designklassiker mit großem Namen steht.

Nach einer erfolgreichen Aufbauphase beginnt die Designsammlung mit der Zusammenlegung ihrer Depots an einem einzigen Standort (gemeinsam mit der Grafiksammlung des MfGZ) ein neues Kapitel in ihrer Geschichte. Die räumliche Veränderung setzt insofern — und ganz im Sinne des Jubiläumsmottos zum 125jährigen Bestehen der HGKZ — ein „Zeichen nach vorn", als damit das Bedürfnis nach leichterer Zugänglichkeit der Sammlungsbestände (etwa 11.000 Objekte und über 20.000 Verpackungen) effizienter erfüllt werden kann. Ab 2004 werden kleinere Wechselausstellungen vor Ort Teile der Sammlung periodisch einer breiten Öffentlichkeit präsentieren. Forschenden steht auch der Blick hinter die Kulissen offen. Denn nicht zuletzt die Verbindung zu Museum und Hochschule und damit zu einer der wenigen Schweizer Ausbildungsstätten für Industrial Design prägt das heutige Selbstverständnis der Sammlung wesentlich mit: Kompetenzzentrum für Design, Ort der Grundlagenforschung mit entsprechender Ausstellungs- und Publikationsaktivität sowie Partnerin für angewandte Forschungsprojekte.

In einer Zeit knapper werdender Ressourcen heisst es auch für die Designsammlung, die Bestandeserweiterung zu drosseln und die Bestands-erschliessung zu intensivieren. Das ist Verpflichtung und Chance zugleich, zukünftig neben den klassischen Sammlungsaufgaben noch aktiver als bisher in den Ausstellungs- und Ausbildungsbetrieb eines renommierten Hauses hineinzuwirken.

N. W. / C. B.

HISTORY OF THE MUSEUM

Founded in 1987, the Design Collection is the most recent of four collections maintained by the Museum für Gestaltung Zürich (MfGZ), which, as the partner of the Hochschule für Gestaltung und Kunst Zürich (HGKZ) thus creates a unique cultural environment for the collection. Thematically the Design Collection is related to the Arts & Crafts Collection which dates back to 1875. While supplementing the latter, the Design Collection does not include unique crafts items but instead serially-produced objects made after 1900 – or objects designed with the intention of being manufactured in such a manner. The focus is on documenting and scholarly research into the key stages in the formal development of products made in Switzerland in the fields of the home, work and leisure time. The backbone of the collection is made up of acquisitions made possible by funding from the Confederation that are on permanent loan.

The restriction to Switzerland is not upheld if a confrontation with significant foreign products can kindle a fruitful dialogue on national design output.

Alongside the objects themselves, the Design Collection also runs a slide collection and an archive for Swiss design. The latter is made up of prototypes, design drawings, instructions for use, brochures, source texts and other documentary materials. This three-pronged approach is based on the wish to factor the question of design qualities into a consideration of technological, socio-cultural, economic and ecological criteria. This specific focus of the Collection explains why here anonymous everyday products exist as equals alongside design classics that are famous.

Following its successful launch phase, the Design Collection is starting to bring its holdings together at a single location (together with the MfGZ's Prints Collection) and has thus commenced a new chapter in its history. Fully in keeping with the jubilee motto for the 125th anniversary of the HGKZ, this change of location sets a signal "going forwards", for it enables use to more readily meet the need for easier accessibility to the holdings (some 11 000 objects and in excess of 20 000 sets of packaging). As of 2004, smaller changing exhibitions will periodically present sections of the Collection to a broader public. Researchers are also free to cast a glance behind the wings. For the way the Collection sees itself today is strongly influenced by its links to the museum and the academy, and thus to one of the few Swiss colleges teaching industrial design. The Collection accordingly views itself as a center of competence on design, a place where basic research can be undertaken (with the corresponding exhibition and publication activities) and the partner for applied research projects.

In an age when resources are increasingly scarce, the Design Collection must also scale back its purchasing and intensify its work documenting holdings. This is both an obligation and an opportunity, for it in future not only to pursue its classic collection activities but also to become more actively involved than hitherto in the exhibition and training side to a renowned museum.

N. W. / C. B.

INITIALS OF THE AUTHORS / AUTORENINITIALEN

A. J.	Annemarie Jaeggi, Bauhaus-Archiv / Museum für Gestaltung, Berlin
A. L.	Angela Lassig, Museum of New Zealand Te Papa Tongarewa, Wellington
A. S.	Angela Schönberger, Staatliche Museen zu Berlin, Stiftung Preußischer Kulturbesitz, Kunstgewerbemuseum
A. v. V . / J. E.	Alexander von Vegesack / Jochen Eisenbrand, Vitra Design Museum, Weil am Rhein
B. B. L.	Bodil Busk Laursen, Det Danske Kunstindustrimuseet, Copenhagen
C. C.	Christine Colin, Fonds national d'art contemporain (Fnac), Paris
C. W.	Christopher Wilk, Victoria & Albert Museum, London
D. C.	Diane Charbonneau, Musée des Beaux-Arts, Montreal
E. M. H.	Eva Maria Hoyer, Museum für Kunsthandwerk / Grassimuseum Leipzig
E. W.–B.	Elsebeth Welander-Berggren, Rösska Museet, Göteborg
F. H.	Florian Hufnagl, Die Neue Sammlung, Staatliches Museum für angewandte Kunst, Munich
H. K.	Helena Koenigsmarkova, Uměleckoprůmyslové museum, Prague
I. d. R.	Ingeborg de Roode, Stedelijk Museum, Amsterdam
I. v. Z.	Ida van Zijl, Centraal Museum, Utrecht
J. S.	Jennifer Sanders, Powerhouse Museum, Sydney
L. D.	Lieven Daenens, Design museum, Ghent
M. A.	Marianne Aav, Designmuseo, Helsinki
M. H. H. / L. A. F.	Morrison H. Heckscher / Lawrence A. Fleischmann, The Metropolitan Museum of Art, New York.
M. L.	Marianne Lamonaca, The Wolfsonian – Florida International University, Miami Beach
M.–L. J.	Marie-Laure Jousset, Centre Georges Pompidou, Musée National d'Art Moderne / Centre de création industrielle
M. S.	Michael Siebenbrodt, Stiftung Weimarer Klassik und Kunstsammlungen, Bauhaus-Museum
M. Y.–H.	Meira Yagid-Haimovici, Tel Aviv Museum of Art
N. W. / C. B.	Norbert Wild / Christian Brändle, Museum für Gestaltung Zürich
P .N.	Peter Noever, MAK – Österreiches Museum für angewandte Kunst, Vienna
S. A.	Silvana Annicchiarico, Fondazione „La Triennale di Milano"
S. V.	Silvia Ventosa, Museu de les Arts Decoratives, Barcelona
W. H.	Widar Halen, Kunstindustrimuseet, Oslo
Y. I.	Yūko Ikeda, The National Museum of Modern Art, Kyoto

PHOTO CREDIT / FOTONACHWEIS

Amsterdam
Object: Stedelijk Museum Amsterdam
Museum: Stedelijk Museum Amsterdam

Barcelona
Object: Tresserra Collection, Barcelona
Museum: Archiv Die Neue Sammlung, Munich

Berlin / Bauhaus-Archiv
Object: Bauhaus-Archiv, Berlin / Fotostudio Bartsch
Museum: Bauhaus-Archiv, Berlin

Berlin / Kunstgewerbemuseum
Object: Staatliche Museen zu Berlin, Preußischer Kulturbesitz,
 Kunstgewerbemuseum / Foto: Saturia Linke
Museum: Staatliche Museen zu Berlin, Preußischer Kulturbesitz,
 Kunstgewerbemuseum / Foto: Saturia Linke

Copenhagen
Object: Kunstindustrimuseet, Copenhagen / Foto: Pernille Klemp
Museum: Kunstindustrimuseet, Copenhagen

Ghent
Object: Design museum Gent
Museum: Foto: Rüdiger Buhl

Göteborg
Object: Röhsska museet Göteborg / Foto: Alf Bokgren
Museum: Röhsska museet Göteborg, Sweden

Helsinki
Object: Designmuseo Helsinki / Foto: Rauno Träskelin
Museum: Designmuseo Helsinki

Kyoto
Object: The National Museum of Modern Art, Kyoto
 Foto: Mitsumasa Fujitsuka
Museum: The National Museum of Modern Art, Kyoto
 Foto: Harumi Konishi

Leipzig
Object: Museum für Kunsthandwerk / Grassimuseum Leipzig
 Foto: Matthias Hildebrand
Museum: Museum für Kunsthandwerk / Grassimuseum Leipzig

London
Object: Stephen Richards, London
Museum: Victoria & Albert Museum, London / Foto: Phil Gatward

Mailand
Object: Fondazione „La Triennale di Milano"
Museum: Fondazione „La Triennale di Milano"

Miami Beach
Object: The Wolfsonian — Florida International University
 Miami Beach, Florida
Museum: The Wolfsonian — Florida International University
 Miami Beach, Florida / Foto: Richard Sexton

Montreal
Object: The Montreal Museum of Fine Arts / Foto: Denis Farley
Museum: The Montreal Museum of Fine Arts / Foto: BJM 1992

Munich
Object: Die Neue Sammlung, Munich
 Foto: Architekturfotografie Rainer Viertlböck
Museum: Die Neue Sammlung, Munich
 Foto: Architekturfotografie Klaus Frahm

New York / Cooper Hewitt
Object: Frank O. Gehry & Associates Inc.
Museum: Cooper-Hewitt, National Design Museum
 Smithsonian Institution / Foto: Matt Flynn

New York / Metropolitan
Object: The Metropolitan Museum of Art, New York
Museum: The Metropolitan Museum of Art, New York
 Photograph©1983 The Metropolitan Museum of Art

Oslo
Object: Kunstindustrimuseet i Oslo
Museum: Kunstindustrimuseet i Oslo

Paris / Centre
Objects: Cnac / MNAM /, Dist. RMN, Foto: Georges Meguertchian
Museum: Archiv Die Neue Sammlung, Munich

Paris / Fnac
Object: Fonds national d'art contemporain / interme
Museum: Fonds national d'art contemporain
 Foto: Deidi von Schiewen

Prague
Object: Museum of Decorative Arts, Prague / Foto: Miloslav Sebek
Museum: Museum of Decorative Arts, Prague

Sydney
Object: Powerhouse Museum, Sydney
Museum: Powerhouse Museum, Sydney

Tel Aviv
Object: Tel Aviv Museum of Art
 Aqua Collections Tel Aviv, New York
Museum: Tel Aviv Museum of Art

Utrecht
Object: droog design, Amsterdam
Museum: Centraal Museum, Utrecht

Vienna
Object: MAK — Österreichisches Museum für angewandte Kunst
Museum: MAK — Österreichisches Museum für angewandte Kunst
 Foto: Gerald Zugmann

Weil
Object: Vitra Design Museum, Weil am Rhein
Museum: Vitra Design Museum, Weil am Rhein

Weimar
Object: Stiftung Weimarer Klassik und Kunstsammlungen,
 Bauhaus-Museum
Museum: Stiftung Weimarer Klassik und Kunstsammlungen

Wellington
Object: Museum of New Zealand Te Papa Tongarewa
Museum: Museum of New Zealand Te Papa Tongarewa

Zürich
Object: Museum für Gestaltung Zürich / Foto: Franz Xaver Jaggy
Museum: Museum für Gestaltung Zürich

Page / Seite 04 / 05 Foto: Margherita Spiluttini
Page / Seite 06 Foto: Annette Kradisch
Page / Seite 08 Foto: Annette Kradisch
Page / Seite 10 Foto: Klaus Frahm
Page / Seite 14 Foto: Gerrit Engel
Page / Seite 20 / 21 Foto: Margherita Spiluttini